O California!

We traveled through the [San Andres] valley some four leagues to the southeast and southeast by south, and crossed the arroyo of San Matheo where it enters the pass through the hills. About a league before this there came out on our road a very large bear, which the men succeeded in killing. There are many of these beasts in that country, and they often attack and do damage to the Indians when they go to hunt, of which I saw many horrible examples. When he saw us so near the bear was going along very carelessly on the slope of a hill where flight was not very easy. When I saw him so close and that he was looking at me in suspense I feared some disaster. But Corporal Robles fired a shot at him with aim so true that he hit him in the neck. The bear now hurled himself down the slope, crossed the arroyo, and hid in the brush, but he was so badly wounded that after going a short distance he fell dead. Thereupon the soldiers skinned him and took what flesh they wished. In this affair we spent more than an hour here.

– Pedro Font

1 Charles Christian Nahl
 California Grizzly Bear, c. 1856

O California!

Nineteenth and Early Twentieth Century
California Landscapes and Observations

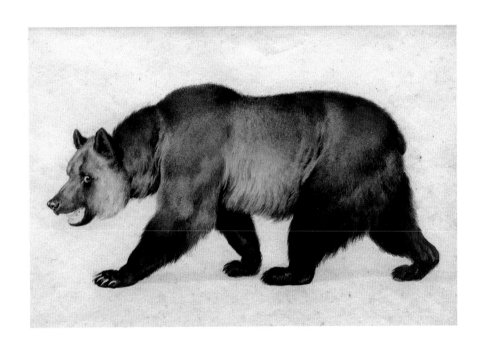

Editor Stephen Vincent
Preface Kevin Starr
Art selection Paul Mills

Bedford Arts, Publishers

San Francisco

Copyright © 1990 by Bedford Arts, Publishers

Published by Bedford Arts, Publishers
250 Sutter Street, Suite 550
San Francisco, California 94108-4482

First printing

Library of Congress Cataloging-in-Publication Data
O California! : nineteenth and early twentieth century California
landscapes and observations / edited by Stephen Vincent; preface by
Kevin Starr; paintings selected by Paul Mills.
p. cm.
Includes bibliographical references.
ISBN 0-938491-20-2 – ISBN 0-938491-33-4 (slipcase)
 1. Landscape – California. 2. California – Description and travel.
3. California in art. 4. California in literature. 5. Authors,
American – Journeys – California. I. Vincent, Stephen, 1941–
II. Mills, Paul, 1924–
F861.018 1990
917.94—dc20 89-36808
 CIP

Editor: Stephen Vincent
Bibliographical Consultant: Kevin Starr
Readers: Beverly Dahlen, George Evans, Carla Harryman
Text and Production Editor: Gail Larrick
Art Editor: Paul Mills
Art Management: Deborah Bruce, Monica Garcia

O California! *is printed in three editions: a clothbound edition and two slipcase*
editions, one of which is quarterbound in leather and limited to one hundred
copies, signed by Stephen Vincent, Kevin Starr, and Paul Mills.

Printed in Japan

Acknowledgments for use of art reproductions and for photography of
art works are included in Illustrations *at the end of this volume.*
Acknowledgments of text sources and permission to reprint, where applicable,
are included in Bibliography *at the end of this volume.*

Cover: Virgil Williams. *View South from Sonoma Hills toward*
San Pablo Bay and Mount Tamalpais, 1864.

Contents

Preface

Kevin Starr

O California! focuses on landscape, art, the written word, and the synergies fusing them together. This unique gazetteer of painting and literature is concerned with the American national experience as well, for California – as a place, as a symbol, as an occasion for art and literature – belongs directly to the larger drama of the United States. *O California!* presents a portion of the American environment in the deepest possible sense: the place *without* and the place *within*, geographies of scientific description, geographies recovered and transformed by art. *O California!* is thus a sampling, a record, a history, shaped and energized by a combination of aesthetic appreciation and present-tense urgency.

The California so glowingly preserved in the landscape art and prose passages of this uniquely intraactive book stands for other American environments – north and south, east and west – blessed with comparable beauty and celebrated in comparable painting and literature. In anthologizing what was seen and painted and written about in nineteenth and early twentieth century California, this volume celebrates the grand drama of an America that once awaited us as a people: the fresh green breast of the New World, as F. Scott Fitzgerald described it, commensurate with mankind's capacity for wonder. Even as we exult in what an earlier era beheld and celebrated, however, disturbing doubts creep into the backs of our minds, then push themselves forward.

The American continent so triumphantly depicted in *O California!* – so grand, so serene, so seemingly eternal and transhuman in its abiding strength – seems less permanent and more vulnerable a hundred years and less from the time these canvases were painted and their accompanying words written. The American artists of an earlier generation might envision the continent as being possessed of the very permanence and power of Divinity itself. A later generation, perusing the paintings of that era, realizes all too sadly that the landscape at the core of our national identity sustains a delicate ecosystem capable of being wantonly destroyed – by an oil spill, perhaps, or a more solid covering of asphalt, through the introduction of toxins into ground water and the extinction of insect, bird, and animal life – or just as wantonly neglected and slowly used up. The message of *O California!* speaks not only about what was once seen or heard, painted, or recorded in prose. The book has a larger message, which it presents to us indirectly and by implication and in a few cases directly as well.

Is the California of *O California!* forever or passing? Will the America of *O America!* be available to future generations only through art? The somewhat hidden but powerful meaning of these questions will come clear after a closer examination of the background and themes of the art and writing in this compelling book.

Can California be used to construe the national, much less the European, experience? Can the whole, the United States, be known by one of its fifty sovereign parts? The central premise of *O California!* is that it can. From the first, California functioned as a direct creation of and a gloss upon the national experience. Nor was it irrelevant to the European experience.

Throughout the early nineteenth century, Europe and the United States were dreaming of California. This envisioning had political, economic, scientific, and imaginative dimensions. Having penetrated as far south as Fort Ross on the Mendocino coast, the Russians dreamed of extending their arc of empire south from Alaska to San Francisco Bay. With their Pacific squadron operating between Mazatlan and the Sandwich Islands, the British speculated on the possibilities of establishing a permanent port of call, a Hong Kong enclave on the California coast, that would link them to the Hudson Bay trappers and traders operating in the interior. In 1842

Eugène Deflot de Mofras, a special emissary of the French government in California, filed a secret memorandum with the Ministry of Foreign Affairs in Paris suggesting that the French Navy sail into San Francisco Bay and reestablish lost Louisiana on the shores of California.

But it was the United States, not any European power, which proved itself capable of seizing the prize and turning the dreams into reality, so that it might begin new dreams of gold, settlement, and art. Americans had been coming and going, intermittently, in California ever since the *Columbia* and the *Lady Washington*, en route to China, skirted the coast in the late 1780s. In November 1826 fur trader Jedediah Smith led the first overland penetration of California by Americans. A few years later Richard Henry Dana, Jr., arrived on the *Pilgrim*, a Bryant and Sturgis brig bound for California in the hide and tallow trade. Dana's account of his California sojourn, *Two Years Before the Mast* (1840), epitomized the amalgam of wonderment, acquisitiveness, and contempt for the Hispanic inhabitants which characterized most American responses to California before the United States seized it during the Mexican War.

Even as European emissaries and Yankee merchants were dreaming of political and economic acquisitions, a concurrent drama of spirit and imagination was also unfolding. In half of the Spanish imagination – the half represented by the Franciscan missionaries – California constituted the spiritual challenge of bringing its aboriginal peoples into the Christian faith and Spanish culture. For the natural scientists who accompanied the many voyages of exploration that touched upon the California coast from the late eighteenth century onwards, beginning with the arrival in 1786 of the French expedition commanded by Comte de La Perouse and the British expedition of 1792 under the command of George Vancouver, California offered a bold and plenteous natural environment for study. Throughout the early and mid-nineteenth century, French, English, Russian, German, Italian, and American naturalists filed reports on the landforms and trees, birds and animals, bays, rivers, and water systems of coastal California. This body of writing (sometimes enlivened by sketches or watercolors or even an oil painting or two) represented the first reconnaissance of the European and American imagination into the environment that painters from Europe and the United States would soon be documenting in landscape art.

This first extension of European and American intelligence to the remote California coast had its spiritual and aesthetic dimensions as well. Europe, after all, in the person of Garcí Ordóñez de Montalvo, author of the prose romance *Las sergas de Esplandían* (1510), had first envisioned California as a Terrestrial Paradise on the right hand of the Indies, inhabited by Amazons and ruled by Queen Calafía. When the Spanish sailed west from Mexico in 1533 and discovered a peninsula jutting south into what is now called the Sea of Cortes, they named the area California, thinking Baja California to be an island and not a peninsula, and this name was in turn extended to Alta California, which the Spanish colonized in 1769.

From the start, then, California was possessed of a mythic dimension, and something of this magic, this sense of transformation in a new place, managed to find expression even in the accounts filed from California by three generations of European scientists and explorers. For Europeans, whether Spanish missionaries or scientists attached to voyages of exploration, California was at once a place to be studied and an imaginative goal to be possessed.

For Americans, this imaginative dimension of California came with special intensity. After all, for the previous two hundred years the Anglo-American imagination had been in the process of spiritualizing the American continent into an environmental text to be assimilated as a mode of revelation second only to Scripture itself. This assimilation of nature as an emanation of the mind of God, a sacred text to be construed, runs parallel to the covenantal impulse that resulted in the establishment of the Republic as the two

preoccupations of Anglo-American mental life in the seventeenth and eighteenth centuries. As early as 1651 (or 1630, when he first began the book) William Bradford, author of *Of Plymouth Plantation*, was envisioning the American landscape in powerfully symbolic terms as an environment fraught with psychological and spiritual challenge. The greatest theologian of the colonial era, Jonathan Edwards, fused the psychological empiricism of John Locke, the philosophical idealism of George Berkeley, and the theology of John Calvin to create a response to the American environment as a landscape to be explored and, simultaneously, as a concrete scientific fact, a transcendental symbol, and an emanation of the mind of God. To encounter the American landscape, then, was to encounter a geography *without* and a geography *within*.

Fortunately, the vast diversity of the American continent was fully equal to this proclivity to regard it as a form of Scripture itself. When Meriwether Lewis and William Clark returned from their epic transcontinental exploration in 1806, they reported to President Thomas Jefferson that, yes, it was even grander than could be imagined: vast prairies, soaring mountain ranges, mighty inland rivers, and finally the Pacific itself, thousands of miles from Atlantic civilization, onto which the Americans had burst after their long trek like Xenophon's Greeks shouting, "The sea! The sea!" Hearing this, Jefferson had his scientific intimations confirmed, for this great Enlightenment savant had long since explored the continent in his imagination in his *Notes on the State of Virginia* (1784), envisioning a Virginia that extended westward across the continent through an open-ended frontier until it reached the Pacific.

As the nineteenth century unfolded, scientific and imaginative energies born in part of religion coalesced to energize the westward movement of the American people. As usual, the imagination leapt out ahead of the actual physical advance. From this perspective, California, which was west of the West, as Theodore Roosevelt would later describe it, functioned as *Ultima Thula*, the final geog-

raphy, the national goal, at the culmination of the advance.

As the ultimate object of expansionist ambition, California called attention to itself on a number of levels. Geographically, it was the final place, the territory at which the Pacific temporarily terminated the agenda of Manifest Destiny. Symbolically, California became the fixed object of the national will. Just as ancient Rome knew that *Delenda est Carthago!* [Carthage must be destroyed] for its pan-Mediterranean destiny to assert itself, the United States knew that California must be acquired for the trans-Mississippi West to be securely obtained and so that, eventually, a Pacific Basin presence could be created. Thus in the poem "Facing West from California's Shores," the greatest national poet of the American experience in that or any other generation, Walt Whitman, put his representative American pilgrim on the shores of California and has him or her ask why, now that the transcontinental, indeed transglobal, migration is complete, he or she is so sad and

> *But where is what I started for so long ago?*
> *And why is it yet unfound?*

Questions of meaning and value in the midst of travel and exploration engendered a vast and diverse literature in California, which is represented in this anthology by some of its best writers – William Brewer, Clarence King, John Muir, Mary Austin, and J. Smeaton Chase, among others. For these writers, to be in California was, simultaneously, to experience an environment commensurate with their capacity for wonder, to apply Fitzgerald's description of the entire American continent, and to seek to decipher and construe this environment in terms not only of its geological or natural history but imaginative resonances as well. Like Whitman's pilgrim they were asking the questions: What does California mean? Why is its impact so powerful? When the Unitarian minister Thomas Starr King visited the Yosemite in July 1860, for example, he experienced "that which the Israelites felt amid the passes of Sinai when the Divine glory was on the mount." Each cliff and waterfall, encountered existentially as the

present-tense emanation of an ongoing divine act of creation, constituted revelations as compelling as Holy Writ. King left the Valley and returned to his pulpit in San Francisco resolved to help create within himself and in others "Yosemites of the soul."

The impact of California – so vivid for geologists and naturalists, inspiring diarists, and memorialists who might otherwise have never taken up the pen – was doubly, triply, compounded for landscape artists. Like Upstate New York, which had inspired the Hudson River School, California offered sublime and romantic vistas of every description. While there was no Niagara Falls, there was the Yosemite, which very soon, thanks to their art, entered the national consciousness alongside Niagara as a major icon of national identity.

The painters represented in *O California!* encompass successive phases of artistic development in every region in California through the early twentieth century. While memberships in each category sometimes overlap, the California painters represented in this volume can be classified as Tourists, Forty-Niners, High Provincials, the Second Generation, and the Southern Californians. The Southern Californians, in turn, encompassed distinct circles in Santa Barbara, Pasadena, Los Angeles, Laguna Beach, San Diego, and the desert, which recruited artists to itself from up and down the entire state.

The Tourists came to paint – period. Then they departed. The Forty-Niners came for gold, but they painted as well. Some Forty-Niners remained in California. Others returned to Europe or the Eastern States. Arriving in the 1860s and 1870s, the High Provincials came both to paint and to stay, which they did for the remaining decades of the nineteenth century. The term High Provincial derives from the California-born Harvard philosopher Josiah Royce. It suggests an attitude of regional loyalty animated by larger ideals. Most nineteenth century American cultures – the Boston of Ralph Waldo Emerson and Oliver Wendell Holmes, Washington

Irving's New York, Charleston in the age of the Pinckneys – participated in this High Provincial mode. Not until the emergence of New York in the late nineteenth and early twentieth century did a different kind of urban culture make its appearance in the United States.

The members of the Second Generation were either born in California or arrived there as young men. Many of them studied with artists of the High Provincial generation. Virtually every member of the Second Generation represented in *O California!* studied in Europe; the Académie Julian in Paris seems at times in the 1890s to be overrun by what aspiring painter Frank Norris, later a novelist, described as the Cowboy Californians. Products, simultaneously, of their California environment and their European training, the Second Generation flourished through the 1890–1920 era, conferring on American art in California an astonishing second burst of energy well before the creativity of the High Provincials had expended itself. The Southern Californians began arriving in the late 1890s and early 1900s and thus overlapped the Second Generation. In terms of region, lineage, and painting style, however, the Southern Californians constitute a distinct group.

O California! amply represents the work of each of these successive waves of California artists, beginning with the Tourists. Albert Bierstadt, for example, was the grandest Tourist of them all in terms of the intensity of his sojourns and their artistic result. Having already sketched in the Rocky Mountains and Wyoming in 1859, Bierstadt first arrived in California in 1863, dividing his time over the course of six months between San Francisco and the Yosemite before returning to New York. In 1871 he arrived in California for a three-year stay that virtually qualifies him as a High Provincial. He remained, however, in the long run a Tourist. Born in Europe and trained there in art after coming to the United States, Bierstadt blended Europe and America in both his painting and personal styles.

It is perhaps difficult to differentiate Tour-

ists from Forty-Niners. The point of differentiation is that the Forty-Niners, while trained artists, came to California primarily to seek gold. Charles Christian Nahl was a Forty-Niner who became a leading High Provincial. His mining experiences on the Yuba River were the most authentic of any of the Argonaut artists, and scenes from the mines soon found their way into newspaper engravings and paintings that Nahl rendered in exchange for gold dust. The greatest Forty-Niner of them all was the Frenchman Erneste Narjot, who arrived in 1849 and spent three years in the Mother Lode. All in all, Narjot spent thirteen years as a prospector, miner, and painter throughout the Southwest before returning to San Francisco in 1865 to join the front ranks of the High Provincials then beginning to arrive from Eastern states and Europe. Narjot filled the next thirty years painting numerous canvases, meticulous and realistic – scenes from the mines, landscapes, portraits, murals for churches and public buildings – which remain today among the glories of California art: those which survived, that is, for much of Narjot's work, like that of William Keith, was destroyed in the earthquake and fire that razed San Francisco in April 1906.

Most of the High Provincials were trained artists who came to California, beginning in the 1860s, with professional ambitions. Even amidst the distractions of the Gold Rush, there were signs that professional painting would one day come to California. As early as 1851, frontier San Francisco supported a quasi-art gallery, the grandly named San Francisco Art Union at 277 Montgomery Street, where paintings and *objets d'art* shipped in from New York were sold at auction. Another auction house, Wainwright, Byrne and Company at 176 Montgomery Street, also handled painting consignments. In the mid-1850s the outlets for art sales broadened to include book and stationery stores. One of these, Marvin and Hitchcock, in 1854 converted its entire second floor into an art gallery. By the early 1860s hotel lobbies had also emerged as important display points for local artistic efforts. Thanks to hotelman

and impresario Robert B. Woodward, San Francisco enjoyed a public art gallery of sorts in the What Cheer House, a men-only temperance hotel built in 1852. Passionately committed to bringing art and culture to San Francisco and the West, Woodward put on permanent exhibition a number of fine paintings in the What Cheer House.

Rapidly, with breathtaking acceleration, the promise of the 1860s became the performance of the 1870s. Inaugurating transcontinental service in May 1869, the Central Pacific Railroad brought California within a week's distance of the East. The railroad also brought out to California for extended, or as it turned out, permanent periods of residence such capable artists as William Hahn, Thomas Moran, and William Alexander Coulter. Such wealthy Californians, meanwhile, as Edwin Bryant Crocker, Leland Stanford, Milton S. Latham, Tiburcio Parrott, James Ben Ali Haggin, Darius Ogden Mills, William Chapman Ralston, and Francis Louis Pioche began to adorn their sumptuous urban homes and suburban villas with paintings by California artists. By the mid-1870s San Francisco enjoyed an art academy, the San Francisco Art Association incorporated in March 1871, and an ever-widening circle of artists who were fanning throughout the central and northern portions of the state in search of landscapes to paint.

A number of High Provincials, including the era's most pivotal figures, Thomas Hill, Virgil Williams, and William Keith, traveled back and forth from East to West to Europe and returned before settling in permanently as California painters. The naturalist John Muir took Keith with him into the Yosemite in 1872, and Keith returned from this sojourn possessed of a vision of California as nature transformed and radiant with spiritual energy. In 1882, Keith came under the influence of the Swedenborgian minister Joseph Worcester, whose East Bay home became a subject for his work. Emanuel Swedenborg's immanentism, his sense of spirit pervading matter and matter as a revelation of spirit, spoke directly to the imaginative needs of art-

ists and intellectuals such as Keith, eager to theologize their intense involvement with nature, and the environment of the Bay Area and Northern California specifically, as the premise of their lifestyle and the subject matter of their art. While Keith never became an active member of Worcester's Church of the New Jerusalem in San Francisco, he did absorb from the theology of Swedenborg and from Worcester a certain dreamy mysticism that exercised a major influence on many of his landscapes.

In 1862 when he was only beginning to aspire to become a painter, Keith had visited the Yosemite in the company of Hill and Williams, who had known each other from New England painting circles in the 1850s. Hill arrived in California with his wife and children in 1861, having made the trip overland by covered wagon in an effort to regain his health. Between 1861 and 1866, Hill devoted himself to what would become the dominant theme of his *oeuvre*, the Yosemite. After 1871, he threw himself increasingly into his Yosemite obsession, living most of the year on the rim of the Valley itself. He would eventually produce some 5000 paintings of the Valley.

Williams, too, embodied synergies of background, preference, and ambition characteristic of the High Provincial California painters. When the San Francisco Art Association formed in March 1871, Williams was at the center of its circle of controlling artists, who looked to him as the most formally prepared and academically educated of their membership. When the California School of Design opened in 1874, Williams was appointed its director and primary professor. Over the next twelve years, before his all-too-early death, Williams taught at and presided over the developing institution.

Well read, diversely traveled and educated, Williams loved social life, good friends and good talk in either English or Italian on any subject, but especially art. He and Hill went on frequent fishing expeditions together, accompanied by their wives. A number of charming paintings survive, painted by both Hill and Williams, which document these camping trips to the Russian River area and as far away as the Yosemite, which Williams visited in 1863 with his friend Albert Bierstadt. Poet Charles Warren Stoddard was a close friend, and in 1879 he introduced Williams to Robert Louis Stevenson, then in San Francisco in pursuit of Fanny Osbourne, the soon-to-be-former wife of Williams's good friend Sam Osbourne. When Stevenson and Fanny Osbourne were married, Virgil and Dora Williams served as best man, bridesmaid, and sole witnesses. At Williams's suggestion, the couple spent their honeymoon in a small cottage near the Hot Springs Hotel at Calistoga in the Napa Valley. Stevenson dedicated his account of this sojourn, *The Silverado Squatters* (1883), to Virgil and Dora Williams.

Succeeding the High Provincials, the Second Generation in Northern and Central California – but not Southern California, which was distinct – built upon their tutelage. Virgil Williams, for example, taught Thaddeus Welch, Julian Rix, Lorenzo Latimer, Theodore Wores, and Charles Rollo Peters at the California School of Design. Williams's pupil Arthur Frank Mathews succeeded him in the School as professor in 1889. Four of the Second Generation were San Francisco-born, further testimony to the growing density of San Francisco as an American art center which could now produce its own painters of note.

A composite portrait of the Second Generation in its Northern and Central Californian mode would include study in San Francisco followed by study in Paris followed by a return to California and an active career, supplemented in part by newspaper and magazine work.

The Second Generation who settled and painted on the Monterey Peninsula overlapped its San Francisco counterparts. Among the Monterey painters represented in *O California!*, for instance, Euphemia Charlton Fortune and Armin Hansen each studied with Arthur Mathews in San Francisco. What brought them to Monterey–Carmel was the sea. Both William Frederick Ritschel and Armin Hansen spent time in their youth as

sailors before the mast. Ritschel ranged across the South Pacific from his stone castle-studio in the Carmel Highlands. Armin Carl Hansen belongs more to the sea than to California, although in a region with more than a thousand miles of coast, his two loyalties were not contradictory. In the case of the Second Generation in its various desert and Southern Californian modes, some continuities exist between north and south. On the whole, however, Southern California represents its own spontaneous and eclectic presence, recruited diversely from the East and from Europe in the way that Northern California filled up with artists in the 1870s. Many came for their health, especially in the 1870–1900 period.

The Pasadena painters represented in *O California!* have the Arroyo Seco in common, together with a preference for architectural landscapes and a distinct mode of Southern Californian impressionism inspired by France via William Merritt Chase and Guy Rose. With its preference for explosive color, its essentially upper-middle-class subject matter and adherence to *plein air* or rapid painting in the outdoors, Chase's approach (he was, after all, the grandest American art teacher of his generation) was immediately applicable to the sun-splashed outdoor drama of the Southland.

Because they were civilized embodiments of the genteel tradition, Pasadenans also sustained a preference for architectural landscapes, as is evidenced in this collection. Living as they did in and around the Arroyo Seco, so suggestive of the primal power of the inland desert as it narrowly penetrated the coast, the Pasadenans enjoyed the solace of bridges and creamy white walls covered in sunlight and flowers.

Their colleagues to the west, in the City of the Angels, as represented in this volume, possessed the dynamic eclecticism of Los Angeles itself. Their founder and patriarch, John Bond Francisco, had experienced the requisite education in Berlin, Munich, and the Académie Julian before arriving in Los Angeles in 1887 where he flourished as a violinist, music teacher, and painter. William Lees Jud-son, another Académie Julian graduate, teaching art at the University of Southern California from 1896 to 1928, became the city's resident art academician, the Virgil Williams or Arthur Mathews of California's southern metropolis. The Otis Art Institute and the Chouinard Art School, two other Los Angeles institutions, offered employment to landscapists Ralph William Holmes and Paul Lauritz, a Norwegian immigrant active until his death at age 87 in 1976.

As was appropriate to the city which had incorporated Hollywood in 1910, Los Angeles supported a talented actor-painter: Granville Redmond, a deaf and speechless student of Arthur Mathews's at the California School of Design in San Francisco and the Académie Julian in Paris. Moving to Los Angeles in 1898, Redmond flourished as a respected painter and as an actor in silent films. Charlie Chaplin learned mime from Redmond and bought his best paintings.

Laguna Beach was to Los Angeles what Carmel was to San Francisco: the seaside bohemian art colony to the south. Pioneer founder Frank William Cuprien was another musician-artist with European training. Settling in Laguna Beach in 1910, Cuprien built a studio for himself on a bluff overlooking the Pacific, where he spent the next 38 years painting and partying and giving piano recitals. The muted impressionism of Mary Orwig Everett, a student of William Merritt Chase who arrived in Laguna Beach in 1919, carried on the master's tradition of vigorous *plein air* civility.

Two San Diego artists were among the Southern Californians. Ammi Merchant Farnham arrived in 1886 from Buffalo, after having studied in Munich in the company of Frank Duveneck. Farnham had prospered as a portrait painter, with a practice in a number of major American cities. Like other Southern Californian painters, he used this nest egg from portrait painting to support a lifestyle which included a leisurely pursuit of local landscapes broken by trips to the East Coast and to Europe, rather expensive propositions in that era. Maurice Braun, a student of Wil-

liam Merritt Chase, was likewise a successful portrait painter before he removed to San Diego in 1910, attracted there by that city's Theosophical Society. Extraordinarily sensitive to the distinct colors of the southern portion of the Southern Californian coast, Braun produced a series of exquisitely hued landscapes that became the founding images of the emergent Southern California landscape style, with its continuing acknowledgment of Chase and the French Impressionists. Maurice Braun was not only the great painter of the San Diego region during the first half of the twentieth century, his landscapes of all Southern California, the Sierra Nevada, and the Southwestern desert brought him national fame as well. Among California painters the desert seemed territory common to Southern and Northern circles.

What did these artists see? They saw California, place by place, region by region. They began, most of them, perceiving the state in terms of San Francisco and the region around the Bay, the first of the geographical subregions in which *O California!* presents their landscapes and utterances. The Spanish had a different perspective, arriving as they did by ship or overland from Mexico into Baja California, then pushing northward up the coast. Raymond Yelland's *The Golden Gate (Looking In)* (1880) stands as the achieved type for innumerable paintings of this magnificent harbor. The same perspective is seen in 1879 by Josiah Royce, a young philosophy instructor at the University of California at Berkeley: as the representative California landscape, urging, through its grandeur, the inhabitants of this new American region to live with a boldness and fullness equal to the scenery. Royce's own campus, to which he returned to formulate his meditations, appears as Edwin Deakin's *Outdoor Study on Strawberry Creek* (1892), and we can almost hear the pealing of the campanile that now stands nearby. Virgil Williams's *View South from Sonoma Hills toward San Pablo Bay and Mount Tamalpais* (1864) presents the other and softer side of California, north and south, the ability of its landscape to

be sculpted by even the lightest human use into an Italianate vista, Campagna-like, of stone-lined trails that seemed to have been trod for a thousand years, herds that appear to have been kept for an equal amount of time, and leisurely huntsmen for whom the outdoors has become, not the harsh frontier, but a panorama of repose, sun-splashed and edenic. Williams's canvas presents the interior to Napa and Sonoma counties, so soon transformed into cultivated vineyards. We encounter this region through the eyes of Robert Louis Stevenson, sojourning on the side of Mt. St. Helena for an idyllic honeymoon, and, among other painters, through a landscape by Jules Pages carpeted in flowers that only a nurturing honey-strong sun could bring to blossom.

Marin County, dominated by Mt. Tamalpais, sacred to the Miwok and their successors, occurs and reoccurs in the art of all four generations of painters covered in this volume. We see Marin heroically through the eyes of Thomas Hill, serenely in one of the innumerable landscapes produced by Thaddeus Welch, and through the more recent impressionistic canvases of Granville Redmond, Arthur Best, and Percy Gray, for whom (as for Welch) the landscapes of Marin proved an inexhaustible source of inspiration. Erneste Narjot's hunting scene offers an unusual, slightly ominous view of the region.

We move north from Marin through the Russian River country up to Fort Ross on the Mendocino coast through the coastal redwood groves that begin at Santa Cruz and give out just past the Oregon border. This region remains today in many of its parts as grand and unchanged and elemental as it was when depicted by the Tourists and the High Provincial and by the painters of the Second Generation. Significant urbanization tapers off dramatically north of metropolitan Sacramento and the Chico area. The vast northern mountain forests of California lured the artists of every generation represented in this book. They still do, for while so much of the rest of California has been transformed by the hand of man, these montane regions still hold

within themselves that very same experience of pristine sublimity that the pioneer painters of California trekked north to experience.

The second subregion of *O California!*, San Francisco Bay and to the Northeast, was actually the first in terms of primacy of travel, for the overland migrations traced this route down to the coast, and, during the Gold Rush, thousands of Forty-Niners fanned east, northeast, and southeast from San Francisco in search of the Golden Fleece. This region, which encompasses the Mother Lode, was already famous by 1850 and, thanks to Bret Harte and the others, became fixed in the imagination of English-speaking peoples around the globe. In these mountainous regions was played out the second (after the conquest) and most important sequence of the American experience in California. Letters from the gold camps, advice from miners, Alburtus Del Orient Browere's *The Lone Prospector* (1853) and *Mokelumne Hill* (1857) – all offer a first-hand look at the Gold Rush. The texts and paintings that frame the accounts of life in the Mother Lode explore the effects of rapid change wrought by the search for gold and the development of transportation – the mule train, the stage coach, the railroad – to support it.

The third subregion, the High Sierra – Lake Tahoe, Hetch Hetchy, Yosemite, and the Big Trees – is paramount in terms of the entire drama of imagination in nineteenth century California. Virtually every artist of the Tourist and High Provincial generations visited and painted the Yosemite, which, as early as 1860, when Californians put it under public protection, had become the single accepted icon of California as a place and state of mind. Thus *O California!* presents the Yosemite, the Hetch Hetchy and its nearby regions through the eyes of the state's most classic painters and some of its renowned writers. This Alpine region inspired the best-known depictions of California in the nineteenth century. The painters represented in this subregion – Hill, Moran, Bierstadt – as well as the authors – Mark Twain, John Muir, Clarence King – are perhaps the most familiar

to a wider audience. Thanks to Bierstadt especially, whose Sierra and Yosemite canvases sold so well in England and on the Continent, but also thanks to Hill and Keith, whose reputations are only now approaching their just due, the Sierra Nevada and the Yosemite of California penetrated the imaginative consciousness of America and Europe. Indeed, thanks again to these paintings and their attendant literary descriptions – in John Muir above everyone else, a Scotsman who became the most representative Californian of them all – Californians developed a tendency by the late nineteenth century to define themselves as a people and a society through the Sierra Nevada and the Yosemite as universal icons of identity. From this self-definition, the Sierra Club of California was founded in 1892, with John Muir as its first president. This organization, then, bridges the exhilarations of nineteenth century mountaineering and artistic celebration with the equally inspiring yet also embattled wilderness encounters of the late twentieth century era. Standing at the center of California and at the center of this book, the Yosemite and surrounding regions anchors both in imagery that reaches out to but a few other places – Niagara, the Mississippi at its widest, the Grand Canyon – for parallels in the national imagination.

First described by Thomas Starr King in 1860 as a direct emanation of the mind of God, the Yosemite was filtered and refracted through every important artistic consciousness, visual or literary, of the nineteenth century. Thomas Starr King, Clarence King, Bierstadt, the photographers Eadweard Muybridge and Carleton Watkins, the publicist-naturalist James Mason Hutchings, the landscape architect Frederick Law Olmsted, Ralph Waldo Emerson, and such figures as Keith, Hill, and Muir, for whom the Yosemite was an oft-frequented shrine – there is no end to the roll call of nineteenth century visitors to this wondrous valley. Each of them experienced something that was the same and something that was different in its mighty cathedral of cliffs and falls; and each, in turn, left a visual or literary testament that caught one or

another dimension of its inexhaustible beauty.

South of the Yosemite runs the Southern Sierra extending into the Southern Deserts. These together constitute the fourth subregion of *O California!* The Sierra Nevada takes on an increasing austerity as it runs south towards the arid regions. Its eastern side participates in the ecosystem of the great basin extending east to the Rocky Mountains. Mountain forests yield to rocky promontories where only the hardiest flora and fauna survive, and, south of the Owens Valley, the mountains come shuddering into the desert like a corded sinewy fist clutching into the earth itself.

The Southern Deserts come to us primarily through painters of the Second Generation, for these arid regions remained remote from human settlement until the late nineteenth century. Thus in terms of accompanying prose, we experience this area most intensely through Indian myth and statement, and through such idiosyncratic desert lovers as Mary Austin and J. Smeaton Chase. Alson Skinner Clark's and Fernand Lungren's Death Valley landscapes depict places which, while remote, nevertheless have affixed themselves to the national, even international, consciousness. While situated in the south, the desert belonged to all Californians. Aesthetically, it did not emerge into its own until the turn of the century. The Forty-Niners, like the Spanish and Mexicans before them, saw it as a barrier guarding the southeastern flank of California. The late nineteenth century dreamt of irrigating it into farmlands and succeeded in the case of the Imperial Valley, watered from the Colorado River in the early 1900s. It took the Second Generation and its literary companions to return to the desert in a spirit of aesthetic appreciation. This generation defined the desert not in terms of its negativity – its heat, the absence of water – but in terms of its dazzling topographical and climatic effects, its iridescent color, the sturdy Gongorism of its cacti, birds, reptiles, and other life forms.

No region could be more in contrast to the desert than the well-watered Monterey Peninsula, which began attracting artists in the late 1870s. By 1910 Monterey and the nearby village of Carmel-by-the-Sea constituted an important center of artistic activity. The Monterey Peninsula, including Carmel, the Salinas Valley, Morro Bay, and the Big Sur coast south towards San Luis Obispo, have inspired not only numerous paintings but a school of painters as well, the Second Generation in its Central California mode.

At the southern edge of this region, another school formed at Santa Barbara, where Central California officially begins. In this region we experience a clustered paradigm of all that California offers: mountains, river-watered valleys awaiting agriculture, exquisite seacoasts, bays, coves and inlets for maritime traffic, wild surf against rocky shores. This fifth subregion, considered as a unit or at least as an axis of movement in *O California!*, begins on the San Francisco peninsula, which is Italy and Greece, moves into the redwood forests of Santa Cruz, reaches out to enfold the flatlands of Salinas Valley, then pushes down the coast, having become Big Sur where the coastal mountains rush shudderingly, abruptly into the Pacific. After the High Sierra and the Yosemite, this is the most painted region of the state, for it offers an inexhaustible variety, a *plenum mundi* of every sort of scenic effect.

The abiding pleasure of the sixth subregion, Los Angeles and the Great Valley, is the opportunity to see these places – Los Angeles, Pasadena, the valleys of San Fernando and San Gabriel – before they were transformed by human settlement. This very process of transformation is acknowledged and reinforced by the literary description, taken from Margaret Collier Graham's *Stories of the Foot-Hills* (1895), of the Arroyo Seco on a warm afternoon in the 1890s. The scene is still and empty as in primal time itself, with only the buzzing of insects to be heard, a Virgilian murmuring of innumerable bees. Little more than a decade and a half later, Franz Bischoff gives us *The Bridge, Arroyo Seco* (1912), and history is upon us. And yet, in J. Smeaton

Chase's descriptions of the San Fernando Valley – treeless, vast, empty, awaiting water and people, awaiting history – and in John Bond Francisco's evocation of the Southern California foothills, we return through art, verbal and visual, to what attracted millions of settlers to come into this place: its power (the San Fernando Valley, once irrigated) and its beauty, which Francisco saw as hills worthy of a classical poet.

The seventh subregion, the Southern Coast south to San Diego, is centered by Laguna Beach, just as the coast between San Francisco and Santa Barbara is centered by Monterey–Carmel. This coastal area is the Costa del Sol, the Côte d'Azur of California, its Riviera shores. The coastline dominates the region, which terminates in the hospitality of San Diego Bay. Inland there extends a back country drama edging into desert, which also caught the attention of the diversely styled painters of San Diego and Laguna Beach. With the exception of the resort island of Santa Catalina, images of settlement are sparse in these landscapes – ironic, given the present population of Orange County and San Diego's preeminence as the second largest city in the state. The Southern Coast, first settled by the Spanish in 1769, remains – at least in *O California!* – in so many ways a primeval place, untouched by history.

The interaction of history and geography is present in virtually every landscape in *O California!* if only through the recognition of a contemporary viewer that a place has remained untouched. That, after all, is a zero sum judgment on historical change. The book opens with the massive historicity of Arthur Mathews's *Discovery of Bay of San Francisco by Portola* (1896), augmented by a passage from the journal of Fray Juan Crespi. Mathews's historical genre painting appropriately introduces a collection of landscapes, for only with the coming of human settlement would California be perceived and painted so gloriously. The paintings of *O California!* are arranged according to sequences of geography, not history; but cumulatively, in the people and architecture of so many of the landscapes, the entire story of California from prehistoric times into the 1920s is obliquely yet consistently presented.

Indian life and culture are present in a score of selected quotations from folklore, prayers, rituals, incantations of every sort. So also in Herman Herzog's *Indian Hogans in the California Sierra* (1874–1875) or in Carl von Perbandt's *Pomo Indians Camped at Fort Ross* (1886) do we catch a glimpse of the first Californians as if in a still-untroubled existence. The description of a massacre in Lake County disturbs us with other realities.

The Spanish era asserts itself in missionary explorers' diaries and land grant documents; the Mexican era, in Otto Von Kotzebue's 1824 description of the Russians at Fort Ross. Prudentia Higuera remembers how *vacqueros* slaughtered cattle in 1840, bartering their hides with the Yankee traders – and how the Mexican children laughed when the Yankee sailors told them that the world was round. Selections from Richard Henry Dana's *Two Years Before the Mast* (1840) harbinger the impending American era, which builds towards the climax of the Mexican War of 1846. The Yankees come in glory, to be sure, sailors and marines landing on the coast, blue-coated and gold-buttoned dragoons riding overland on the Old Spanish Trail; yet dystopian possibilities are there as well in journal entries recorded by a member of the Donner Party, which became stranded and frozen and driven to a horrible hunger in the Year of Decision 1846. Through Edwin Bryant, who rode with John Charles Frémont's California battalion, we experience the state as it makes the transition into its American identity. Through the letters of Louise Clapp, writing as Dame Shirley, through another letter home from a young Forty-Niner, telling his family how hard life was in the mines, we experience the Gold Rush which accelerated California into what the nineteenth century San Francisco historian Hubert Howe Bancroft described as a rapid monstrous maturity. Alburtus Browere's *The Lone Prospector* (1853) and Charles Nahl's and Frederick Wender-

oth's *Miners in the Sierras* (c. 1851–52) suggest the Gold Rush in its solitary and communal aspects. There could be cooperation and joy; but there was also solitary work, all of it self-financed and on speculation, most of it doomed to yield few results.

The 1850s, which began in the Gold Rush era and ended with the beginnings of High Provincialism, are appropriately introduced by William Smith Jewett's *The Promised Land – The Grayson Family* (1850). This pioneering portrait of the entrepreneur and ornithologist Andrew Jackson Grayson, with his wife and child, is suggestive of the fact that it would be families, businesses, agriculture – and not the pursuit of gold – that would transform the region into a settled, civilized American place. Notice the elegant shirt and cravat behind Grayson's buckskin jacket. At the time of this painting, Grayson had already established himself as a San Francisco businessman and a Marin County landowner. He would later take to painting the birds of the Pacific Coast and to collecting ornithological specimens on behalf of the Smithsonian Institution, of which he became a corresponding member. The very presence of Grayson's wife and child in this painting, each so decorously attired against the wilderness, testifies to the rapidly emergent civility of California in its first frontier era.

Such a settled province is apparent by the early 1860s, when so many talented painters themselves arrived. Landscapes from the 1860s and early 1870s – the era described by Royce as the High Province – abound in *O California!* In both social and artistic terms, this was the time that California, sealed off by the Sierra Nevada and by the vast continent from the Civil War in the East, consolidated its identity in its own proper terms and circumstances. From this era, the greatest High Provincial of them all, Unitarian Minister Thomas Starr King of San Francisco, makes a cameo appearance, chatting briefly with geologist William Brewer on a Sacramento River steamer in 1861. Congregationalist minister and educator Henry Durant, searching for a site for the College of California, strides the

vales of what is now the campus of the University of California at Berkeley and, discovering the place where he wishes to establish his school, cries out, "Eureka! Eureka!" as if he were a prospector who had come upon gold. Durant returns some years later as the subject of a funeral eulogy, his work now finished. The decade ends with Henry George's 1868 *Overland Monthly* essay, "What the Railroads Will Bring Us," in which the great San Francisco journalist and economist ponders on the end of California's protected provincial era.

We encounter the 1870s in Charles Nordhoff's descriptions of the dairies of Marin County. The Chinese Californians who built the railroad appear now as fisher folk in a coastal landscape by Henry Cleenewerck, reinforced by the prose descriptions of Robert Louis Stevenson, sojourning in Monterey. Meanwhile, as *O California!* presents texts and images that move, albeit crabwise, from discovery to Gold Rush to settlement to planned cities and industry, themes assert themselves as well, captured explicitly in prose and implicitly in the visual dimension.

The scenes depicted in *O California!* constitute representative American landscapes. It is part of the national dimension of California that its landscape encompasses representative portions of every landscape region in the nation, including – in the Sacramento Delta – swamps. While spectacular, the landscape of California is also noneccentric in its general features. The philosopher Josiah Royce noted this more than 100 years ago. The topography of California, Royce claimed, was a clearly discernible interplay of mountains, valleys, and seashore. While local environments could be complicated or even mysterious, California in general made its topographical statements in bold swift terms.

This clarity is apparent throughout the pages of *O California!* Mountains dominate the landscapes as they always do, beginning with Mt. Tamalpais, so adjacent physically to the city of San Francisco and yet so suggestive as well of the montane nature of coastal

and Sierran California. Mt. Diablo across the Bay from the city attracts a comparable amount of attention in the first period, as does Mt. St. Helena in Napa during the High Provincial era. If Tamalpais is mysterious, and Diablo slightly threatening, Mt. St. Helena is, as Robert Louis Stevenson describes it, the Mont Blanc of the California coastal range: the one signature feature, that is, on the landscape. But it is the mountains of the interior – Ritter, Lydell, and Shasta – that raise themselves to the most sublime heights topographically and in art. Keith, Muir, King, Miller: the master spirits of nineteenth century California are concerned with these mountains, for they are the most powerful emblems of identity on the landscape. In this regard Mt. Shasta, the mighty Matterhorn of the North, deserves and receives the most attention from the nineteenth century palette and literary pen and paper.

By their very definition mountains imply valleys and canyons. California is an exquisite repetition of these two topographical elements, mountain and valley, including the valley plain extending as far as the eye can see in the central regions of the state. The two great valleys of California, the Sacramento and the San Joaquin (they are actually one Central Valley), are depicted by Tourists, High Provincials, and Second Generation painters alike, beginning with Bierstadt's *California Spring* (1875); and there are painterly and prose Yosemites aplenty – from Bierstadt, Hill, Thomas Moran, and Herman Herzog on canvas, from Keith and Muir in prose. But the painters of the Southland, encouraged by the crisscrossing of mountain ranges and spur change in their region, give us their valleys as well: Hanson Puthuff's *Transient Shadows, Sespe Canyon* (n.d.), above which the condors soar; Henry Chapman Ford's *Glen Annie Canyon* (1879), at once a ranch and resort; Marion Kavanaugh Wachtel's *In San Gabriel Cañon* (c. 1920); and William Alexander Griffith's *Santa Ana Canyon* (1928), each so complete in themselves as they are. We cannot perceive these images today without an awareness of what

human settlement would bring to the landscapes they portray.

Settlement would take water, and water is everywhere in these paintings, at least in the north. Through Julian Rix's eyes we see the Upper Sacramento, the Mississippi of the north. Raymond Dabb Yelland brings us to the Russian River in Sonoma County, wending its way lazily to the sea. Through the eyes of John Muir we witness the glacial birth of a mountain lake, while Lorenzo Latimer gives us the glacier itself looming over Upper Angora Lake above Fallen Leaf Lake in the High Sierra near Tahoe. William Keith camps on the shores of Lake Tenaya in 1875, 8500 feet above sea level. Edwin Deakin paints Cascade Lake in 1877. The Yosemite abounds in water: the Vernal Falls as presented by Moran; Mirror Lake as seen by Herman Herzog. Edwin Deakin provides us as well with the intimate Strawberry Creek that runs through Berkeley, suggestive of a thousand creeks and streams draining down from the Sierra foothills and the coast ranges.

Seascapes constitute a virtually independent genre in *O California!*, for the state has more than 1200 miles of jagged coastline. All of the great bays and natural harbors – San Diego, Santa Barbara, Monterey, and San Francisco – are depicted, as well as Morro Bay on the central coast which in its own way vies for harbor status. We experience the hidden shoreline places as well – Eugen Neuhaus's *Whalers' Cove, Point Lobos* (n.d.), William Frederick Ritschel's *The Poets' Cove* (1915) – and they stand for a thousand secret inlets between San Diego and Eureka: places where Chinese and Italian fishermen rested their boats, where lumber was skidded towards a mill, or, in the Southland especially, where a resort hotel was placed on a nearby promontory.

Functioning intercessionally between the geological landscape and human settlement are trees and animals, in ascending orders of complexity. The landscapes of *O California!* can be taken narrowly but with much satisfaction as a series of paeans to trees: the mighty redwoods and sequoias, timeless in their gran-

deur, hearing only the music of the wind and the distant Pacific surf; the Monterey pines and cypresses which writhe Dantesquely on the surf-lashed coast; the rich red madrones, having soaked in the sun to the point where the tree itself assumes the sun's color, a tree almost warm to the touch; the live oaks of the foothills and Central Valley extending their branches long and wide in benediction; the eucalyptus, an import from Australia, thriving in California with an intensity unknown in its native region, a tree perfect to break the sweep of wind from off the coast, to delineate a pathway leading to a village or a villa, to suggest where one vast property ends and another begins; and the palm, as painted by Guy Rose, a scarce and solitary tree. Found in their wilderness state in only a few places in the Southland, as in the canyon at Palm Springs, the desert palms march in single file up the declivity like soldiers advancing to the front.

On the plains and in the valley floors formed by the mountains we encounter the agrarian landscapes which constitute the prized garden of human settlement. William Smith Jewett's *Hock Farm* (1851) stands as an early archetype of this fact; it was among the first such farms to be painted in the American era. William Hahn, the painter poet of the 1870s, is especially adept at such scenes, with his *Horses Grazing, Berkeley, California* (1875), *Ranch Scene, Monterey, California* (1875), and his *Harvest Time* (1875), counterpointed by Frank Norris's famous description of ploughing in the San Joaquin Valley from *The Octopus* (1901). Hahn is indeed the premier painter of animals on the California landscape – horses, cattle, even wild bears. The fruit pickers in the San Joaquin Valley, as painted by Alson Skinner Clark, must stand for millions of agricultural workers who across a century and a half transformed California into the Garden of the West.

Architecture introduces an expressly historical element into the agrarian landscape. In Williams's painting of Sonoma Valley, architecture is at a distance and diminutive, signaling itself by rising smoke. Soon archi-

tecture asserts itself more conspicuously on the landscape: in the Mission series by Deakin, most noticeably, but also in the charming suburban villas that sit like satisfied country gentlemen in a landscape caught between wilderness and garden. Frost's *Belmont House of William C. Ralston* (1874), a carefully composed piece, expresses this imagery of architecture as emblem of civility. William Keith's *View of Bay from Piedmont (Reverend Joseph Worcester's House)* (1883) suggests a simpler, more democratic and inclusive ideal of homes for the middle classes, not just the elite, which will motivate – beginning with Worcester's inspiration – the architectural style known as Bay Region. Worcester's home rises naturally from its site as if the wood itself were not cut and assembled but were growing, treelike, from the earth. The statement is that of nature and architecture reconciled, and in this simple home we encounter a prophetic paradigm of the architecture of Bernard Maybeck, who would in a few years hence be covering the hills of Berkeley with exquisite redwood homes directly inspired by Worcester's prototype, so lovingly painted by Keith.

The suburban villas of the 1870s suggest an important social fact that was of most relevance in the southern part of the state. In the 1870s and beyond, California developed in part as a resort. Santa Barbara commenced its High Provincial life as a health sanitarium, as did Los Angeles itself, and Pasadena, and many other townships of Los Angeles, Orange, and San Diego counties. Indeed, a number of painters, Thomas Hill most conspicuously, whose work is depicted in this volume, came to California not so much for scenery as for a chance to live the outdoor life in a salubrious climate and regain their health. Hill's *Our Camp* (n.d.) glosses perfectly this sense of nature in California as restive and healing. No hastily constructed bivouac, his camp is a place to sojourn for some time in the mountains, walking and painting and musing by night at the campfire. Hill's depiction of himself and his wife fishing with Virgil and Dora Williams expresses this

relationship even more explicitly. The men and women are dressed as if for a day of punting on the Isis or the Cam. Is this the frontier? Certainly it is at least the Charles or the Concord rivers in suburban Boston, and not the California wilderness. The civility continues in Ernest Narjot's *Santa Catalina Island* (1889), the bathers in their Victorian costumes so reminiscent of the beach resorts of the East painted by Winslow Homer and described by William Dean Howells. The mountains, rivers, and seashores of California call to wilderness trekking and restorative relaxation as well as to the harsher relationships of mining and lumbering and the more gentle attentions of agriculture. The excerpt from the *Annals of Bohemia* describing the Cremation of Care and the other ceremonies of the annual Midsummer Encampment of the Bohemian Grove in Sonoma County brings the resort metaphor to dramatic completion, for this society, originally of writers and artists, founded in San Francisco in 1872, codified and made liturgical in their annual Bohemian Grove rites the special affinity which Californians believed existed among themselves, their natural environment, and the art impulse.

Gideon Jacques Denny's *"City of Lakeport" on Clear Lake* (1876) bespeaks the certainty that industry and technology are coming to California – in addition to the recent culture symbolized by the Bohemian Grove and Santa Catalina. Denny's steamer offers perhaps the solitary instance of technology in this collection – set, that is, in a natural landscape; for the fulfillment of human technology is the city itself as a total work of engineering, economics, and art. *O California!* is in one sense a book about wilderness, and yet even in its profusion of landscapes, towns and cities assert themselves. It begins with Browere's *View of City of Stockton* (1858) and continues through Richardt's *Oaks at Madison and 8th Streets, Oakland, California* (1869), Dahlgren's *Alameda County Courthouse, East Oakland* (1882), and Yelland's *Cities of the Golden Gate* (1893). Charles Rollo Peters gives us a crowded *Fisherman's Wharf* (1885) in San

Francisco. Early twentieth century Los Angeles, still a sleepy semi-Spanish city barely past the 100,000 mark, is glimpsed through the canvases of Paul Lauritz and Mary Orwig Everett. But it is Coulter's crowded canvas of San Francisco aflame in April 1906 that most arrests our attention. Why has such a vivid and dystopian cityscape been allowed in this collection? What does the city of flames have to do with the sublimities and serenities of landscape?

Is it to assert, finally, the primacy of nature over human arrangements? Is it to suggest that the environment, in this instance through cataclysmic earthquake, has the capacity to trip the delicately balanced arrangements of human society into destruction? The earthquake disrupted San Francisco, but it was San Francisco's failure to provide for its own safety and good order that allowed the post-earthquake fires to devour the city. The most complete instance of human creativity in *O California!*, the city of San Francisco, is depicted at a moment when nature is in the process of correcting through chastisement human error and misuse.

In his "Meditation before the Gate" (1879), the aspiring philosopher Josiah Royce suggested that Californians functioned best when they functioned in proper relationship to the grandeur and power of their environment. This affinity suggests a proper mixture of use and letting alone in the realm of society and economics. It suggests a reverential relationship in the realms of spirit and art, as is so evident in all of the paintings in this book. *O California!* opens with Nahl's *California Grizzly Bear* (c. 1856). But attached to this is a section from Pedro Font's *Complete Diary of Anza's California Expeditions* (1776) describing how a solitary grizzly bear was for no purpose hunted down by the Spaniards and slaughtered. In this ironic juxtaposition of celebration and slaughter of an animal once known to the regions painted so dramatically by the first generation of artists is a message to be pondered. The natural California depicted in these paintings deserves a continuing celebra-

tion through art. But it deserves preservation and proper use as well. Unlike the grizzly bear, it must not be used up to no purpose. Otherwise, the pristine landscapes depicted in these paintings will survive in our consciousness as terrible judgments.

To paraphrase Walt Whitman's pilgrim in "Facing West from California's Shores," the circle has been circled. California enters the national consciousness in the nineteenth century as the very paradigm of all that the continent offered Americans in terms of imaginative release. And now, the landscapes so elegantly reproduced in *O California!* celebrate this environment on its own terms. In them we can see the very emblem of what was once enjoyed and what can now be lost. While elegiac, *O California!* is not an unambiguous lament for lost possibilities. While many of the landscapes presented in the book, in greater Los Angeles and greater San Francisco especially, have been obscured by human settlement, much of the pristine grandeur of the state remains.

This environment, however, is embattled. Just imagine, for instance, what a major oil spill, such as the one that occurred in Prince William Sound in 1989, would do to the sea coasts so lovingly depicted in this collection. Even now, at the height of the summer tourist season, smog hovers over the floor of the Yosemite Valley. To suggest such present and possible dangers is not to repudiate human settlement. It is merely to suggest a paradox put forward to Californians by the philosopher George Santayana in 1911 in an address before the Philosophical Union at the University of California at Berkeley. In terms of human society, Santayana suggested, California was primarily an urban and suburban place. Its next most characteristic landscape was agrarian. Yet Californians by and large took the wilderness environment as their most agreed-upon social symbol. Somehow, to be a Californian was to be in dialogue with nature untouched by human habitation. Californians were ever in search of that special sense of release through Otherness that only the environment can confer.

Such had ever been the quest of Americans across three centuries of environmental encounter. Coexisting with the dark side of the heedless, headlong exploitation which Henry Thoreau saw epitomized in the environmental depredations of the Gold Rush, was an equally compelling desire to respect the Otherness of nature and to be at peace in the environment. The current generation will not be able easily to formulate this need in universally acceptable theological terms, as Jonathan Edwards, Thomas Starr King, and John Muir were once so readily able to do. The divinity that once spoke directly through nature has become pluralistic and hence problematic in formulation. But the search for aesthetic contact and proper balance remain. In this quest the landscapes of *O California!* serve a purpose beyond regional celebration, for they provide all Americans recovered emblems of that transforming beauty our ancestors experienced. These earlier American communions and celebrations are still possible – not in the same way, perhaps, but with an even greater force born of tragic awareness. Americans of the nineteenth and early twentieth century knew and loved the landscape of California, but they did not realize – at least, consciously and vividly – that it could be lost. We *do*, and from this recognition is engendered tragic awareness and a call to corrective action. *O California!* reminds us of what others have seen and urges us to see these things as well – and to keep them possible for future generations.

Studying Geography:
The Search for Paintings

Paul Mills

O California!: Nineteenth and Early Twentieth Century California Landscapes and Observations is organized as no other book on the art of California has been: not by artist, nor style, but by location. It takes its readers on a series of journeys through the landscape of the state, north and south. The painters range from its earliest artists up through the Impressionists and Post Impressionists of the 1930s. Stephen Vincent, editor of the book, was prompted to envision this volume when he and Kevin Starr, whose preface adorns it, saw the color slides of Nan and Roy Farrington Jones of Ross, California. The Joneses are a remarkable couple who have spent decades traveling throughout the state to take slides of the work of California artists. They have been kind enough to say that their project was inspired in part by the California art efforts of the Oakland Museum. The Joneses have been familiar with the museum's specialization almost since its beginning – in my days there. The archive of slides of early California art created by the Joneses is a remarkable accomplishment, and they have been most generous in inviting scholars and others to make productive use of it.

What a difference in the selection process this regional journey idea made from, for example, organizing the typical exhibition. First, all – or nearly all – of the paintings had to be identified with a specific site, either as indicated in the artist's title or as made clearly evident in the image itself. An artist such as Albert Bierstadt always worked with site in mind; an artist such as William Keith was rarely concerned with location, particularly in his later years. Consequently, the balance among artists is quite different in this book than it might be in a book or exhibition organized along different lines.

Second, the selection by site has other consequences. Almost every artist painted such places as Yosemite, the Golden Gate, the Carmel coast, and other familiar spectacles. To avoid having an excess of views of any of these favorite spots, we had to be merciless in paring them down. We have, on the one hand, avoided dozens of redwoods, even very good ones. On the other hand, we were gleeful when we found paintings of subjects that artists seldom painted, such as some parts of inland Southern California.

Third, this process of organization required that I learn something more about the geography of California. In 1986, Steve Brezzo, director of the San Diego Museum of Art, quite courageously invited me to organize an all-California landscape exhibition, which we came to call *The Golden Land*. That exhibition helped generate my role in this book. I felt a bit like a Yankee in Confederate territory as I selected Southern California art for San Diego. That has been true for *O California!* as well. I appreciate the gentle guidance given me by collectors, dealers, and art historians of the south who know a lot more about the art of the southern regions than I do. Those we contacted for this book have been unfailingly generous in sharing their works with the world. They also suggested literally hundreds of other paintings we might choose from; I only wish that the limitations of the book form did not prevent the inclusion of many of these fine suggestions.

Even so, the orientation of this book does tilt slightly to the north, although we have tried to prevent this slant. Cities grew first to the north, and painters were drawn to them. Fewer were drawn to the south in the years this book encompasses, and they came late in that period. For a while, we felt that, unless we were able to better represent Southern California, we would have to change the title of the book. But *O Northern California!* just didn't have the same literary ring to it! In our final selections, we feel we have achieved the best balance we could.

I want to thank specifically a few people who served as major sources – in addition to

the Joneses, whose resources produced most of the Northern California works included. Ruth Westphal, a gracious person whose own California *plein air* books are splendid, led us to a number of works. Art dealer Gary Breitweiser, in Santa Barbara, ransacked both his files for photographs and his memories of many years to suggest collectors and other sources. Others who contributed in ways beyond what we asked of them include Peter Fairbanks and the staff of Montgomery Gallery, San Francisco; John Garzoli of Garzoli Gallery, San Rafael; Alfred Harrison of Northpoint Gallery, San Francisco; Mark Hoffman of Maxwell Gallery, San Francisco; George Stern of George Stern Fine Arts, Encino; Jean Stern of Peterson Gallery, Beverly Hills; and collectors Don Crocker and David Packard.

In the brief biographies of the painters included in *O California!*, we relied heavily upon Edan Milton Hughes's excellent book, *Artists in California 1786–1940*. During my years at the Oakland Museum, someone was always starting such a compilation. Hughes is to be complimented for seeing the project all the way through and for doing such a good job.

My work on this book lasted for only a few months. When we reached the point where we had four or five times as many excellent works in our files as could be used in *O California!* it seemed like a favor to no one to continue adding nominations. The photographs from which our final choice was made in no way exhausted the resources of important collectors, dealers, or public institutions. I hope this awareness prompts others to realize that additional books on California landscape art deserve to be done.

I have enjoyed working with all the people at Bedford Arts, Publishers, and I was pleased to meet the publisher, Kirsten Bedford. Stephen Vincent, the genial director of the press, who conceived of the book, has been imaginative and creative in seeing it through. Deborah Bruce and Monica Garcia served ably in obtaining permissions and reproductions of the paintings.

Many friends and old associates might have contributed greatly to this book, and I am sorry that I was unable to see everyone in my pursuit for images.

I owe much of the privilege of remaining active in the arts to the circumstances created in my life by my wife, Jan. I would like to thank her, and to dedicate my part in this book to her.

Last of all, I am very pleased to have been part of this unusual enterprise. I have been remote from the evolution of Kevin Starr's preface and from the search for texts to complement the paintings. Many of us California art folk, dedicated as we are to visual imagery, remain further from California's literary history than we should. I am looking forward to reading *O California!* myself.

The Making of the Book: An Editor's Note

Stephen Vincent

O California! was born of a variety of impulses and histories. The book was begun more than three years ago; the first intention was to capture the painting, the history, and the spirit of the artists and writers who, in the early 1860s, created San Francisco's Bohemian Club. Kevin Starr's extensive research into the Club inevitably broke the parameters of this project into a much larger vision of California. The Bohemian Club members were just one crucial element of an even larger contingent of writers and artists who, in one way or another, sought to articulate their own discovery of the West.

The next editorial step was to create a frame in which the book could reveal the new state's vast geographic diversity, and the variety of ways in which its writers and artists responded to the challenges of its landscape. We decided to orchestrate the book into geographic sections representing the state's subregions. We chose Paul Mills as the book's art editor. During the 1950s and 1960s Paul was director of the Oakland Museum and one of the primary forces behind the creation of that museum's very fine California collection. His task, perhaps a novel one for a curator, was to research each of the subregions in search of the finest landscapes he could find. Several months of research – with the kind help of museums, galleries, collectors, and researchers, especially Nan and Roy Farrington Jones with their large collection of slides – gave us several hundred images from throughout the State from which to choose approximately one hundred images. Several editing sessions later, we had managed to create a visual incarnation of California as it was painted from the 1850s up into the 1920s. The sad exception was Humboldt and some of the other northern counties, where paintings were either nonexistent or our research

resources had exhausted themselves. The Northern California work focuses on the prolific output of the nineteenth century, while, in general, the landscape painting of Southern California, for a variety of historical reasons, emerges after the century's turn.

From this geographic vision, we next turned to a literary one. Kevin Starr, who, from all apparent evidence, has read most of the literature ever created in or about California, sat down with us one afternoon to review the paintings, many of which he had never seen. Our project was to emerge with a bibliography that would enable us to find writing that would respond to the landscapes, and the histories of those landscapes, displayed in front of us. Three cathartic hours later, during which Kevin seemed to have tapped every California memory vein in his body, we had a list of more than one hundred book titles, authors, and various kinds of documentation.

O California! required a special kind of reading. To respond to Kevin's bibliography – and we went back to him several times – we had three readers: the poets Beverly Dahlen, George Evans, and Carla Harryman. Given the nature of the book, we wanted the language chosen to be rich, lively, and full of character and insight. As literary prospectors, the readers' task was to find the texts – complete or partial – from which we could mine and draw out the fragments and sections that would respond to and work with the paintings. Although their areas of focus would often overlap, each reader, partly by virtue of background, was initially assigned a different part of the state. Beverly, who is from Northern California, started with the San Francisco Bay Area and the northern counties. George was given the Central Valley and the Gold Country, where he has lived off and on over the past several years. And Carla, a native of Orange County, was given Southern California.

The research and the reading and choosing of texts took a period of several months. The actual choices involved a great deal of latitude. We wanted the writing to do what the paintings could not. We wanted the language

to capture some primal element of each landscape – the character of the people who lived within the place, a significant historical event, the naming of the texture of the color, shape, and light. Equally we wanted to capture the diverse voices and perspectives that can crowd and reinforce the memory of a particular place: Indian creation myths and fables, journals of first European and American explorers, the traveling accounts of nineteenth century visitors, the first indigenous writing in English by the people who chose to stay, and the novelistic witnesses of the dramatic changes that rapidly engulfed great parts of the California landscape. Through these sources the readers searched and chose the texts from which we would shape the book.

The final editing stage – which included the early assistance of Deborah Bruce – was a dialogue among Gail Larrick – our text editor – myself, and the paintings and texts. Our objective was to weave a web in which language and image would resonate to evoke the myth and reality of California's birth and youth. It has been a passionate exercise. We have had the delight of working with wonderful pieces of writing and paintings. The ways in which various writers explore similar or opposing concerns have been constantly astonishing and revelatory. And it has been a delightful challenge to play the writing with or sometimes against a particular view of the landscape in which the writing takes place.

A reader might ask why we did not work with paintings of cities or with direct portraits of California's inhabitants, or why we did not use many of the fine photographs from the same period. By limiting our vision to landscapes, we allow the language of the writing to take on a more revelatory position. The life within and around a particular landscape ironically becomes richer and fuller than if we had relied on the singular fragmentary photograph or portrait. Looking at the paintings and reading the texts in *O California!* is perhaps most similar to visiting a historic site from which the participants have long since disappeared. While we look at the

hills, trees, meadows, lakes, or streams within the site, we hear and replay the voices and legends that inform our memory of that history.

I want to point out one limit to our approach. Many different language groups came to the West, not all of which left a written literature to which we had access. If China opens again to the West, for example, it will be interesting to see what emerges from her archives. Is there a Chinese equivalent to Robert Louis Stevenson's *Amateur Emigrant*? We will never know how many voices and points of view were never formally articulated for reasons of class, education, and lack of power. We will know these different angles of vision only through the imaginative reconstruction of those lives in contemporary writing.

The final stage of *O California!* was the literal construction of the book. Typographer and designer Jack Stauffacher of San Francisco's internationally renowned Greenwood Press, was chosen to bring this vast amount of visual and literary material into one frame. It was his responsibility to make the writing and the paintings resonate within the larger context of the book to reveal the twisting, changing landscape of the entire state. Jack is the poet behind the poets, physically designing the whole – making a visual, textual symphony from its ultimately quite disparate parts. The printing and binding of the book was achieved in Japan during the summer of 1989.

During the process of making *O California!* it rapidly became clear how much our contemporary consciousness obscures and ignores most genuine historical exploration. Perhaps the twentieth century's love affair with a utopian vision of the future is responsible for our historical sense of amnesia. I do not know. However, as a fourth-generation Californian, I found that much of the pleasure of creating this volume was in the discovery and revelation of a history of both a place and a time that dwells on the periphery of the memories of both my ancestors and of my own experience of having traveled and lived in different areas of the state. But far beyond

the awakening and reconciliation with my own personal background, I have found the making of *O California!* to be an extraordinary and provocative unveiling of the spirit of adventure, comedy, tragedy, work, and pleasure that informed the migration to, the discovery of, and the preliminary settlement in what for, at least a brief moment, appeared to be a physical paradise.

From this late twentieth century lens and hindsight, *O California!* is intended as both a celebration and a lament. It celebrates both the indigenous beauty and diversity of the land as seen through the eyes of its painters and those makers of language who first sought to name the land and the ways of its inhabitants. And it is a lament for the violation and loss of this original, almost primal vision. This loss is a burden that all of us carry. Our human presence, the needs we express, and the complex tools we have developed irrevocably alter both the shape of the natural landscape and its inhabitants. As we turn toward the next century – and a new millennium – and look back at the past 150 years, the degree of change is absolutely staggering. As I read many of these texts and looked at the landscapes, often I found it impossible not to weep for the loss of such enormous natural bounty. In making *O California!* we realized that at some level we were pulling together a yet unsung elegy. True to the elegiac form, our intention has not been to damn the race for the sake of the mountain. On an unintentioned level, in both celebration and lament, *O California!* startled and reawakened us to the exploration of the meaning, consequences, and future – aesthetic, spiritual, economic, and political – of our ongoing partnership with the natural planet.

The world was made by O'-ye the Coyote-man. The earth was covered with water. The only thing that showed above the water was the very top of Oon'-nah-pi's [Sonoma Peak, about forty miles north of San Francisco].

In the beginning O'-ye came on a raft from the west, from across the ocean. His raft was a mat of tules and split sticks; it was long and narrow. O'-ye landed on the top of Oon'-nah-pi's and threw his raft-mat out over the water – the long way north and south, the narrow way east and west; the middle rested on the rock on top of the peak. This was the beginning of the world and the world is still long and narrow like the mat – the long way north and south, the narrow way east and west.

When O'-ye was sitting alone on top of Oon'-nah-pi's, and all the rest of the world was covered with water, he saw a feather floating toward him, blown by the wind from the west – the direction from which he himself had come. He asked the feather, "Who are you?"

The feather made no reply.

He then told the feather about his family and all his relatives. When he came to mention Wek'-wek, his grandson, the feather leaped up out of the water and said, "I am Wek'-wek, your grandson."

O'-ye the Coyote-man was glad, and they talked together.

Every day O'-ye noticed Ko-to'-lah the Frog-woman sitting near him. Every time he saw her he reached out his hand and tried to catch her, but she always jumped into the water and escaped.

After four days the water began to go down, leaving more land on top of the mountain, so that Ko-to'-lah had to make several leaps to reach the water. This gave O'-ye the advantage and he ran after her and caught her. When he had caught her he was surprised to find that she was his own wife from over the ocean. Then he was glad.

When the water went down and the land was dry O'-ye planted the buckeye and elderberry and oak trees, and all the other kinds of trees, and also bushes and grasses, all at the same time. But there were no people and he and Wek'-wek wanted people. Then O'-ye took a quantity of feathers of different kinds, and packed them up to the top of Oon'-nah-pi's and threw them up into the air and the wind carried them off and scattered them over all the country and they turned into people, and the next day there were people all over the land.

– Miwok legend

1. San Francisco Bay and to the Northwest

The Golden Gate, the Bay, San Francisco, the East Bay,
Mt. Tamalpais and Marin, Napa, Sonoma, Clear Lake,
the Russian River, Fort Ross, Mt. Shasta

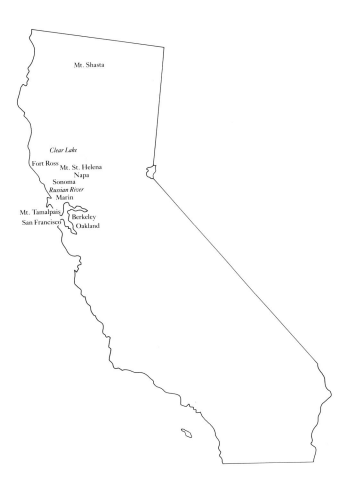

The Portola Expedition

Fray Juan Crespi, journal, 1769. Crespi was the chronicler for the Portola expedition.

Thursday, November 2 – To-day, All Souls' Day, we two celebrated Mass for the souls in Purgatory, and after Mass some of the soldiers asked permission to go out to hunt, for many deer have been seen. Some of them went quite a distance from the camp and climbed the hills, so that it was already night when they returned. They said that toward the north they had seen an immense arm of the sea, or an estuary, which penetrated into the land as far as the eye could reach, extending to the southeast. . . . The report confirmed us still more in the opinion that we were on the port of Our Father San Francisco, and that the arm of the sea which they told us about was certainly the estuary of which the pilot Cabrera Bueno spoke, the mouth of which we had not seen because we went down to the harbor through a ravine. . . .

Friday, November 3 – To-day we had a feast on the good and very large mussels that are to be found in such abundance in this harbor. At night the explorers returned, firing loud salutes, thus letting us know in advance that they were bringing some good news. They told us what they had learned or inferred from the uncertain signs made by the heathen; that is, that two days' march from the place which they had reached, which was the end or head of the estuary, there was a harbor and a ship in it. As a result of this many now believed that we were at Monterey, and that the packet *San José* or the *San Carlos* was awaiting us. And certainly our necessities made us wish, even if we did not believe, that we were in Monterey instead of San Francisco. In consequence of these reports the commander decided to continue the journey in search of the port and ship of which the heathen had given information to our explorers.

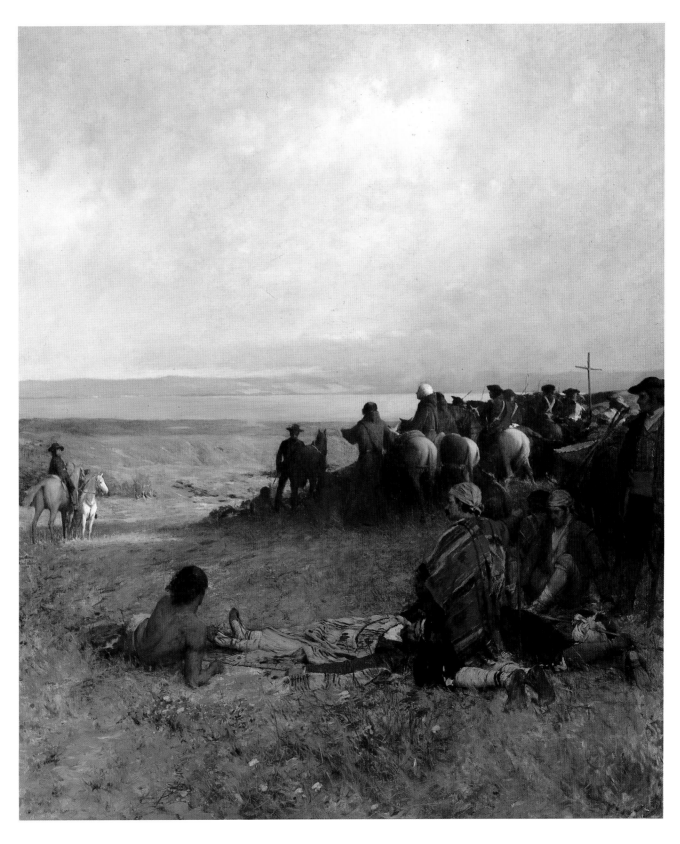

2 Arthur Frank Mathews
Discovery of Bay of San Francisco by Portola, 1896

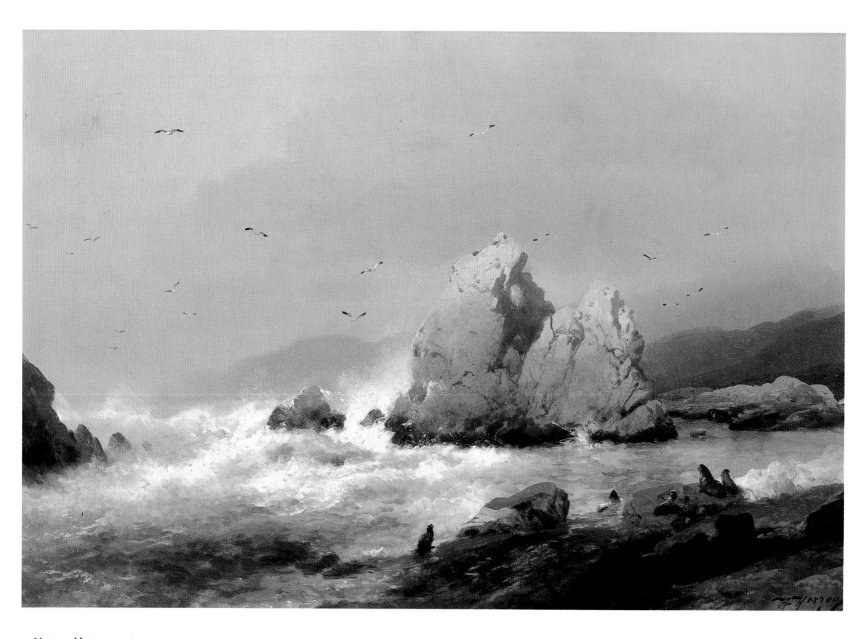

3 Herman Herzog
 Seal Rock, San Francisco, California, c.1874

The Anza Expedition

Wednesday, March 27 – I said Mass. In the morning the weather was fair and very clear, a favor which God granted us during all these days, and especially today, in order that we might see the harbor which we were going to explore, which we would not have been able to do if the fog had risen. We set out from the little arroyo at seven o'clock in the morning, and shortly after eleven halted on the banks of a lake or spring of very fine water near the mouth of the port of San Francisco, having traveled some six leagues. . . . Through here we saw many bears, but although the men chased them they were not able to kill any. Then we entered lands somewhat broken and sandy, with plentiful grass and brushy growth, and stretches of groves of shrubby live oaks, but without any large trees. Then, going around the sand dunes of the beach, which we kept at our left and in whose vicinity we saw a good-sized lake of fresh water [Lake Merced], we came to the lake [Mountain Lake, at the southern edge of the Presidio] where we halted.

We . . . ascended the sand hills, descended to the arroyo, and crossed high hills until we reached the edge of the white cliff [Fort Point, San Francisco] which forms the end of the mouth of the port, and where begins the great estuary containing islands. The cliff is very high and perpendicular, so that from it one can spit into the sea. From here we saw the pushing and resistance which the outgoing water of the estuary makes against that of the sea, forming there a sort of a ridge like a wave in the middle, and it seems as if a current is visible. We saw the spouting of whales, a shoal of dolphins or tunny fish, sea otter, and sea lions.

This place and its vicinity has abundant pasturage, plenty of firewood, and fine water, all good advantages for establishing here the presidio or fort which is planned. It lacks only timber, for there is not a tree on all those hills, though the oaks and other trees along the road are not very far away. The soldiers chased some deer, of which we saw many today, but got none of them. We also found antlers of the large elk which are so very plentiful on the other side of the estuary. The sea is so quiet in the harbor that the waves scarcely break, and from the camp site one scarcely heard them, although it is so near. Here and near the lake there are *yerba buena* and so many lilies that I had them almost inside my tent. Today the only Indians we saw were one who was far away on the beach of the estuary, and two who came to the camp as soon as we arrived. They were of good body and well bearded. They were attentive and obsequious, and brought us firewood. They remained at camp a while, but when the commander gave them glass beads they departed. . . .

The port of San Francisco . . . is a marvel of nature, and might well be called the harbor of harbors, because of its great capacity, and of several small bays which it enfolds in its margins or beach and in its islands. The mouth of the port, which appears to have a very easy and safe entrance, must be about a league

Pedro Font, *Complete Diary of Anza's California Expeditions*, 1776. Font was the chronicler for the expedition.

long and somewhat less than a league wide on the outside, facing the sea, and about a quarter of a league on the inside, facing the harbor. . . .

Thursday, March 28 – I said Mass. In the morning the weather was fair, although there were some clouds which scarcely permitted me to observe; but at length by dint of care and patience I succeeded in making the observation. The commander decided to erect the holy cross, which I blessed after Mass, on the extreme point of the white cliff at the inner terminus of the mouth of the port [Fort Point]. At eight o'clock in the morning he and I went there with the lieutenant and four soldiers, and the cross was erected on a place high enough so that it could be seen from all the entry of the port and from a long distance away, and at the foot of it the commander left written on a paper under some stones a notice of his coming and of his exploration of this port.

On leaving we ascended a small hill and then entered upon a mesa that was very green and flower-covered, with an abundance of wild violets. The mesa [now the Presidio] is very open, of considerable extent, and level, sloping a little toward the harbor. It must be about half a league wide and somewhat longer, getting narrower until it ends right at the white cliff. This mesa affords a most delightful view, for from it one sees a large part of the port and its islands, as far as the other side, the mouth of the harbor, and of the sea all that the sight can take in as far as beyond the farallones. Indeed, although in my travels I saw very good sites and beautiful country, I saw none which pleased me so much as this. And I think that if it could be well settled like Europe there would not be anything more beautiful in all the world, for it has the best advantages for founding in it a most beautiful city, with all the conveniences desired, by land as well as by sea, with that harbor so remarkable and so spacious, in which may be established shipyards, docks, and anything that might be wished . . .

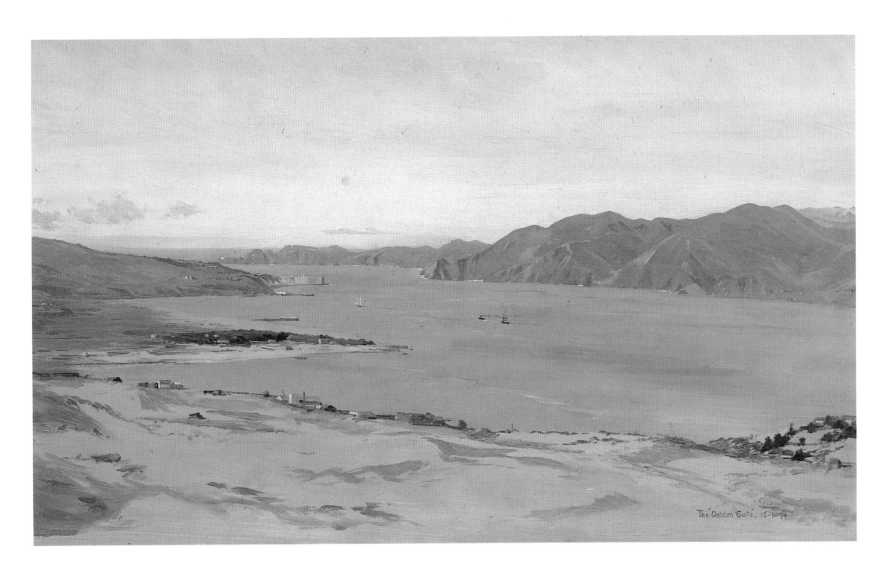

The Golden Gate, 12-10-79

4 Unknown Artist
The Golden Gate, 1879

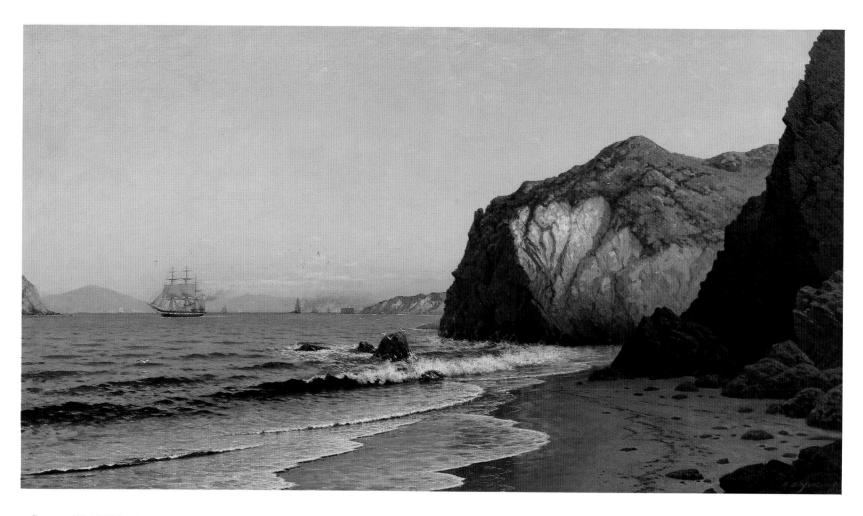

5 Raymond Dabb Yelland
 The Golden Gate (Looking In), 1880

The Clipper Ship

It was in the winter of 1835–6 that the ship *Alert*, in the prosecution of her voyage for hides on the remote and almost unknown coast of California, floated into the vast solitude of the bay of San Francisco. All around was the stillness of nature. One vessel, a Russian, lay at anchor there, but during our whole stay not a sail came or went. Our trade was with remote missions, which sent hides to us in launches manned by their Indians. Our anchorage was between a small island, called Yerba Buena, and a gravel beach in a little bight or cove of the same name, formed by two small, projecting points. Beyond, to the westward of the landing place, were dreary sand hills, with little grass to be seen, and few trees, and beyond them higher hills, steep and barren, their sides gullied by the rains. Some five or six miles beyond the landing place, to the right, was a ruinous presidio, and some three or four miles to the left was the mission of Dolores, as ruinous as the presidio, almost deserted, with but few Indians attached to it, and but little property in cattle. Over a region far beyond our sight there were no other human habitations, except that an enterprising Yankee, years in advance of his time, had put up, on the rising ground above the landing, a shanty of rough boards, where he carried on a very small retail trade between the hide ships and the Indians. Vast banks of fog, invading us from the North Pacific, drove in through the entrance, and covered the whole bay; and when they disappeared, we saw a few well-wooded slopes on the east, and the vast stretch of the bay to the southward, where we were told lay the missions of Santa Clara and San José, and still longer stretches to the northward and northeastward, where we understood smaller bays spread out, and large rivers poured in their tributes of waters. There were no settlements on these bays or rivers, and the few ranchos and missions were remote and widely separated. Not only the neighborhood of our anchorage, but the entire region of the great bay, was a solitude. On the whole coast of California there was not a lighthouse, a beacon, or a buoy, and the charts were made up from old and disconnected surveys by British, Russian, and Mexican voyagers. Birds of prey and passage swooped and dived about us, wild beasts ranged through the oak groves, and as we slowly floated out of the harbor with the tide, herds of deer came to the water's edge, on the northerly side of the entrance, to gaze at the strange spectacle.

Richard Henry Dana, Jr., "Twenty-Four Years After," 1859. Dana sailed for two years on a ship of the hide and tallow trade and commented on the contrasts he found in California twenty-four years later.

Meditation before the Gate

Josiah Royce, *Fugitive Essays*, 1879. Royce, a philosopher, was concerned with questions of the frontier.

I am a Californian, and day after day, by the order of the World Spirit (whose command we all do ever obey, whether we will it or no), I am accustomed to be found at my tasks in a certain place that looks down upon the Bay of San Francisco and over the same out into the water of the Western Ocean. The place is not without beauty, and the prospect is far-reaching. Here as I do my work I often find time for contemplation. . . .

That one realizes the greatness of the world better when he rises a little above the level of the lowlands, and looks upon the large landscape beneath, this we all know; and all of us, too, must have wondered that a few feet of elevation should tend so greatly to change our feeling toward the universe. Moreover the place of which I speak is such as to make one regret when he considers its loveliness that there are not far better eyes beholding it than his own. For could a truly noble soul be nourished by the continual sight of the nature that is here, such a soul would be not a little enviable. Yet for most of us Nature is but a poor teacher.

Still even to me, she teaches something. The high dark hills on the western shore of the Bay, the water at their feet, the Golden Gate that breaks through them and opens up to one the view of the sea beyond, the smoke-obscured city at the south of the Gate, and the barren ranges yet farther to the left, these are the permanent background whereon many passing shapes of light and shadow, of cloud and storm, of mist and of sunset glow are projected as I watch all from my station on the hillside. The seasons go by quietly, and without many great changes. The darkest days of what we here call winter seem always to leave not wholly without brightness one part of the sky, that just above the Gate. When the rain storms are broken by the fresh breezes from the far-off northern Sierras, one sees the departing clouds gather in threatening masses about the hilltops, while the Bay spreads out at one's feet, calm and restful after its little hour of tempest. When the time of great rains gives place to the showers of early spring one scarcely knows which to delight in the more, whether in the fair green fields, that slope down gently to the water, or in the sky of the west, continually filled with fantastic shapes of light and cloud – nor does even our long dry summer, with its parched meadows and its daily sea winds leave this spot without beauty. The ocean and the Bay are yet there; the high hills beyond change not at all for any season; but are ever rugged and cold and stern; and the long lines of fog, borne in through the Gate or through the depressions of the range, stretch out over many miles of country like columns of an invading host, now shining in innocent whiteness as if their mission were but one of love, now becoming dark and dreadful, as when they smother the sun at evening. So, while the year goes by, one is never without the companionship of Nature. And there are heroic deeds done in cloud-land, if one will but look forth and see them.

But I have here . . . to speak not so much of Nature as of Life. And I shall undertake to deal with a few problems such as are often thought to be metaphys-

ical (whereby one means that they are worthless), and are also often quite rightly called philosophical (whereby one means that it were the part of wisdom to solve them if we could). With these problems I shall seek to busy myself earnestly, because that is each one's duty; independently, because I am a Californian, as little bound to follow mere tradition as I am liable to find an audience by preaching in this wilderness; reverently, because I am thinking and writing face to face with a mighty and lovely Nature, by the side of whose greatness I am but as a worm.

Records of Passage

The things I saw and heard at that time in California were so unusual, so beyond the natural order of human events, so extraordinary in the speed with which they followed one another, that only by having noted them down as they occurred and seeing them in my own hand later can I believe that all I am stating is not a dream.

Vincente Pérez Rosales, *Recuerdos del pasado*, 1890

We leaped resolutely to dry land – or rather mud, for the outgoing tide had left nothing between the point at which our ship became grounded in the slime and the base of the slope of solid earth on which the town began. To the right of our landing place stood a kind of plank fence enclosing some beeves. Perched on the boards sat a row of crows croaking their appreciation of the odor of blood.

Some of our friends had stressed the necessity for leaving the ship armed, and always in the company of at least one other person. This is in fact how we went, and how most of the tradesmen of the town also went, displaying not only their merchandise but a dagger at the waist or else a revolver, a weapon that was then becoming common. . . . The streets were wide arcs each of whose ends came down to the beach, arcs broken by other streets at right angles that came down to the water, in each case to piers that hindered rather than facilitated the unloading of vessels. Some of the buildings arrayed in lines at either side of the streets of this maze must have been worth $100,000. But there was no uniformity among them. By the side of a costly though rough and simple structure stood rows of tents covered with wretched awnings, board shacks and cabins, some already set up, others in the very active process of construction. The Parker House Hotel was leased for $175,000 a year. There were no sidewalks in the streets, nor anything resembling them, and the center was a slough of trampled mud whose solidest parts were formed by the thousands of broken bottles thrown from the buildings as emptied. The inhabitants, of heterogeneous nationality, numbering about fifteen hundred permanent residents and as many transients, might have been thought to be celebrating a vast and noisy masquerade ball, such were their exotic costumes, their language, and the very nature of

their occupations. Even the women we thought must be dressed as men, for seek as one might through that Babylon, one found never a skirt recognizable as such. The furs of the Oregonion with his hectoring look, the Maule cap, the parasol-like headgear of the Chinese, the enormous boots of the Russian that appeared to swallow up their wearer, the Frenchman, the Englishman, the Italian in sailor attire, the rustic whose coat was about to take its last farewell, the gentleman with no coat at all; everything, in short, that might have been found in some gigantic carnival was here to be found gathered together and whirling in movement. At every step we were compelled to get out of the way, plunging our legs into the mire to give passage to some former dandy now arrayed in woolen shirt and rolled up pants and sweating under the weight of some load he was carrying from the beach to the dwellings at four dollars a burden. Or perhaps we had to avoid being picked up by a more fortunate porter who, the proud owner of a wheelbarrow, strode stiffly ahead with perfect unconcern exciting the envy of those who lacked a comparable tool. Quiet and ease were words without meaning in San Francisco. . . .

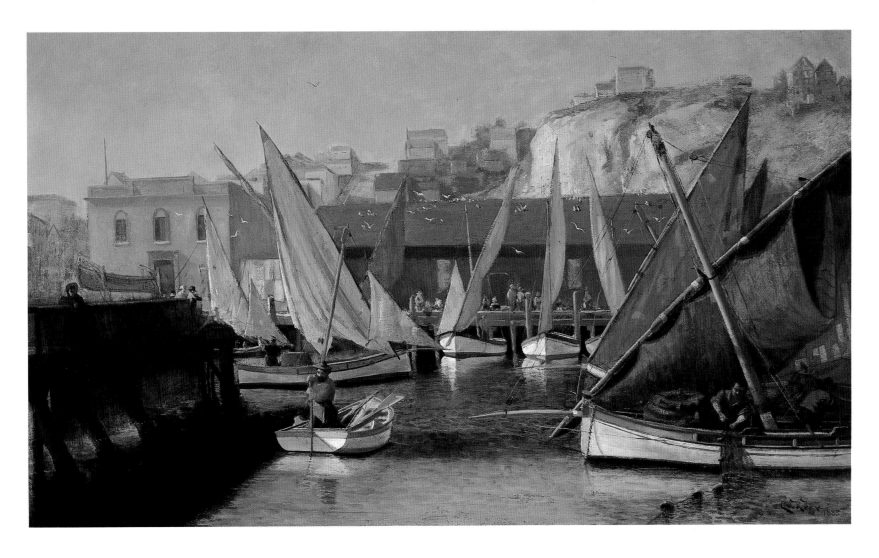

6 Charles Rollo Peters
Fisherman's Wharf, 1885

The Burning City

Mary Austin, "The Temblor,"
1907

. . . There are three things that I shall never be able to abide in quietness again – the smell of burning, the creaking of house-beams in the night, and the roar of a great city going past me in the street. . . .

Almost before the dust of ruined walls had ceased rising, smoke began to go up against the sun, which, by nine of the clock, showed bloodshot through it as the eye of Disaster. . . .

I recall the red flare of a potted geranium undisturbed on a window ledge in a wall of which the brickwork dropped outward, while the roof had gone through the flooring; and the cross-section of a lodging house parted cleanly with all the little rooms unaltered, and the halls like burrows, as if it were the home of some superior sort of insect laid open to the microscope. . . .

Before the red night paled into murky dawn thousands of people were vomited out of the angry throat of the street far down toward Market. Even the smallest child carried something, or pushed it before him on a rocking chair, or dragged it behind him in a trunk, and the thing he carried was the index of the refugee's strongest bent. All the women saved their best hats and their babies, and, if there were no babies, some of them pushed pianos up the cement pavements.

All the faces were smutched and pallid, all the figures sloped steadily forward toward the cleared places. Behind them the expelling fire bent out over the lines of flight, the writhing smoke stooped and waved, a fine rain of cinders pattered and rustled over all the folks, and charred bits of the burning fled in the heated air and dropped among the goods. There was a strange, hot, sickish smell in the street as if it had become the hollow slot of some fiery breathing snake. I came out and stood in the pale pinkish glow and saw a man I knew hurrying down the gutted district, the badge of a relief committee fluttering on his coat. "Bob," I said, "it looks like the day of judgment!" He cast back at me over his shoulder unveiled disgust at the inadequacy of my terms. "Aw!" he said, "it looks like hell!" . . .

Large figures of adventure moved through the murk of those days – Denman going out with his gun and holding up express wagons with expensively saved goods . . . that food might be carried to unfed hundreds; Father Ramm cutting away the timbers of St. Mary's tower, while the red glow crept across the charred cross out of reach of the hose. . . .

From Gough Street, looking down, we saw the great tide of fire roaring in the hollow toward Russian Hill; burning so steadily for all it burned so fast that it had the effect of immense deliberation; roaring on toward miles of uninhabited

*The sandy peninsula of San Francisco, mirroring itself on one side in the bay, beaten on the other by the surge of the Pacific, and shaken to the heart by frequent earthquakes, seems in itself no very durable foundation. According to Indian tales, perhaps older than the name of California, it once rose out of the sea in a moment, and sometime or other shall, in a moment, sink again. No Indian, they say, cares to linger on that doubtful land. "The earth hath bubbles as the water has, and this is one of them."
– Robert Louis Stevenson, 1895*

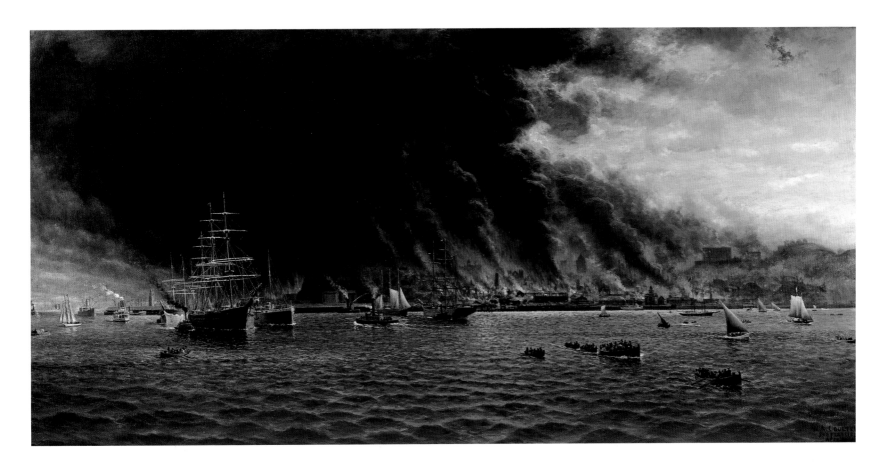

7 William Alexander Coulter
San Francisco Fire, *1906*

dwelling so lately emptied of life that they appeared consciously to await their immolation; beyond the line of roofs, the hill, standing up darkly against the glow of other incalculable fires, the uplift of flames from viewless intricacies of destruction, sparks belching furiously intermittent like the spray of bursting seas. Low down in front ran besmirched Lilliputians training inadequate hose and creating tiny explosions of a block or so of expensive dwellings by which the rest of us were ultimately saved; and high against the tip of flames where it ran out in broken sparks, the figure of the priest chopping steadily at the tower with the constrained small movement of a mechanical toy. . . .

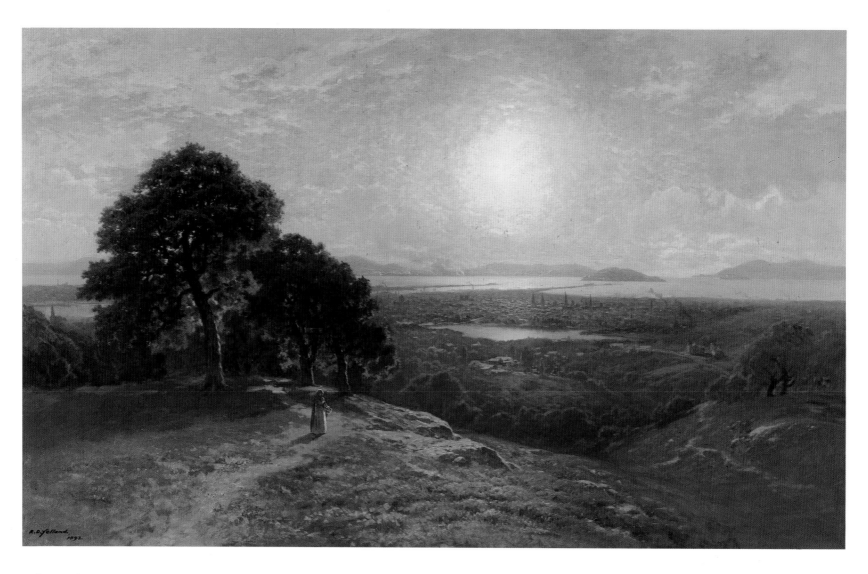

8 Raymond Dabb Yelland
 Cities of the Golden Gate, 1893

The East Bay

. . . When I looked across the bay to the eastward, and beheld a beautiful town on the fertile, wooded shores of the Contra Costa, and steamers, large and small, the ferryboats to the Contra Costa, and capacious freighters and passenger carriers to all parts of the great bay and its tributaries, with lines of their smoke in the horizon – when I saw all these things, and reflected on what I once was and saw here, and what now surrounded me, I could scarcely keep my hold on reality at all, or the genuineness of anything, and seemed to myself like one who had moved in "worlds not realized."

Richard Henry Dana, Jr., *Two Years Before the Mast*, 1840

Trading

Prudencia Higuera, *Century*, 1890

In the autumn of 1840 my father lived near what is now called Pinole Point, in Contra Costa County, California. I was then about twelve years old, and I remember the time because it was then that we saw the first American vessel that traded along the shores of San Pablo Bay. One afternoon a horseman from the Peraltas, where Oakland now stands, came to our ranch, and told my father that a great ship, a ship "with two sticks in the center," was about to sail from Yerba Buena into San Pablo and Suisun, to buy hides and tallow.

The next morning my father gave orders, and my brothers, with the peons, went on horseback into the mountains and smaller valleys to round up all the best cattle. They drove them to the beach, killed them there, and salted the hides. They tried out the tallow in some iron kettles that my father had bought from one of the Vallejos, but as we did not have any barrels, we followed the common plan in those days. We cast the tallow in round pits about the size of a cheese, dug in the black adobe and plastered smooth with clay. Before the melted tallow was poured into the pit an oaken staff was thrust down in the center, so that by the two ends of it the heavy cake could be carried more easily. By working very hard we had a large number of hides and many pounds of tallow ready on the beach when the ship appeared far out in the bay and cast anchor near another point two or three miles away. The captain soon came to our landing with a small boat and two sailors, one of whom was a Frenchman who knew Spanish very well, and who acted as interpreter. The captain looked over the hides, and then asked my father to get into the boat and go to the vessel. Mother was much afraid to let him go, as we all thought the Americans were not to be trusted unless we knew them well. We feared they would carry my father off and keep him a prisoner. Father said, however, that it was all right: he went and put on his best clothes, gay with silver braid, and we all cried, and kissed him good-by, while mother clung about his neck and said we might never see him again. Then the captain told her: "If you are afraid, I will have the sailors take him to the vessel, while I stay here until he comes back. He ought to see all the goods I have, or he will not know what to buy." After a little my mother let him go with the captain, and we stood on the beach to see them off. Mother then came back, and had us all kneel down and pray for father's safe return. Then we felt safe.

He came back the next day, bringing four boat-loads of cloth, axes, shoes, fish-lines, and many new things. There were two grindstones, and some cheap jewelry. My brother had traded some deerskins for a gun and four tooth-brushes, the first ones I had ever seen. I remember that we children rubbed them on our teeth till the blood came, and then concluded that after all we liked best the bits of pounded willow root that we had used for brushes before. After the captain had carried all the hides and tallow to his ship he came back, very much pleased with his bargain, and gave my father, as a present, a little keg of what he called Boston rum. We put it away for sick people.

After the ship sailed my mother and sisters began to cut out new dresses, which the Indian women sewed. On one of mine mother put some big brass buttons about an inch across, with eagles on them. How proud I was! I used to rub them hard every day to make them shine, using the tooth-brush and some of the pounded egg-shell that my sisters and all the Spanish ladies kept in a box to put on their faces on great occasions. Then our neighbors, who were ten or fifteen miles away, came to see all the things we had bought. One of the Moragas heard that we had the grindstones, and sent and bought them with two fine horses.

Soon after this I went to school, in an adobe, near where the town of San Pablo now stands. A Spanish gentleman was the teacher, and he told us many new things, for which we remember him with great respect. But when he said the earth was round we all laughed out loud, and were much ashamed. That was the first day, and when he wrote down my name he told me that I was certainly "La Cantinera, the daughter of the regiment." Afterward I found out it was because of my brass buttons. One girl offered me a beautiful black colt she owned for six of the buttons, but I continued for a long time to think more of those buttons than of anything else I possessed.

Courthouse History

William Halley, *The Centennial Year Book of Alameda County, California*, 1876

So far the affairs of [Alameda] county progressed pleasantly, the principal drawback having been the loss of the county and State monies, stolen from their insecure place of deposit in Alvarado. It appears at this date [1856] exceedingly stupid on the part of the Supervisors not to have ordered the deposit of those monies in the San Francisco banks for safe keeping, when they possessed no place of safety at home. It may be, however, that there was no great faith put in the banks referred to, and the treasure had to take its chances. . . .

Up to this time Alameda County had been dependent on her neighbors for jail facilities, and at the March meeting of the Board a committee was appointed to ascertain the cost of building a structure of bricks for the purpose of a County Jail. On the 6th of May the Building Committee was instructed to proceed to Martinez to see the new Court-house and Jail erected there, and report on the feasibility of building a Court-house and Jail on a similar plan. . . .

On August 19th the proposal of C. B. Tool for building a Court-house and Jail for $32,400 was accepted. The plans were subsequently amended so as to make a reduction of $2,400, leaving the cost $30,000.

The bid of Orrin Hamlin to house, feed and take care of the indigent sick of the county, at a charge of $12 each, per week, was accepted.

Mr. Eagar had a herculean task imposed upon him at this meeting. It was nothing short of an instruction "to proceed according to law to remove the obstruction of the public highway between the town of Brooklyn and the city of Oakland, being a certain gate placed upon the bridge, known as the Oakland bridge." Mr. Eagar did not undertake this arduous duty at once, but a short time afterwards Mr. Carpentier appeared before the Board, coolly requesting it to do as the Court of Sessions had illegally done to make a contract with him with regard to the bridge. This proposition was rejected by a vote of four to one.

It is evident that our citizens in the southern part of the county had time for other work than farming about this time, because two of them became the inventors of washing machines, which they offered for sale, and claimed superiority for them over all others in the market.
– William Halley, 1863

The matter of providing sufficient and safe county offices was becoming daily more pressing, and on the 1st of September the Grand Jury of the Court of Sessions made the following presentment, exhibiting the piteous condition of the county in this aspect, and which justified the Board of Supervisors in taking the steps already recorded in providing a new brick building:
The treasury and county records are but baits for the burglar and incendiary. The misfortune of the county heretofore in the loss of a large amount of money – the destruction by fire of one Court-house and the narrow escape of the records covering transactions of immense value to our fellow citizens. While we consider it neither becoming nor economical that we should be yet unprovided with a place of confinement to enforce the decrees of our own Courts, having to depend upon the charity of our neighbors to supply a necessity we are well able to furnish ourselves.

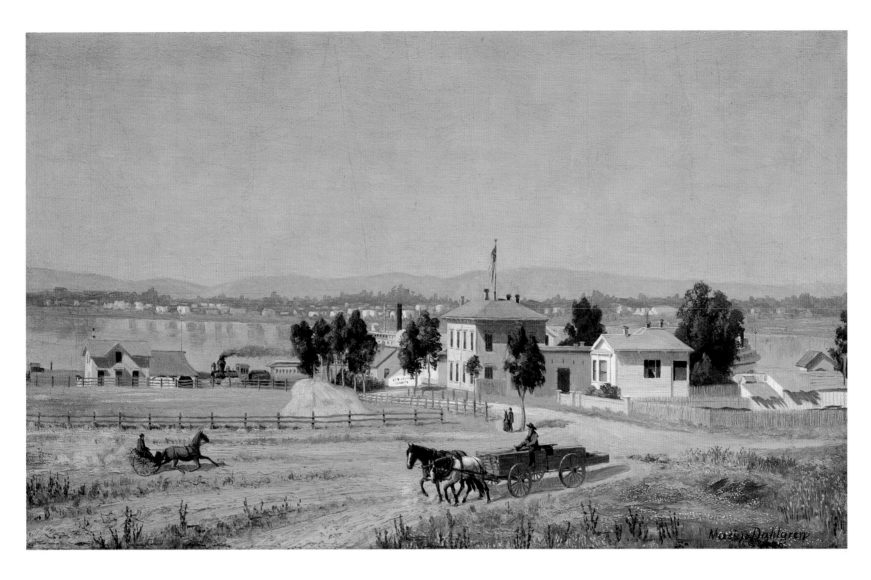

9 Marius Dahlgren
 Alameda County Courthouse, East Oakland, 1882

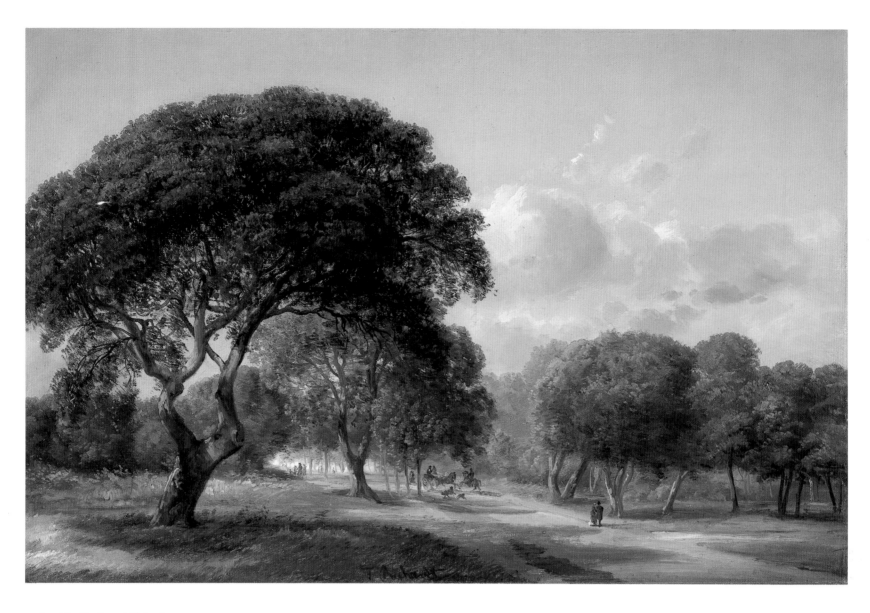

10 Joachim Ferdinand Richardt
Oaks at Madison and 8th Streets, Oakland, California, 1869

The Peralta Land Grant

There is no knowledge of any one settling on our soil prior to 1820. In that year, Don Luis Peralta, a Spanish soldier, who had put in about forty years of service, and was long attached to the Presidio of San Francisco, applied for a grant of land from the Spanish Government, and got it. He claimed it upon the Contra Costa, and in due time secured a tract "commencing at the 'deep creek of San Leandro,' about eight leagues from the Mission of San José, or in a northerly or northwesterly direction along the coast, and from that to a hill adjoining the sea-beach, along the coast in the same course, containing about four or five leagues of land" – most fortunate selection. But that princely grant was not then considered of any great prospective value. . . . It was easily taken possession of, for there were then no Indians nor squatters to dispute his right and enjoyment, excepting, perhaps, the Fathers of the Mission of San Francisco, on whose pastureage he was deemed to have somewhat encroached in the direction of San Pablo.

William Warren Ferrier, *The Story of the Naming of Berkeley*, 1929

The sons were named José Domingo, Vincente, Antonio Maria and Ygnacio. To José Domingo he allotted the most northerly quarter, on which now sits the Town of Berkeley; to Vincente he gave the quarter next adjoining [where has grown up the Village of Temescal and the City of Oakland] – the most valuable real estate gift ever bestowed by a private citizen upon a son; the next quarter fell to the lot of Antonio Maria, and embraced the ground occupied by Alameda, Brooklyn, Fruit Vale and Melrose. The last quarter constituted the most southerly, and took in the locations of Damon's Landing, Fitchburg and Seminary Park. . . .

There were two encinals, or oak-grove peninsulas, on this vast estate; that forming the original site of Oakland, which was known as the Encinal de Temescal; and that of Alameda, which was called the Encinal de San Antonio.

Each brother built himself a house, took there his wife, and reared his children, and the whole four rejoiced in large herds of cattle. . . .

Space will not permit a description of the mode of life followed by those pioneers and patriarchs of our county, nor any philosophizing on the possibilities of the wealth and honor that awaited them, could they but properly realize the present or anticipate the future. Vincente, especially, held in his hands not only the most eligible, but also the most beautiful, of town sites. Delightful vistas, lovely slopes, beautiful groves, pleasant hill-sides, a rich soil, abundant water and an inviting landscape, formed portions of the attractions presented by this Pacific Eden. Until the year 1850, but the bellowing of the Spanish bull and the tramp of wild cattle disturbed the silence of those beauteous solitudes. Besides these four men and their families, together with a few retainers, there were no other inhabitants between Berkeley and San Leandro.

Losing the Land

William Warren Ferrier, *The Story of the Naming of Berkeley*, 1929

[In February 1850] three brothers named Patten – Robert F., William and Edward – natives of the State of Maine, crossed the Bay, from San Francisco, in a row-boat, pulled up the slough and landed near by where the Twelfth-street bridge now crosses, on the East Oakland side.

The Pattens prospected around the place; they ascended the mountains and viewed the valley, and saw that it was of surpassing loveliness. They visited the Redwoods beyond San Antonio, and to their astonishment and satisfaction found that civilization had there preceded them. They found lumber already made, but no one in charge of it or making a claim to ownership. They took what they wanted of shingles and scantling, holding themselves prepared to pay for them when the owner became known to them. On their return to Clinton they found at San Antonio a Frenchman, who was running a dairy, and through this man they opened negotiations with Antonio Maria Peralta to purchase or lease a portion of his land. They secured the possession of 150 acres in this way, on one year's lease, and commenced farming. The next year they got a lease covering between 300 and 400 acres, which land they fenced in on one side with posts and redwood rails. . . . The town of Clinton was started.

During the summer of the same year, 1850, the notorious firm of Moon, Carpentier & Adams appeared upon the scene, in Oakland. They squatted upon the land, and built a small house at the foot of Broadway. They sought not out Signor Peralta, the rightful owner of the soil, to purchase or lease his acres, but set him boldly at defiance, relying upon other means than those usually dictated by a sense of right and justice, to maintain possession and grab all that they could. Moon and Carpentier were lawyers; the latter, at least, was well versed in all the devious ways of chicanery and legal trickery, and being altogether free from the slightest trace of honest conviction or the merest scruple of conscience, at once entered upon a career of fraud and villainy that has no parallel in the annals of our State. Carpentier and his companions boldly assumed that the ground was government land, and immediately parceled it out among themselves. The State was then in its infancy, the Courts were not organized, and justice was tardy.

My sons, God gave that gold to the Americans. If he had wanted the Spaniards to have it, he would have let them discover it before now. So, you had better not go after it, but let the Americans go. You can go to your ranch and raise grain, and that will be your best gold field, because we all must eat while we live.
– Don Luis Peralta, 1848

Other squatters soon followed. Lying so near the great city, that was springing up on the opposite side of the bay, and possessing such a delightful aspect, soil and climate, it is no wonder that once the example was set and the way broken that many followed. The place was soon overrun and the lawful owners hemmed in and surrounded on every side by trespassers. . . . The thousands of cattle belonging to Peralta that roamed among the oaks and fed upon the plains were stolen and killed; the timber that had become a valuable source of revenue, was cut and carried off, and all kinds of depradations practiced.

Peralta at first got a writ of ejectment, from the County Court at Martinez, against Moon, Carpentier & Adams, and a posse of men, under Deputy Sheriff Kelley was sent to eject them. It consisted of ten or twelve men. On arriving at

Vincente Peralta's residence, it was joined by a reinforcement of native Californians, the friends and retainers of the rightful owner of the soil. Before proceeding to assault the 16 x 12 shanty of the trespassers, situated near the landing, the Sheriff's party were hospitably entertained by the Californian, on whose errand they had come. They were treated to tortillas and roast beef, and beans, then the usual diet of the natives. Peralta's reinforcement consisted of about forty mounted men, who wore the usual picturesque Mexican costume of leather breeches, buttoned down the sides, broad sombreros and bright-colored sashes around their waists. . . . Arrived at the shanty, they found Moon alone in possession. . . . Moon listened quietly to the complaint, was calm and complacent, and affected great astonishment at the proceeding. He protested there was nothing further from his intentions, and of his associates, than to do Don Peralta, who he affected to esteem highly, any injury. Anything they could do to satisfy Peralta would be done, and such a display of force and authority he considered altogether unnecessary.

Peralta complained of the many wrongs he was enduring, and said it was absolutely necessary for his protection that trespassers of all kinds should be punished, and these gentlemen, he declared, had shown no regard for the safety of his property or the possession of his rights. After some further palaver, in which Moon displayed the smoothness of his tongue and the wilyness of his way, the party that came so fully armed were completely disarmed by the innocent manner and abundant promises of Moon. Stratagem was better than battle, and perfidy won the day. A lease was agreed upon for a certain number of acres of land, on certain conditions. . . . The squatters soon assumed the attitude of owners, and proceeded to lay out a town.

Naming

William Warren Ferrier, *The Story of the Naming of Berkeley*, 1929

The town of Berkeley, now the city of Berkeley, was born on the first day of September, 1864. She was not, however, christened until May 24, 1866 – when she was nearly two years old. . . . "Young parents never pondered so long over the name of their first baby. . . ."

On the 15th of November, 1864, the board of trustees of the College of California appointed a committee consisting of Messrs. J. A. Benton, Henry Durant and Ira P. Rankin to choose a name for the recently platted town and names for the streets thereof. . . . There is, . . . in existence a letter from Frederick Law Olmsted, the landscape architect who had been engaged for the laying out of the grounds . . . in which there are many suggestions concerning the name for the town.

In that letter Mr. Olmsted remarked: "I think the best way to form an English name is to find a word signifying something characteristic of the place to be named, or the name of a person, event or quality which would be satisfactorily associated with it; and if the word or name is not sufficiently agreeable in itself, complete with some of the old English terminations of localities." And he mentioned many, among them being: burne, lea, mead, mere, croft, wood, lynne, cot, holme, val, stock. . . .

In that connection, Mr. Olmsted observed: "Of persons, I have heard you mention but two . . . Dr. Bushnell and Mr. Billings. Either would make a good name for a locality itself. Bushnell has a particularly Saxon local association, and I should like it best alone. For a combination, Bushnellwood, Billingsley, Billingsbrook, are easily turned. . . . I don't think water should be the characteristic quality, since your water becomes quite insignificant, if it does not wholly disappear in the more important points of the ground in summer. If the locality is named from the creek, therefore, it should be by some word which implies merely a small water course or which is at least unspecific in regard to water. You have what might properly be called a grove, perhaps a wood, and you will have thickets, coppices; two kinds of trees are prominent – the oak . . . and the laurel. . . ."

Mr. Olmsted concluded: "I believe your property was formerly included in the ranch of Peralta. If this name has not been appropriated to designate any other locality it would be natural and proper to take it, and it is not bad. . . . "

It was not until the 7th of May, 1866, that the committee which had been constituted on the 15th of November, 1864, reported selection of names for the college town and its streets. The records for the 1st of May make mention of a report in part and of a request that the committee make final and complete report on the 7th. The record for the 7th is: "The committee on the matter of naming the town and streets reported, recommending that there should be scientific streets and literary ways – the streets to run north and south, the ways east and

west; that the streets be called in alphabetical order after the names of American men of science, and the ways in like order after American men of letters. . . ."

. . . The people of California for all time will be thankful that soon after the name of Peralta had been thus recommended the line, "Westward the course of empire takes its way" came into the mind of Frederick Billings, a College trustee, "A sort of inspiration," he wrote in later years, and they will be thankful also that as a result at a meeting held in San Francisco, May 24, 1866, the town was named Berkeley – after the great philosopher and devoted friend of education.

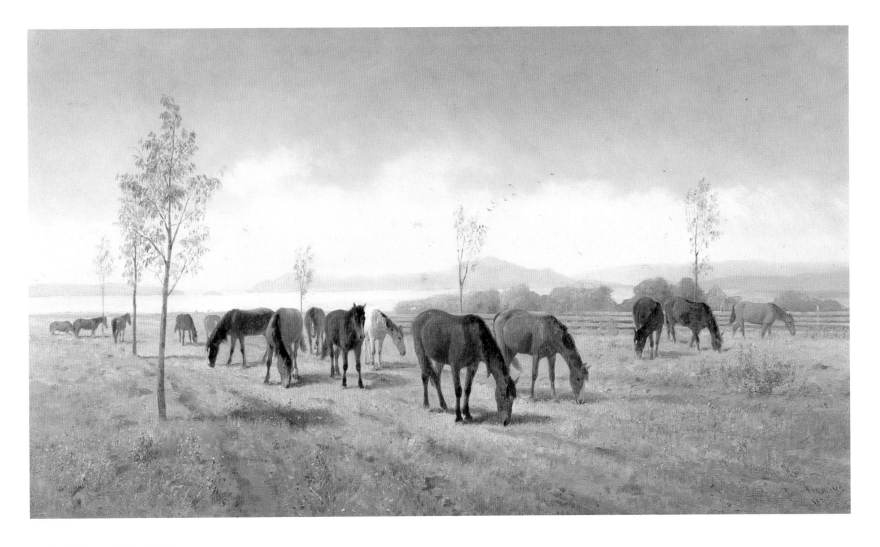

11 Carl Wilhelm (William) Hahn
 Horses Grazing, Berkeley, California, 1875

An Educator's Vision

John E. Felton, memorial lecture for Henry Durant, 1875

A few years ago, but many years in California experience, Dr. [Henry] Durant set out with some friends to seek a place where learning might find a permanent home on our Pacific shore. He passed in review many of the most beautiful valleys of our State, so rich in landscapes that delight the eye and gladden the heart. One by one he rejected sites full of beauty, for in his mind there was an ideal spot where nature would present herself in her loveliest form to the young student and lead him by her display of outward beauty to an appreciation of all that is good and beautiful in the inner world of the heart and the mind.

One morning in spring, when the air, purified by the rains of winter, brought out in clear relief the lines of ocean, valley, hill and mountain, when the trees were budding and the turf was green, and a vague dark spot in the sunlight – the Farallone Islands – showed itself through the Golden Gate, he passed through fields unbroken by roads, untrodden by man and came to the present site of Berkeley.

"Eureka!" he exclaimed. "Eureka! I have found it. I have found it. . . ."

He had found what he sought through life. Not alone the glory of the material landscape drew from him the cry "Eureka! I have found it." Before him, on that beautiful spring morning, other scenes, invisible save to him, passed before his mental vision. On the hill that looks out through the Golden Gate he saw the stately edifice opening wide its gates to all, the rich and the poor, the woman and the man; the spacious library loomed up before him, with its well-filled shelves, bringing together in ennobling communion the souls of the great and good of past ages with the souls of the young, fresh starters in the onward march of progress. In its peaceful walls those who had made a new goal for progress were urging on their descendants to begin where their career had ended, and to recognize no good as final save that which ends in perfect and entire knowledge. And before him in long procession the shadowy forms defiled of those to come.

Standing on the heights of Berkeley, he bade the distant generations "Hail" and saw them rising, "demanding life, impatient for the skies," from what were then fresh, unbounded wildernesses on the shore of the great tranquil sea. He welcomed them to the treasures of science and the delight of learning, to the immeasurable good of rational existence, the immortal hopes of Christianity, the light of everlasting truth.

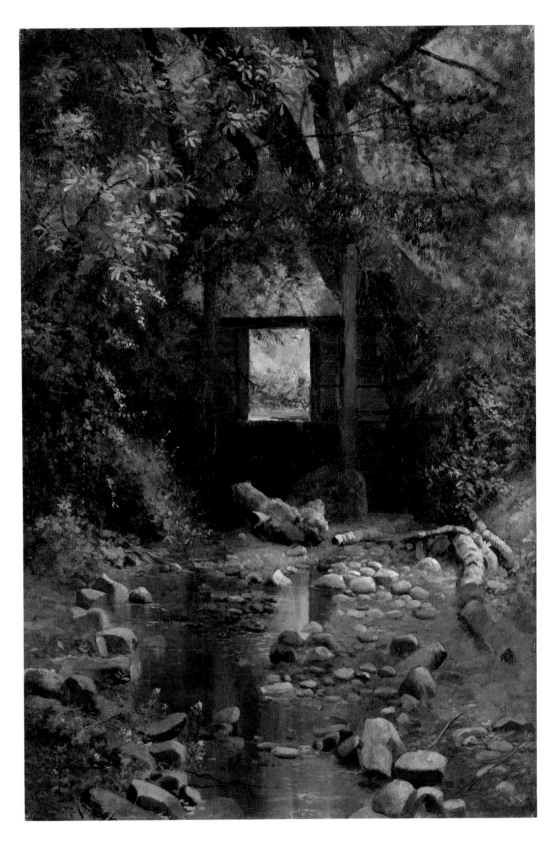

12 Edwin Deakin
Outdoor Study on Strawberry Creek, 1892

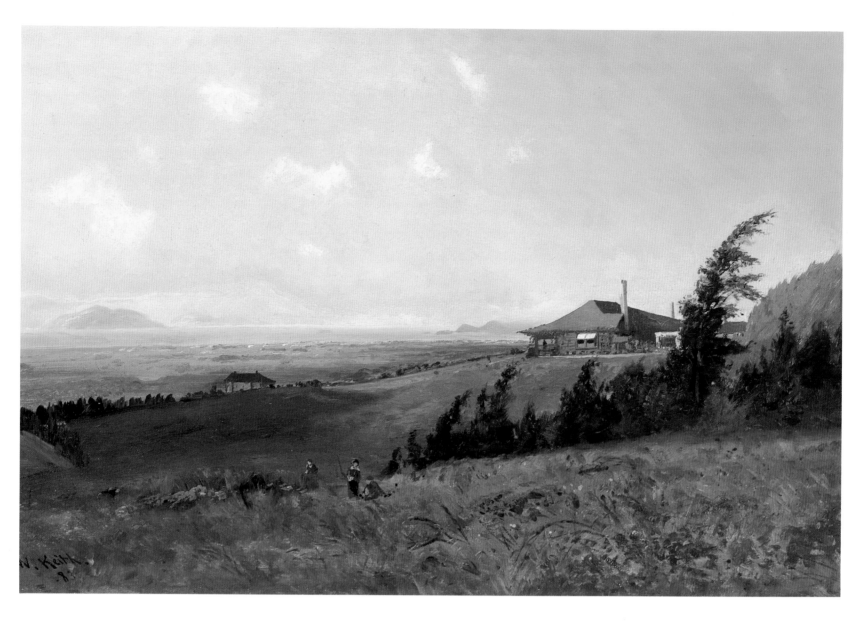

13 William Keith
 *View of Bay from Piedmont
 (Reverend Joseph Worcester's House)*, 1883

The Simple Home

A movement toward a simpler, a truer, a more vital art expression, is now taking place in California. It is a movement which involves painters and poets, composers and sculptors, and only lacks co-ordination to give it significant influence upon modern life. One of the first steps in this movement, it seems to me, should be to introduce more widely the thought of the simple home – to emphasize the gospel of the simple life, to scatter broadcast the faith in simple beauty, to make prevalent the conviction that we must live art before we can create it. . . .

The region about San Francisco Bay has a very different climate [from a warm, arid country]. The proportion of sunny days is far less; during the winter there is an abundant rainfall, while in summer much foggy weather is experienced. The winters are so mild that furnace fires are seldom considered a necessity, while the summers are so cool that there are only a few days when sunlight is not welcome for its warmth. Thus it follows that about San Francisco Bay we need to introduce into our homes all the sunlight we can get. Here the deep shadowing porches or outside corridors are out of place, as are also deep-set windows of small dimensions. We need plenty of glass on the south, east and west. A small glass room on the south side of the house is a great luxury, as well as an economy in the matter of heating the entire home.

Furthermore, the bay climate is mild enough to enable people to sit out of doors during two-thirds of the year if shelter is provided against the prevalent sea breeze from the west. Wide porches without roofing, on the east side of the house, or on the south side with a wall of wood or glass at the western end, are therefore the best means of promoting an out-of-door life in the family. These porches are most useful when large enough to accommodate a table and chairs, and they may be protected from publicity by means of bamboo strip curtains or by a screen of vines. A movable awning or a large Japanese umbrella overhead makes the porch into a livable open-air room. . . .

Now for a last word on home building: Let the work be simple and genuine, with due regard to right proportion and harmony of color; let it be an individual expression of the life which it is to environ, conceived with loving care for the uses of the family. Eliminate in so far as possible all factory-made accessories in order that your dwelling may not be typical of American commercial supremacy, but rather of your own fondness for things that have been created as a response to your love of that which is good and simple and fit for daily companionship. Far better that our surroundings be rough and crude in detail, provided that they are a vital expression conceived as party of an harmonious scheme, than that they be finished with mechanical precision and lacking in genuine character. Beware the gloss that covers over a sham!

Charles Keeler, *The Simple Home*, 1904. Keeler set forth the aesthetic principles of the East Bay Hillside Club, and his own, advocating architectural simplicity and organic harmony of home, setting, and site.

Am beautifully located in new house. We have a big living room, every inch of it, floor and ceiling, finished in redwood. . . . The rest of the house is finished in redwood too, and is very, very comfortable. . . . A most famous porch, broad and long and cool, a big clump of magnificent pines, flowers and flowers galore . . . half of ground in bearing orchard and half sprinkled with California poppies . . . our view commands all of San Francisco Bay for a sweep of thirty or forty miles, and all the opposing shores.
– Jack London, a later tenant of Worcester House, 1902

The Deaths of José R. Berreyesa and the De Haro Twins

Jasper O'Farrell, *Los Angeles Star*,
September 27, 1856

I was at San Rafael in June 1846 when the then Captain Frémont arrived at that Mission with his troops. The second day after his arrival there was a boat landed three men at the mouth of the estero on Point San Pedro. As soon as they were descried by Frémont there were three men (of whom Kit Carson was one) detailed to meet them. They mounted their horses and after advancing about one hundred yards halted and Carson returned to where Frémont was standing on the corridor of the Mission, in company with Gillespie, myself, and others, and said: "Captain, shall I take these men prisoners?" In response Frémont waved his hand and said: "I have got no room for prisoners." They then advanced to within fifty yards of the three unfortunate and unarmed Californians, alighted from their horses, and deliberately shot them. One of them was an old and respected Californian, Don José R. Berreyesa, whose son was the Alcade of Sonoma. The two others were twin brothers and sons of Don Francisco de Haro, a citizen of the Pueblo of Yerba Buena. I saw Carson some two years ago and spoke to him of this act and he assured me that then and since he regretted to be compelled to shoot those men, but Frémont was bloodthirsty enough to order otherwise, and he further remarked that it was not the only brutal act he was compelled to commit while under his command.

I should not have taken the trouble of making this public but that the veracity of a pamphlet published by C. E. Pickett, Esq., in which he mentions the circumstance has been questioned – a history which I am compelled to say is, alas, too true – and from having seen a circular addressed to the native Californians by Frémont, or some of his friends, calling on them to rally to his support, I therefore give the above act publicity, so as to exhibit some of the warrior's tender mercies and chivalrous exploits, and must say that I feel degraded in soiling paper with the name of a man whom, for that act, I must always look upon with contempt and consider as a murderer and a coward.

The last ascent [of Tamalpais] was very steep. We climbed up the rocks, and just as we reached the highest crag the fog began to clear away. Then came glimpses of the beautiful landscape through the fog. It was more grand, more like some views in the Alps than anything I have seen before—those glimpses of the landscape beneath through foggy curtains. But now the fog and clouds rolled away and we had a glorious view indeed—the ocean on the west, the bay around, the green hills beneath with lovely valleys between them.
– William Henry Brewer, 1862

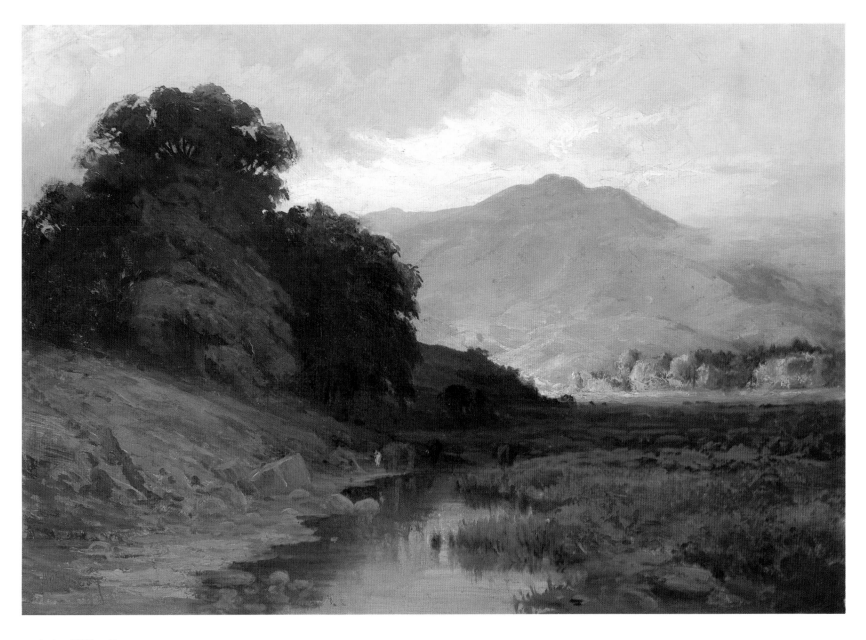

14 Arthur William Best
Mount Tamalpais, c.1900

How Witches Kill People [Hookooeko (Miwok)]

Our country is on the north side of San Francisco Bay and reaches from San Rafael to Tomales Bay. Before the white man came and destroyed us there used to be witches among the people. The people used to burn the dead. Sometimes after a burning the witches would save the ashes and burnt bones (called *me'-cham yem'-me-um*) and pound them up fine in a stone mortar and use them to kill with. The witches had two ways of killing people. One way was to put the powdered bones and ashes on the windward side of the house or rancheria of the person they wished to harm. Then the wind would blow the fine dust over the enemy. Next day he would have a headache and feel sick, and every day grow worse until by and by he died.

Another way was to take the hollow wing bone of a Turkey-buzzard and go to windward of the person to be injured. The witch then blew through the bone toward the person. The person soon had bad dreams and felt lonesome, and next day went crazy, and after a while died.

With the right kind of a buzzard bone (called *to'-kah*) a witch could blow harm to a person from a distance as great as two miles.

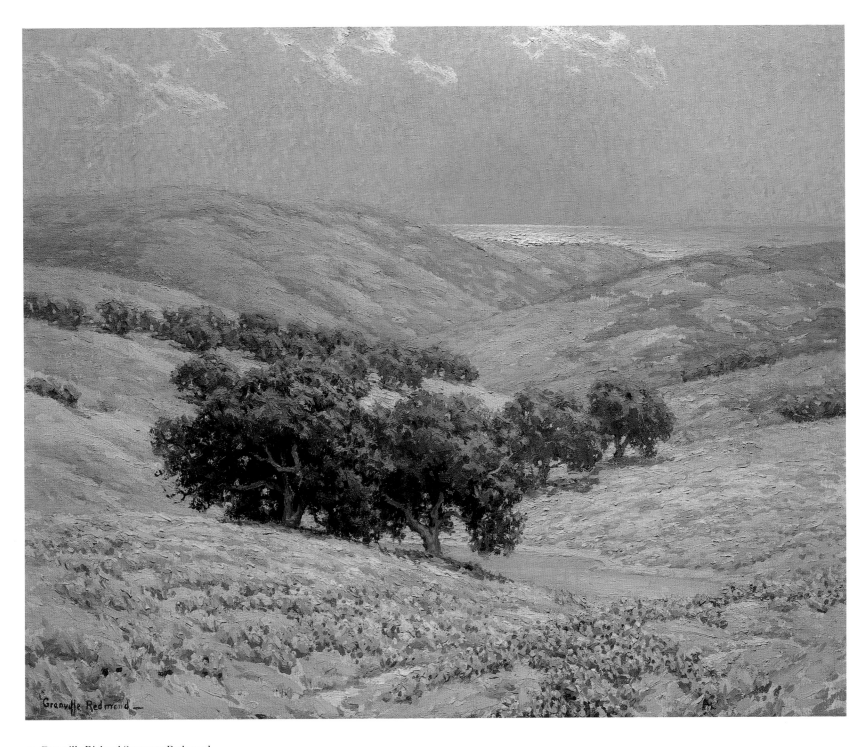

15　Granville Richard Seymour Redmond
　Lupine and Poppies, Marin, n.d.

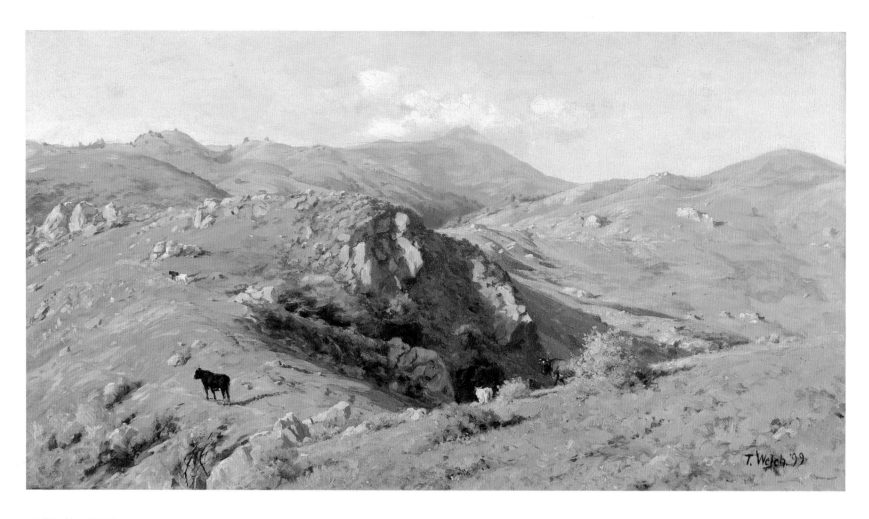

16 Thaddeus Welch
Marin County Hills, 1899

Butter Ranchos

. . . Marin County contains some large "butter ranchos" . . . which are a great curiosity in their way. The Californians, who have a singular genius for doing things on a large scale which in other States are done by retail, have managed to conduct even dairying in this way, and have known how to "organize" the making of butter in a way which would surprise an Orange County farmer. Here, . . . – to take the most successful and complete of these experiments – is the ranch of Mr. Charles Webb Howard, on which I had the curiosity to spend a couple of days. It contains eighteen thousand acres of land well fitted for dairy purposes. On this he has . . . nine separate farms, occupied by nine tenants engaged in making butter. . . .

He fences each farm, making proper subdivisions of large fields; he opens springs, and leads water through iron pipes to the proper places, and also to the dwelling, milk-house, and corral. He builds the houses, which consist of a substantial dwelling, twenty-eight by thirty-two feet, a story and a half high, and containing nine rooms, all lathed and plastered; a thoroughly well-arranged milk-house, twenty-five by fifty feet, having a milk-room in the centre twenty-five feet square, with a churning-room, store-room, wash-room, etc.; a barn, forty by fifty feet, to contain hay for the farm-horses; also a calf-shed, a corral, or inclosure for the cows, a well-arranged pig-pen; and all these buildings are put up in the best manner, well painted, and neat.

The tenant receives from the proprietor all this, the land, and cows to stock it. He furnishes, on his part, all the dairy utensils, the needed horses and wagons, the furniture for the house, the farm implements, and the necessary labor. The tenant pays to the owner twenty-seven dollars and a half per annum for each cow, and agrees to take the best care of the stock and of all parts of the farm; to make the necessary repairs, and to raise for the owner annually one-fifth as many calves as he keeps cows, the remainder of the calves being killed and fed to the pigs. He agrees also to sell nothing but butter and hogs from the farm, the hogs being entirely the tenant's property.

Under this system fifteen hundred and twenty cows are now kept on nine separate farms on this estate, the largest number kept by one man being two hundred and twenty-five, and the smallest one hundred and fifteen. Mr. Howard has been for years improving his herd; he prefers short-horns, and he saves every year the calves from the best milkers in all his herd, using also bulls from good milking strains. I was told that the average product of butter on the whole estate is now one hundred and seventy-five pounds to each cow; many cows give as high as two hundred, and even two hundred and fifty pounds per annum.

Men do the milking, and also the butter-making, though on one farm I found a pretty Swedish girl superintending all the indoor work, with such skill and order in all the departments, that she possessed . . . the model dairy on the estate.

Charles Nordhoff, *California: For Health, Pleasure, and Residence*, 1874. Nordhoff's travel books lured many to the new frontier.

Here, said I to myself, is now an instance of the ability of women to compete with men which would delight Mrs. Stanton and all the Woman's Rights people; here is the neatest, the sweetest, the most complete dairy in the whole region; the best order, the most shining utensils, the nicest butter-room – and not only butter, but cheese also, made, which is not usual; and here is a rosy-faced, white-armed, smooth-haired, sensibly-dressed, altogether admirable, and, to my eyes, beautiful Swedish lass presiding over it all; commanding her men-servants, and keeping every part of the business in order.

Alas! Mrs. Stanton, she has discovered a better business than butter-making. She is going to marry – sensible girl that she is – and she is not going to marry a dairy-farmer either.

I doubt if any body in California will ever make as nice butter as this pretty Swede; . . . every other dairy [now] seemed to me commonplace and uninteresting. . . . the young man who has had the art to persuade her to love him ought to be hanged, because butter-making is far more important than marrying. . . .

The cows are milked twice a day, being driven for that purpose into a corral, near the milk-house. I noticed that they were all very gentle; they lay down in the corral with that placid air which a good cow has; and whenever a milkman came to the beast he wished to milk, she rose at once, without waiting to be spoken to. One man is expected to milk twenty cows in the season of full milk. On some places I noticed that Chinese were employed in the milk-house . . .

The tenants are of different nationalities, American, Swedes, Germans, Irish, and Portuguese. A tenant needs about two thousand dollars in money to undertake one of these dairy-farms. . . . Milkers and farm hands receive thirty dollars per month and "found"; good milkers are in constant demand. Every thing is conducted with great care and cleanliness, the buildings being uncommonly good for this State, water abundant, and many labor-saving contrivances used.

At one end of the corral or yard in which the cows are milked is a platform, roofed over, on which stands a large tin, with a double strainer, into which the milk is poured from the buckets. It runs through a pipe into the milk-house, where it is again strained, and then emptied from a bucket into the pans ranged on shelves around. The cream is taken off in from thirty-six to forty hours; . . . the milk keeps sweet thirty-six hours, even in summer. The square box-churn is used entirely, and is revolved by horse-power. They usually get butter . . . in half an hour.

The butter is worked on an ingenious turn-table, which holds one hundred pounds at a time, and can, when loaded, be turned by a finger; and a lever, working upon a universal joint, is used upon the butter. When ready, it is put up in two-pound rolls, which are shaped in a hand-press, and the rolls are not weighed until they reach the city. It is packed in strong, oblong boxes, each of which holds fifty-five rolls.

The cows are not driven more than a mile to be milked; the fields being so arranged that the corral is near the centre. When they are milked, they stray back of themselves to their grazing places.

The Jealousy of Wek'-wek and Death of Lo'-wut [Miwok]

Wek'-wek the Falcon-man was Chief and Captain of all the bird-people. He used to hunt birds for food and also used to catch birds alive to bring back to his *han-nā'-boo* (roundhouse) where he kept them locked up until he could turn them into people. *O-la-nah* the Coyote-man stood guard at the door of the *han-nā'-boo*.

Wek'-wek the Falcon-man and *Ho'-pah* the White-headed Eagle-man had the power to make people out of birds. For this reason they were jealous of one another. Besides, *Ho'-pah* was in love with *Wek'-wek's* wife, *Lo'-wut*, the Gray Goose-woman. So *Wek'-wek* had cause to be jealous.

Once when he went out to go hunting he hid and watched and saw *Ho'-pah* and *Lo'-wut* together. This made him very angry. When he came back he asked *Lo'-wut*, his wife, "Have you anything ready to eat? I'm hungry."

"Yes," she replied.

"Bring me some water first," he said, "I'm thirsty; bring good water; don't get it from the edge of the river; go out where it is deep and get it there."

Lo'-wut did as she was told and came back with good clear water, but when she reached the house with it, it had turned into snakes and frogs and other water animals. Five times she went out into the river for water, each time with the same result. The last time she waded out till the water was above her waist.

While she was gone, *Wek'-wek* went to her bed and fixed in it four long spear points of flint with the points up. When she came the fifth time with snakes and frogs instead of water, *Wek'-wek* seized her and threw her down on the bed and the four spear points pierced her body and killed her.

To-to'-kol the Sandhill Crane-woman was *Lo'-wut's* mother; she was very angry because *Wek'-wek* had killed her daughter, and wanted to punish him.

O-lā'-nah the Coyote-man and *Soo'-choo-koo* the Spoon-bill Duck came to carry *Lo'-wut's* dead body to the *han-nā'-boo*, but when they lifted it they saw on the breast the black marks which *Ho'-pah* her lover had painted there. *Wek'-wek* had seen these before and knew. So *O-la'-nah* and *Soo'-choo-koo* took the dead body and buried it.

When *Lo'-wut* died she left two children, a baby and a little boy. Their grandmother, *To-to'-kol*, took care of them and every day sent the little boy with the baby to the roundhouse to be fed – and for four days *Lo'-wut* the dead mother came each day to the *han-nā'-boo* to give milk to her young child.

On the fourth day *Wek'-wek* asked his little boy where he went every day with the little one. The boy, afraid to tell the truth, said he took the child to give it milk of the milkweed plant.

Wek'-wek hid in the top of an oak tree and watched. He saw his dead wife *Lo'-wut* come to the roundhouse to give breast to the child; and saw her rise from the ground and shake the earth of the grave out of her hair.

Then *Wek'-wek* found that he loved her still, although she had been unfaithful

to him. So he went into the roundhouse and caught her in his arms and hugged her.

"Let me go," she said, "You can't get me back; I'm not well as I used to be."

"That doesn't make any difference," he said, "I'll cure you." And he took her away to his own roundhouse, where the other bird-people were. It was dark when they arrived.

Yu-koo'-le the Meadowlark was there. He had never liked *Wek'-wek's* wife and had quarreled with her. Now he made a great fuss and noise.

"*Hoo,*" he said, "light a light; I smell something like a dead body."

At that very moment *Wek'-wek* was sitting in the middle of the roundhouse holding the body of his wife, whom he was bringing back to life. But when *Yu-koo'-le* spoke and said what he did, the dead woman disappeared.

Wek'-wek was very angry. He spoke and said to the rest of the birds (all of whom were going to be people): "This now is the way it will be with us all. When we die we shall die forever. Had it not been for *Yu-koo'-le* we would live again after the fourth day and be alive forever, the same as before."

When *Wek'-wek* had said this he seized *Yu-koo'-le* and tore his mouth open and killed him, and to this day you can see under the meadowlark's throat the black mark where his mouth was torn down, and the marks on his head where the skull was crushed.

Then *Wek'-wek* sent all the bird-people away, but before they went he spoke to them and said: "Now you will never be people but will be real birds; if *Yu-koo'-le* had not said what he did my wife would have lived and all of you would have turned into people."

All the bird-people in the roundhouse were angry at what *Yu-koo'-le* had done. They said, "Were it not for *Yu-koo'-le* we would turn into people; now we must turn into animals." Then they came out of the roundhouse, one at a time, and as each came out it sang the song of the kind of bird it was to be, and became that kind, and went away.

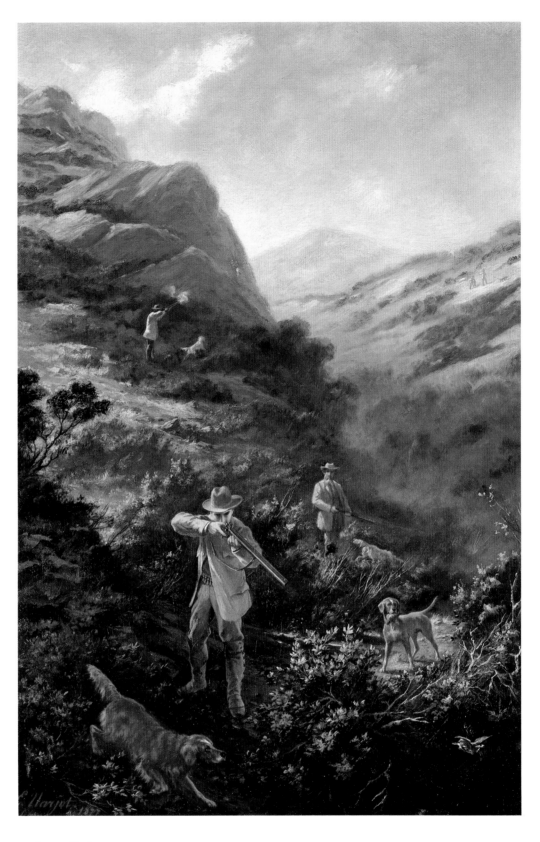

17 Erneste Narjot
 Quail Hunting in Marin, 1877

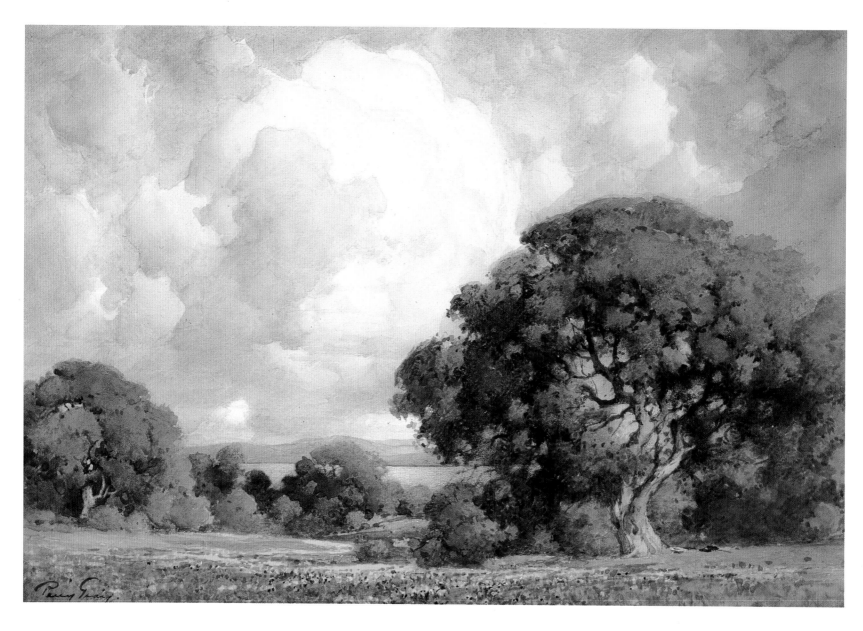

18 Henry Percy Gray
Marin Landscape, n.d.

Marin Shores

Miles of [the Franciscan tidelands], barely above the level of the slow-moving water, spread a magic carpet of blending crimsons, purples, and bronzes. Under the creeping mists and subject to the changes of the water, beaten to gold and copper under the sun, it redeems the flat lines of the landscape with the touch of Oriental splendor.

For it is a flat Kingdom, that of the Little Duck; – the hills hanging remotely on the horizon, the few trees, and scattered, hugging the low shore of the sloughs as the ship-wrecked cling to their rafts, desperate of rescue. The rich web of the samphire, the shifting color of the water, faintly reminiscent of Venice, borrow another foreign touch from the names under which the borders are recommended to attention: Sausalito, "little willows," Tiburon, Corta Madero, San Quentin, San Rafael. Approached from the water these names, with the exception of San Quentin, do no more than stir the imagination. San Quentin, on one of those courtesy islands newly rescued from the primordial mud, shows itself uncompromisingly for what it is, one of those places for the sequestration of public offenders which is itself an offense to our common humanity to say nothing of our common sense. Free tides, free sails go by, and long, untrammeled lines of birds. . . . Along with the bastions of San Quentin, [Mare Island] strikes somehow, the note of human distrust amid all this charm of light and line and elusive color, as if suddenly one should discover the tip of a barbed tail under the skirt of some seductive stranger. . . .

Between San Quentin and the Straits, all about the curve of the bay, winding, wide-mouthed sloughs give access to a land as fertile as Egypt. A slough is a mere wallow of unprofitable waters, waters unused by men and still reluctant of the sea. Pushed aside by the compelling tides, too undisciplined to make proper banks for themselves, they are neglected by all but a few fringing willows and shapeless sycamores in which the herons nest.

Often at evening white-faced ibises can be seen flying in long, voiceless lines, just clearing the twilight-tinted water, to their accustomed night perches in the wind-beaten willows. They return there, if undisturbed, year after year, accompanied in few and far between seasons by the egret and snowy heron, grown man-shy, or, if they but knew the purpose for which their nuptial plumage is sacrificed, woman-shy, and seldom seen even by the most wishful eyes.

Mary Austin, *The Land of the Sun*, 1914

The air is all alive with the metallic glint of dragonflies; now and then the plop of some shining turtle dropping into the smooth lagoon, or the frightened splash of some marsh nesting bird, skims the silence.
– Mary Austin, 1914

Elk Hunting and Wild Horses

William Heath Davis, *Seventy-five Years in California*, 1889. Davis first visited California in 1861 and 1864 before becoming a life-long resident.

On Mare Island I often saw in the years from [1840] to '43 as many as two or three thousand elk, it being their habit to cross and recross by swimming between the island and the mainland, and I remember one occasion, when on the schooner *Isabella*, of sailing through a band of these elk, probably not less than a thousand, which were then crossing from Mare Island to the mainland. It was a grand and exciting scene. The captain of the boat wanted to shoot at some of them, but I prevented him from doing so because we could not stop to get the game on board and I did not like to see the elk wantonly destroyed.

These elk were killed for their hides and tallow by the *rancheros* in considerable numbers, at the time they slaughtered their cattle. . . .

The cattle were slaughtered in the summer season; the killing commenced about the 1st of July and continued until the 1st of October, for the hides and tallow; about two hundred pounds of the best part of the bullock was preserved, by drying, for future consumption, the balance of the animal being left to go to waste; it was consumed by the buzzards and wild beasts. . . .

A large number of horses were needed on each rancho for herding stock, as they were used up very fast. They were numerous and cheap, and the owners placed no restraint upon the *vaqueros*, who rode without a particle of regard for the horses till they soon became unfit for further use in this way. . . . There were large bands of wild horses in the San Joaquin, which at that time was entirely unsettled. At times, a few mares, and perhaps a young stallion, would stray away from a rancho and get out of reach, until in the course of time there were collected in that valley immense herds, thousands and tens of thousands of horses, entirely wild and untamed, living and breeding by themselves, finding there plenty of good feed to sustain them.

Frequently during the summertime, young men, the sons of *rancheros*, would go in companies of eight or ten or twelve to the valley on their best and fleetest steeds to capture a number of these wild horses and bring them to the ranchos. On reaching the place where a large band was collected, they prepared for the sport in this way: The saddles being removed, the horses were ridden bareback, a piece of reata being tied loosely around the body of each horse just behind the forelegs, and the rider, having no saddle or stirrups, slipped his knees under the rope, one end of the lasso being tied to the rope also. Thus prepared, they rode toward the wild horses, who, on seeing them approach, would take alarm and rush off at great speed, the riders following. Sometimes the chase lasted for miles before they came up with the horses. On getting near enough each horse-man selected his victim, pursued him, and at the right moment cast a lasso, which never failed to encircle the neck of the horse; then bringing his own horse to a stand, there was a wild struggle, the rider holding his horse firm, and the captured horse pulling and straining on the rope until he became so choked and exhausted that he was compelled to succumb. . . . When fifty or sixty of the wild horses were thus captured, they were taken to the ranchos, corralled at night and herded in the daytime, until they became sufficiently subdued to be introduced among the horses of the ranch. . . .

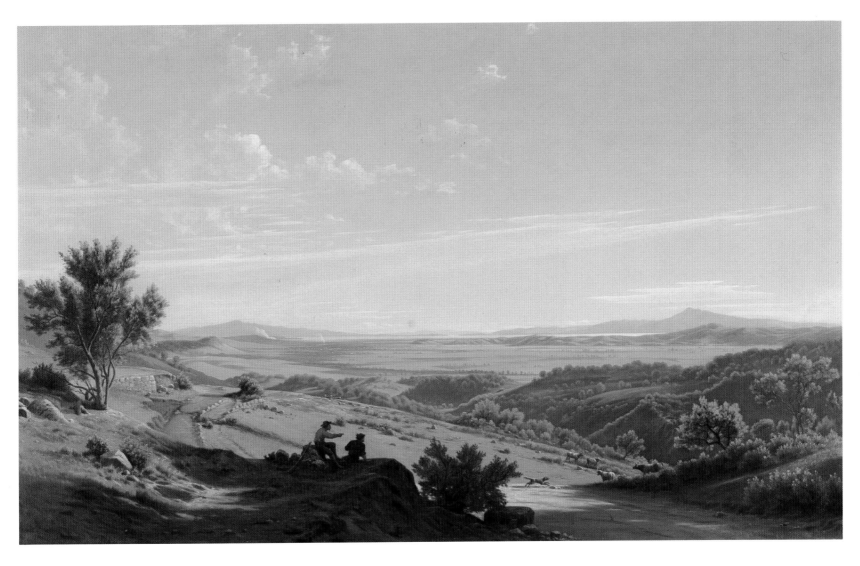

19 Virgil Williams
View South from Sonoma Hills
toward San Pablo Bay and Mount Tamalpais, 1864

Mount Saint Helena

Robert Louis Stevenson, *The Silverado Squatters*, 1883

Mount Saint Helena . . . is the Mont Blanc of one section of the Californian Coast Range, none of its near neighbours rising to one-half its altitude. It looks down on much green, intricate country. It feeds in the spring-time many splashing brooks. From its summit you must have an excellent lesson of geography: seeing, to the south, San Francisco Bay, with Tamalpais on the one hand and Monte Diablo on the other; to the west and thirty miles away, the open ocean; eastward, across the cornlands and thick tule swamps of Sacramento Valley, to where the Central Pacific railroad begins to climb the sides of the Sierras; and northward, for what I know, the white head of Shasta looking down on Oregon. Three counties, Napa County, Lake County, and Sonoma County, march across its cliffy shoulders. Its naked peak stands nearly four thousand five hundred feet above the sea; its sides are fringed with forest; and the soil, where it is bare, glows warm with cinnabar.

Life in its shadow goes rustically forward. Bucks, and bears, and rattlesnakes, and former mining operations, are the staple of men's talk. Agriculture has only begun to mount above the valley. And though in a few years from now the whole district may be smiling with farms, passing trains shaking the mountains to the heart, many-windowed hotels lighting up the night like factories, and a prosperous city occupying the site of sleepy Calistoga; yet in the meantime, around the foot of that mountain the silence of nature reigns in a great measure unbroken, and the people of hill and valley go sauntering about their business as in the days before the flood. . . .

. . . It was then that favoured moment in the Californian year, when the rains are over and the dusty summer has not yet set in; often visited by fresh airs, now from the mountain, now across Sonoma from the sea; very quiet, very idle, very silent but for the breezes and the cattle-bells afield. And there was something satisfactory in the sight of that great mountain that enclosed us to the north; whether it stood, robed in sunshine, quaking to its topmost pinnacle with the heat and brightness of the day; or whether it set itself to weaving vapours, wisp after wisp growing, trembling, fleeting, and fading in the blue. . . .

The tangled, woody, and almost trackless foothills that enclose the valley, shutting it off from Sonoma on the west, and from Yolo on the east – rough as they were in outline, dug out by winter streams, crowned by cliffy bluffs and nodding pine-trees – were dwarfed into satellites by the bulk and bearing of Mount Saint Helena. She overtowered them by two-thirds of her own stature. She excelled them by the boldness of her profile. Her great bald summit, clear of trees and pasture, a cairn of quartz and cinnabar, rejected kinship with the dark and shaggy wilderness of lesser hilltops. . . .

. . . Vineyards and deep meadows, islanded and framed with thicket, gave place more and more as we ascended to woods of oak and madrona, dotted with enormous pines. It was these pines, as they shot above the lower wood, that produced that pencilling of single trees I had so often remarked from the valley. Thence, looking up and from however far, each fir stands separate against the sky no bigger than an eyelash; and all together lends a quaint fringed aspect to the hills. The oak is no baby; even the madrona, upon these spurs of Mount Saint Helena, comes to a fine bulk and ranks with forest trees; but the pines look down upon the rest for underwood. As Mount Saint Helena among her foothills, so these dark giants out-top their fellow-vegetables. Alas! if they had left the redwoods, the pines, in turn, would have been dwarfed. But the redwoods, fallen from their high estate, are serving as family bedsteads, or yet more humbly as field fences, along all Napa Valley.

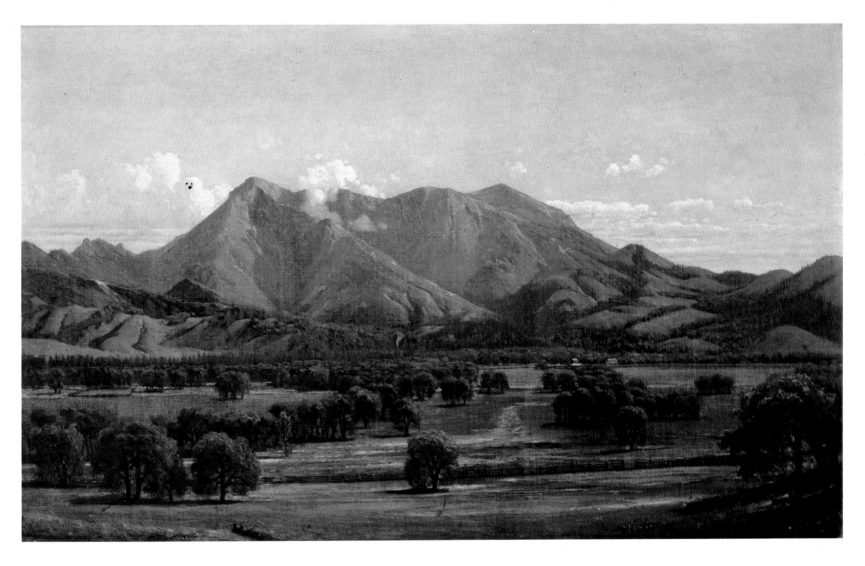

20 Virgil Williams
Mount St. Helena from Knight's Valley, n.d.

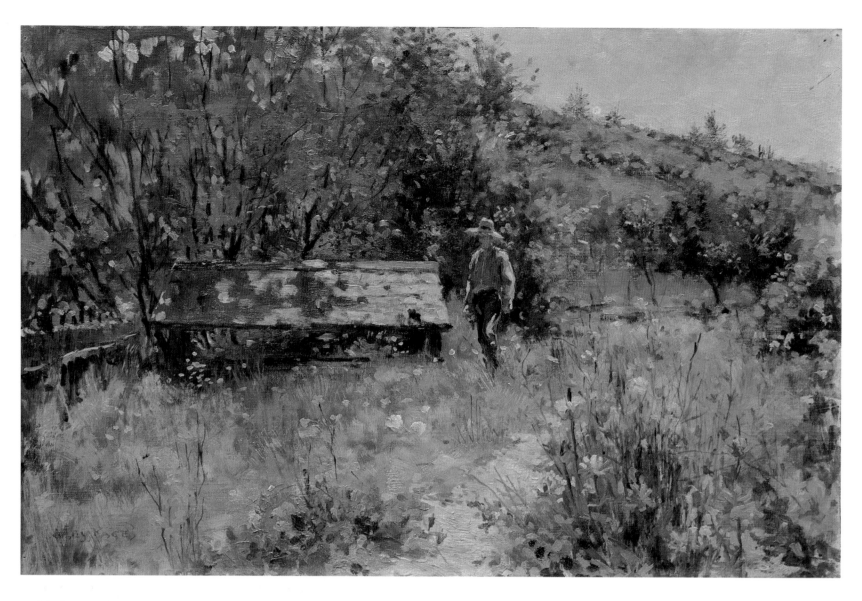

21 Jules Pages
Sonoma County Landscape, n.d.

. . . Two great birds flew up the cañon and disappeared into the rocks that there touch the sky. Eagles, a mountain hawk, or what not, it was strange how our interest depended on the name, for the eagle is so nobly named, and figures in so many brave stories and legends, that no other bird can be compared with it. Again late at night we heard from up the cañon three strange squalls or screams; like, but somewhat different from, those I had attributed to a wild cat, on our first arrival. In our usually silent cañon, they made a great effect. One thought it was an eagle; one of our eagles; for Joe could already make out the eagle's nest; another was sure it was a California lion; a third was once more in favour of the wild-cat theory; and one of the Hanson boys, to whom the cry was imitated, and that scandalously ill, at once pronounced it that of a fox. I leave the reader there. That night, also, the unwearied ringing whistle of a cricket rang for near an hour on end from the rocks above the ledge.

And like the light in darkness, so was this clumsy human speech, and the call of the cricket in the healing silence. After I was in bed and the candles out, looking right upward through the hole of the old stove chimney, I saw a single star looking right down into my eyes. It was faint, unspeakably distant, and so unspeakably small. Its smallness haunted me like a monstrosity; and I was fain to shut my eyes and keep it out. . . .

. . . I have never seen such a night. It seemed to throw calumny in the teeth of all the painters that ever dabbled in starlight. The sky itself was of a ruddy, powerful, nameless, changing colour, dark and glossy like a serpent's back. The stars, by innumerable millions, struck boldly forth like lamps. The milky way was bright, like a moonlit cloud; half heaven seemed milky way. The greater luminaries shone each more clearly than a winter's moon. Their light was dyed in every sort of colour – red, like fire; blue, like steel; green, like the tracks of sunset; and so sharply did each stand forth in its own lustre that there was no appearance of that flat, star-spangled arch we know so well in pictures, but all the hollows of heaven was one chaos of contesting luminaries – a hurly-burly of stars. Against this the hills and rugged treetops stood out redly dark.

. . . The lesser lights and milky ways first grew pale, and then vanished; the countless hosts of heaven dwindled in number by successive millions; those that still shone had tempered their exceeding brightness and fallen back onto their customary wistful distance; and the sky declined from its first bewildering splendour into the appearance of common night. Slowly this change proceeded, and still there was no sign of any cause. Then a whiteness like mist was thrown over the spurs of the mountains. Yet awhile, and, as we turned a corner, a great leap of silver light and net of forest shadows fell across the road and upon our wondering waggonful; and swimming low among the trees, we beheld a strange, misshapen, waning moon, half tilted on her back. . . .

The more one stays here, the more one is struck by the arid character of the earth's face. There is nothing here but rock and stone and gravel. Given such an aspect of the earth, we should expect the lizards, which swarmed thick on every side, and the rattle-snakes, which grew here, as they told us, to unusual bigness, but we should never expect the amount or the nature of the vegetation. . . . All that grows here, but the eternal poison-oak, is beautiful, healthy, scented, and rich in bloom.
– Robert Louis Stevenson, 1883

Massacre [Pomo]

William Ralganal Benson, a Pomo, in his narrative account of the 1850 massacre, describes the sadistic treatment of his tribe by the ranchers Stone and Kelsey, their murders, and the retaliation against the Pomos by a military expedition. "The starvetion of the indians," Benson says, "was the cause of the massacre of stone and kelsey."

one day the lake watchers saw a boat came around the point. som news coming they said to each others. two of the men went to the landing. to see what the news were. they were told that the white warriors had came to kill all the indians around the lake. so hide the best you can. the whites are making boats and with that they are coming up the lake. so we are told by the people down there. so they had two men go up on top of uncle sam mountain. the north peak. from there they watch the lower lake. for three days they watch the lake. one morning they saw a long boat come up the lake with pole on the bow with red cloth. and several of them came. every one of the boats had ten to fifteen men. the smoke signal was given by the two watchmen. every indian around the lake knew the soldiers were coming up the lake. and how many of them. and those who were watching the trail saw the infantrys coming over the hill from lower lake. these two men were watching from ash hill. they went to stones and kelseys house. from there the horsemen went down torge the lake and the soldiers went across the valley torge lakeport. they went on to scotts valley. shoot afew shoots with their big gun and went on to upper lake and camped on Emmerson hill. from there they saw the indian camp on the island. the next morning the white warriors went across in their long dugouts. the indians said they would met them in peace. so when the whites landed the indians went to wellcome them. but the white man was determined to kill them. Ge-We-Lih said he threw up his hands and said no harm me good man. but the white man fired and shoot him in the arm and another shoot came and hit a man staning along side of him and was killed. so they had to run and fight back; as they ran back in the tules and hed under the water; four or five of them gave alittle battle and another man was shoot in the shoulder. some of them jumped in the water and hed in the tuleys. many women and children were killed on around this island.

Lyman L. Palmer, *History of Napa and Lake Counties*, 1881

The *City of Lakeport* . . . was built in 1875 by Captain R. S. Floyd and was constructed after the pattern of the Pacific Mail Company's finest steamers. In fact she is a miniature ocean steamer, and is a perfect beauty. She is seventy-eight feet overall, and seventy-two feet between perpendiculars, is nine feet three inches in beam and six feet in depth of hold. Her frame is made out of Eastern oak, her stern from Clear Lake oak, and the remainder of the wood used in her construction is Oregon pine, and the trimmings are of teak. She is strong, substantial, and perfectly seaworthy. She is brig rigged, having a fore and main topsail, square foresail, spanker, fore spenser, fore staysail and jib. There are two engines in her, which are six and one-half inches in diameter and have an eight-inch stroke. The propeller has two blades, forty-eight inches in diameter, and with a six-foot pitch. There are two cabins in the boat, one forward of and the other abaft the engine room. There is a jaunty little pilot house in front, and a small after-deck.

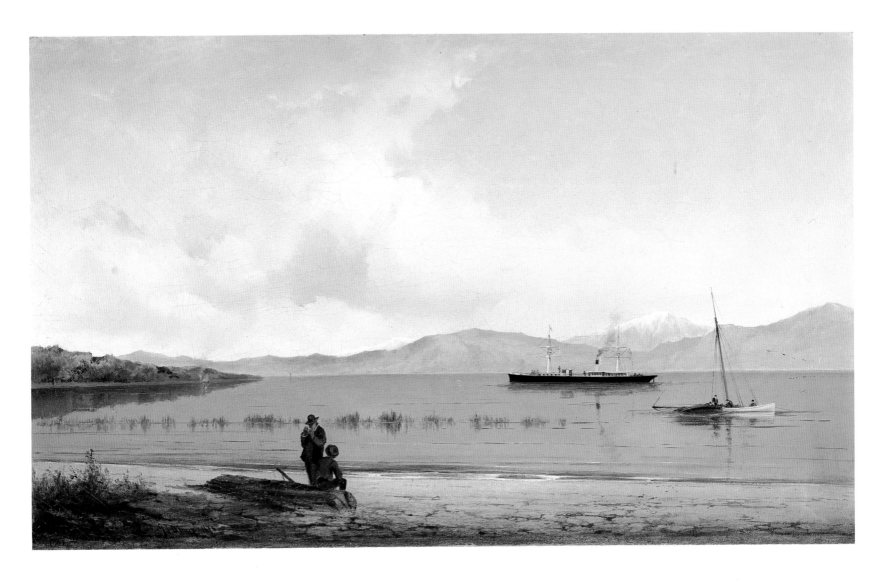

22 Gideon Jacques Denny
 "City of Lakeport" on Clear Lake, 1876

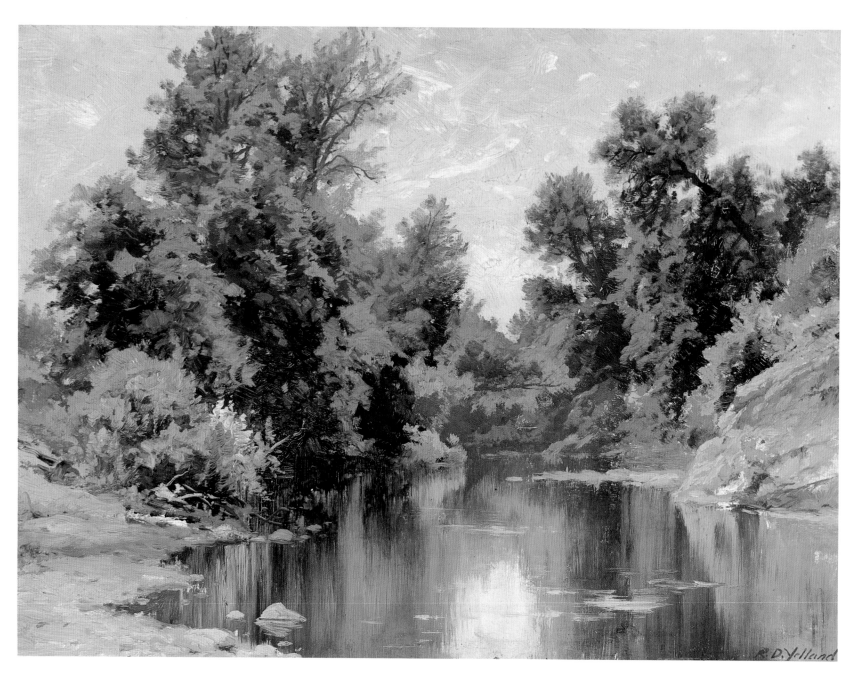

23 Raymond Dabb Yelland
 Russian River, Sonoma County, n.d.

The Cremation of Care

One of the greatest occurrences in the history of Bohemia . . . took place [in 1879], no less an affair than the first Midsummer High Jinks held in the redwoods. . . . But the greatest event of [a later Jinks] was one that, like the midsummer outing itself, has grown with the years, until it has developed into the most famous ceremonial of Bohemia; we refer to the "Cremation of Care. . . ."

The Annals of The Bohemian Club [1872–1880]

Seated on logs, or lying on the ground, the Bohemians smoke their pipes in the balmy night air and listen to the addresses and music of the High Jinks. At the conclusion of these services the sound of martial strains is heard approaching; there is a red glare of torches, and a band of musicians, robed in sombre gowns, is seen slowly advancing through the trees. Following the band comes a company of men, also robed in long gowns, with hoods concealing their faces, each carrying a torch, and preceded by the High Priest of Bohemia in his robes of office. Following these comes another company, bearing upon its shoulders a bier, and on the bier a coffin, and in the coffin lies that enemy of mankind, the sworn foe of Bohemia, Dull Care. Following these again, and guarding the corpse, are imps, devil-masked and garbed in crimson, horned and cloven hoofed, brandishing torches. As the funeral procession approaches, the Club members silently arise, and two by two, with arms locked, follow it, soberly and with decorum.

In and out through the midnight forest this strange cortege bears the Body, to the wailing of brass and the rolling of muffled drums, the torches appearing and disappearing among the trees with a fitful glow that but makes the shadows blacker. Suddenly as at a magic touch, the woods are lighted up in a dazzling green splendor more brilliant than the light of day, revealing the distant forest aisles and overhead the glittering tracery of twigs and leaves that fret the bulky trees rearing themselves into the darkness of the midnight sky. It is a radiant dream of a forest, and like a dream, it vanishes, and the dirge wails on, while the torches gleam once more against the rugged bark of the real trees. Again and again is the forest revealed in that supernatural light, and again and again reverts to darkness and the dull red torches, while the solemn music pulsates and throbs among the walls of verdure. At last an open place is reached, a sort of amphitheatre, in the center of which is a funeral pyre; on this is placed the coffin. The High Priest mounts a platform, the music stops, and he addresses the expectant multitude:

Friends, Bohemians and Countrymen, I come to bury Care, to praise him. I come here in the forest, where trees tell us of our littleness in the great creation of the world, to place upon this pyre all our prejudices, all our resentments, all our thoughts that are in spirit harmful to men and women, and all our unpaid bills. For a few hours, at least, we shall forgive and forget, and the "night shall be filled with music."

CHOIR (Chanting): *With music and with light*

I've labored long and hard for bread, for honor and for riches, But on my corns too long you've tred You fine-haired sons of bitches. – A clue left by the bandit Black Bart after a stagecoach robbery near the Russian River, 1877

With joy and with delight
Shall the mind be filled.

HIGH PRIEST: *It is my duty and my privilege first of all to consign to these flames one of Charlie Elliott's poems. Let him take warning by this fearful holocaust and forswear the allurements of rhyme. Better had a man take to strong drink, if he can find some one else to pay for it, than to rhyme. And so Lord help him!*

CHOIR (Chanting): *Lord help him to refrain*
From ever making verse again;
Worse than the demon Rum
The habit doth become;
Lord help him to abstain.

HIGH PRIEST: *Let us place here everything in our daily life that vexes or annoys us; hatred, malice and all uncharitableness. Let us place here that favorite story of Smyth Clark's which hath grown old in service; let us place here Martinez' high C, so that he may content himself hereafter with a plain, ordinary chest note. But let us not place here the memory of good men and noble women; rather let our recollections live in our hearts, for our own guidance and the guidance of generations yet to come, forever and ever. For it is said that man born of woman is of few days and full of trouble. Let us forget it and put his fullness here.*

CHOIR (Chanting): *In their appointed time all things approach fullness, even men. So hath it ever been and so it will ever be.*

HIGH PRIEST: *This is the gospel of Bohemia,* LOVE ONE ANOTHER. *And to make it easier to practice, I have been asked to consign to these flames our dearly beloved brother Paul Neumann's latest purchase of cigars. Those of you who are to leeward had better come up to windward.*

Finally, in the name of the Owl, that revered Bird of Wisdom, I place on this coffin all the sins and sorrows of every member of our beloved organization, and, as High Priest, command that they be consigned to flames. And from the ashes may great joy ascend!

At this signal the imps touch their torches to the four corners of the pyre, the flames seize it and go roaring up in the still air, the coffin is enveloped and the next moment there is an explosion; rockets go streaming up into the heavens, bursting bombs send forth colored lights into the velvet darkness, and the whole coffin full of fireworks ascend whizzing, banging, and whirling, in a grand pyrotechnic display. The band plays a merry tune, the Bohemians joining hands dance around the blazing pile until the last cracker has gone off, and then falling into line, march back to the camp in a lively quickstep; after which, supper and Low Jinks. For Care is dead in Bohemia – at least for one night.

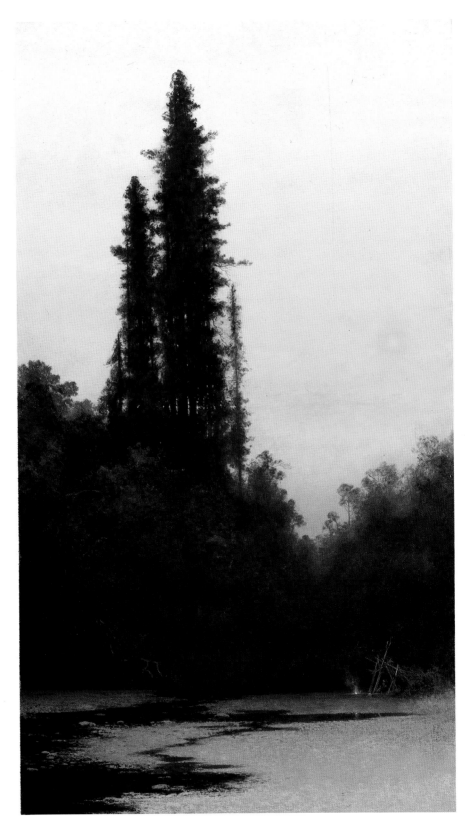

24 Julian Walbridge Rix
*Twilight Scene with Stream and
Redwood Trees, n.d.*

The Russians in California

. . . Our guide led us in a northwesterly direction further into the interior. . . . We met with numerous herds of small deer, so fearless, that they suffered us to ride fairly into the midst of them, but then indeed darted away with the swiftness of an arrow. We sometimes also . . . saw another species of stag (elks), as large as a horse, with branching antlers. . . .

Towards noon . . . we reposed under the shade of some thick and spreading oaks, while our horses grazed and our meal was preparing. . . .

Our road now lay sometimes across hills and meadows, and sometimes along the sands so near the ocean that we were sprinkled by its spray. We passed Port Romanzow [Bodega], and soon after forded the bed of another shallow river to which the Russians have given the name of Slavianka (Russian River). . . . the Russians have proceeded up it a distance of a hundred werts, or about sixty-seven English miles. . . . From the summit of a high hill, we at length, to our great joy, perceived beneath us the fortress of Ross. . . . We spurred our tired horses, and excited no small astonishment as we passed through the gate at a gallop. . . .

The settlement of Ross, situated on the seashore . . . and on an insignificant stream was founded in the year 1812. . . . The intention in forming this settlement was to pursue the chase of the sea-otter on the coast of California, where the animal was then numerous, as it had become extremely scarce in the more northern establishments. The Spaniards, who did not hunt them, willingly took a small compensation for their acquiescence in the views of the Russians. . . .

The Spaniards lived at first on the best terms with the new settlers, and provided them with oxen, cows, horses and sheep; but when . . . the Russian establishment became more flourishing than theirs, envy and apprehension of future danger took possession of their minds; they then required that the settlement should be abandoned. . . .

The founder and then commander of the fortress of Ross . . . gave a very decided answer . . . [He said] none had a right but the natives; that these latter had freely consented to his occupation of the land, and therefore that he would yield to no such unfounded pretension as that now advanced by the Spaniards, but should be always ready to resist force by force.

. . . The Spaniards quietly gave up all farther thought of hostilities, and entered again into friendly communications with our people. . . .

In order that the Russians might not extend their dominion to the northern shore of the Bay of St. Francisco, the Spaniards immediately founded the missions of St. Gabriel (Rafael) and St. Francisco Salano (Sonoma). It is a great pity that we were not beforehand with them. The advantages of possessing this beautiful bay are incalculable, especially as we have no harbor but the bad one of Bodega or Port Romanzow. . . .

The inhabitants of Ross live in the greatest concord with the Indians, who

repair, in considerable numbers, to the fortress, and work as day laborers for wages. At night they usually remain outside the palisades. . . . Should the blessing of civilization ever be extended to the rude inhabitants of these regions the merit will be due to the Russian settlements, certainly not to the Spanish missions. . . .

After a stay of two days we took leave of the estimable M. Von Schmidt [the governor] and returned by the same way that we came without meeting with any remarkable occurrence. . . .

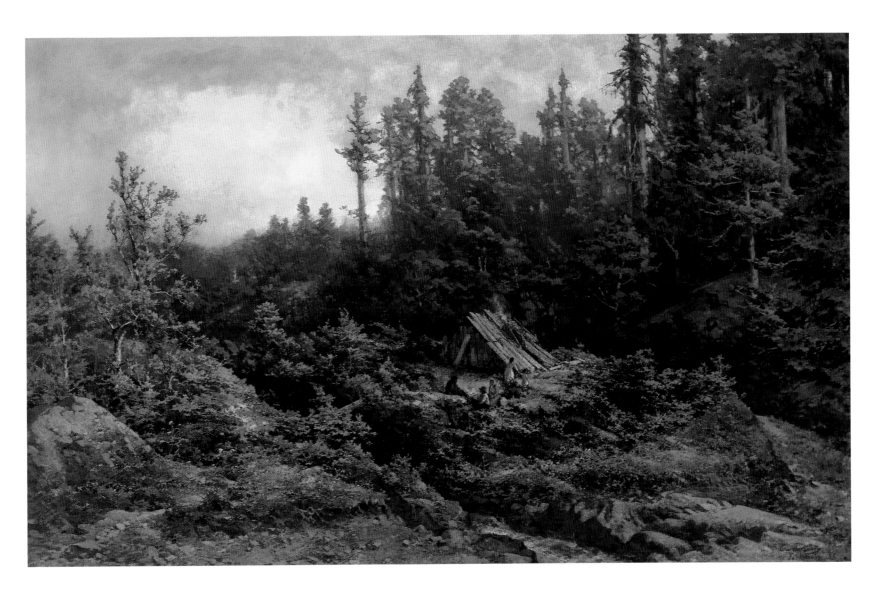

25 Carl von Perbandt
Pomo Indians Camped at Fort Ross, 1886

The View from Shasta

Joaquin Miller, *Unwritten History: Life Among the Modocs*, 1873

Lonely as God, and white as a winter moon, Mount Shasta starts up sudden and solitary from the heart of the great black forests of Northern California.

You would hardly call Mount Shasta a part of the Sierras; you would say rather that it is the great white tower of some ancient and eternal wall, with here and there the white walls overthrown.

It has no rival! There is not even a snow-crowned subject in sight of its dominion. A shining pyramid in mail of everlasting frosts and ice, the sailor sometimes, in a day of singular clearness, catches glimpses of it from the sea a hundred miles away to the west; and it may be seen from the dome of the capitol 300 miles distant. The immigrant coming from the east beholds the snowy, solitary pillar from afar out on the arid sage-brush plains, and lifts his hands in silence as in answer to a sign. . . .

You will see . . . by the trail a pile of rocks high as your head. . . .Dismount and contribute a stone to the monument from the loose rocks that lie up and down the trail. It is a pretty Indian custom that the whites sometimes adopt and cherish. . . . I uncover my head, take up a stone and lay it on the pile, then turn my face to Mount Shasta and kiss my hand, for the want of some better expression.
– Joaquin Miller, 1873

Ascend this mountain, stand against the snow above the upper belt of pines, and take a glance below. Toward the sea nothing but the black and unbroken forest. Mountains, it is true, dip and divide and break the monotony as the waves break up the sea; yet it is still the sea, still the unbroken forest, black and magnificent. To the south the landscape sinks and declines gradually, but still maintains its column of dark-plumed grenadiers, till the Sacramento Valley is reached, nearly a hundred miles away. Silver rivers run here, the sweetest in the world. They wind and wind among the rocks and mossy roots, with California lilies, and the yew with scarlet berries dipping in the water, and trout idling in the eddies and cool places by the basketful. On the east, the forest still keeps up unbroken rank till the Pit River valley is reached; and even there it surrounds the valley, and locks it up tight in its black embrace. . . .

My good helper, stone pile, you give me good luck. I am going out to hunt now. I give you this [stone]. Help me to have good luck hunting deer. That is what I want you to do.
– Modoc prayer

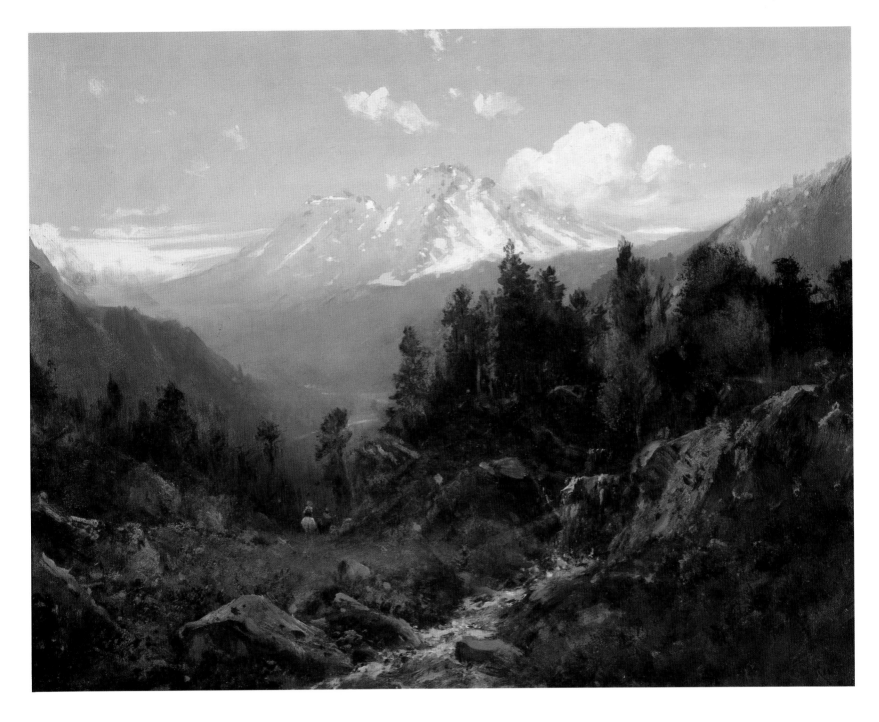

26 William Keith
 Mount Shasta, c.1880

Once there was a time when there was nothing in the world but water. About the place where Tulare Lake is now, there was a pole standing far up out of the water, and on this pole perched a hawk and a crow. First one of them would sit on the pole a while, then the other would knock him off and sit on it himself. Thus they sat on top of the pole above the waters for many ages. At length they wearied of the lonesomeness, and they created the birds which prey on fish such as the kingfisher, eagle, pelican, and others. Among them was a very small duck, which dived down to the bottom of the water, picked its beak full of mud, came up, died, and lay floating on the water. The hawk and the crow then fell to work and gathered from the duck's beak the earth which it had brought up, and commenced making the mountains. They began at the place now known as Ta-hi-cha-pa Pass, and the hawk made the east range, while the crow made the west one. Little by little, as they dropped in the earth, these great mountains grew athwart the face of the waters, pushing north. It was a work of many years, but finally they met together at Mount Shasta, and their labors were ended. But, behold, when they compared their mountains, it was found that the crow's was a great deal the larger. Then the hawk said to the crow, "How did this happen, you rascal? I warrant you have been stealing some of the earth from my bill, and that is why your mountains are the biggest." It was a fact, and the crow laughed in his claws. Then the hawk went and got some Indian tobacco and chewed it, and it made him exceedingly wise. So he took hold of the mountains and turned them round in a circle, putting his range in place of the crow's; and that is why the Sierra Nevada is larger than the Coast Range.

– Yokut legend

2. Mt. Diablo and across the Valley

The Sacramento Delta, Stockton, and the Foothill Country

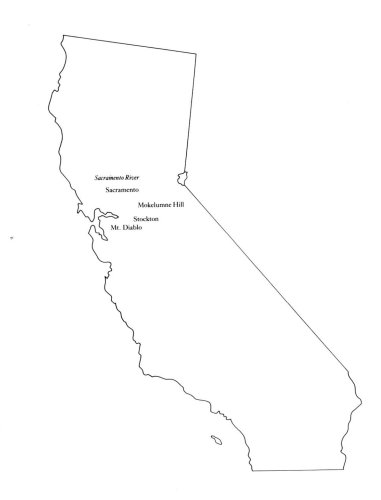

Sacramento River

Sacramento

Mokelumne Hill

Stockton

Mt. Diablo

Exploring Mount Diablo

William Henry Brewer, *Up and Down California*, 1861. Brewer, a professor and farmer, was a member of the original California State Geological Survey team.

Friday, September 13, we went up the San Ramon Valley about twelve miles, and left our party to camp, while we pushed up the valley, then climbed the hill, 2,500 or 2,800 feet high, where we had an extensive and comprehensive view. Mount Diablo was the grandest object in the landscape. . . .

The strata here are all filled with shells and are of enormous thickness. They are turned up at high angles and much broken. The whole country is of mountains 2,000 to 3,500 feet in elevation, made by the broken edges of the strata. We saw sections of these strata over a mile in thickness, yet full of shells through their whole thickness. I think the Tertiary rocks of this region are two or three miles thick! Who shall estimate the countless ages that must have elapsed while they were being deposited in that ancient ocean? While these myriads of animals were called into existence, generations lived and died, and at last the species themselves became extinct. Each day reveals new marvels in our labors, teaches us new truths in the world's history. . . .

Clayton, at the foot of Mount Diablo, October 4. The Californians tell us that once in olden time they had a battle with the Indians here; it was going hard with the Spaniards, when the Devil came out of the mountain, helped the Spaniards, and the Indians were vanquished. I cannot vouch for the truth of their story, but the story gave the name to the mountain, and the rocks certainly do look as if the devil had been about at some time. There is a breaking up and roasting of strata on a grand scale.

Clayton (formerly Deadfall), Sunday, October 6. The strata about Mount Diablo are of most enormous thickness, in all probability not less than one and a half or two miles! . . . Scattered through these are many fossils, and in this great mass is a bed of coal over four feet thick. The bed, like the strata in which it is found, is inclined about forty-five degrees. Several mines are opened, and companies have formed with capital to the amount of some three or four millions of dollars. They are now getting perhaps a hundred tons per day and making preparations for more extensive work. . . .

Last week we were on a ridge 2,200 feet high, where wagon loads of immense oyster shells might be picked up. Today I found also the joint of a whale's backbone! These are some of the marvels of California geology.
– William Henry Brewer, 1861

Corral Hollow, Sunday, October 18. The San Joaquin (pronounced *San Waughkeen'*) plain lies between the Mount Diablo Range and the Sierra Nevada – a great plain here, as much as forty to fifty miles broad, desolate, without trees save along the river, without water during nine or ten months of the year, and practically a desert. The soil is fertile enough, but destitute of water, save the marshes near the river and near the Tulare Lake. The marshy region is unhealthy and infested with mosquitoes in incredible numbers and of unparalleled ferocity. The dry plain on each side abounds in tarantulas by the thousands. These are spiders, living in holes, and of a size that must be seen to be appreciated. I shall try and catch some to send home, but I have seen them where two would cover this page, as they stand, their bodies as large as a half-grown mouse, their hairy legs of proportionate size, their fangs as large as those of a moderate sized rattlesnake. Pleasant companions! . . .

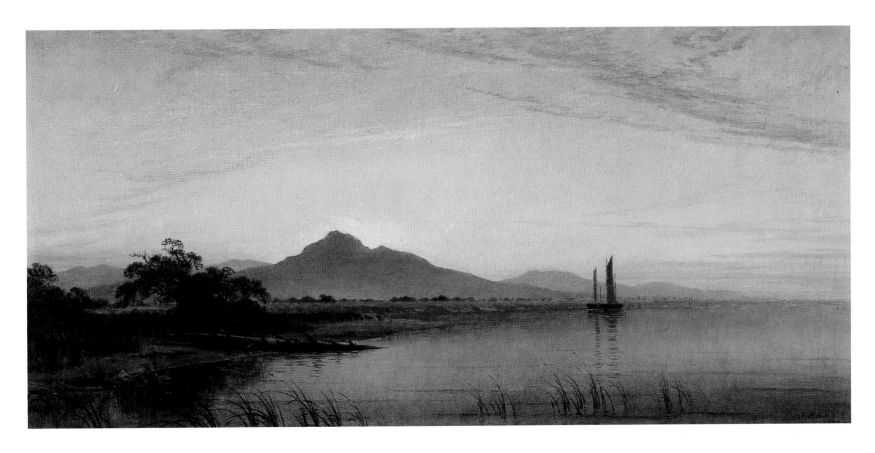

27 John Ross Key
 Mt. Diablo, 1871

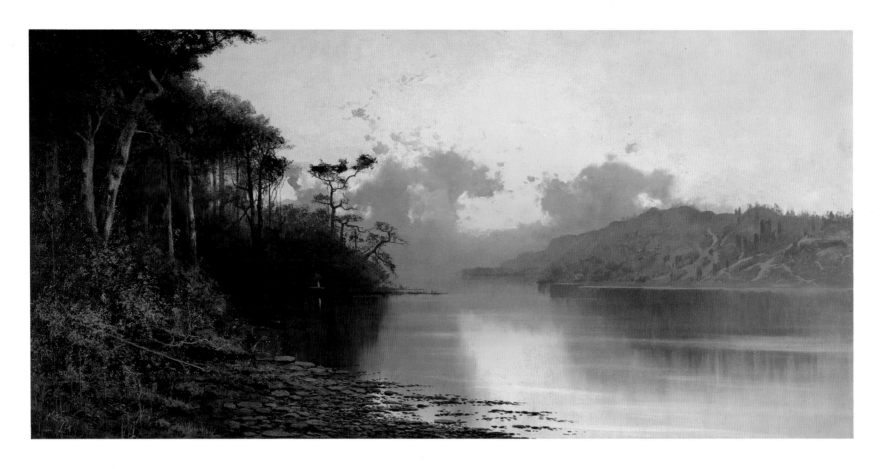

28 Julian Walbridge Rix
 Upper Sacramento River, c.1876

On the Sacramento

The Sacramento river, at this point, is a stream nearly half a mile in width. The tide rises and falls some two or three feet. The water is perfectly limpid and fresh. The river is said to be navigable for craft of one hundred tons burden, at all seasons, a hundred miles above this place. In the season of high waters, from January to July, it is navigable a much greater distance. The Sacramento rises above latitude 42° north, and runs from north to south nearly parallel with the coast of the Pacific, until it empties into the Bay of San Francisco by several mouths in latitude 38-1/2° north. It is fringed with timber, chiefly oak and syca-more. Grape-vines and a variety of shrubbery ornament its banks, and give a most charming effect when sailing upon its placid and limpid current. I never saw a more beautiful stream. In the rainy season, and in the spring, when the snows on the mountains are melting, it overflows its banks in many places. It abounds in fish, the most valuable of which is the salmon. These salmon are the largest and the fattest I have ever seen. I have seen salmon taken from the Sacra-mento five feet in length. All of its tributaries are equally rich in the finny tribe. American enterprise will soon develop the wealth contained in these streams, which hitherto has been entirely neglected.

The site of the town of Nueva Helvetia, which has been laid out by Captain Sutter, is about a mile and a half from the Sacramento. It is on an elevation of the plain, and not subject to overflow when the waters of the river are at their high-est known point. There are now but three or four small houses in this town, but I have little doubt that it will soon become a place of importance.

. . . It is scarcely possible to imagine a more delightful temperature, or a cli-mate which is more agreeable and uniform. The sky is cloudless, without the slightest film of vapor apparent in all the vast azure vault. In the middle of the day the sun shines with great power, but in the shade it is nowhere uncomfort-able. At night, so pure is the atmosphere, that the moon gives a light sufficiently powerful for the purposes of the reader or student who has good eyesight. There is no necessity of burning the "midnight oil." Nature here, lights the candle for the bookworm.

Edwin Bryant, *What I Saw in California*, 1848. Bryant accompanied the party of Captain John Charles Frémont.

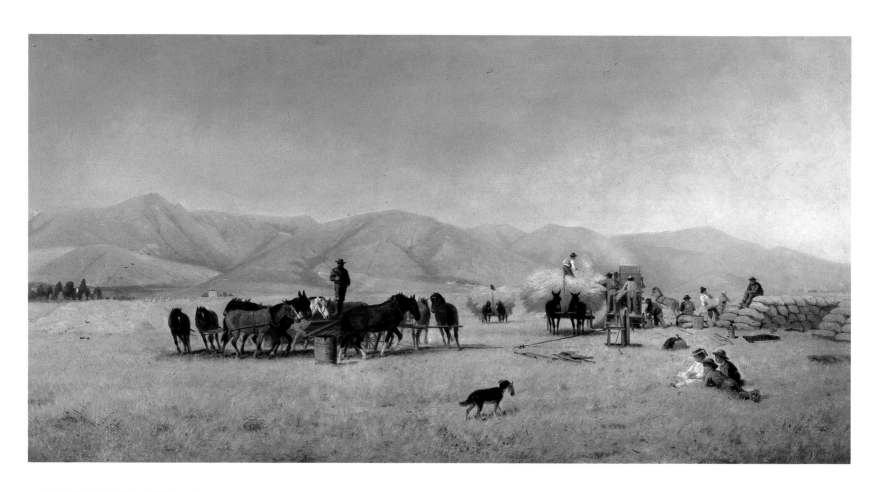

29 Carl Wilhelm (William) Hahn
 Harvest Time, 1875

Farming in the Central Valley

In the 1850s, when the California gold rush was at full flood, the Great Central Valley traversed by the miners on the way to the mother lode was an American Serengeti – a blond grassland in the summertime, a vast flourishing marsh during the winter and spring. The wildlife, even after a century and a half of Spanish settlement, was unbelievable: millions of wintering ducks, geese and cranes, at least a million antelope and tule elk, thousands of grizzly bears.

The winter of 1861 and 1862 was the beginning of the end for this scene of wild splendor. Relatively few of the Forty-niners found enough gold to pay their fare back home, let alone retire in the style of which they dreamed. California in the 1850s was full of broken men, searching for whatever day labor they could find. Many of them, having given up on returning home, decided to make a try at farming or ranching in the Central Valley. Most of the pioneers who followed the miners in wagon trains had farming on their minds, too, and by the 1860s the Central Valley was already a vista of cows.

Marc Reisner, *Cadillac Desert: The American West and Its Disappearing Water*, 1987

River and State Fair

William Henry Brewer, *Up and Down California*, 1861

Sacramento, September 20. We left the city by steamer for Sacramento, 120 miles, at 4 P.M. and did not get into the river until after dark. The sail up the bay is very fine. The islands and the shores of hills are bare and brown now – I mean bare of trees – only dried grass. The effect of the setting sun, illuminating this with its mellow light, was most beautiful indeed. Mount Diablo stood up, a grand object, in the landscape.

The Rev. T. Starr King, the celebrated orator and clergyman, was on board with us. I got an introduction and had a pleasant time with him. He is as agreeable in conversation as he is eloquent in the rostrum. Night closed in on us before we entered the Sacramento River, and when I got up in the morning we were lying quietly at the wharf of that new city, the capital of the state, the "Albany" of California.

The State Fair is being held here. The noise and bustle distracts me. I feel nervous and excited and long for the camp again, with its clear air, calm still nights, simple life, and its loneliness, rather than this bustle and crowd. . . .

The Fair is like other fairs – hundreds of big cattle, horses, etc. (the horses the finest) – many more Durhams than I expected to see, few Devons (in fact, none at all), some few sheep, fewer hogs, some mules and jacks. The grounds are fine, over twenty acres enclosed with a high brick wall with ten entrances, a fine track, etc. The stalls for cattle are finely arranged around the outside, and a promenade is to be built on the flat roofs of the stalls. There is a large stand for two thousand spectators, and a fine track. The races were received with California gusto, where horsemanship is such an accomplishment.

Indoors the Fair was more peculiar – no flowers at all, but fine fruits. These latter were more remarkable for *size* than any other characteristic. It is too late for the best plums and peaches. . . . Numbers of apples which *I measured* were over 15 inches in circumference – one 16½ inches! Three pears on one plate, I measured, both around them lengthwise and around the largest part crosswise, and their measurements in circumference were 17 inches by 14, 16½ by 14⅞, and 8⅞ by 14¾ inches respectively, the three weighing 6½ pounds! Numbers of pears were seen measuring over fifteen inches around, and proportionately larger if measured around from stem to blossom end. In two instances of three pears on one stem, each cluster weighed together over five pounds. There were grapes of four-, five-, six-, and even seven-pound clusters! Yet, I must say candidly that I think the quality of all the fruit, except pears, to be inferior to the same kinds in the eastern states. Pears grow peculiarly well here.

. . . a noticeable feature of the Fair was the gambling. Besides the usual side-shows of live snakes, big cows, fat hogs, fat women, etc., there were hundreds of *fan*, *monte*, and other gaming tables, each with their piles of silver and gold, often to the value of hundreds and even thousands of dollars, in full blast, with the crowds around. Music, females singing or dealing cards to draw the custom, liquor, noise, swearing, etc., were the accompaniments. Yet the whole Fair was orderly. I never saw a Fair in the East where the crowds were more orderly or so well dressed as at this.

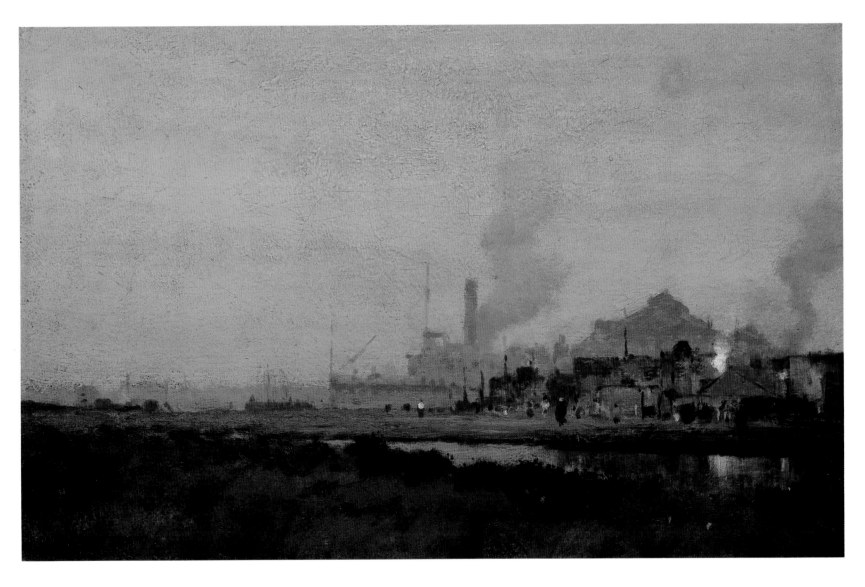

30 Will Sparks
Late Sunset, n.d.

Stockton

Bayard Taylor, *Eldorado, or Adventures in the Path of Empire*, 1850. Taylor, a traveler and one of the most popular and prolific writers of his day, was known as the "Poet Laureate of the Gilded Age."

A view of Stockton was something to be remembered. There, in the heart of California, where the last winter stood a solitary ranch in the midst of the tule marshes, I found a canvas town of a thousand inhabitants, and a port with twenty-five vessels at anchor! The mingled noises of labor around – the click of hammers and the grating of saws – the shouts of mule-drivers – the jingling of spurs – the jar and jostle of wares in the tents – almost cheated me into the belief that it was some old commercial mart, familiar with such sounds for years past. Four months, only, had sufficed to make the place what it was; and in that time a wholesale firm established there (one out of a dozen) had done business to the amount of $100,000. The same party had just purchased a lot eighty by one hundred feet, on the principal street, for $5,000, and the cost of erecting a common one-story clapboard house on it was $15,000. . . .

[After a journey to the Mokelumne Diggings] I found Stockton more bustling and prosperous than ever. The limits of its canvas streets had greatly enlarged during my week of absence, and the crowd on the levee would not disgrace a much larger place at home. Launches were arriving and departing daily for and from San Francisco, and the number of mule-trains, wagons, etc., on their way to the various mines with freight and supplies kept up a life of activity truly amazing. Stockton was first laid out by Mr. Weaver, who emigrated to the country seven years before, and obtained a grant of eleven square leagues from the Government, on condition that he would obtain settlers for the whole of it within a specified time. In planning the town of Stockton, he displayed a great deal of shrewd business tact, the sale of lots having brought him upwards of $500,000. A great disadvantage of the location is the sloughs by which it is surrounded; which, in the wet season, render the roads next to impassable. There seems, however, to be no other central point so well adapted for supplying the rich district between Mokelumne and Tuolumne, and Stockton will evidently continue to grow with a sure and gradual growth.

Between the time he became an outlaw in 1851 and his death in 1853, the Mexican bandit Joaquin Murrieta ranged as far north as Stockton. On one occasion he rode into town, noticed a sign offering a reward for his capture, wrote underneath, "I will give $10,000 – Joaquin!" then galloped off through the crowd, unmolested.
– The WPA Guide to California, *1939*

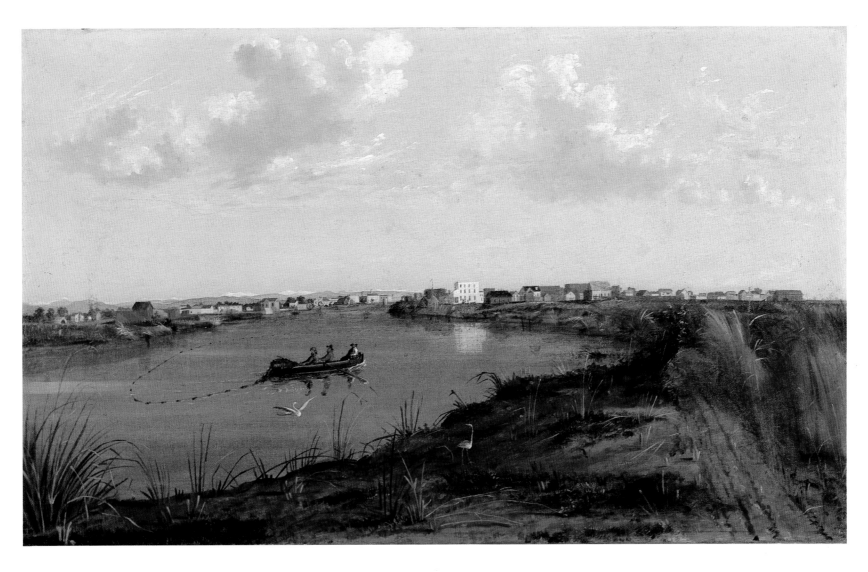

31 Alburtus Del Orient Browere
 View of City of Stockton, 1858

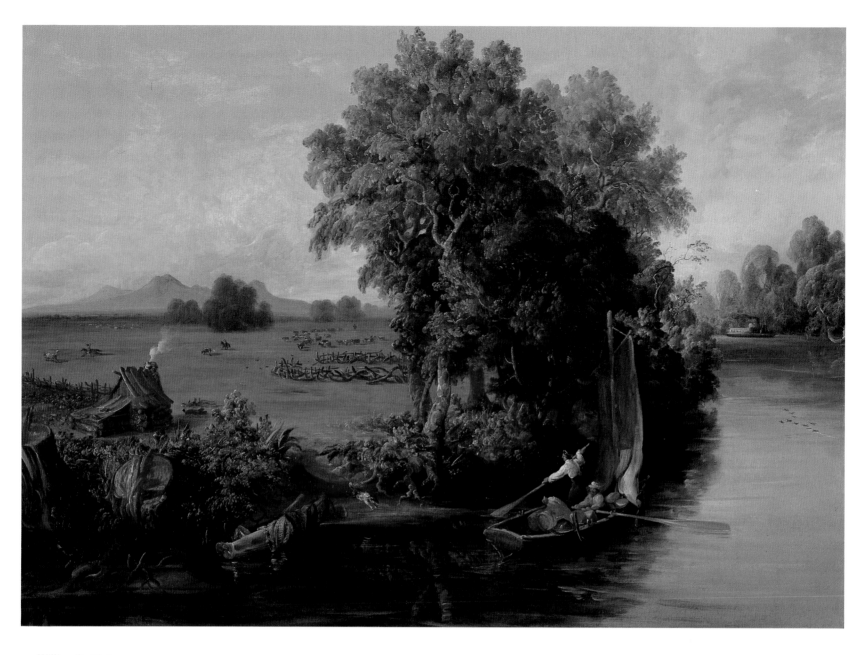

32 William Smith Jewett
Hock Farm, *1851*

Yuba Valley

Descending the rocky ravine a few miles, we emerged from it and entered a
beautiful level valley, some four or five miles in length from east to west, and
about two miles in breadth. A narrow, sluggish stream runs through this valley,
the waters of which are of considerable depth, and the banks steep and miry. A
luxuriant growth of grasses, of an excellent quality, covered the entire valley
with the richest verdure. Flowers were in bloom; and although late in August,
the vegetation presented all the tenderness and freshness of May. This valley has
been named by the emigrants "Uber [Yuba] Valley;" and the stream which runs
through it, and is a tributary of the Rio de los Plumas, or Feather river, has the
same name. It is sometimes pronounced *Juba*; but I think Uber is the correct ety-
mology. How the name was derived, I never could learn.

Edwin Bryant, *What I Saw in California*, 1848

We found, after some search, a place where we could ford the stream without
stalling our animals in its soft and spongy banks and bed. But it was some time
before we could discover at what point the wagon-trail left the valley.

Leaving the valley we crossed a high undulating country, timbered with
pines, firs, and cedars, whose symmetrical proportions and rich foliage, with the
bright green moss clothing their branches, would baffle the skill and coloring of
the most artistical painter, to represent them faithfully on canvass. This country
is watered by a connected chain of seven small lakes, between which, and sur-
rounded by the beautiful and fairy-like groves I have mentioned, there are sev-
eral green grassy lawns and openings, which lend to the scenery a charm and a
fascination more like that which the imagination ascribes to the effect of
enchantment, or the creations of a beautiful dream, than the presentations of
reality. The soil of this rolling country is rich and highly fertile, where there is
any moisture to sustain vegetation.

Our course continued nearly south, until we reached and entered another
deep ravine or gorge, down which runs a small stream of water, in a direction
nearly west. After proceeding down this ravine a few miles, the elevated moun-
tain walls on both sides of the stream, at the foot of which immense granite rocks
raise their impassable forms, approach each other so nearly as to form a *cañon*, to
avoid which the trail winds up and down the side of the mountain, over and
under steep precipices and impending cliffs.

The Ridge of the Sierra

Clarence King, *Mountaineering in the Sierra Nevada*, 1871. King, a geologist with the California State Geological Survey under Professors William H. Brewer and Josiah Dwight Whitney (for whom Mt. Whitney was named), served in 1879 as the first director of the United States Geological Survey.

For four hundred miles the Sierras are a definite ridge, broad and high, and having the form of a sea-wave. Buttresses of sombre-hued rock, jutting at intervals from a steep wall, form the abrupt eastern slopes; irregular forests, in scattered growth, huddle together near the snow. The lower declivities are barren spurs, sinking into the sterile flats of the Great Basin.

Long ridges of comparatively gentle outline characterize the western side, but this sloping table is scored from summit to base by a system of parallel transverse cañons, distant from one another often less than twenty-five miles. They are ordinarily two or three thousand feet deep, falling at times in sheer, smooth-fronted cliffs, again in sweeping curves like the hull of a ship, again in rugged V-shaped gorges, or with irregular, hilly flanks opening at last through gateways of low, rounded foot-hills out upon the horizontal plain of the San Joaquin and Sacramento.

Every cañon carries a river, derived from constant melting of the perpetual snow, which threads its way down the mountain, a feeble type of those vast ice-streams and currents that formerly discharged the summit accumulation of ice and snow while carving the cañons out from solid rock. Nowhere on the continent of America is there more positive evidence of the cutting power of rapid streams than in these very cañons. Although much is due to this cause, the most impressive passages of the Sierra valleys are actual ruptures of the rock; either the engulfment of masses of great size, as Professor [Josiah Dwight] Whitney supposes in explanation of the peculiar form of the Yosemite, or a splitting asunder in yawning cracks. From the summits down half the distance to the plains, the cañons are also carved out in broad, round curves by glacial action. The summit gorges themselves are altogether the result of frost and ice. Here, even yet, may be studied the mode of blocking out mountain peaks; the cracks riven by unequal contraction and expansion of the rock; the slow leverage of ice, the storm, the avalanche.

The western descent, facing a moisture-laden, aerial current from the Pacific, condenses on its higher portions a great amount of water, which has piled upon the summits in the form of snow, and is absorbed upon the upper plateau by an exuberant growth of forest. This prevalent wind, which during most undisturbed periods blows continuously from the ocean, strikes first upon the western slope of the Coast Range, and there discharges, both as fog and rain, a very great sum of moisture; but, being ever reinforced, it blows over their crest, and, hurrying eastward, strikes the Sierras at about four thousand feet above sea-level. Below this line the foot-hills are oppressed by an habitual dryness, which produces a rusty olive tone throughout nearly all the large conspicuous vegetation, scorches the red soil, and, during the long summer, overlays the whole region with a cloud of dust.

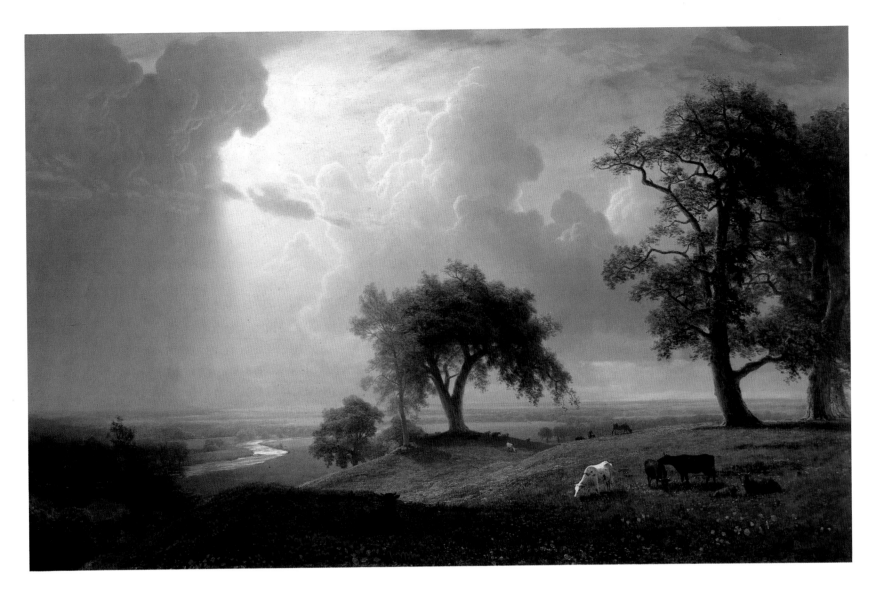

33 Albert Bierstadt
California Spring, 1875

While I looked [toward the Sierra from Pacheco Pass] the sun descended; shadows climbed the Sierra, casting a gloom over foot-hill and pine, until at last only the snow summits, reflecting the evening light, glowed like red lamps along the mountain wall for hundreds of miles. The rest of the Sierra became invisible. The snow burned for a moment in the violet sky, and at last went out.
– Clarence King, 1871

Dull and monotonous in color, there are, however, certain elements of picturesqueness in this lower zone. Its oak-clad hills wander out into the great plain like coast promontories, enclosing yellow, or in spring-time green, bays of prairie. The hill forms are rounded, or stretch in long longitudinal ridges, broken across by the river cañons. Above this zone of red earth, softly modelled undulations, and dull, grayish groves, with a chain of mining towns, dotted ranches and vineyards, rise the swelling middle heights of the Sierras, a broad billowing plateau cut by sharp sudden cañons, and sweeping up, with its dark, superb growth of coniferous forest to the feet of the summit peaks.

For a breadth of forty miles, all along the chain, is spread this continuous belt of pines. From Walker's Pass to Sitka one may ride through an unbroken forest, and will find its character and aspect varying constantly in strict accordance with the laws of altitude and moisture, each of the several species of coniferous trees taking its position with an almost mathematical precision. Where low gaps in the Coast Range give free access to the western wind, there the forest sweeps downward and encamps upon the foot-hills, and, continuing northward, it advances toward the coast, securing for itself over this whole distance about the same physical conditions; so that a tree which finds itself at home on the shore of Puget Sound, in the latitude of Middle California has climbed the Sierras to a height of six thousand feet, finding there its normal requirements of damp, cool air. As if to economize the whole surface of the Sierra, the forest is mainly made up of twelve species of conifers, each having its own definitely circumscribed limits of temperature, and yet being able successively to occupy the whole middle Sierra up to the foot of the perpetual snow. The average range in altitude of each species is about twenty-five hundred feet, so that you pass imperceptibly from the zone of one species into that of the next. Frequently three or four are commingled, their varied habit, characteristic foliage, and richly colored trunks uniting to make the most stately of forests. In the centre of the coniferous belt is assembled the most remarkable family of trees. Those which approach the perpetual snow are imperfect, gnarled, storm-bent; full of character and suggestions, but lacking the symmetry, the rich, living green, and the great size of their lower neighbors. In the other extreme of the pine-belt, growing side by side with foot-hills oaks, is an equally imperfect species, which, although attaining a very great size, still has the air of an abnormal tree. The conditions of drought on the one hand, and rigorous storms on the other, injure and blast alike, while the more verdant centre, furnishing the finest conditions, produces a forest whose profusion and grandeur fill the traveller with the liveliest admiration.

The Gold Trade

Inasmuch as the gold region with scores of mining camps and several towns offered a far greater market than San Francisco, most of the imports were loaded onto smaller boats for the 150-mile passage up the Sacramento or San Joaquin rivers to Sacramento City or Stockton. Sacramento City served as the commercial and transport center for the northern mines scattered along the tributaries of the Sacramento River, while Stockton was equally important for the southern mines on the tributaries of the San Joaquin. From a few wooden shanties and canvas-covered structures in the spring, both settlements grew rapidly during the summer of 1849. Then in the fall they felt the impact of the overlanders' needs for food, tents, boots, blankets, and everything else abandoned on the trails. In both cities warehouses, hotels, stores, restaurants and gambling halls were built of logs, canvas, sheet iron, bricks – whatever could be found, purchased or cannibalized. Along the rivers' banks scores of ships were tied up, their cargoes stacked under the sycamore and cottonwood trees. As at San Francisco, many of these vessels had been abandoned by their crews, and merchants had taken them as storehouses and hotels.

Few if any of the miners, businessmen, merchants, shippers, speculators, bankers, gamblers – the thousands of men in the instant cities and scores of mining camps – paused that fall of 1840 to consider what wondrous changes had been accomplished in a matter of months: village to metropolis at San Francisco, wilderness to thriving ports at Sacramento City and Stockton, canyons and gulches to one-street mining towns, quiet rivers to commercial thoroughfares – everywhere the sounds of growth, business and high hopes. It had all been done without technology. Except for the oceangoing sidewheelers that came into San Francisco bay, there were few if any steam engines as yet in California. Mining techniques were primitive, building materials and methods simple; transport was by sail, muleback or wagon, and communication by interminable mail. The motive forces had been avarice, impatience, inventiveness and optimism.

Yankee enterprise and investment accelerated the transformation of California. Delivery of everything the mining region needed came by sailing vessels upriver from San Francisco, a voyage that took three to ten days. With demand so great and prices fluctuating wildly from day to day, merchants and speculators needed faster, more reliable transport for their merchandise. In response, East Coast businessmen shipped three disassembled steamboats to San Francisco. Launched in September, they replaced the uncertainty of sail with the dependability of steam; but they were too small to carry tons of freight and hundreds of passengers. Beginning in October, larger steamers that had sailed around Cape Horn established ten-to-twelve-hour scheduled service between San Francisco and the river ports. The first of what the San Francisco newspapers admiringly described as "floating palaces," the 750-ton *Senator* made a profit of over $60,000 each month during the first year of operation.

J. S. Holliday, *The World Rushed In*, 1980

[In 1850] a boiled egg cost 75 cents, a $2,000 steam engine sold for $15,000, a prostitute claimed to have made $50,000 in 1849, a farmer made $25,000 selling vegetables – blankets cost $12, boots $35, flour $35 per barrel.
– J. S. Holliday

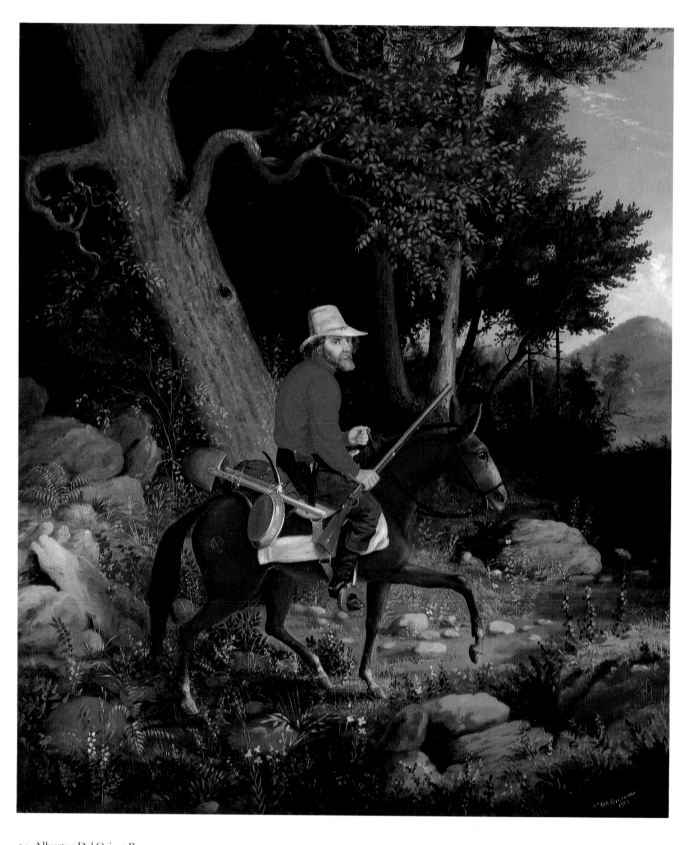

34 Alburtus Del Orient Browere
 The Lone Prospector, 1853

In the Diggings

George, I tell you this mining among the mountains is a dog's life. A man has to make a jackass of himself packing loads over mountains that God never designed man to climb, a barbarian by foregoing all the comforts of civilized life, and a heathen by depriving himself of all communication with men away from his immediate circle. ["We see nothing here but hills, mountains and rocks . . . no farming operations, no meetings, no horses and carriages or cattle, no female society – hear no music except the occasional squeaking of a hoarse fiddle in some lone cabin, and the croaking of ravens, the chattering of woodpeckers and the roaring of the Rio de los Plumas. . . ."]

William Swaim, letter, 1848

There was some talk of your coming to this country. For God's sake think not of it. Stay at home. Tell all whom you know that are thinking of coming that they have to sacrifice everything and face danger in all its forms, for George, thousands have laid and will lay their bones along the routes to and in this country. Tell all that "death is in the pot" if they attempt to cross the plains and hellish mountains. Say to Playter [a Youngstown resident] never to think of the journey; and as for you, *stay at home*, for if my health is spared, I can get enough for both of us.

My health has been extremely good since I arrived here. I am fifteen pounds heavier than when I left home and measured six feet last evening. . . .

You may think from the tenor of this letter that I am sick of my job, but not so. I have not seen the hour yet when I regretted starting for California, nor have any one of our little party ever regretted that we undertook the enterprise. I have seen hard times, faced the dangers of disease and exposure and perils of all kinds, but I count them nothing if they enable me to place myself and family in comfortable circumstances.

Now you will think that there is a contradiction in the advice that I gave you and others about coming to California and the declaration of my own satisfaction that I have performed the journey. The fact is that gold is plenty here and the accounts received before I left home did not exaggerate the reality. Therefore I am glad that I am here. But the time is past – if it ever existed – when fortunes could be obtained for picking them up. Gold is found in the most rocky and rough places, and the streams and bars that are rich are formed of huge rocks and stones. In such places, you will see, it requires robust labor and hard tugging and lifting to separate the gold from the rock. But this is nothing to the risk of life run in traveling to this country. Therefore, if I was at home and knew all the circumstances, I think I should stay at home; but having passed those dangers in safety, I thank God that I am here in so favorable circumstances. . . .

. . . Give my love to Mother, if she is yet living. . . . Tell Sabrina . . . as soon as I can get the rocks in my pocket I shall hasten home as fast as steam can carry me.

An onion in the mines is worth a dollar, and boots $40 per pair. I have paid $8 for a jar of pickles.
– William Swaim, 1848

The cholera has just commenced its ravages here [Sacramento City], and the citizens are actively engaged in cleansing the city. It is in a filthy condition – piles of rubbish are burning in the streets in every direction, filling the sky with suffocating smoke. The lurid fires, shining in the murky air, burn old shoes and boots and clothes by the ton and cartloads of bones and raw hides and putrid meat and spoiled bacon – so that the end of the matter is worse than the beginning.
– William Swaim, 1850, on his homeward journey

On Mining

Louise Clapp, "The Shirley Letters," 1852. Clapp lived among the miners in the gold rush of 1848 and for several years recorded her observations in letters signed "Dame Shirley."

From our log cabin, Indian Bar, April 10, 1852 . . . As to the discovery of gold. In California, at least, . . . science appears to be completely at fault; – or, as an intelligent and well-educated miner remarked . . . the other day, "I maintain that science is the blindest guide that one could have on a gold-finding expedition. Those men, who judge by the appearance of the soil, and depend upon geological calculations, are invariably disappointed, while the ignorant adventurer, who digs just for the sake of digging, is almost sure to be successful". . . . Wherever Geology has said that gold *must* be, there, perversely enough, it lies not; and wherever her ladyship has declared that it could *not* be, there has it oftenest garnered up in miraculous profusion the yellow splendor of its virgin beauty. . . .

Our countrymen are the most discontented of mortals. They are always longing for "big strikes." If a "claim" is paying them a steady income, by which, if they pleased, they could lay up more in a month, than they could accumulate in a year at home, still, they are dissatisfied, and, in most cases, will wander off in search of better "diggings." There are hundreds now pursuing this foolish course, who, if they had stopped where they first "camped," would now have been rich men. Sometimes, a company of these wanderers will find itself upon a bar, where a few pieces of the precious metal lie scattered upon the surface of the ground; of course they immediately "prospect" it, which is accomplished, by "panning out" a few basinsful of the soil. If it "pays," they "claim" the spot, and build their shanties; the news spreads that wonderful "diggings" have been discovered at such a place, – the monte-dealers, those worse than fiends, rush vulture-like upon the scene and erect a round tent, where, in gambling, drinking, swearing and fighting, the *many* reproduce Pandemonium in more than its original horror, while a *few* honestly and industriously commence digging for gold, and lo! as if a fairy's wand had been waved above the bar, a full-grown mining town hath sprung into existence.

But first, let me explain to you the "claiming" system. As there are no State laws upon the subject, each mining community is permitted to make its own. Here, they have decided that no man may "claim" an area of more than forty feet square. This he "stakes off" and puts a notice upon it, to the effect that he "holds" it for mining purposes. If he does not choose to "work it" immediately, he is obliged to renew the notice every ten days; for without this precaution, any other person has a right to "jump it," that is, to take it from him. There are many ways of evading the above law. For instance, an individual can "hold" as many "claims" as he pleases, if he keeps a man at work in each, for this workman represents the original owner. I am told, however, that the laborer, himself, can "jump" the "claim" of the very man who employs him, if he pleases so to do. This is seldom, if ever, done; the person who is willing to be hired, generally prefers to receive the six dollars *per diem*, of which he is *sure* in any case, to running

the risk of a "claim" not proving valuable. . . . There are many ways of *really* out-witting this rule, . . . which give rise to innumerable arbitrations, and nearly every Sunday, there is a "miners' meeting" connected with this subject.

. . . Here, in the mountains, the labor of excavation is extremely difficult, on account of the immense rocks which form a large portion of the soil. Of course, no man can "work out" a "claim" alone. For that reason, and also for the same that makes partnerships desirable, they congregate in companies of four or six, generally designating themselves by the name of the place from whence the majority of the members have emigrated; as for example, the "Illinois," "Bunker Hill," "Bay State," etc., companies. In many places the surface-soil, or in mining phrase, the "top dirt," "pays" when worked in a "Long Tom." This machine, (I have never been able to discover the derivation of its name,) is a trough, generally about twenty feet in length, and eight inches in depth, formed of wood, with the exception of six feet at one end, called the "riddle," (query, why riddle?) which is made of sheet-iron, perforated with holes about the size of a large marble. Underneath this cullender-like portion of the "long-tom," is placed another trough, about ten feet long, the sides six inches perhaps in height, which divided through the middle by a slender slat, is called the "riffle-box." It takes several persons to manage, properly, a "long-tom." Three or four men station them-selves with spades, at the head of the machines, while at the foot of it, stands an individual armed "wid de shovel and de hoe." The spadesmen throw in large quantities of the precious dirt, which is washed down to the "riddle" by a stream of water leading into the "long-tom" through wooden gutters or "sluices." When the soil reaches the "riddle," it is kept constantly in motion by the man with the hoe. Of course, by this means, all the dirt and gold escapes through the perfora-tions into the "riffle-box" below, one compartment of which is placed just beyond the "riddle." Most of the dirt washes over the sides of the "riffle-box," but the gold being so astonishingly heavy remains safely at the bottom of it. When the machine gets too full of stones to be worked easily, the man whose business it is to attend to them throws them out with his shovel, looking care-fully among them as he does so for any pieces of gold, which may have been too large to pass through the holes of the "riddle." I am sorry to say that he generally loses his labor. At night they "pan out" the gold, which has been collected in the "riffle-box" during the day. Many of the miners decline washing the "top dirt" at all, but try to reach as quickly as possible the "bed-rock," where are found the richest deposits of gold. The river is supposed to have formerly flowed over this "bed-rock," in the "crevices" of which, it left, as it passed away, the largest por-tions of the so eagerly sought for ore. The group of mountains amidst which we are living is a spur of the Sierra Nevada; and the "bed-rock," (which in this vicinity is of slate) is said to run through the entire range, lying, in distance vary-ing from a few feet to eighty or ninety, beneath the surface of the soil. On Indian Bar, the "bed-rock" falls in almost perpendicular "benches," while at Rich Bar, the friction of the river has formed it into large, deep basins, in which the gold,

The American forty-niners began to talk of arrastres, bateas, piojos, and frijoles, while basic American profan-ity enriched the speech of Indians and Chinese.
– John Walton Caughey

instead of being found, as you would naturally suppose, in the bottom of it, lies for the most part, just below the rim. . . .

When a company wish to reach the bed rock as quickly as possible, they "sink a shaft," (which is nothing more nor less than digging a well,) until they "strike" it. They then commence "drifting coyote holes" (as they call them) in search of "crevices," which . . . often pay immensely. These "coyote holes" sometimes extend hundreds of feet into the side of the hill. Of course they are obliged to use lights in working them. They generally proceed, until the air is so impure as to extinguish the lights, when they return to the entrance of the excavation, and commence another, perhaps close to it. When they think that "coyote hole" has been faithfully "worked," they "clean it up," which is done by scraping the surface of the "bed rock" with a knife, – lest by chance they have overlooked a "crevice," – and they are often richly rewarded for this precaution.

Now I must tell you how those having "claims" on the hills procure the water for washing them. The expense of raising it in any way from the river, is too enormous to be thought of for a moment. In most cases it is brought from ravines in the mountains. A company, to which a friend of ours belongs, has dug a ditch about a foot in width and depth, and more than three miles in length, which is fed in this way. . . . I never beheld a NATURAL streamlet more exquisitely beautiful. It undulates over the mossy roots, and the gray, old rocks, like a capricious snake, singing all the time a low song with the "liquidest murmur," and one might almost fancy it the airy and coquettish Undine herself. When it reaches the top of the hill, the sparkling thing is divided into five or six branches, each one of which supplies one, two, or three "long-toms." There is an extra one, called the "waste-ditch," leading to the river, into which the water is shut off at night and on Sundays. This "race" (another and peculiar name for it) has already cost the company more than five thousand dollars. They sell the water to others at the following rates: Those that have the first use of it pay ten per cent upon all the gold that they take out. As the water runs off from their machine, (it now goes by the elegant name of "tailings,") it is taken by a company lower down; and as it is not worth so much as when it was clear, the latter pay but seven per cent. If any others wish the "tailings," now still less valuable . . . , they pay four per cent on all the gold which they take out, be it much or little. The water companies are constantly in trouble; . . . arbitrations on that subject are . . . frequent.

. . . Gold mining is Nature's great lottery scheme. A man may work in a claim for many months, and be poorer at the end of the time than when he commenced; or he may "take out" thousands in a few hours. It is a mere matter of chance. . . . Almost all with whom we are acquainted seem to have lost. . . . If a fortunate or an unfortunate (which shall I call him?) *does* happen to make a "big strike," he is almost sure to fall into the hands of the professed gamblers, who soon relieve him of all care of it. . . . As the spring opens, they flock in like ominous birds of prey. . . . Surely it would be kinder to take a man's life, than to poison him with the fatal passion for gambling.

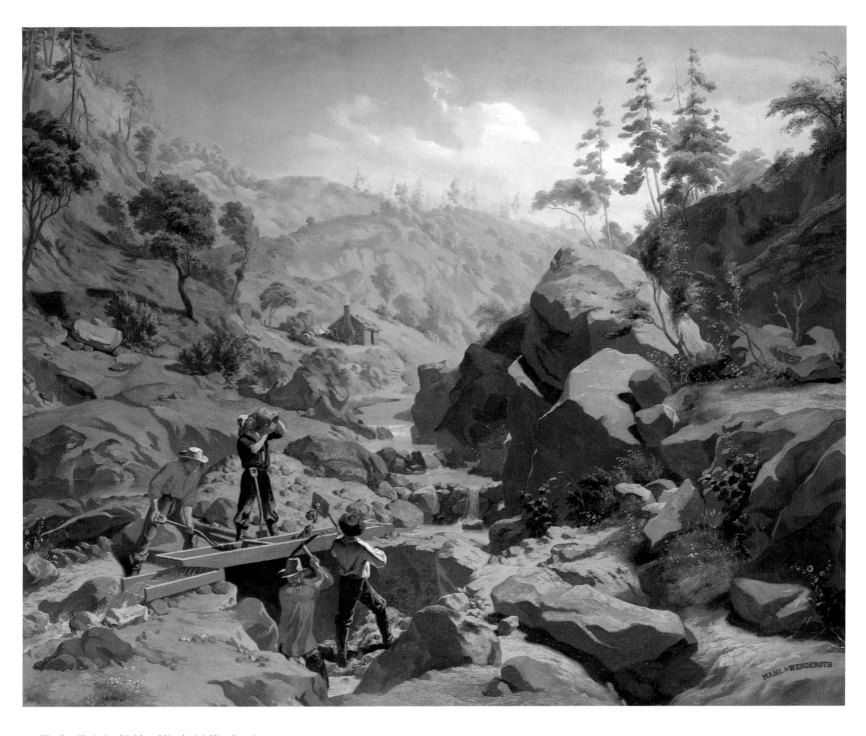

35 Charles Christian Nahl and Frederick Wenderoth
 Miners in the Sierras, c.1851–52

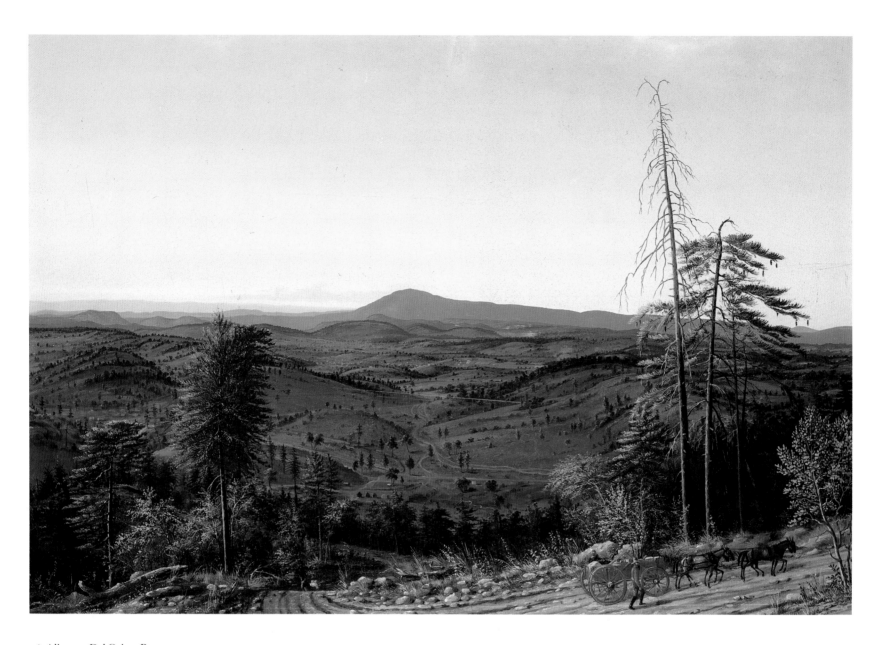

36 Alburtus Del Orient Browere
Mokelumne Hill, 1857

Mule Trains

While the river transport system was modernized, getting the barrels of flour, kegs of pork and liquor, bags of beans, bales, sacks and boxes from the river ports up to the mining camps and towns depended on wagons and pack mules. Each day throughout the dry season (May to October or November) hundreds of mule- and ox-drawn wagons set out from Sacramento City and Stockton over dusty roads, headed upcountry to the stores, hotels, and gambling saloons. In country too steep for wagons, long trains of pack mules followed trails that climbed high along narrow ridges and descended sharply to remote collections of miners' tents and shanties. Even the surefooted mules, "clipper ships of the mountains," were often delayed by storms, mountain slides or deep snowdrifts which made packing hazardous and sometimes impossible. But great profits could be made in this trade, with the packers charging as much as 75 cents per pound.

By spring 1850, competition among steamboats, freighters and packers would drive prices down, easing the risks of the small merchants and the living expenses of the miners. But meantime, with gold seemingly inexhaustible and the population vastly increased, the forces were obviously at hand to create a staggering inflation. A boiled egg cost 75 cents, a $2,000 steam engine sold for $15,000, a prostitute claimed to have made $50,000 in 1849, a farmer made $25,000 selling vegetables – blankets cost $12, boots $35, flour $35 per barrel. Whatever the price today or expected tomorrow, all depended on the miners' continued success and their increasing demand for food, shelter, transport, supplies and entertainment.

The economy was based on gold production, but no one knew just how much was being mined, put into circulation and shipped back to the States or to Europe, Mexico and South America. Such statistics were calculated in later years, but even then they would reflect considerable uncertainty. Estimates of gold production for 1848 ranged from $245,000 to $10 million, with similar imprecision for 1840: $10 million to $40 million. Whatever the actual numbers, the fact was that California boomed on gold, with production reaching a more accurate total of $81 million in 1852.

J. S. Holliday, *The World Rushed In*, 1980

Profits were bounded only by the obstinancy of the mules, whose distressing habit of dying under stress of the heat, the dust and two hundred pound loads was a great sorrow to the proprietors.
– Joseph Henry Jackson

A man might work all day in the burning sun, neglect to shave, get along through the week on salt pork, beans, and soggy bisquit. But if he felt like oysters and champagne on a Saturday night, if he insisted on the best Havana cigars and the finest liquors the States could furnish – and could pay for them – then somebody would get these things to him, no matter what.
– Joseph Henry Jackson

The Concord Was a Lady

Joseph Henry Jackson, *Anybody's Gold*, 1941

So shrewdly put together that its weight of some 2,500 pounds was utterly disguised, the Concord coach through sheer perfection of design was trim and tidy as a ship. . . . She took the road as the clipper took the seas, a lady and no two ways about it. . . .

. . . The heart and soul of the Concord was the thoroughbrace, that inspired device which made her what she was, gave her the strength and elasticity to ride the rough new roads, to give gracefully when play was needed, to recover as gracefully and go on.

These thoroughbraces were simply two lengths of manifold heavy leather straps from which the body of the coach was suspended so that it might rock fore and aft, cradling roadshock. Most people have thought of thoroughbraces as a plan to make the passengers more comfortable, but their job was far more significant than this . . . [About their] second function . . . the Bannings [authors of a classic on Western stages] write:

Thoroughbraces performed a vital duty far beyond the province of any steel springs. It was a function of such importance to the Western staging world that we may hazard the contention that an empire, as well as the body of its coach, once rocked and perhaps depended upon thoroughbraces.

Without them there could have been no stage to meet a crying need. Without them, any vehicle carrying the loads that had to be carried, maintaining such speed as the edicts of staging demanded, would have been efficient only as a killer of horses. For thoroughbraces, while they served the purpose of springs to an adequate extent, had the prime function of acting as shock-absorbers for the benefit of the team. By the thoroughbraces, violent jerks upon the traces due to obstructions in the road were automatically assuaged and generally eliminated. It was the force of inertia – the forward lunge and the upward lurch of the rocking body – that freed the wheels promptly from impediment, and thus averted each shock before it came upon the animals.

. . . When the enterprise of the stage-owners and the courage and dash of their drivers began to extend the lines into the hills . . . the Concord took its place as a prime factor in the development of the country. There was no lost time. By the spring of 1851 there were a dozen busy stage-lines in operation, covering roads that a year before had seen nothing faster than mule-teams and lumbering wagons. When California's first Concord, resplendent in gold scrolls, damask curtains at its windows, rolled around the San Francisco Plaza on June 25, 1850, the gold mines of the foot-hills, a hundred and twenty-five miles away, entered upon their era of growth. With the stage-coach to tie it together, to knit it into a coherent whole, the Mother Lode country came into being as an entity for the first time. Slim, strong and lovely, proud and trim, the Concord was a lady, and, as a lady may, she lent men the strength to come of age.

Small boys and big men looked up to the stage-driver while he looked down on them from the strategic height of the Concord's driving seat. Whip in hand, elbows squared, fingers sensitive to the least tug of the lines between them, the Concord driver knew pride in his profession and showed it. Six horses, four wheels and a brake – with this equipment the California Jehu would engage to get his passengers anywhere.
– Joseph Henry Jackson

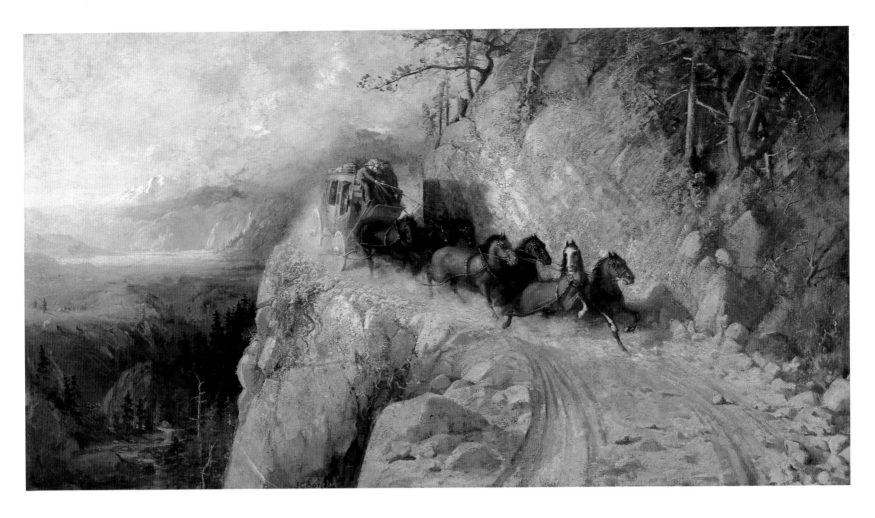

37 John Gutzon de la Mothe Borglum
 Staging in California, 1889

What the Railroads Will Bring Us

Henry George, "What the Railroads Will Bring Us," 1868. George, a popular nineteenth-century political economist, settled in California in 1857, working as a printer, gold hunter, editor, and author.

Upon the plains this season railroad building is progressing with a rapidity never before known. . . . Before midsummer comes again, this "greatest work of the age" will be completed, and an unbroken track stretch from the Atlantic to the Pacific. . . . What is the railroad to do for *us*? – this railroad that we have looked for, hoped for, prayed for so long? . . .

The sharpest sense of Americans – the keen sense of gain, which certainly does not lose its keenness in our bracing air – is the first to realize what is coming with our railroad. All over the state, land is appreciating – fortunes are being made in a day by buying and parcelling out Spanish ranches; the Government surveyors and registrars are busy; speculators are grappling the public domain by the hundreds of thousands of acres; while for miles in every direction around San Francisco, ground is being laid off into homestead lots. . . .

After the first impulse which settled California had subsided, there came a time of stagnation, if not of absolute decay. As the placers one after another were exhausted, the miners moved off; once populous districts were deserted, once flourishing mining towns fell into ruin, and it seemed to superficial observers as though the state had passed the acme of her prosperity. . . . The aggregate population and wealth of the state diminished rather than increased. Through this period we have passed. Although the decay of portions of mining regions still continues, there has been going on for some time a steady, rapid development of the state at large – felt principally in the agricultural counties and the metropolis, but which is now beginning to make itself felt from one end of the state to the other. To produce this, several causes have combined, but prominent among them must be reckoned the new force to which we principally and primarily look for the development of the future – railroads. . . .

The California of the new era will be greater, richer, more powerful than the California of the past; but will she be still the same California whom her adopted children, gathered from all climes, love better than their own motherlands; from which all who have lived within her bounds are proud to hail; to which all who have known her long to return? She will have more people; but among those people will there be so large a proportion of full, true men? She will have more wealth; but will it be so evenly distributed? She will have more luxury and refinement and culture, but will she have such general comfort, so little squalor and misery; so little of the grinding, hopeless poverty that chills and cramps the souls of men, and converts them into brutes?

Amid all our rejoicing and all our gratulation, let us see clearly whither we are tending. Increase in population and in wealth past a certain point means simply an approximation to the condition of older countries – the eastern states and Europe. . . .

We want great cities, large factories, and mines worked cheaply, in this California of ours! Would we esteem ourselves gainers if New York, ruled and

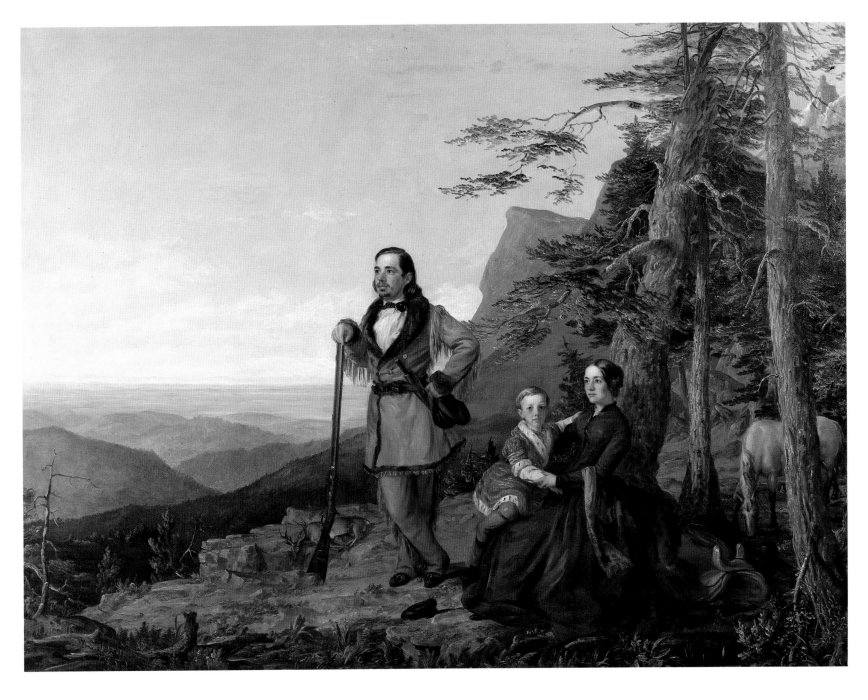

38 William Smith Jewett
 The Promised Land – The Grayson Family, 1850

robbed by thieves, loafers and brothel-keepers; nursing a race of savages fiercer and meaner than any who ever shrieked a war-whoop on the plains; could be set down on our bay tomorrow? Would we be gainers, if the cottonmills of Massachusetts, with their thousands of little children who, official papers tell us, are being literally worked to death, could be transported to the banks of the American; or the file and pin factories of England, where young girls are treated worse than even slaves on southern plantations, be reared as by magic at Antioch? Or if among our mountains we could by wishing have the miners, men, women and children, who work the iron and coal mines of Belgium and France, where the condition of production is that the laborer shall have meat but once a week – would we wish them here?

Can we have one thing without the other? . . .

The truth is, that the completion of the railroad and the consequent great increase of business and population, will not be a benefit to all of us, but only to a portion. As a general rule (liable of course to exceptions) those who *have*, it will make wealthier; for those who *have not*, it will make it more difficult to get. Those who have lands, mines, established businesses, special abilities of certain kinds, will become richer for it and find increased opportunities; those who have only their own labor will become poorer, and find it harder to get ahead – first, because it will take more capital to buy land or to get into business; and second, because as competition reduces the wages of labor, this capital will be harder for them to obtain.

What . . . does the rise in land mean? Certainly and prominently this: that it will be harder in [the] future for a poor man to get a farm or a homestead lot. In some sections of the state, land which twelve months ago could have been had for a dollar an acre, cannot now be had for less than fifteen dollars. . . . The settler who last year might have had at once a farm of his own, must now either go to work on wages for someone else, pay rent or buy on time, . . . being compelled to give to the capitalist a large proportion of the earnings which, had he arrived a year ago, he might have had all for himself. And as proprietorship is thus rendered more difficult and less profitable to the poor, more are forced into the labor market to compete with each other, and cut down the rate of wages. . . .

To say that "Power is constantly stealing from the many to the few," is only to state in another form the law that wealth tends to concentration. . . . The locomotive is a great centralizer. It kills little towns and builds up great cities, and in the same way kills little businesses and builds up great ones. . . .

One millionaire involves the existence of just so many proletarians. It is the great tree and the saplings over again. We need not look far from the palace to find the hovel. When people can charter special steamboats to take them to watering places, pay four thousand dollars for the summer rental of a cottage, build marble stables for their horses, and give dinner parties which cost by the thousand dollars a head, we may know that there are poor girls on the streets pondering between starvation and dishonor. When liveries appear, look out for bare-footed children.

[The Chinese] were as steady, hard-working a set of men as could be found. They were paid from $30 to $35, in gold, a month, finding themselves, while the white men were paid about the same, but with their board thrown in.
– John R. Gillis, 1865

But there is another side: we are to become a great, populous, wealthy community. And in such a community many good things are possible that are not possible in a community such as ours has been. There have been artists, scholars, and men of special knowledge and ability among us, who could and some of whom have since won distinction and wealth in older and larger cities, but who here could only make a living by digging sand, peddling vegetables or washing dishes in restaurants. It will not be so in the San Francisco of the future. We shall keep such men with us, and reward them, instead of driving them away. We shall have our noble charities, great museums, libraries and universities; a class of men who have leisure for thought and culture; magnificent theaters and opera houses; parks and pleasure gardens.

We shall develop a literature of our own, issue books which will be read wherever the English language is spoken, and maintain periodicals which will rank with those of the East and Europe. . . .

But again comes the question: will this California of the future . . . possess still the charm which makes Californians prefer their state, even as it is, to places where all these things are to be found?

What constitutes the peculiar charm of California, which all who have lived here long enough feel? Not the climate alone. . . . Not merely that there is less social restraint. . . . Not simply that the opportunities of making money have been better here. . . . It certainly is not in the growth of local attachment, for the Californian has even less local attachment than the average American, and will move about from one end of the state to the other with perfect indifference. It is not that we have the culture or the opportunities to gratify luxurious and cultivated tastes that older countries afford, and yet those who leave us on this account as a general thing come back again.

No: the potent charm of California, which all feel but few analyze, has been more in the character, habits and modes of thought of her people – called forth by the peculiar conditions of the young state – than in anything else. In California there has been a certain cosmopolitanism, a certain freedom and breadth of common thought and feeling, natural to a community made up from so many different sources, to which every man and woman has been transplanted – all travelers to some extent, and with native angularities of prejudice and habit more or less worn off. Then there has been a feeling of personal independence and equality, a general hopefulness and self-reliance, and a certain large-heartedness and open-handedness which were born of the comparative evenness with which property was distributed, the high standard of wages and of comfort, and the latent feeling of everyone that he might "make a strike," and certainly could not be kept down long. . . .

The characteristics of the principal business – mining – gave a color to all California thought and feeling. It fostered a reckless, generous, independent spirit, with a strong disposition to "take chances" and "trust to luck". . . . If it could have been united with ownership of land and the comforts and restraints of

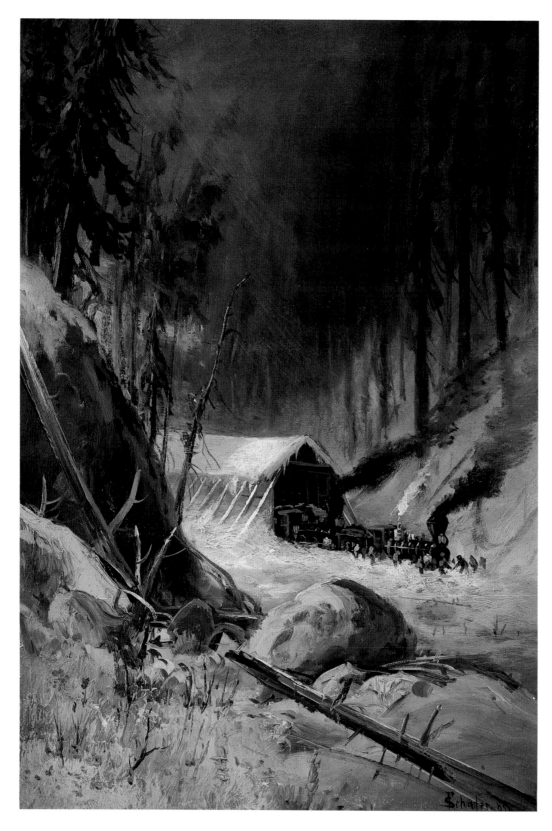

39 Frederick Ferdinand Schafer
After a Snowstorm in the Sierra Nevada Mountains,
near Summit Station, Central Pacific Railroad, 1885

home, it would have given us a class of citizens of the utmost value. . . .

This crowding of people into immense cities, this aggregation of wealth into large lumps, this marshalling of men into big gangs under the control of the great "captains of industry," does not tend to foster personal independence – the basis of all virtues – nor will it tend to preserve the characteristics which particularly have made Californians proud of their state.

However, we shall have some real social gains, with some that are only apparent. We shall have more of home influences, a deeper religious sentiment, less of the unrest that is bred of an adventurous and reckless life. We shall have fewer shooting and stabbing affrays, but we will have probably something worse, from which, thank God, we have hitherto been exempt – the low, brutal, cowardly rowdyism of the great eastern cities. We shall hear less of highway robberies in the mountains, but more, perhaps, of pickpockets, burglars and sneak thieves.

That we can look forward to any political improvement is, to say the least, doubtful. There is nothing in the changes which are coming that of itself promises that. . . . Can we rely upon sufficient intelligence, independence and virtue among the many to resist the political effects of the concentration of great wealth in the hands of a few? . . .

With our gains and our losses will come new duties and new responsibilities. Connected more closely with the rest of the nation, we will feel more quickly and keenly all that affects it. We will have to deal, in time, with all the social problems that are forcing themselves on older communities (like the riddles of a Sphinx, which not to answer is death), with one of them, the labor question, rendered peculiarly complex by our proximity to Asia. Public spirit, public virtue, the high resolve of men and women who are capable of feeling "enthusiasm of humanity," will be needed in the future more than ever. . . .

Let us not imagine ourselves in a fool's paradise, where the golden apples will drop into our mouths; let us not think that after the stormy seas and head gales of all the ages, *our* ship has at last struck the trade winds of time. The future of our State, of our nation, of our race, looks fair and bright; perhaps the future looked so to the philosophers who once sat in the porches of Athens – to the unremembered men who raised the cities whose ruins lie south of us. Our modern civilization strikes broad and deep and looks high. So did the tower which men once built almost unto heaven.

All California has been glaciated, the low plains and valleys as well as the mountains. [So believed John Muir in 1912.] Traces of an ice-sheet, thousands of feet in thickness, beneath whose heavy folds the present landscapes have been molded, may be found everywhere, though glaciers now exist only among the peaks of the High Sierra. No other mountain chain on this or any other of the continents that I have seen is so rich as the Sierra in bold, striking, well-preserved glacial monuments. Indeed, every feature is more or less tellingly glacial. Not a peak, ridge, dome, canyon, yosemite, lake-basin, stream or forest will you see that does not in some way explain the past existence and modes of action of flowing, grinding, sculpturing, soil-making ice. For, notwithstanding the post-glacial agents – the air, rain, snow, frost, river, avalanche, etc. – have been at work upon the greater portion of the range for tens of thousands of stormy years, each engraving its own characters more and more deeply over those of the ice, the latter are so enduring and heavily emphasized, they still rise in sublime relief, clear and legible, through every after-inscription. . . . Tracing the ways of glaciers, learning how Nature sculptures mountain-waves in making scenery-beauty that so mysteriously influences every human being, is glorious work.

The most striking and attractive of the glacial phenomena in the upper Yosemite region are the polished glacier pavements, because they are so beautiful, and their beauty is of so rare a kind, so unlike any portion of the loose, deeply weathered lowlands where people make homes and earn their bread. They are simply flat or gently undulating areas of hard resisting granite, which present the unchanged surface upon which with enormous pressure the ancient glaciers flowed. They are found in most perfect condition in the subalpine region, at an elevation of from eight thousand to nine thousand feet. Some are miles in extent, only slightly interrupted by spots that have given way to the weather, while the best preserved portions reflect the sunbeams like calm water or glass, and shine as if polished afresh every day, notwithstanding they have been exposed to corroding rains, dew, frost, and snow measureless thousands of years.
– John Muir

3. The High Sierra and Yosemite

Lake Tahoe, Hetch Hetchy, Yosemite, Big Trees and the Mariposa Grove

Donner Pass

Lake Tahoe

Yosemite
Hetch Hetchy

Mariposa Grove

Journal of a Sufferer

Patrick Breen, Donner Party journal, October 31, 1846, to March 1, 1847, and George McKinstry, Jr., report of Donner Party return, April 29, 1847

Truckee Lake [later known as Donner Lake], Nov. 20. – Came to this place on the 31st of last month; went into the Pass, the snow so deep we were unable to find the road, and when within three miles from the summit, turned back to this shanty on Truckee Lake. Stanton came up one day after we arrived here; we again took our teams and wagons and made another unsuccessful attempt to cross in company with Stanton; we returned to the shanty, it continuing to snow all the time. We now have killed most part of our cattle, having to remain here until next spring, and live on lean beef without bread or salt. It snowed during the space of eight days with little intermission, after our arrival here, though now clear and pleasant, freezing at night, the snow nearly gone from the valleys. – 29. Still snowing, now about three feet deep . . . killed my last oxen to-day; gave another yoke to Foster; wood hard to be got. – 30. Snowing fast, looks as likely to continue as when it commenced; no living thing without wings can get about.

Dec. 1. – Still snowing, wind w.; snow about six or six and a half feet deep; very difficult to get wood, and we are completely housed up; our cattle all killed but two or three, and these, with the horses and Stanton's mules, all supposed to be lost in the snow; no hopes of finding them alive. – 5. Beautiful sunshine, thawing a little; looks delightful after the long storm; snow seven or eight feet deep. – 9. Commenced snowing about 11 o'clock. . . . Took in Spitzer yesterday so weak, that he cannot rise without help, caused by starvation. Some have a scant supply of beef; Stanton trying to get some for himself and Indians; not likely to get much. – 17. Pleasant. Wm. Murphy returned from the mountain party last evening; Balis Williams died night before last; Milton and Noah started for Donner's [camp] eight days ago; not returned yet; think they are lost in the snow. – 20. Clear and pleasant . . . Charles Berger set out for Donner's; turned back, unable to proceed; tough times, but not discouraged; our hopes are in God, Amen. – 21. Milton got back last night from Donner's camp; sad news, Jacob Donner, Samuel Shoemaker, Rhinehart, and Smith, are dead the rest of them in a low situation; snowed all night. . . . Began this day to read the "Thirty days' prayers." Almighty God grant the requests of unworthy sinners; – 24. Rained all night and still continues; poor prospect for any kind of comfort, spiritual or temporal. – 25. Offered our prayers to God this Christmas morning; the prospect is appalling but we trust in Him. – 27. Snow nine feet deep; wood growing scarce; a tree when felled sinks into the snow and hard to be got at. – 30. Charles Berger died last evening. . . . – 31. Last of the year; may we, with the help of God, spend the coming year better than we have the past, which we propose to do if it is the will of the Almighty to deliver us from our present

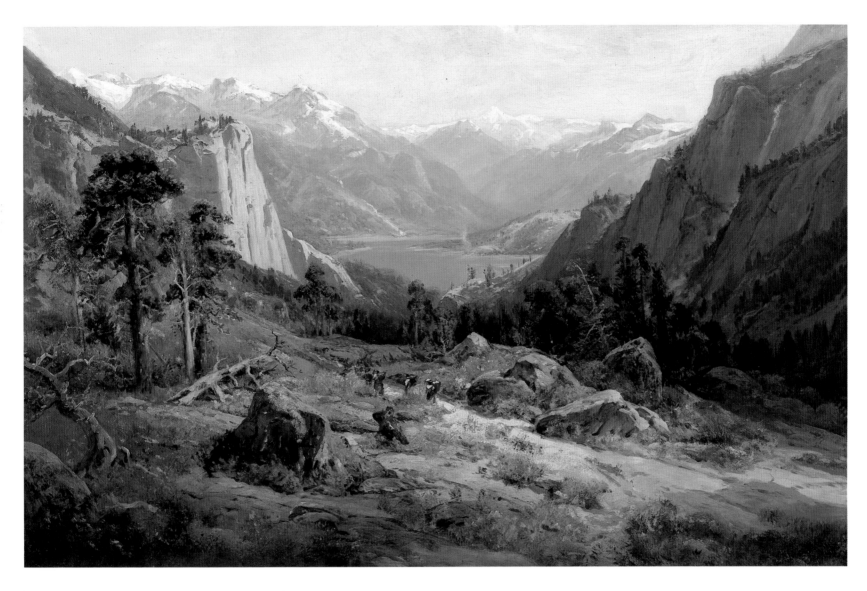

40 William Keith
 Donner Pass, c.1890

dreadful situation, Amen. . . . Looks like another snow-storm – snow-storms are dreadful to us. . . .

Jan 1, 1847. – We pray the God of mercy to deliver us from our present calamity, if it be His holy will. . . . provisions getting very scant; dug up a hide from under the snow yesterday – have not commenced on it yet. – 13. Snowing fast – snow higher than the shanty; it must be 13 feet deep; cannot get wood this morning; it is a dreadful sight for us to look upon. – 14. The sun shining brilliantly renovates our spirits, praises be to the God of heaven. – 15. Mrs. Murphy blind; Lantron not able to get wood, has but one axe between him and Keysburg; it looks like another storm. – 17. Eliza Williams came here this morning; Lantron crazy last night; provisions scarce, hides our main subsistence. May the Almighty send us help. – 21. Fine morning; John Battise and Mr. Denton came this morning with Eliza; she will not eat hides. Mrs. ——— sent her back to live or die on them. – 23. Blew hard and snowed all night, the most severe storm we have experienced this winter. – 27. Lew (Sutter's Indian) died three days ago; wood getting scarce; don't have fire enough to cook our hides. – 31. Landron Murphy died last night. . . .

Feb. 5. – Many uneasy for fear we shall all perish with hunger; we have but a little meat left and only three hides; Mrs. Reed has nothing but one hide and that is on Graves' house; Milton lives there and likely will keep that – Eddy's child died last night. – 6. It snowed faster last night and to-day than it has done this winter before, still continues without intermission. – 7. Ceased to snow at last. . . . McCutcheon's child died on the second of this month. – 8. Fine clear morning, Spitzer died last night, we shall bury him in the snow. Mrs. Eddy died on the night of the seventh. – 9. Mr. Pike's child all but dead. Milton is at Murphy's not able to get out of bed; Keysburg never gets up, says he is not able. . . . – 10. Beautiful morning, thawing in the sun. Milton Elliot died last night at Murphy's shanty. . . . All are entirely out of meat but a little we have. Our hides are nearly all eat up, but with God's help spring will soon smile upon us. – 14. Fine morning, but cold; buried Milton in the snow. John Denton not well. – 16. Weather changeable, sunshine then light showers of hail and wind at times. We all feel very unwell. – 19. Seven men arrived from California yesterday evening with provisions, but left the greater part on the way. . . . Some of the men have gone to Donner's camp; they will start back on Monday. – 22. The Californians started this morning, twenty-four in number, some in a very weak state. Mrs. Keysburg started with them and left Keysburg here unable to go; buried Pike's child this morning in the snow, it died two days ago. – 23. Shot a dog today and dressed his flesh. – 25. To-day Mrs. Murphy says the wolves are about to dig up the dead bodies around her shanty, and the nights are too cold to watch them, but we hear them howl. – 26. Hungry times in camp; plenty of hides, but the folks will not eat them; we eat them with tolerable good appetite, thanks be to the Almighty God. Mrs. Murphy said here yesterday that she thought she would commence on Milton and eat him; I do not think she has

done so yet – it is distressing; the Donner's told the California folks four days ago that they would commence on the dead people if they did not succeed that day or next in finding their cattle, then ten or twelve feet under the snow, and did not know the spot or near it; they have done it ere this. – 28. One solitary Indian passed by yesterday, came from the Lake, had a heavy pack on his back, gave me five or six roots resembling onions in shape, tasted some like a sweet potato full of tough little fibres.

March 1. – Ten men arrived this morning from Bear Valley with provisions; we are to start in two or three days and shall cache our goods here. They say the snow will remain until June.

The above mentioned ten men started for the valley with seventeen of the sufferers; they travelled fifteen miles and a severe snow-storm came on; they left fourteen of the emigrants, the writer of the above journal and his family, and succeeded in getting in but three children. Lieut. Woodworth immediately went to their assistance, but before he reached them they had eaten three of their number, who had died from hunger and fatigue; the remainder Lieut. Woodworth's party brought in. On the 29th of April, 1847, the last member of that party was brought to Capt. Sutter's Fort; it is utterly impossible to give any description of the sufferings of the company. Your readers can form some idea of them by perusing the above diary.

Yours, &c.
George McKinstry, Jr.

Fort Sacramento, April 29, 1847.

The Indian

John Muir, *My First Summer in the Sierra*, 1911

June 16. One of the Indians from Brown's Flat got right into the middle of the camp this morning, unobserved. I was seated on a stone, looking over my notes and sketches, and happening to look up, was startled to see him standing grim and silent within a few steps of me, as motionless and weather-stained as an old tree-stump that had stood there for centuries. All Indians seem to have learned this wonderful way of walking unseen – making themselves invisible like certain spiders I have been observing here, which, in case of alarm, caused, for example, by a bird alighting on the bush their webs are spread upon, immediately bounce themselves up and down on their elastic threads so rapidly that only a blur is visible. The wild Indian power of escaping observation, even where there is little or no cover to hide in, was probably slowly acquired in hard hunting and fighting lessons while trying to approach game, take enemies by surprise, or get safely away when compelled to retreat. And this experience transmitted through many generations seems at length to have become what is vaguely called instinct.

How smooth and changeless seems the surface of the mountains about us! Scarce a track is to be found beyond the range of the sheep except on small open spots on the sides of the streams, or where the forest carpets are thin or wanting. On the smoothest of these open strips and patches deer tracks may be seen, and the great suggestive footprints of bears, which, with those of the many small animals, are scarce enough to answer as a kind of light ornamental stitching or embroidery. Along the main ridges and larger branches of the river Indian trails may be traced, but they are not nearly as distinct as one would expect to find them. How many centuries Indians have roamed these woods nobody knows, probably a great many, extending far beyond the time that Columbus touched our shores, and it seems strange that heavier marks have not been made. Indians walk softly and hurt the landscape hardly more than the birds and squirrels, and their brush and bark huts last hardly longer than those of woodrats, while their more enduring monuments, excepting those wrought on the forests by the fires they made to improve their hunting grounds, vanish in a few centuries.

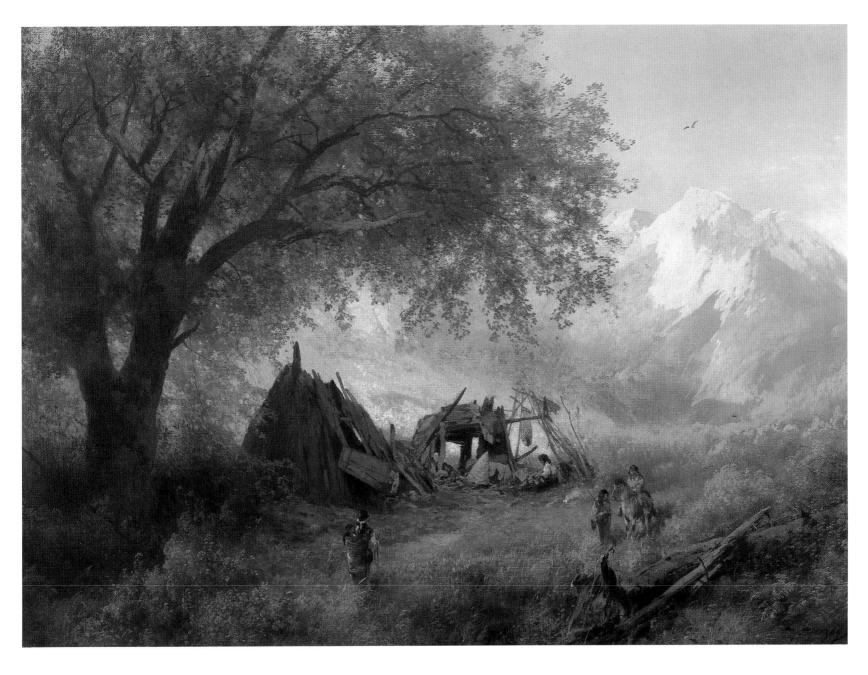

41 Herman Herzog
Indian Hogans in the California Sierra, 1874–75

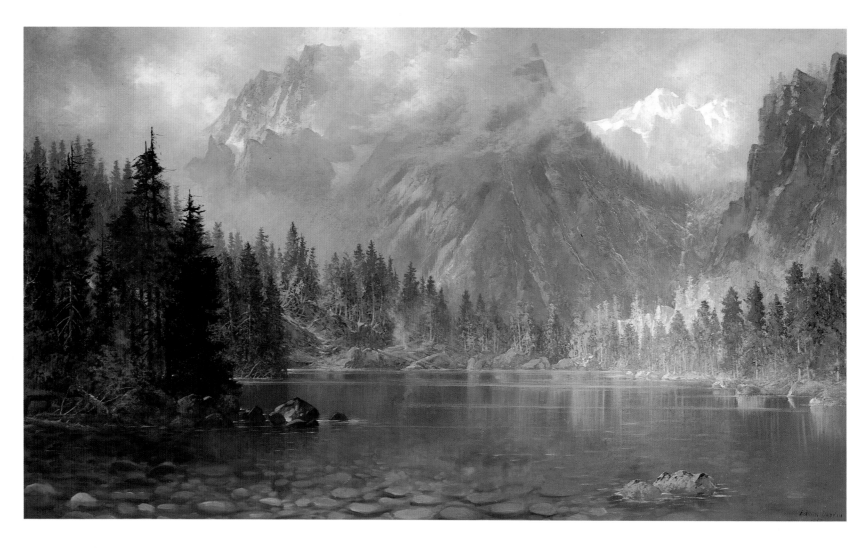

42 Edwin Deakin
 Mount Tallac, California, from Cascade Lake, 1877

The Birth of a Lake

When a mountain lake is born, – when, like a young eye, it first opens to the light, – it is an irregular, expressionless crescent, inclosed in banks of rock and ice, – bare, glaciated rock on the lower side, the rugged snout of a glacier on the upper. In this condition it remains for many a year, until at length, toward the end of some auspicious cluster of seasons, the glacier recedes beyond the upper margin of the basin, leaving it open from shore to shore for the first time, thousands of years after its conception beneath the glacier that excavated its basin. The landscape, cold and bare, is reflected in its pure depths; the winds ruffle its glassy surface, and the sun thrills it with throbbing spangles, while its waves begin to lap and murmur around its leafless shores, – sun-spangles during the day and reflected stars at night its only flowers, the winds and the snow its only visitors. Meanwhile, the glacier continues to recede, and numerous rills, still younger than the lake itself, bring down glacier-mud, sand-grains, and pebbles, giving rise to margin-rings and plats of soil. To these fresh soil-beds come many a waiting plant. First, a hardy carex with arching leaves and a spike of brown flowers; then, as the seasons grow warmer, and the soil-beds deeper and wider, other sedges take their appointed places, and these are joined by blue gentians, daisies, dodecatheons, violets, honey-worts, and many a lowly moss. Shrubs also hasten in time to the new gardens, – kalmia with its glossy leaves and purple flowers, the arctic willow, making soft woven carpets, together with the healthy bryanthus and casiope, the fairest and dearest of them all. Insects now enrich the air, frogs pipe cheerily in the shallows, soon followed by the ouzel, which is the first bird to visit a glacier lake, as the sedge is the first of plants.

So the young lake grows in beauty, becoming more and more humanly lovable from century to century. Groves of aspen spring up, and hardy pines, and the hemlock spruce, until it is richly overshadowed and embowered. But while its shores are becoming enriched, the soil-beds creep out with incessant growth, contracting its area, while the lighter mud-particles deposited on the bottom cause it to grow shallower, until at length the last remnant of the lake vanishes, – closed forever in ripe and natural old age. And now its feeding-stream goes winding on without halting through the new gardens and groves that have taken its place.

John Muir, *Mountains of California*, 1894

A Glacier Once Came Down

Joseph Le Conte, (*American Journal of Science and Arts*, 3rd series, 1875). Le Conte came to California in 1869 to help organize the University of California, where for 32 years he taught natural sciences. In 1870 he helped form the University Excursion Party, concerned ecologists who rode horseback to Yosemite, Tuolumne Meadows, Mono Lake, Tahoe, and Sacramento. Their concern spurred action to retain the beauty of the High Sierra.

Fallen Leaf Lake lies on the plain of Lake Valley, about one and a half miles from Lake Tahoe, its surface but a few feet above the level of the latter Lake; but its bottom far, probably several hundred feet, below that level. It is about three to three and one-half miles long and one and one-fourth miles wide. From its upper end runs a canyon bordered on either side by the highest peaks in this region. The rocky walls of this canyon terminate on the east side at the head of the lake, but on the west side, a little farther down. The lake is bordered on each side by an admirably marked debris ridge (moraine) three hundred feet high, four miles long, and one and one-half to two miles apart. These moraines may be tracked back to the termination of the rocky ridges which bound the canyon. On one side the moraine lies wholly on the plain; on the other side its upper part lies against the slope of Mount Tallac. Near the lower end of the lake a somewhat obscure branch ridge comes off from each main ridge, and curving around it forms an imperfect terminal moraine through which the outlet of the lake breaks its way.

On ascending the canyon the glaciation is very conspicuous, and becomes more and more beautiful at every step. From Glen Alpine Springs upward it is the most perfect I have ever seen. In some places the white rocky bottom of the canyon, for many miles in extent, is smooth and polished and gently undulating, like the surface of a glassy but billowy sea. The glaciation is distinct also up the sides of the canyon 1000 feet above its floor. There can be no doubt, therefore, that a glacier once came down this canyon filling it 1000 feet deep, scooped out Fallen Leaf Lake just where it struck the plain and changed its angle of slope, and pushed its snout four miles out on the level plain, nearly to the present shores of Lake Tahoe, dropping its debris on either side and thus forming a bed for itself. In its subsequent retreat it seems to have rested its snout some time at the lower end of Fallen Leaf Lake, and accumulated there an imperfect terminal moraine.

Even dogs and horses, when first led up the mountains, study geology to this extent that they gaze wonderingly at the strange brightness of the ground and smell it, and place their feet cautiously upon it as if afraid of falling or sinking.
– John Muir, 1912

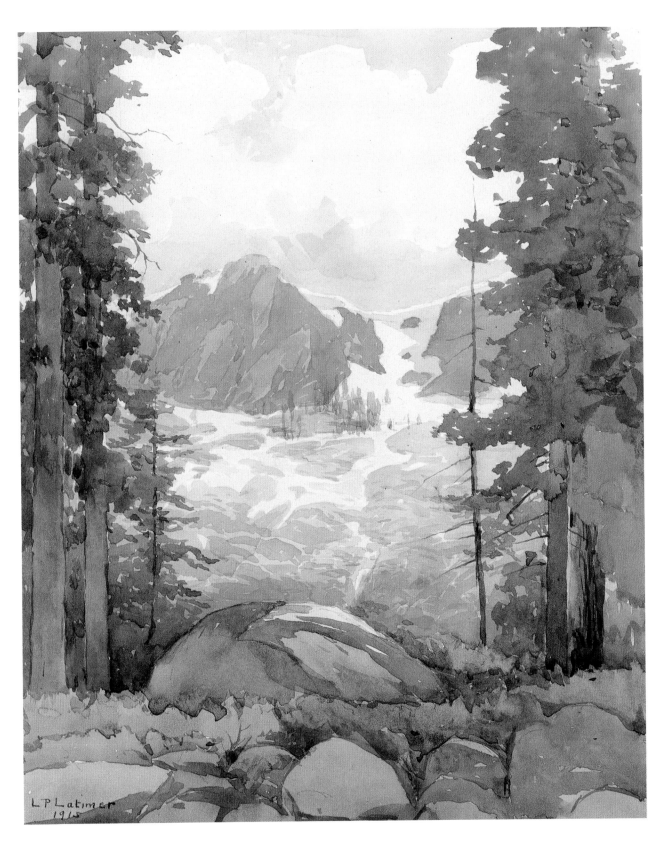

43 Lorenzo Palmer Latimer
Glacier above Upper Angora Lake,
near Fallen Leaf, Lake Tahoe, California, 1915

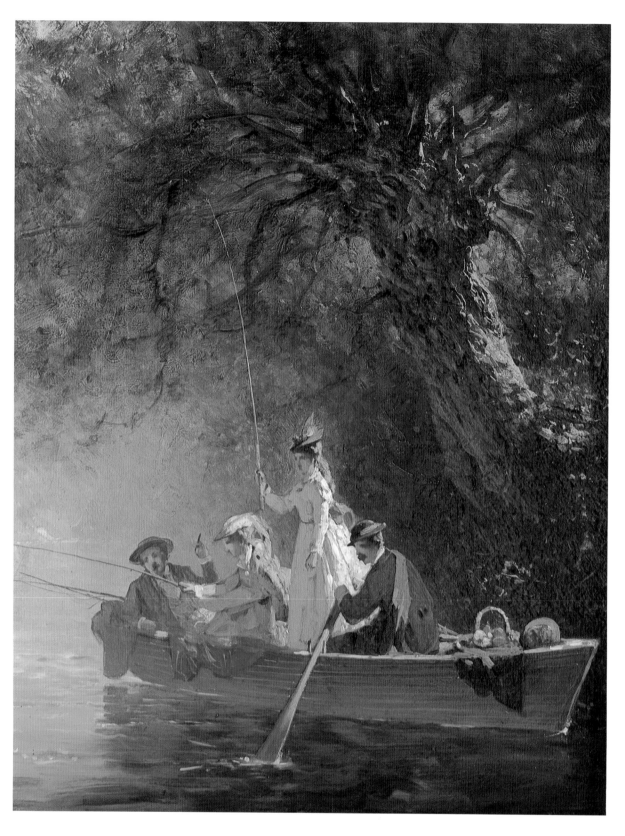

44 Thomas Hill
Thomas Hill and Virgil Williams,
with Wives, Fishing, c.1873

Journal of Ramblings

August 19. – From the top of this ridge I saw many fine peaks of columnar basalt, evidently the remnants of old lava streams. The descent into Hope Valley is much more gentle. This valley is a famous resort for fishing and hunting parties. As we entered the valley, . . . we met one of these – a large party of ladies and gentlemen. . . . We straightened up and dashed by in fine style, and immediately dismounted and camped on a grassy meadow on the banks of the creek. They seemed much amused and somewhat astonished at our wild appearance. . . .

We now proceeded by a good wagon-road, and therefore quite rapidly. . . . We . . . camped at 7 p.m. in a fine grove of tamaracks on the very borders of the lake.

We have . . . passed through the region of slate (mining region) and the region of lava-flows, and are again in the region of granite. The granite about Tahoe . . . is finer grained than that about Yosemite and Tuolumne Meadows. . . .

August 20. – After breakfast we hired a sail-boat. . . .

Oh, the exquisite beauty of this lake! – its clear water, emerald-green, and the deepest ultramarine blue; its pure shores, rocky or cleanest gravel, so clean the chafing of the waves does not stain in the least the bright clearness of the waters; the high granite mountains, with serried peaks, which stand close around its very shore to guard its crystal purity – this lake, not *among*, but *on*, the mountains, lifted six thousand feet towards the deep-blue overarching sky, whose image it reflects! . . . We sailed some six or eight miles, and landed in a beautiful cove on the Nevada side. Shall we go in swimming? Newspapers in San Francisco say there is something peculiar in the waters of this high mountain lake. It is so light, they say, that logs of timber sink immediately, and bodies of drowned animals never rise; that it is impossible to swim in it; that, essaying to do so, many good swimmers have been drowned. These facts are well attested by newspaper scientists, and therefore not doubted by newspaper readers. Since leaving Oakland, I have been often asked by the young men the scientific explanation of so singular a fact. I have uniformly answered, "We will try scientific experiments when we arrive there." That time had come.

"Now then, boys," I cried, "for the scientific experiment I promised you!" I immediately plunged in head foremost and struck out boldly. I then threw myself on my back, and lay on the surface with my limbs extended and motionless for ten minutes, breathing quietly the while. All the good swimmers quickly followed. It is as easy to swim and float in this as in any other water. Lightness from diminished atmospheric pressure! Nonsense! In an almost incompressible liquid like water, the diminished density produced by diminished pressure would be more than counterbalanced by increased density produced by cold.

Joseph Le Conte, *Journal of Ramblings*, 1870

When a day is calm, there is a ring of the Lake, extending more than a mile from shore, which is brilliantly green. Within this ring the vast center of the expanse is of a deep, yet soft and singularly tinted blue. Hues cannot be more sharply contrasted than are these permanent colors. They do not shade into each other; they lie as clearly defined as the course of glowing gems in the wall of the New Jerusalem. . . .

Brethren, this question of color in nature, broadly studied, leads us quickly to contemplate and adore the love of God. . . . If religion is . . . hostile to the natural good and joy which the heart seeks instinctively, . . . I do not believe that the vast deeps of space above us would have been tinted with tender azure, biding their awfulness; I do not believe that storms would break away into rainbows, and that the clouds of sunset would display the whole gamut of sensuous splendor; . . . I do not believe that the mountains would crown the complete, the general loveliness of the globe.
– Reverend Thomas Starr King, 1863

On the Lake

Mark Twain, *Roughing It*, 1871

. . . While smoking the pipe of peace after breakfast we watched the sentinel peaks put on the glory of the sun, and followed the conquering light as it swept down among the shadows, and set the captive crags and forests free. We watched the tinted pictures grow and brighten upon the water till every little detail of forest, precipice, and pinnacle was wrought in and finished, and the miracle of the enchanter complete. Then to "business."

That is, drifting around in the boat. We were on the north shore. There, the rocks on the bottom are sometimes gray, sometimes white. This gives the marvelous transparency of the water a fuller advantage than it has elsewhere on the Lake. We usually pushed out a hundred yards or so from the shore and then lay down on the thwarts in the sun, and let the boat drift by the hour whither it would. We seldom talked. It interrupted the Sabbath stillness, and marred the dreams the luxurious rest and indolence brought. The shore all along was indented with deep, curved bays and coves, bordered by narrow sand-beaches; and where the sand ended, the steep mountain-sides rose right up aloft into space – rose up like a vast wall a little out of the perpendicular, and thickly wooded with tall pines.

So singularly clear was the water, that where it was only twenty or thirty feet deep the bottom was so perfectly distinct that the boat seemed floating in the air! Yes, where it was even *eighty* feet deep. Every little pebble was distinct, every speckled trout, every hand's-breadth of sand. Often, as we lay on our faces, a granite bowlder, as large as a village church, would start out of the bottom apparently, and seem climbing up rapidly to the surface, till presently it threatened to touch our faces, and we could not resist the impulse to seize an oar and avert the danger. But the boat would float on, and the bowlder descend again, and then we could see that when we had been exactly above it, it must have been twenty or thirty feet below the surface. Down through the transparency of these great depths, the water was not *merely* transparent, but dazzlingly, brilliantly so. All objects seen through it had a bright, strong vividness, not only of outline, but of every minute detail, which they would not have had when seen simply through the same depth of atmosphere. So empty and airy did all spaces seem below us, and so strong was the sense of floating high aloft in mid-nothingness, that we called these boat excursions "balloon-voyages."

We fished a good deal, but we did not average one fish a week. We could see trout by the thousand winging about in the emptiness under us, or sleeping in shoals on the bottom, but they would not bite – they could see the line too plainly perhaps. We frequently selected the trout we wanted, and rested the bait patiently and persistently on the end of his nose at a depth of eighty feet, but he would only shake it off with an annoyed manner, and shift his position.

Some of Mr. Bierstadt's mountains swim in a lustrous, pearly mist, which is so enchantingly beautiful that I am sorry the Creator hadn't made it instead of him, so that it would always remain there.
– *Mark Twain, 1867*

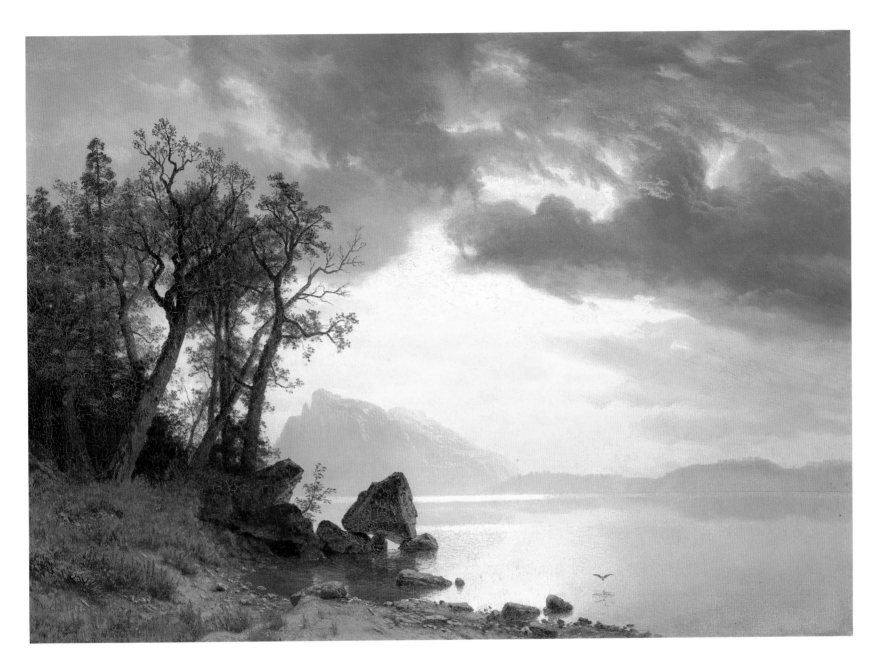

45 Albert Bierstadt
Lake Tahoe, California, 1867

Hetch Hetchy

John Muir, in Francis P. Farquhar, *History of the Sierra Nevada*, 1965 [1872]

. . . Imagine yourself in Hetch Hetchy on a sunny day in June, standing waist-deep in grass and flowers (as I have often stood), while the great pines sway dreamily with scarcely perceptible motion. Looking northward across the Valley you see a plain, gray granite cliff rising abruptly out of the gardens and groves to a height of 1800 feet, and in front of it Tueeulala's silvery scarf burning with irised sun-fire. In the first white outburst at the head there is abundance of visible energy, but it is speedily hushed and concealed in divine repose, and its tranquil progress to the base of the cliff is like that of a downy feather in a still room. Now observe the fineness and marvelous distinctness of the various sun-illumined fabrics into which the water is woven; they sift and float from form to form down the face of that grand gray rock in so leisurely and unconfused a manner that you can examine their texture, and patterns and tones of color as you would a piece of embroidery held in the hand. Toward the top of the fall you see groups booming, comet-like masses, their solid, white heads separate, their tails like combed silk interlacing among delicate gray and purple shadows, ever forming and dissolving, worn out by friction in their rush through the air. Most of these vanish a few hundred feet below the summit, changing to varied forms of cloud-like drapery. Near the bottom the width of the fall has increased from about twenty-five feet to a hundred feet. Here it is composed of yet finer tissues, and is still without a trace of disorder – air, water and sunlight woven into stuff that spirits might wear.

After supper I took a stroll along the backbone of the ridge and looked down into the little Hetch Hetchy Valley, looked plumb down one mile. . . . You felt as if you had no resting place, but floated on space. . . . The summits, in the clear higher air, looked like a company of angels with their lofty heads tipped with the sun's last rays in a flush of glory; patches of snow rose-colored, patches of pine and chaparral, dashes of purple and blue and gold, and over it all the silence of eternity – inexpressible things. . . .
– William Keith, 1875

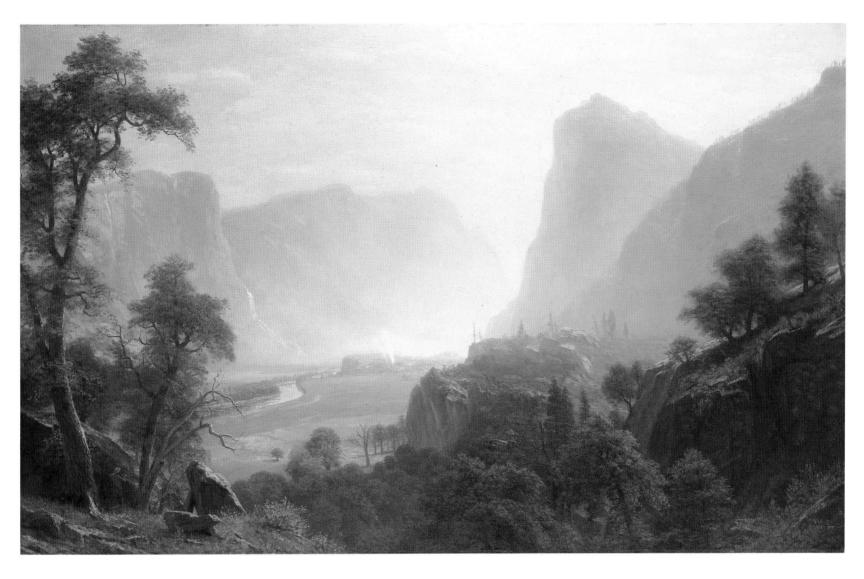

46 Albert Bierstadt
The Hetch-Hetchy Valley, California, c.1874–80

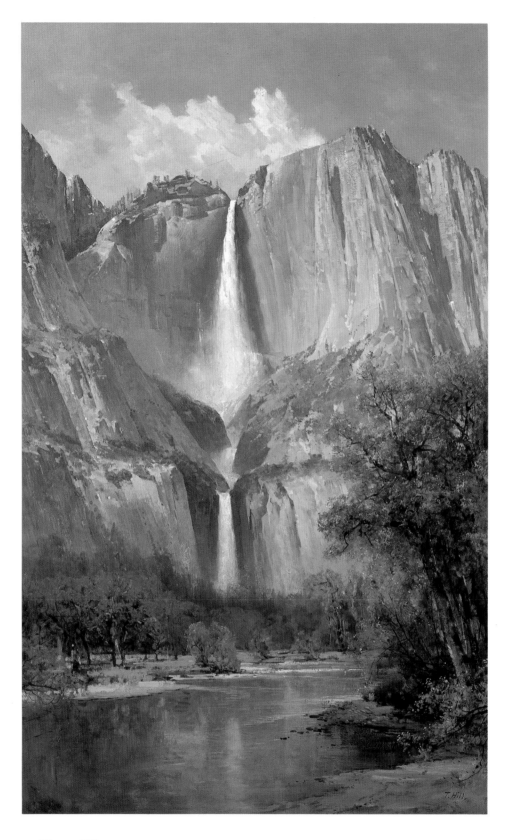

47 Thomas Hill
Yosemite Falls, n.d.

The Yosemite Fall

Long ago before I had traced this fine stream to its head back of Mount Hoffman, I was eager to reach the extreme verge to see how it behaved in flying so far through the air; but after enjoying this view and getting safely away I have never advised anyone to follow my steps. The last incline down which the stream journeys so gracefully is so steep and smooth one must slip cautiously forward on hands and feet alongside the rushing water, which so near one's head is very exciting. But to gain a perfect view one must go yet farther, over a curving brow to a slight shelf on the extreme brink. This shelf, formed by the flaking off of a fold of granite, is about three inches wide, just wide enough for a safe rest for one's heels. To me it seemed nerve-trying to slip to this narrow foothold and poise on the edge of such a precipice so close to the confusing whirl of the waters; and after casting longing glances over the shining brow of the fall and listening to its sublime psalm, I concluded not to attempt to go nearer, but, nevertheless, against reasonable judgment, I did. Noticing some tufts of artemisia in a cleft of rock, I filled my mouth with the leaves, hoping their bitter taste might help to keep caution keen and prevent giddiness. In spite of myself I reached the little ledge, got my heels well set, and worked sidewise twenty or thirty feet to a point close to the out-plunging current. Here the view is perfectly free down into the heart of the bright irised throng of comet-like streamers into which the whole ponderous volume of the fall separates, two or three hundred feet below the brow. So glorious a display of pure wildness, acting at close range while cut off from all the world beside, is terribly impressive. A less nerve-trying view may be obtained from a fissured portion of the edge of the cliff about forty yards to the eastward of the fall. Seen from this point towards noon, in the spring, the rainbow on its brow seems to be broken up and mingled with the rushing comets until all the fall is stained with iris colors, leaving no white water visible. This is the best of the safe views from above, the huge steadfast rocks, the flying waters, and the rainbow light forming one of the most glorious pictures conceivable.

John Muir, *The Yosemite*, 1912

The Vernal Fall

John Muir, *The Yosemite*, 1912

The Vernal, about a mile below the Nevada, is 400 feet high, a staid, orderly, graceful, easy-going fall, proper and exact in every movement and gesture, with scarce a hint of the passionate enthusiasm of the Yosemite or of the impetuous Nevada, whose chafed and twisted waters hurrying over the cliff seem glad to escape into the open air, while its deep, booming, thunder-tones reverberate over the listening landscape. Nevertheless it is a favorite with most visitors, doubtless because it is more accessible than any other, more closely approached and better seen and heard. A good stairway ascends the cliff beside it [the Mist Trail] and the level plateau at the head enables one to saunter safely along the edge of the river as it comes from Emerald Pool and to watch its waters, calmly bending over the brow of the precipice, in a sheet eighty feet wide, changing in color from green to purplish gray and white until dashed on a boulder talus. Thence issuing from beneath its fine broad spray-clouds we see the tremendously adventurous river still unspent, beating its way down the wildest and deepest of all its canyons in gray roaring rapids, dear to the ouzel, and below the confluence of the Illilouette, sweeping around the shoulder of the Half Dome on its approach to the head of the tranquil levels of the Valley.

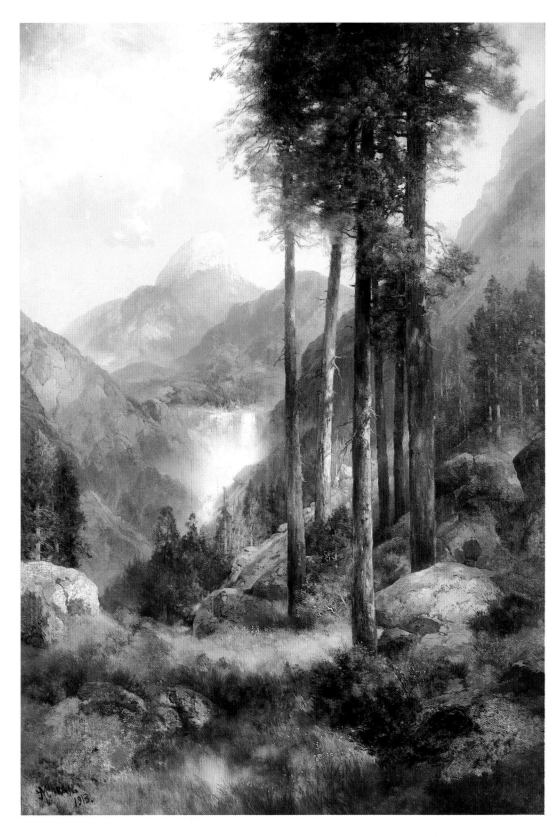

48 Thomas Moran
Vernal Falls, Yosemite Valley, 1913

An Artist in the Sierra

William Keith, letter, 1875

Yosemite has yet to be painted; painters' visits of a month or so have not done it. Time is required to take it in, and digest it, or else the inevitable result will be artistic dyspepsia (in the shape of the conventional yellow and red rocks), which, perhaps is the reason for the average Californian's disgust for Yosemite pictures. The cliffs are neither red nor yellow, but an indescribable shifting gray, changing and shifting even as you look. The lightness and evanescence of the morning gray, and the burnishing light of the evening sun are not to be gotten by a lucky hit. A French painter of the first rank, like Corot or Lambinet (?), would rejoice in this richness of gray – but French painters do not paint mountain pictures. We have had some cloudy, foggy days, when the tops of the cliffs would be hidden in place; others would seem to be moving up and out of the fog-cloud; sometimes the wind would tear into shreds the shifting fog-masses, until they looked like torn cobwebs, and out and in the Yosemite Falls would weave, in a slow and downward motion, distinguished from the clouds only by its shape and capacity in the thickest places. It all looks very deep and dark in tone, yet over all is the lightness of grayness, which you can only know by trying to mix the different tones; a hasty dash will only approximate to its truth of color. "Try, try again, and if at first you don't succeed, try, try again," is a very good motto to calm your rising agitation.

Four of us – Muir the naturalist, John Swett, and Mr. McChesney, and myself – came up here, with the intention of going up higher in the mountains; and after a detention of some days, which was spent very profitably in color study, leisurely walking, we started by way of Gentry, proposing to cross Yosemite Creek, up to Lake Tanaya, past Mount Hoffman, Tuolumne Meadows, Soda Springs, past Dana and Gibbs, up over the Summit, down Bloody Cañon to Mono Lake, and skirting the eastern slope of the Sierra, exploring the head of Owen's River, etc.; all of which I propose to relate.

It looked cloudy and threatening the morning we left the valley, but, trusting to luck and to keeping our provisions dry, we followed an exceedingly melancholy and heavy-laden mule. Just as we passed El Capitan it commenced to drizzle, and by the time we had half climbed the mountains the rain came down in good earnest with gusts of wind. We slowly climbed, up and up, until the rain changed to sleet, snow, and hail – poor companions for a journey in the mountains. When we got to Gentry's on top of the mountain, we found a deserted cabin, and resolved to stay there for the night at least. It stormed and thundered and lightened all night, and next morning was like a winter morning – the ground covered a foot or more deep with snow. The day was half sunshine, half cloud, and the snow rapidly melted – the flowers looked curious peeping out from their beds of snow – and at evening there was a glorious sunset, with the sky perfectly clear, while below were patches of snow and snow-shadow, sunlight on distant cliff and pine, and the valley beneath filled nearly to the brim by

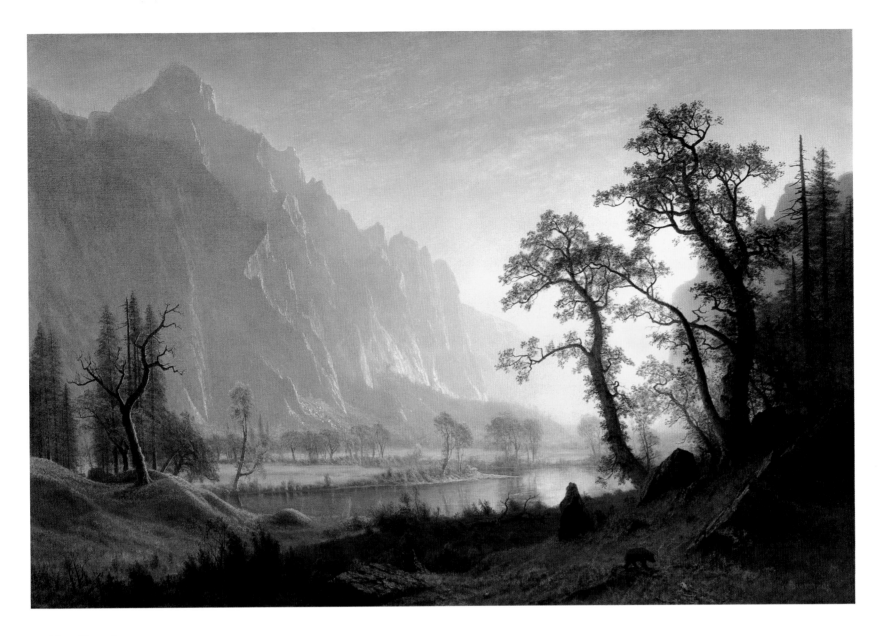

49 Albert Bierstadt
Sunrise, Yosemite Valley, n.d.

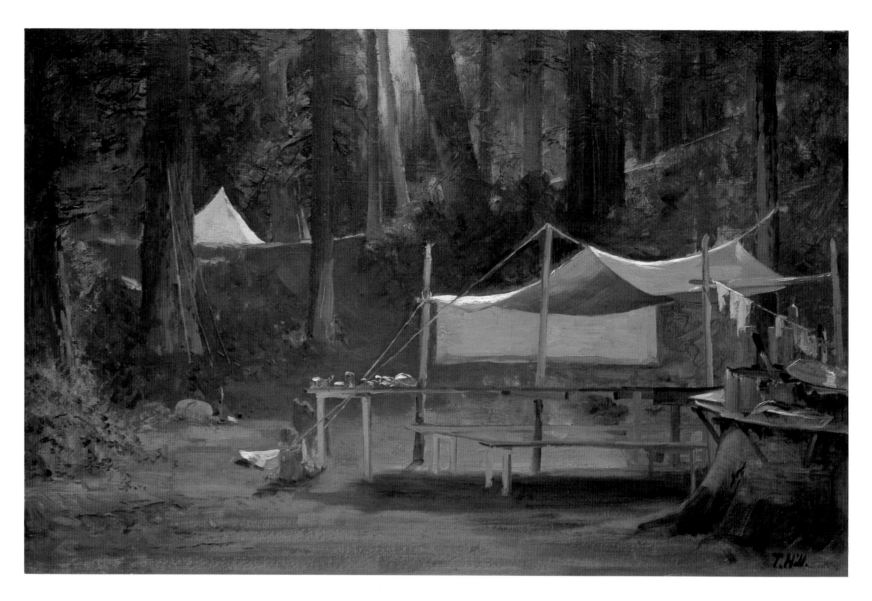

50 Thomas Hill
Our Camp, n.d.

a great heavy sodden mass of cloud, moving with a scarcely perceptible motion, slow and solemn, weird and white, except where touched by the sunlight. At the top the cloud was shaped square, and angular at the bottom, and it filled the valley with a foam-like smoke; the purple middle-ground of pine gradually receding, fainter and fainter, into this ghostly mass; the foreground in sharp and sudden relief, in color a yellow-green, the green fused into the yellow, as in a roaring camp-fire at night you see the fusion of orange, sulphur, and gold. I made a quick sketch, which looked better next morning, and watched the light throbbing away, fainter and fainter, into the night. Next morning we went through magnificent groves of pines (noblest among them all, the yellow-pine), through the shifting sunshine, deeper and deeper through the thick rich forest, climbing up and down; on every side riches of color, riches of sunshine and shadow; passing two still lakes, that seem to have lost themselves in the woods and grown contented there; down steep and rocky mountains, and, after a rough scramble, crossed Yosemite Creek, and on the Mono Trail, up and up, until the sun told us to camp, which we did by a little meadow, where there was feed for the horses, and by its side fragrant pine-boughs, which we made into springy beds for the party.

Early next morning on the trail again, still passing through rich forests, with glimpses now and then of the promised land. There was the head of South Dome, on one side shadowed by gray, purple, and blue; on the other bathed with that light-gray radiance which is neither shadow nor light, but simply radiance — with bare promontories clear and cutting against their background of purple and green woods. Higher and higher we slowly climbed until we arrived at the top of the ridge; then down, over glaciated pavements glittering and shining in the sun. As we descended we caught glimpses of Lake Tenaya — a blue-black, at the edge lighter in tone, and dashed with greenish-gray light. These mountain lakes have their peculiarity — I mean their intense depth of gray color; they look like spots in the picture, and seem to make the shadows of other things lighter; they are much darker than the top of the sky, which is an intense blue-gray, wonderfully soft and deep.

Still going down, and crossing over bare rocks — ribbed and cleft, showing the tremendous pressure to which they have been subjected — we approached the lake, through groves of pine (two-leafed), small and stunted, comparatively dwarfed by their winter plights. Some stand two and three together, as if for mutual protection; others spring from one rough yellowish trunk, and then split, one half full of life and vigor, the other a liver-gray stick, sapless, dead. The green tufted ends of their foliage (something like the yellow-pine tufts, but lacking their flexibility, grace, and silvery shine) have a certain sturdy vigor which challenges admiration. Through such groves the trail winds on to the meadow, green in spots, everywhere traversed by clear snow-fed streams, two, three and four feet wide; their beds full of pebbles, rocks, and sand; their waters, cool and trans-

Sitting in their divine workshop, by a little after sunrise our artists [Albert Bierstadt, Virgil Williams, and Enoch Wood Perry, Jr.] began labor in that only method which can ever make a true painter or a living landscape, – color-studies on the spot; . . . I will assert that during their seven weeks' camp . . . they learned more and gained greater material for future triumphs than they had gotten in all their lives before at the feet of the greatest masters.
– Fritz Ludlow, 1864

parent, tempting you all the time to drink, and the more you drink the more you want.

Crossing the stream which issued from the lake, we arrived at the lake's edge. Lake Tenaya is 8,500 feet above sea-level, and is one of the largest and finest lakes in this part of the Sierra, fed constantly by the snow-streams from the higher mountains. Strange dome-shaped rocks, round and bare, hemmed us in; no *chaparral*; on the sides occasionally a pine-tree. In fact, the chief characteristics of this region are its rocks, bareness, the round and burnished domes, and dwarf two-leafed pines. The deep transparent waters of the lake – on the edge great white and grim bowlders, brown under the water, and swaths of sand – seem of a pale opalescent green, gradually melting into an intense blue-black, an effect which is more marked when you are on a level with the lake. Faint reflections of the dome-shaped cliffs, especially when they are in full sunshine, and the reflection of the trees, show the local color of the lake's water more fully. When ruffled it seems to partake of the extreme top of the sky, modified by a deeper purplish hue; the deep blue of the sky joining to the light-gray rounded and polished cliffs and the purples and browned pines in the distance, the green foliage and yellow-trunked trees of the foreground, together with the clear pure waters of the lake. Gaudy butterflies; bees droning and humming in the summer air; winged insects of different kinds – all unite to make a picture which indelibly impresses itself on the mind. Breathing in such beauty with the pure air, free from taint of every kind, no wonder that to us the echoes sounded their return joyously on and up through the glittering sunshine, sparkling on every twig and rock and leaf, dancing back from the surface of laughing and gurgling brooks. We seemed to float on ethereal wings up and up, until, looking back, the deep dark lake appeared to have engulfed the sunlight.

Nature takes kindly to her children; if they would but leave their swaddling-clothes of conventionality and submit themselves to her influences – leave carking cares and come to the mountains, for a little while at least. Do not fancy that June is the only month; July is good, August is better, September is yet better, and October is the blessed one of all the year.

Riding along – coming now to snow-banks, with living water, clear and pure, streaming out from every side – past Mount Hoffman, sometimes hidden, other times nodding and smiling to itself in some still secret lake; on our right strange flat-topped trees upon high cliffs, gnarled and twisted, and seemingly in inextricable confusion; over striated rocks, and loose bowlders looking just as if they had been left by nature in a hurry; up and down, getting confused with different impressions. There are glimpses every now and then of a great valley. One climb more – and there are the Tuolumne Meadows lying at our feet, green and grassy, and the main Tuolumne River flowing down to the sea. Up the valley, slowly and more slowly as the camping-place appears in view; across the ford, the strong steady stream almost carrying the horse from his feet; a slight acclivity gained – here's camp! A drink at the soda springs cheers tired nature, and on a fragrant pine-bough bed we are at rest.

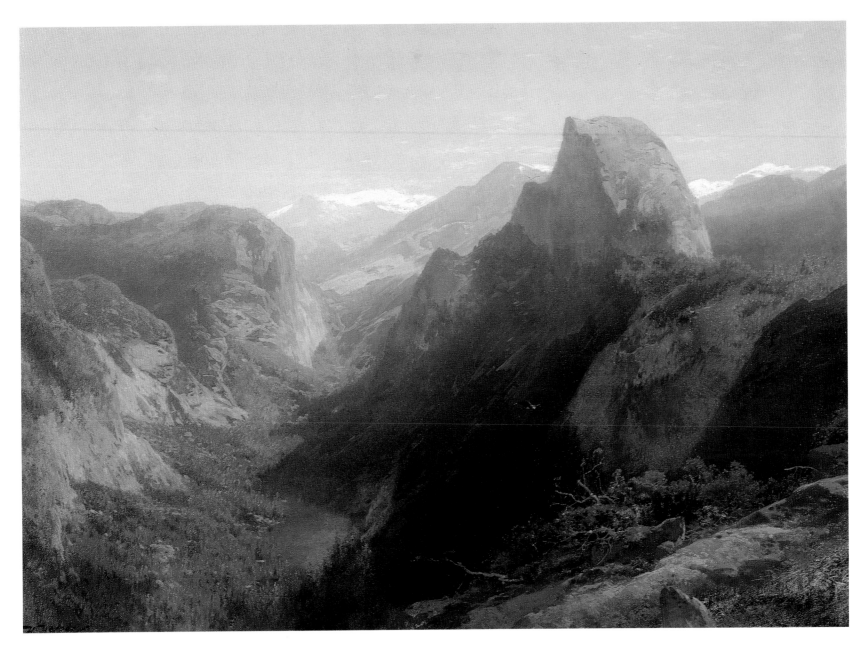

51 Herman Herzog
Mirror Lake, Yosemite, c.1874–75

Mount Lyell

William Keith, letter, 1875

When we got to Mount Lyell it was the grandest thing I ever saw. It was late in October, and at an elevation of 10,000 feet. The frost had changed the grasses and a kind of willow to the most brilliant yellows and reds; these contrasting with the two-leafed pine and Williamson spruce (the only other kinds of trees growing at that elevation), the cold gray rocks, and the colder snow, made a glorious sight.

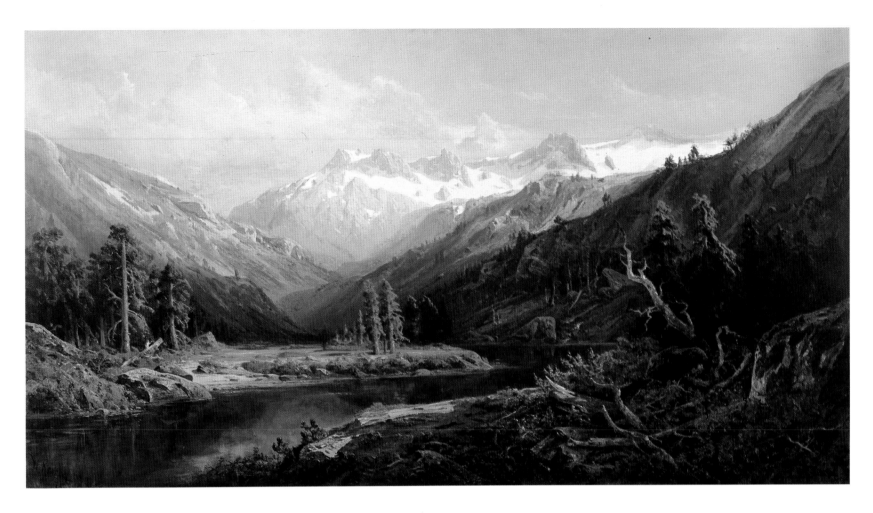

52 William Keith
 Sierra Nevada Mountains, 1876

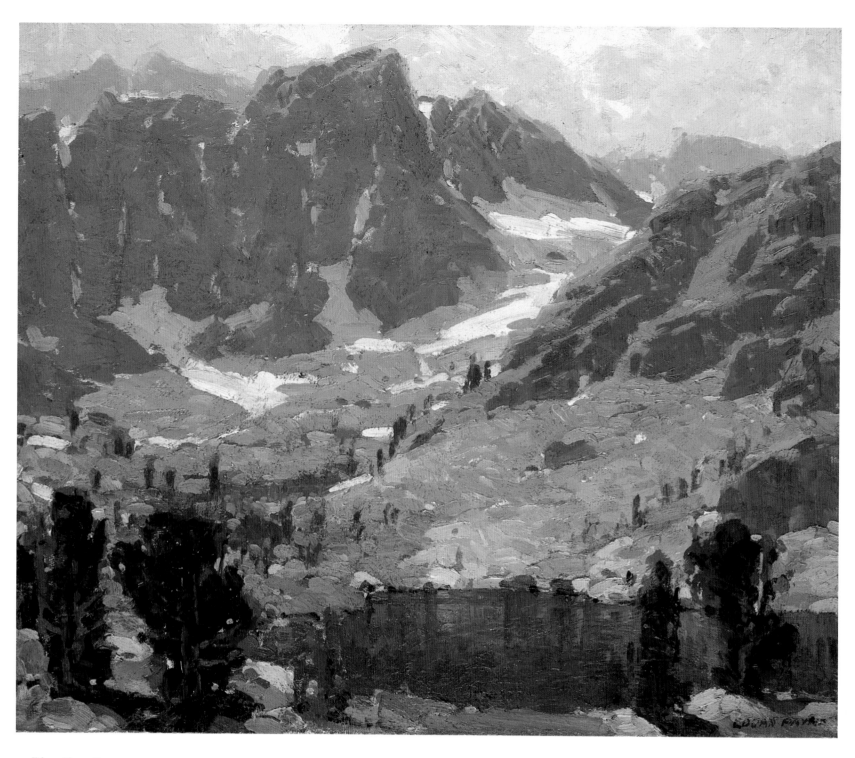

53 Edgar Alwyn Payne
 Sierra (Mount Ritter/Lake Ediza), c.1924

On Mount Ritter

. . . I fastened a hard durable crust to my belt and set forth free and hopeful.
Immediately in front loomed the majestic mass of Mount Ritter, with a glacier
swooping down its face nearly to my feet, then curving westward and pouring
its frozen flood into a dark blue lake. I began instinctively to scrutinize every
notch and gorge and weathered buttress of the mountain, with reference to mak-
ing the ascent. I succeeded in gaining the foot of the cliff on the eastern extrem-
ity of the glacier, and discovered the mouth of a narrow avalanche gully. Its
general course is oblique to the plane of the mountain-face, and the metamorphic
slates of which it is built are cut by cleavage planes in such a way that they
weather off in angular blocks, giving rise to irregular steps that greatly facilitate
climbing. The situation was becoming gradually more perilous, but, having
passed several dangerous spots, I dared not think of descending. At length, I
found myself at the foot of a sheer drop in the bed of the avalanche channel,
which seemed to bar all further progress. The tried dangers beneath seemed
even greater than that of the cliff in front; therefore, after scanning its face again
and again, I commenced to scale it, picking my holds with intense caution. After
gaining a point about half-way to the top, I was brought to a dead stop, with
arms outspread, clinging close to the face of the rock, unable to move hand or
foot either up or down. My doom appeared fixed. I *must* fall. When this final dan-
ger flashed in upon me, I became nerve-shaken for the first time since setting
foot on the mountain, and my mind seemed to fill with a stifling smoke. But the
terrible eclipse lasted only a moment, when life burst forth again with preternat-
ural clearness. I seemed suddenly to become possessed of a new sense. The other
self – the ghost of by-gone experiences, Instinct, or Guardian Angel – call it what
you will – came forward and assumed control. Then my trembling muscles
became firm again, every rift and flaw was seen as through a microscope, and my
limbs moved with a positiveness and precision with which I seemed to have
nothing at all to do. Had I been borne aloft upon wings, my deliverance could
not have been more complete. Above this memorable spot, the face of the moun-
tain is still more savagely hacked and torn. But the strange influx of strength I
had received seemed inexhaustible. I found a way without effort, and soon stood
upon the topmost crag in the blessed light.

John Muir, *The Yosemite*, 1912

The Sequoia

John Muir, *The Yosemite*, 1912

So harmonious and finely balanced are even the mightiest of these monarchs in all their proportions that there is never anything overgrown or monstrous about them. Seeing them for the first time you are more impressed with their beauty than their size, their grandeur being in great part invisible; but sooner or later it becomes manifest to the loving eye, stealing slowly on the senses like the grandeur of Niagara or of the Yosemite domes. When you approach them and walk around them you begin to wonder at their colossal size and try to measure them. They bulge considerably at the base, but not more than is required for beauty and safety and the only reason that this bulging seems in some cases excessive is that only a comparatively small section is seen in near views. . . . No description can give anything like an adequate idea of their singular majesty, much less of their beauty. Except the sugar pine, most of their neighbors with pointed tops seem ever trying to go higher, while the Big Tree, soaring above them all, seems satisfied. Its grand domed head seems to be poised about as lightly as a cloud, giving no impression of seeking to rise higher. Only when it is young does it show like other conifers a heavenward yearning, sharply aspiring with a long quick-growing top. Indeed, the whole tree for the first century or two, or until it is one hundred or one hundred and fifty feet high, is arrowhead in form, and, compared with the solemn rigidity of age, seems as sensitive to the wind as a squirrel's tail. As it grows older, the lower branches are gradually dropped and the upper ones thinned out until comparatively few are left. These, however, are developed to a great size, divide again and again and terminate in bossy, rounded masses of leafy branchlets, while the head becomes dome shaped, and is the first to feel the touch of the rosy beams of the morning, the last to bid the sun good night. Perfect specimens, unhurt by running fires or lightning, are singularly regular and symmetrical in general form, though not in the least conventionalized, for they show extraordinary variety in the unity and harmony of their general outlines. The immensely strong, stately shafts are free of limbs for one hundred and fifty feet or so. The large limbs reach out with equal boldness in every direction, showing no weather side, and no other tree has foliage so densely massed, so finely molded in outline and so perfectly subordinate to an ideal type. A particularly knotty, angular, ungovernable-looking branch, from five to seven or eight feet in diameter and perhaps a thousand years old, may occasionally be seen pushing out from the trunk as if determined to break across the bounds of the regular curve, but like all the others it dissolves in bosses of branchlets and sprays as soon as the general outline is approached. Except in picturesque old age, after being struck by lightning or broken by thousands of snow-storms, the regularity of forms is one of their most distinguishing characteristics.

The marvelous of size does not go into gilt frames. You paint a Big Tree, and it only looks like a common tree in a cramped coffin.
– Fritz Ludlow, 1864

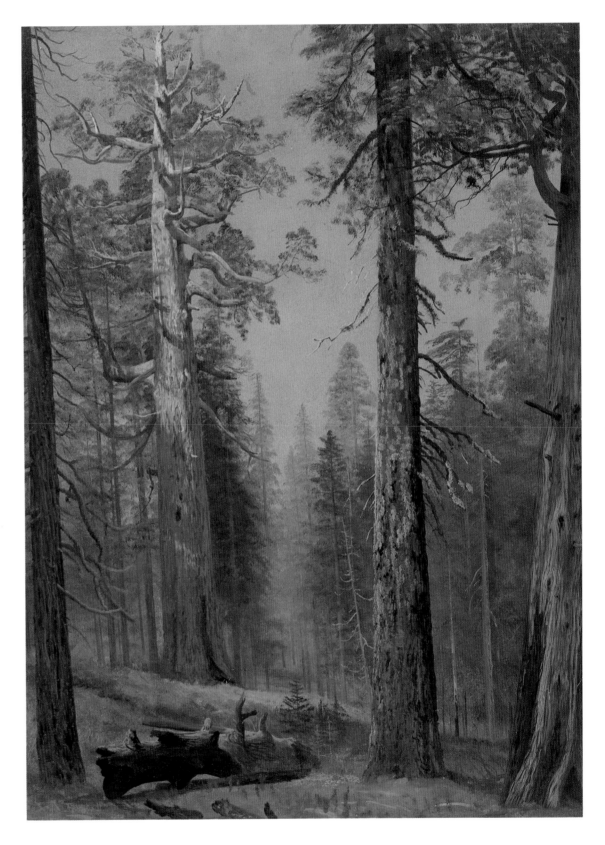

54 Albert Bierstadt
*The Grizzly Giant Sequoia, Mariposa
Grove, California, c.1872–73*

. . . The topographic extremes of the United States
proper are both within the limits of Inyo county.
Mt. Whitney lifts its head nearer to heaven than
any other spot. Death Valley sinks further toward
the orthodox nether regions than any other; deeper
below the sea's level, and is at least not surpassed on
earth in its power of torment for the human atoms
who may fall within its clutches. . . . The territory
had to be under some jurisdiction, and it was wished
upon Inyo.
– Willie Arthur Chalfant

One goes south and south, within hearing of the lip-
lip-lapping of the great tideless lake, and south by
east over a high rolling district, miles and miles of
sage and nothing else. So one comes to the country of
the painted hills – old red cones of craters, wasteful
beds of mineral earths, hot, acrid springs, and steam
jets issuing from a leprous soil. After the hills the
black rock, after the craters the spewed lava, ash
strewn, of incredible thickness, and full of sharp,
winding rifts. There are picture writings carved
deep in the face of the cliffs to mark the way for those
who do not know it. On the very edge of the black
rock the earth falls away in a wide sweeping
hollow. . . .
South the land rises in very blue hills, blue because
thickly wooded with ceanothus and manzanita, the
haunt of deer and the border of the Shoshones. East-
ward the land goes very far by broken ranges, nar-
row valleys of pure desertness, and huge mesas
uplifted to the sky-line, east and east, and no man
knows the end of it.
– Mary Austin

4. The Southern Sierra and the Deserts to San Gorgonio Pass

*The Southern Range, Death Valley, the Mojave Desert,
the Salton Sea, Mt. San Jacinto*

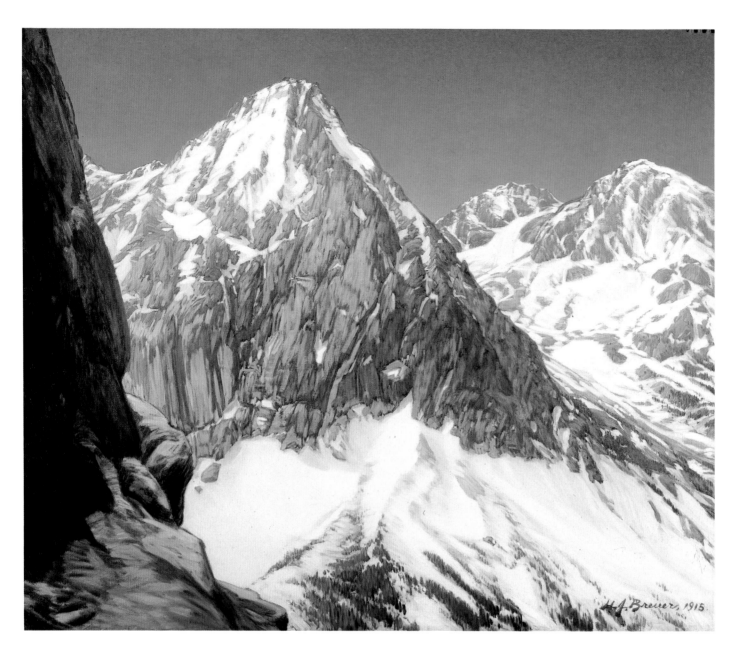

55 Henry Joseph Breuer
 Southern Sierras, 1915

Mount Tyndall

[From the summit] two parallel chains, enclosing an intermediate trough, face each other. Across this deep enclosed gulf, from wall to wall, juts the thin, but lofty and craggy ridge, or "divide," . . . which forms an important water-shed, sending those streams which enter the chasm north of it into Kings River, those south forming the most important sources of the Kern. . . .

Fronting us stood the west chain, a great mural ridge watched over by two dominant heights, Kaweah Peak and Mount Brewer. . . . Bold buttresses jut out through fields of ice, and reach down stone arms among snow and debris. North and south of us the higher, or eastern summit stretched on in miles and miles of snow-peaks, the farthest horizon still crowded with their white points. East the whole range fell in sharp, hurrying abruptness to the desert, where, ten thousand feet below, lay a vast expanse of arid plain intersected by low parallel ranges, traced from north to south. Upon the one side a thousand sculptures of stone, hard, sharp, shattered by cold into infiniteness of fractures and rift, springing up, mutely severe, into the dark, austere blue of heaven; scarred and marked, except where snow or ice, spiked down by ragged granite bolts, shields with its pale armor these rough mountain shoulders; storm-tinted at summit, and dark where, swooping down from ragged cliff, the rocks plunge over cañon-walls into blue, silent gulfs.

Upon the other hand, reaching out to horizons faint and remote, lay plains clouded with the ashen hues of death; stark, wind-swept floors of white, and hill-ranges, rigidly formal, monotonously low, all lying under an unfeeling brilliance of light, which, for all its strange, unclouded clearness, has yet a vague half-darkness, a suggestion of black and shade more truly pathetic than fading twilight. No greenness soothes, no shadow cools the glare. Owens Lake, an oval of acrid water, lies dense blue upon the brown sage-plain, looking like a plate of hot metal. Traced in ancient beach-lines, here and there upon hill and plain, relics of ancient lake-shore outline the memory of a cooler past, – a period of life and verdure when the stony chains were green islands among basins of wide, watery expanse.

Clarence King, *Mountaineering in the Sierra Nevada*, 1864

The Sky Above

Clarence King, "The Range," *Mountaineering in the Sierra Nevada*, 1871

The two halves of [the] view, both in sight at once, express the highest, the most acute, aspects of desolation, – inanimate forms out of which something living has gone forever. From the desert have been dried up and blown away its seas. Their shores and white, salt-strewn bottoms lie there in the eloquence of death. Sharp white light glances from all the mountain-walls, where in marks and polishings has been written the epitaph of glaciers now melted and vanished into air. Vacant cañons lie open to the sun, bare, treeless, half shrouded with snow, cumbered with loads of broken debris, still as graves, except when flights of rocks rush down some chasm's throat, startling the mountains with harsh, dry rattle, their fainter echoes from below followed too quickly by dense silence.

The serene sky is grave with nocturnal darkness. The earth blinds you with its light. That fair contrast we love in lower lands between bright heavens and dark cool earth here reverses itself with terrible energy. You look up into an infinite vault, unveiled by clouds, empty and dark, from which no brightness seems to ray, an expanse with no graded perspective, no tremble, no vapory mobility, only the vast yawning of hollow space.

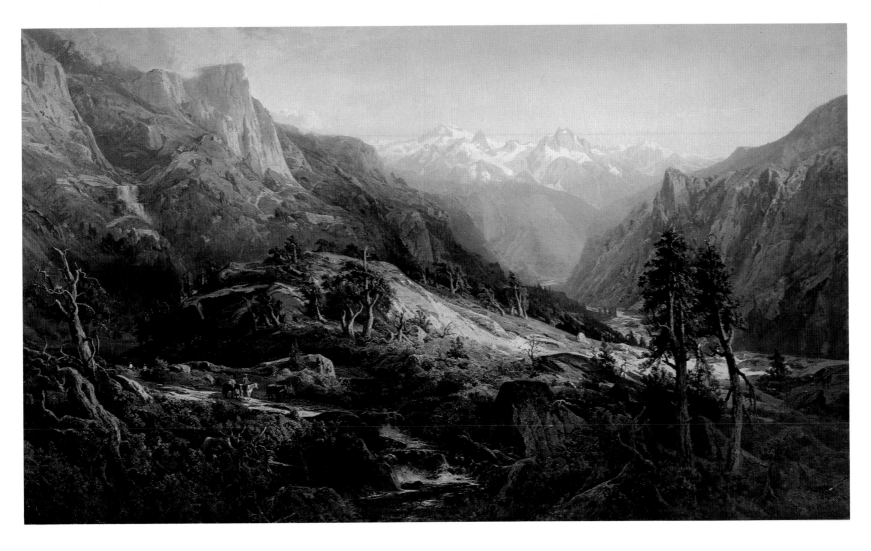

56 William Keith
Upper Kern River, 1876

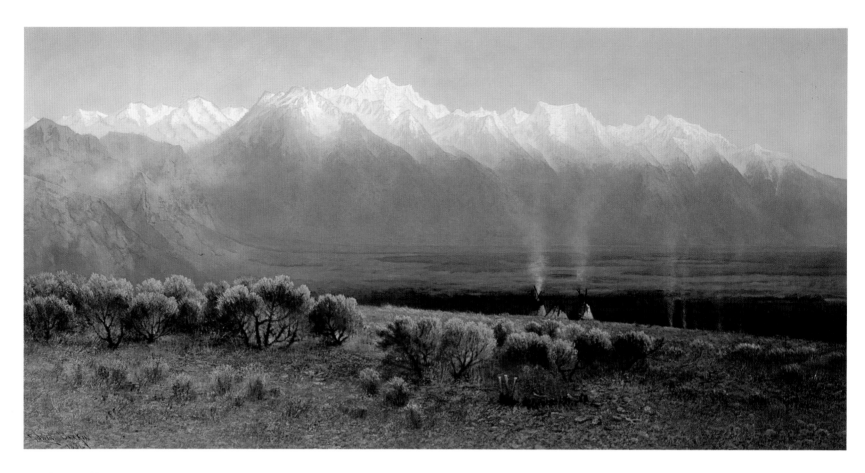

57 Edwin Deakin
 Owens Valley, 1884

Desolation below the Summit

With an aspect of endless remoteness burns the small white sun, yet its light seems to pass invisibly through the sky, blazing out with intensity upon mountains and plain, flooding rock details with painfully bright reflections, and lighting up the burnt sand and stone of the desert with a strange blinding glare. There is no sentiment of beauty in the whole scene; no suggestion, however far remote, of sheltered landscape; not even the air of virgin hospitality that greets us explorers in so many uninhabited spots which by their fertility and loveliness of grove or meadow seem to offer man a home, or us nomads a pleasant campground. Silence and desolation are the themes which nature has wrought out under this eternally serious sky. A faint suggestion of life clings about the middle altitudes of the eastern slope, where black companies of pine, stunted from breathing the hot desert air, group themselves just beneath the bottom of perpetual snow, or grow in patches of cloudy darkness over the moraines, those piles of wreck crowded from their pathway by glaciers long dead. Something there is pathetic in the very emptiness of these old glacier valleys, these imperishable tracks of unseen engines. One's eye ranged up their broad, open channel to the shrunken white fields surrounding hollow amphitheatres which were once crowded with deep burdens of snow, – the birthplace of rivers of ice now wholly melted; the dry, clear heavens overhead, blank of any promise of ever rebuilding them.

Clarence King, *Mountaineering in the Sierra Nevada*, 1864

Creation [Piute]

Long ago there was no land; there was nothing but water. The coyote and the tiger were brothers, and had lived forever. "We need land," the coyote said to the tiger. "There is too much water. Let us make land, so we can go about on the earth." "There is the vast sky," the tiger said, "full of air through which you can go anywhere. Why not fly?" So the coyote flew one whole day throughout the heavens. On returning to the tiger, the coyote said, "Flying is not enough. There is no place to alight, and we must have land with its plains and valleys, its hills and mountains and streams, with grass and plants and trees and animals." "All right," the tiger replied. "We will make land in the morning."

The tiger had in each ear an earring of cane, about three inches long and a quarter of an inch thick. The next morning he removed one of the earrings and blew upon it, and then holding it over his palm he shook out its contents in the form of dirt and threw it into the water. The dirt itself immediately created other dirt. The coyote urged the tiger to keep on, and asked him to throw the dirt to the east all the time and leave water to the west. By night the land was made, leaving the great sea to the west.

From the waters and muds and slimes came all grasses, plants and trees, vegetables of all kinds, and all creatures but man.

After their creation many of the animals went down to Coso Springs, the land of mystery. There the tiger and coyote saw and talked with two captains who had no bodies and were not flesh and bone, but just evil spirits. The two captains then made a great round pit, very deep, with a great fire at its bottom, and two men and two women sitting beside the fire.

But the two captains seized one of the men and one of the women and threw them into the fire and burned them up. This made the coyote so angry that he declared he would burn up the sun. Though the other animals protested that if he did there would be no warmth and they would all die, he pulled down the sun and burned it in the fire in the pit. So there was no sun for a whole year, only darkness and cold everywhere, and great suffering, and the coyote ran about crying in the dark.

At the end of the year the duck said to the coyote: "You have made trouble enough, but if you will let me alone and just listen I will call back the sun." Accordingly the duck quacked for a long time, and suddenly the sun appeared, and all were happy, at the light and the warmth and the knowledge that they would again have grass and wild fruits and berries and taboose for food.

The tiger took the form of a duck, and taking with him two big red frogs went back to Coso Springs, where there are still deposits of red moist earth. Out of it he fashioned two beautiful red images, one a man and one a woman, and the Great Spirit made them to live. They were the first Indians and the first human beings, and from them all men have come.

The way of the Indian was very hard. First they learned the way of the Spanish Fathers. Then they learned the way of the Mexicans. Then they had to learn again, very different, the way of the white man. So they could not please every one.
– Palm Springs Tribe

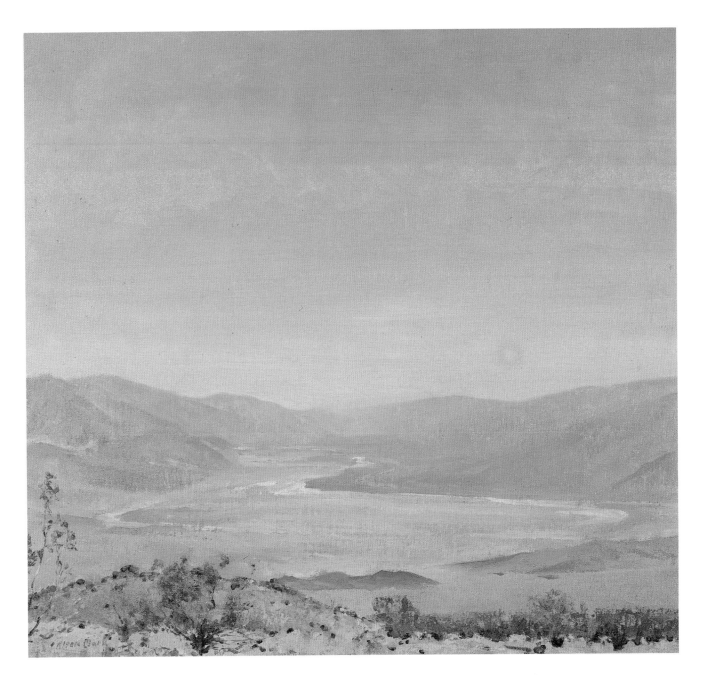

58 Alson Skinner Clark
Death Valley, c.1929–30

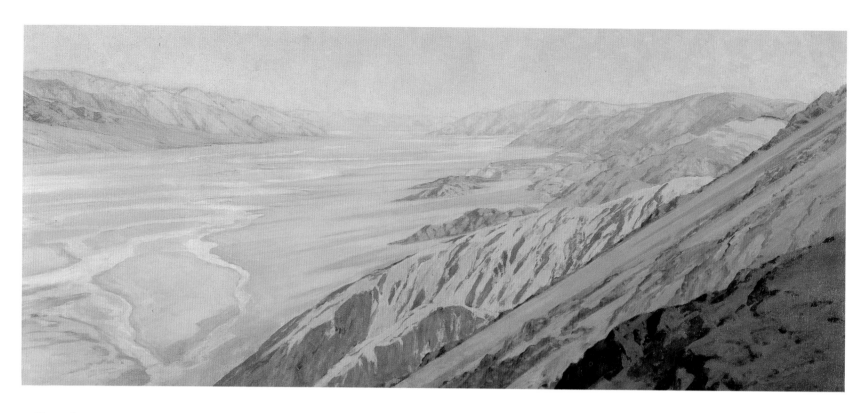

59 Fernand Lungren
 Death Valley, Dante's view, n.d.

Death Valley, Liars, and Lost Mines

The story of the "Death Valley Party" of emigrants is only second in horror to the tale of the Donner Party. . . . Among the survivors was . . . honest John Goller, our pioneer blacksmith. This John Goller was a sturdy German about thirty years old when he stumbled into José Salazar's house with Death grabbing at his heels. When he hit town he was still loaded down with gold nuggets he had picked up in Death Valley and clung to in spite of Hell. John reported that where he found them he could have loaded a pack mule with gold had there remained with the party any such animal uneaten. . . . The "Goller Mine" is one of the real phantoms to-day in mining lore; real because it has an actual substantial value far exceeding that of the mythical Peg-Leg Mine. . . . Peg-Leg [Smith] was the biggest horse thief that ever ranged the country between the Missouri River and the Pacific Ocean. In 1850, away up in what is now Idaho, I saw old Peg-Leg with a herd of fifteen hundred horses which the year previously he had stolen from the Los Angeles valley – the "Spanish Country," as he called it, after the habit of the trappers and early explorers.

Indeed, Peg-Leg was a magnificent thief on the wholesale plan and the most superlative liar that ever honored California with his presence. In the latter days of the '50's, dilapidated and played-out, he found his way once more to Los Angeles and sat around the old Bella Union bar, telling big lies and drinking free whiskey. . . .

Ever since the old man died people have been searching for the Peg-Leg Mine, but they will never find it in spite of certain ore which he procured somewhere and exhibited, because it is a myth, a Peg-Leg lie. But the Goller Mine will some day be found, and it will provide plenty of excitement.

This section of the Death Valley Party with which Goller arrived struggled for fifty-two days across a blistered volcanic desert. It makes a terrible tale, this journey of fifty-seven people through the then unknown and desolate region. They covered eight hundred miles of utter wilderness, climbed dead volcanoes never seen by white men before, traversed the hideous Death Valley, dragged along for days without water, ate the hides and very bones of their starved cattle. . . . Most of them were young men and they were well equipped . . .

Major Horace Bell, *On the Old West Coast*, 1881. Bell, an officer and an attorney, recorded the history of much of Southern California's settlement.

Sign at Furnace Creek, Death Valley: Hell, 8 miles; Nowhere, 150 miles

When meat is fresh killed, cut thin and dipped in brine, the sun cures it in an hour. Eggs can be roasted in the sand. Fig trees thrive in the genial air of late winter and early spring, but their fruit never matures. Furniture warps, splits and falls to pieces. Water barrels lost their hoops within an hour after emptied. One end of a blanket that had been washed dried while the other end was in the tub.
– Willie Arthur Chalfant, 1922

The Land of Little Rain

Mary Austin, *The Land of Little Rain*, 1903

East away from the Sierra, south from Panamint and Amargosa, east and south many an uncounted mile, is the Country of Lost Borders.

Ute, Paiute, Mojave, and Shoshone inhabit its frontiers, and as far into the heart of it as man dare go. Not the law, but the land sets the limit. Desert is the name it wears upon the maps, but the Indian's is the better word. Desert is a loose term to indicate land that supports no man; whether the land can be bitted and broken to that purpose is not proven. Void of life it never is, however dry the air and villainous the soil.

This is the nature of that country. There are hills, rounded, blunt, burned, squeezed up out of chaos, chrome and vermilion painted, aspiring to the snow-line. Between the hills lie high level-looking plains full of intolerable sun glare, or narrow valleys drowned in blue haze. The hill surface is streaked with ash drift and black, unweathered lava flows. After rains water accumulates in the hollows of small closed valleys, and, evaporating, leaves hard dry levels of pure desertness that get the local name of dry lakes. Where the mountains are steep and the rains heavy, the pool is never quite dry, but dark and bitter, rimmed about with the efflorescence of alkaline deposits. A thin crust of it lies along the marsh over the vegetating area, which has neither beauty nor freshness. In the broad wastes open to the wind the sand drifts in hummocks about the stubby shrubs, and between them the soil shows saline traces. The sculpture of the hills here is more wind than water work, though the quick storms do sometimes scar them past many a year's redeeming. . . .

> *Men die there from lack of moisture, but waterfowl tarry in Death Valley on their migrations.*
> *– Willie Arthur Chalfant, 1922*

Since this is a hill country one expects to find springs, but not to depend upon them; for when found they are often brackish and unwholesome, or maddening, slow dribbles in a thirsty soil. Here you find the hot sink of Death Valley, or high rolling districts where the air has always a tang of frost. Here are the long heavy winds and breathless calms on the tilted mesas where dust devils dance, whirling up into a wide, pale sky. Here you have no rain when all the earth cries for it, or quick downpours called cloudbursts for violence. A land of lost rivers, with little in it to love; yet a land that once visited must be come back to inevitably. If it were not so there would be little told of it.

This is the country of three seasons. From June on to November it lies hot, still, and unbearable, sick with violent unrelieving storms; then on until April, chill, quiescent, drinking its scant rain and scanter snows; from April to the hot season again, blossoming, radiant, and seductive. . . .

> *Sometimes the mountains sink, and flat land rises. The water ocean covers whole country that was not ocean before. The lakes and rivers are gone, to come again in strange places. No one knows the place that was called home any more.*
> *– Palm Springs Tribe*

The desert floras shame us with their cheerful adaptations to the seasonal limitations. Their whole duty is to flower and fruit, and they do it hardly, or with tropical luxuriance, as the rain admits. . . .

There are many areas in the desert where drinkable water lies within a few feet of the surface, indicated by the mesquite and the bunch grass (*Sporobolus airoides*). It is this nearness of unimagined help that makes the tragedy of desert

deaths. It is related that the final breakdown of that hapless party that gave Death Valley its forbidding name occurred in a locality where shallow wells would have saved them. But how were they to know that? Properly equipped it is possible to go safely across that ghastly sink, yet every year it takes its toll of death, and yet men find there sun-dried mummies, of whom no trace or recollection is preserved. To underestimate one's thirst, to pass a given landmark to the right or left, to find a dry spring where one looked for running water – there is no help for any of these things.

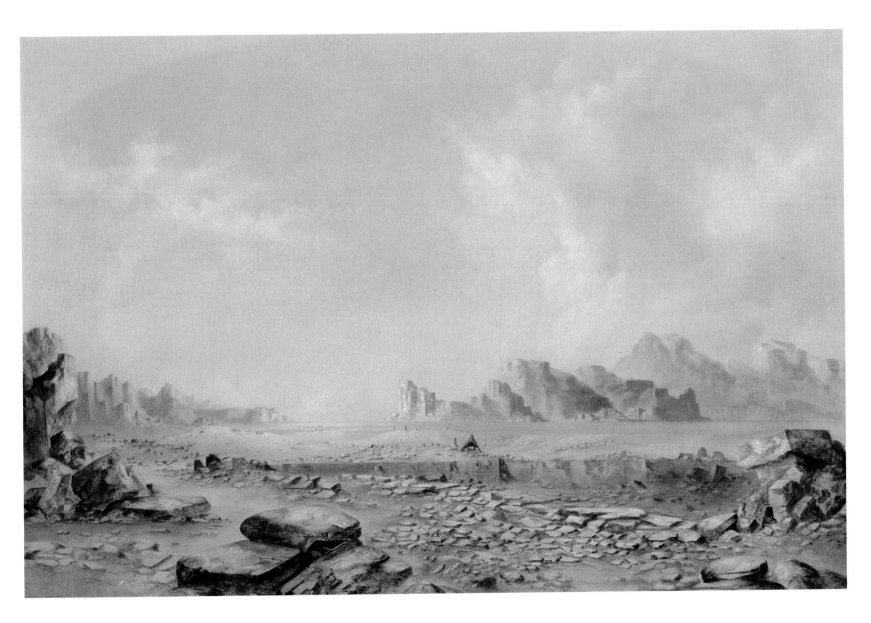

60 George Douglas Brewerton
Jornada del Muerto, 1853

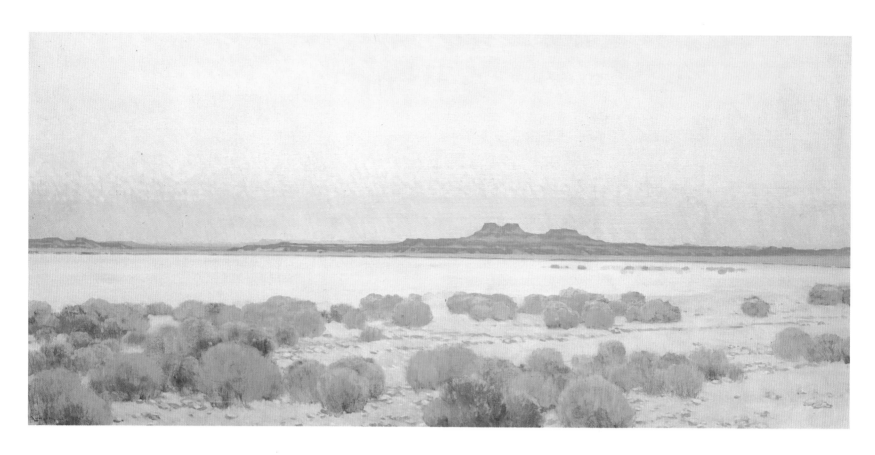

61 Fernand Lungren
Evening at Dry Lake, Mojave Desert, n.d.

The Desert's Hold

If one is inclined to wonder at first how so many dwellers came to be in the lone-
liest land that ever came out of God's hands, what they do there and why stay,
one does not wonder so much after having lived there. None other than this long
brown land lays such a hold on the affections. The rainbow hills, the tender
bluish mists, the luminous radiance of the spring, have the lotus charm. They
trick the sense of time, so that once inhabiting there you always mean to go away
without quite realizing that you have not done it. Men who have lived there,
miners and cattle-men, will tell you this, not so fluently, but emphatically, curs-
ing the land and going back to it. For one thing there is the divinest, cleanest air
to be breathed anywhere in God's world. Some day the world will understand
that, and the little oases on the windy tops of hills will harbor for healing its ail-
ing, house-weary broods. There is promise there of great wealth in ores and
earths, which is no wealth by reason of being so far removed from water and
workable conditions, but men are bewitched by it and tempted to try the
impossible. . . .

For all the toll the desert takes of a man it gives compensations, deep breaths,
deep sleep, and the communion of the stars. . . . It is hard to escape the sense of
mastery as the stars move in the wide clear heavens to risings and settings unob-
scured. They look large and near and palpitant; as if they moved on some stately
service not needful to declare. Wheeling to their stations in the sky, they make
the poor world-fret of no account. Of no account you who lie out there watch-
ing, nor the lean coyote that stands off in the scrub from you and howls and
howls.

Mary Austin, *The Land of Little Rain*, 1903

*In the night time I think. I think so
much – about the power that comes,
the spirits, the people, of the world
and what it means, but I cannot get it
all. I am too little.
– Palm Springs Tribe*

Desert Cloudburst

Willie Arthur Chalfant, *The Story of Inyo*, 1922

Right in the clear sky appears a cloud, black and ominous, streaked with fire, growing with wonderful rapidity, and eventually sagging down like a great sack. The cloud is always formed above the mountains, and after a time its bulbous, sagging body strikes a peak. Floods of water are released on the instant, and in waves of incredible size they roll down the cliffs and canyons. Precipices and peaks are carried away, gulches are filled with the debris, mesas and foothills are covered. The face of a mountain may be so changed within an hour as to be scarcely recognizable, and even the lighter storms rip the heart out of a canyon, so that only jagged gulches and heaps of broken rock are found where once, perhaps, a good trail existed.

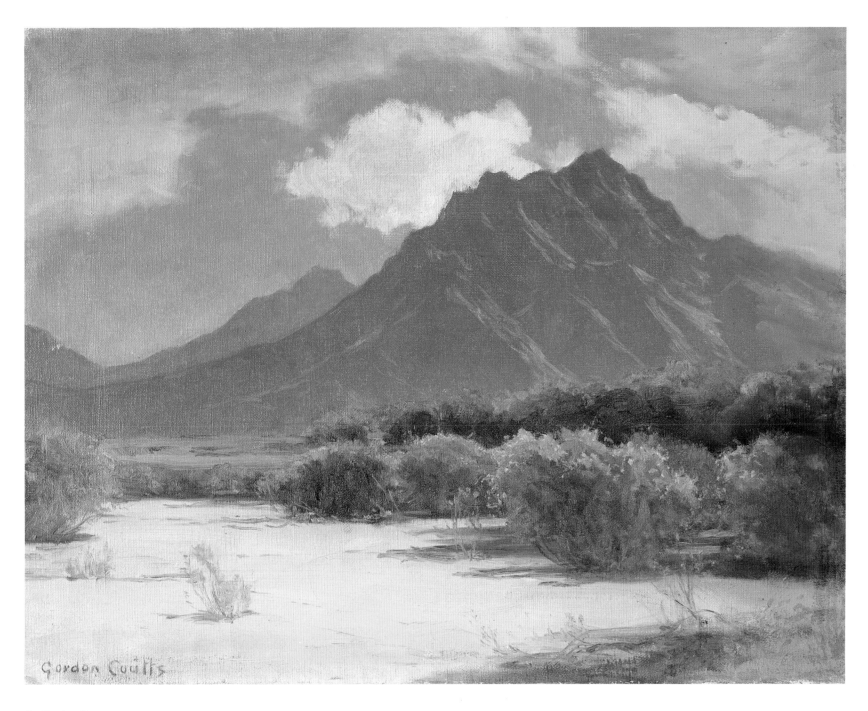

62 Gordon Coutts
Desert Wash, c.1913

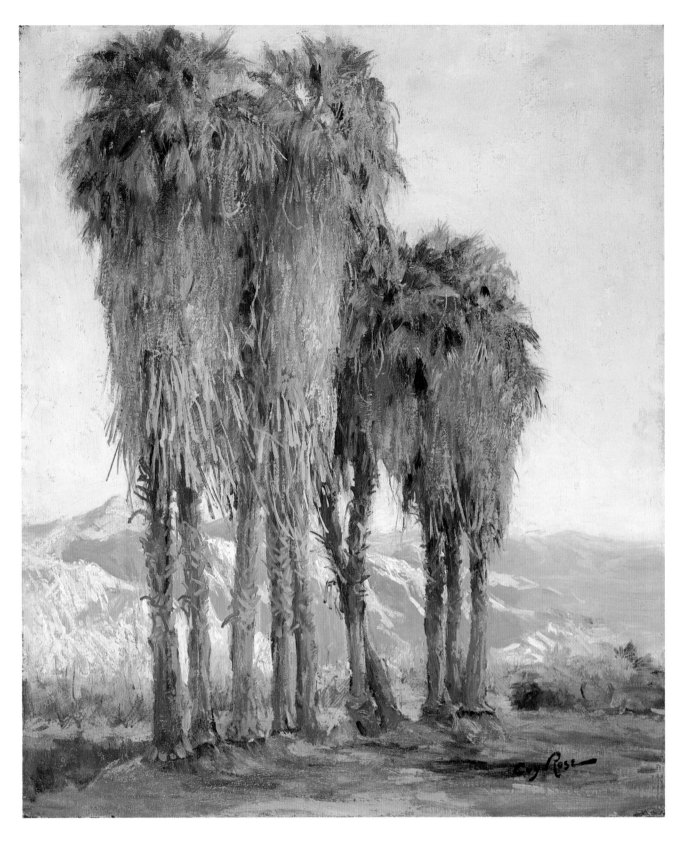

63 Guy Rose
Palms, c.1918

146

Desert Palms

Though the palm is certainly not the most beautiful, it is perhaps the most poetic of trees. In symmetry of tapering shaft, fountain-like burst of crown, and play of glossy frond, it is the ideal of gracefulness in plant life. . . .

Spreading up from Northern Mexico, a number of groups of the fan-palm, *Washingtonia filifera*, are found in the cañons and oases of the Colorado Desert. . . . Such human life as the desert has – that is, the actual desert, the unconquered and unconquerable wastes of burning sand and mountain – drifts and circles about these spots: necessarily so, since the presence of palms means the presence also of that rarest, strictest necessity, water. The Arabs' axiom regarding the date-palm, that its foot must be in water and its head in open sun, is true of its relative the fan-palm. Thus, in the talk of desert men the palm figures constantly. You hear of Dos Palmas, Thousand Palms, Palm Springs, Twenty-nine Palms, Seventeen Palms, Two-Bunch Palms, and so on; and the names mean to the traveller not only water, but shade, with the chance of grass for his animals, and the relief of verdure for his sorely harassed eyes.

Some of the groups occur about the boundary of the sea that anciently filled the great depression which is now partly occupied by the Salton Sea, and whose beach-mark is to-day startlingly plain at the base of the encircling hills. Such groups, probably, represent the indigenous growths. A number more are found at higher altitudes, but of these many are known to have been planted by the present or former Indian inhabitants of the region.

The westerly limit of growth is a rocky defile on the south side of Snow Creek Cañon, which is a rift of San Jacinto Mountain, about opposite Whitewater Station on the Southern Pacific Railway. This group marks the nearest approach made by the wild palm to coastal conditions of climate, for the spot is within a few miles of the crest of the San Gorgonio Pass, which here forms the dividing line between California barren and California fertile. A thread of tepid water moistens the roots of the trees, while not a mile away rushes the icy brook that gives its name to the cañon.

I camped, at various times, in most of the considerable cañons of the upper part of the desert. Each has its special charm, while those that come down from the high mountains that shut off desert from coast possess a dual beauty – the characteristics of a true mountain cañon, such as trees, cascading streams, and the varied life that goes with them, together with the features of a land made savage by torturing sun, unblessed by the mercy of rain. . . .

J. Smeaton Chase, *California Desert Trails*, 1919. On horseback Chase wandered through California, inland and along the coast from Mexico to Oregon in the early 1900s.

With its isolation, its strange warm fountain, its charming vegetation varied with grasses, trailing water-plants, bright parterres in which were minute flowers of turquoise blue, pale gold, mauve, and rose, and its two graceful palms, this oasis evoked a strange sentiment. I have never felt such a sense of absolute and remote seclusion. . . . It was a deep pleasure to lie under the palms and look up at their slow-moving green fans, and hear in those shaded recesses the mild, sweet twittering of our traveller-friends, the birds, who stayed, like ourselves, overcome with the languor of perfect repose.
– Clarence King, 1871

San Gorgonio Pass

Clarence King, *Mountaineering in the Sierra Nevada*, 1864

A long, wearisome ride of forty hours brought us to the open San Gorgonio Pass. Already scattered beds of flowers tinted the austere face of the desert; tufts of pale grass grew about the stones, and tall stems of yucca bore up their magnificent bunches of bluish flowers. Upon all the heights overhanging the road gnarled, struggling cedars grasp the rock, and stretch themselves with frantic effort to catch a breath of the fresh Pacific vapor. It is instructive to observe the difference between those which lean out into the vitalizing wind of the pass, and the fated few whose position exposes them to the dry air of the desert. Vigor, soundness, nerve to stand on the edge of sheer walls, flexibility, sap, fulness of green foliage, are in the one, a shroud of dull olive leaves scantily cover the thin, straggling, bayonet-like boughs of the others: they are rigid, shrunken, split to the heart, pitiful. . . .

Before us opened a broad gateway six or seven miles from wall to wall, in which a mere swell of green land rises to divide the desert and Pacific slopes. Flanking the pass along its northern side stands Mount San Bernardino, its granite framework crowded up above the beds of more recent rock about its base, bearing aloft tattered fragments of pine forest, the summit piercing through a marbling of perpetual snow up to the height of ten thousand feet. Fronting it on the opposite wall rises its compeer, San Jacinto, a dark crag of lava, whose flanks are cracked, riven, and waterworn into innumerable ravines, each catching a share of the drainage from the snow-cap, and glistening with a hundred small waterfalls.

Numerous brooks unite to form two rivers, one running down the green slope among ranches and gardens into the blooming valley of San Bernardino, the other pouring eastward, shrinking as it flows out upon the hot sands, till, in a few miles, the unslakable desert has drunk it dry.

There are but few points in America where such extremes of physical condition meet. What contrasts, what opposed sentiments, the two views awakened! Spread out below us lay the desert, stark and glaring, its rigid hill-chains lying in disordered grouping, in attitudes of the dead. The bare hills are cut out with sharp gorges, and over their stone skeletons scanty earth clings in folds, like shrunken flesh; they are emaciated corpses of once noble ranges now lifeless, outstretched in a long sleep. . . . A white light beat down, dispelling the last trace of shadow, and above hung the burnished shield of hard, pitiless sky.

Sinking to the *west* from our feet the gentle golden-green *glacis* sloped away, flanked by rolling hills covered with a fresh vernal carpet of grass, and relieved by scattered groves of dark oak-trees. Upon the distant valley were checkered

fields of grass and grain just tinged with the first ripening yellow. The bounding Coast Ranges lay in the cool shadow of a bank of mist which drifted in from the Pacific, covering their heights. Flocks of bright clouds floated across the sky, whose blue was palpitating with light, . . . Tranquillity, abundance, the slow beautiful unfolding of plant life, dark shadowed spots to rest our tired eyes upon, the shade of giant oaks to lie down under, while listening to brooks, contralto larks, and the soft distant lowing of cattle.

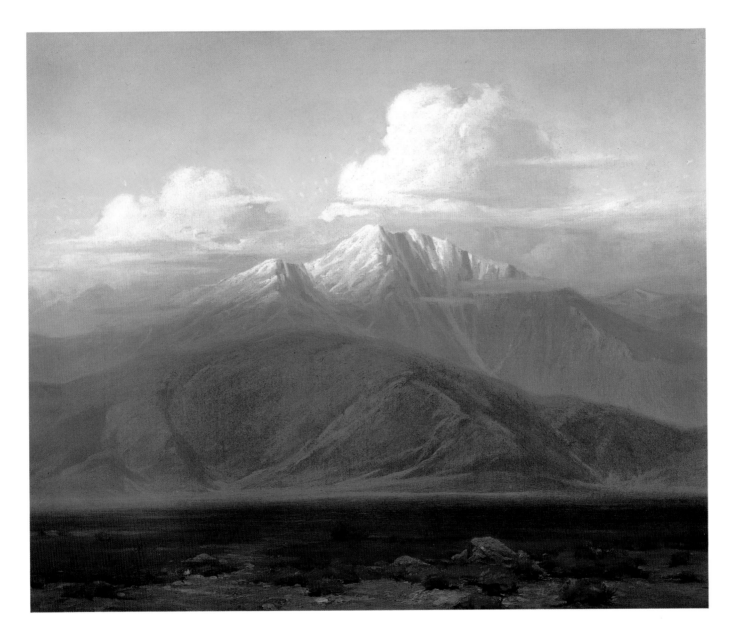

64 Victor Clyde Forsythe
Morning, 1923

The last of the old whaling-men of Monterey may still be haunting the water-front, and in the marine-store you may see a bomb-gun awaiting the purchaser who will never appear. On the bay, the mixture of dories, lateen-sailed fishing-craft, steam-launches, and glass-bottomed observation boats from which tourists may spy out wonders of Davy Jones's locker, mark the intermingling of the old and the newer interests.

It was evening as I walked again up the long street. As I passed along, I encountered now a tinkle of mandolins, now an odor of Spanish cookery and roses tangled together, quite unspeakable. Children played in the cypress-shaded gardens, or sat at the doors of the hunchbacked adobes with their fathers and mothers. . . . The last swallows were wheeling home, and the sparrows in the ivy were sleepily querulous. The fading light lingered on the crumbling cornices, and the tile-capped belfry rose peacefully into the clear dusk of the sky. After all, age is a kind of sacrament.
— J. Smeaton Chase

The wheat, now close to its maturity, had turned from pale yellow to golden yellow, and from that to brown. Like a gigantic carpet, it spread itself over all the land. There was nothing else to be seen but the limitless sea of wheat as far as the eye could reach, dry, rustling, crisp and harsh in the rare breaths of hot wind out of the southeast.
— Frank Norris

5. The San Francisco Peninsula to the San Joaquin

Santa Clara Valley, Santa Cruz, Monterey, Carmel, Point Lobos, the Salinas Valley, the San Joaquin Valley, and Bakersfield

The Age of Ostentation

Oscar Lewis, *Here Lived the Californians*, 1957

The discovery, in 1859, of rich deposits of silver on the slopes of Nevada's Sun Mountain marked the beginning of a new and grandiose era in San Francisco. During the next decade and a half new wealth flowed into the city . . . transforming a group of former merchants, innkeepers, bankers, and speculators into multimillionaires.

One of their number was William Chapman Ralston, picturesque financial plunger whose Bank of California, through its branch in Virginia City, enabled him and his partners to gain control of several of the Comstock Lode's most profitable mines. . . . Ralston launched a series of spectacular enterprises: the building of the Palace Hotel, the establishment of steamship lines, water companies, a theater, and so many other projects that he presently became known as "the man who built San Francisco."

Not the least impressive of Ralston's accomplishments was the building of Belmont, his huge, rambling residence . . . where for a decade or longer he entertained on a scale previously unknown on the west coast. When he acquired the property, which was situated on a pleasantly wooded hillside some twenty miles south of San Francisco, it was occupied only by a modest little villa. However, he at once began an extensive building program, adding story after story and wing after wing to the original structure, laying out elaborate gardens, and constructing greenhouses, stables, and quarters for the small army of household servants, gardeners, grooms, and other retainers needed to maintain the establishment.

Everything was done on a scale that set new standards even in that age of ostentation. [In] the stables housing his scores of horses . . . the stalls [were] finished in mahogany inlaid with mother-of-pearl, and in the harness room the gleaming harnesses and other equipment were hung from hooks of solid silver. One of the many outlying buildings was a gymnasium, containing a fully equipped Turkish bath, with trained attendants constantly on duty . . . Ralston built gasworks, and to assure an adequate supply of water, installed a dam and reservoir higher in the hills, plus an elaborate distribution system.

. . . On the house itself . . . the greatest care was expended. . . . Ralston . . . , a man of convivial instincts, . . . had constituted himself the unofficial host to distinguished visitors passing through San Francisco, [and] groups of guests were constantly enjoying his hospitality, their number rarely less than twenty and frequently reaching several times that many. . . . He several times enlarged the mansion; one authority states that by 1868 the big, rambling building could comfortably put up as many as 120.

Throughout his career Ralston had a flair for the dramatic and nothing pleased him more than to astound his guests at Belmont by some spectacular surprise. Sometimes this took the form of the viands set before them in the big dining room, as on the occasion when the main course of the three-hour-long

repast consisted of "a humming-bird filled with baked almonds, surrounded by a Spring linnet, which in turn, was enveloped by an English snipe." Another of his favorite devices was to assemble his guests in the library, the chairs and divans of which had all been arranged to face in the same direction; then, after a period of waiting, the entire wall before them rose slowly upward and disappeared into the ceiling, revealing the well-laden, snowy-white tables of the banquet hall, an army of Chinese waiters standing at attention.

The spectacular failure of Ralston's bank in the summer of 1875, and his subsequent drowning in the waters of the bay, brought Belmont's opulent period to a sudden close.

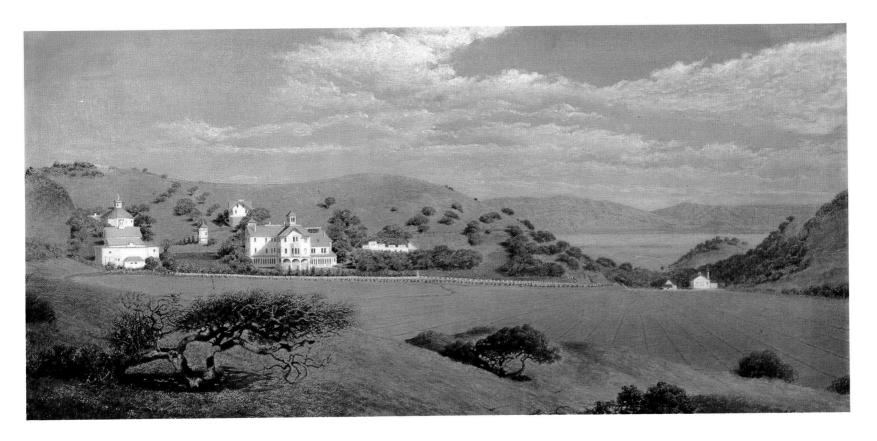

65 George Albert Frost
Belmont House of William C. Ralston, 1874

Across the Santa Clara Valley

John Muir, letter, 1868

We crossed the bay by the Oakland Ferry and proceeded up the Santa Clara valley to San José. This is one of the most fertile of the many small valleys of the coast; its rich bottoms are filled with wheat-fields, and orchards, and vineyards, and alfalfa meadows.

It was now spring-time, and the weather was the best we ever enjoyed. Larks and streams sang everywhere; the sky was cloudless, and the whole valley was a lake of light. The atmosphere was spicy and exhilarating, my companion acknowledging over his national prejudices that it was the best he ever breathed – more deliciously fragrant than that which streamed over the hawthorn hedges of England. This San José sky was not simply pure and bright, and mixed with plenty of well-tempered sunshine, but it possessed a positive flavor, a *taste* that thrilled throughout every tissue of the body. Every inspiration yielded a well-defined piece of pleasure that awakened thousands of new palates everywhere. Both my companion and myself had lived on common air for nearly thirty years, and never before this discovered that our bodies contained such multitudes of palates, or that this mortal flesh, so little valued by philosophers and teachers, was possessed of so vast a capacity for happiness.

We were new creatures, born again; and truly not until this time were we fairly conscious that we were born at all. Never more, thought I as we strode forward at faster speed, never more shall I sentimentalize about getting free from the flesh, for it is steeped like a sponge in immortal pleasure.

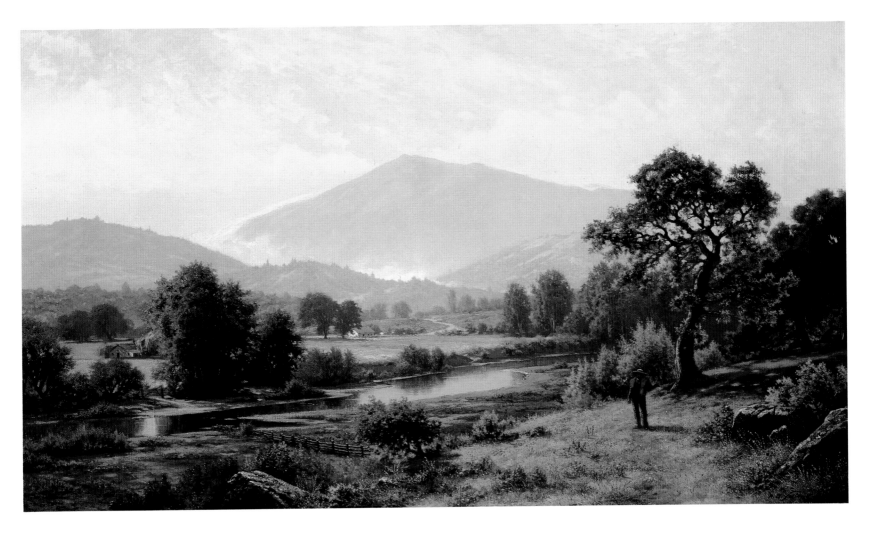

66 Raymond Dabb Yelland
 Summer Morning near Los Gatos, 1879

Orchard Country

Mary Austin, *The Land of the Sun*, 1914

Nothing could be more ethereally lovely than the spring aspect of the orchard country. It begins with the yellowing of the meadowlark's breast, and then of early mornings, the appearance, as if flecks of the sky had fallen, of great flocks of bluebirds that blow about in the ploughed lands and are dissolved in rain. Then the poppies spring up, like torchmen in the winter wheat, and along the tips of the apricots, petals begin to show, crumpled like the pink lips of children shut upon mischievous secrets. A day or two of this and then the blossoms swarm like bees; white fire breaks out among the prunes, it scatters along the foothills like the surf. Toward the end of the blooming season, all the country roads are defined by thin lines of petal drift and any wind that blows is alive with whiteness. After which, thick leafage covers the ripening fruit and the valley dozes through the summer heat with the farms outlined in firm green like patchwork drawn up across the mountains' knees.

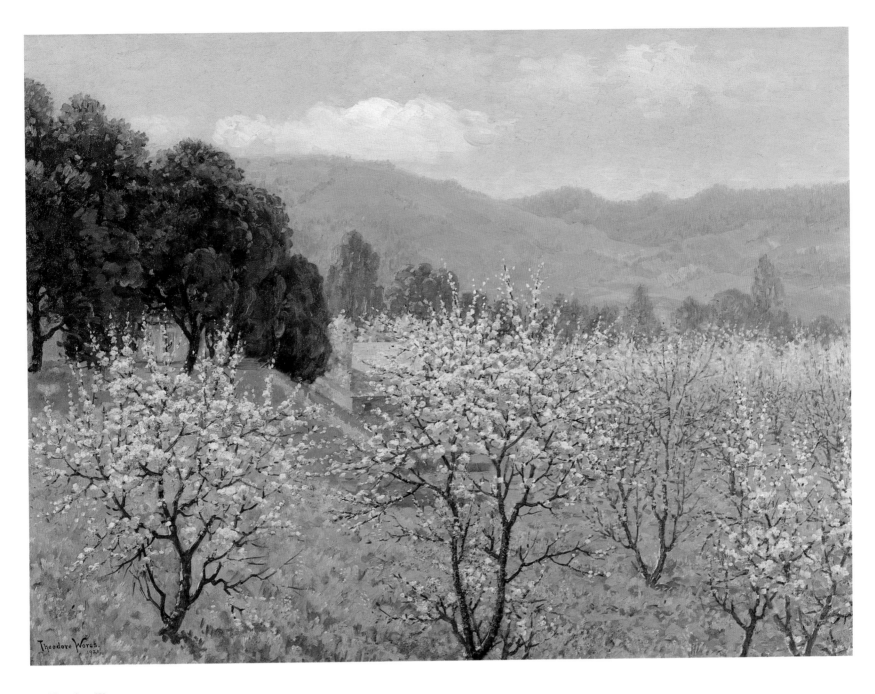

67 Theodore Wores
Tree Blossoms, 1920

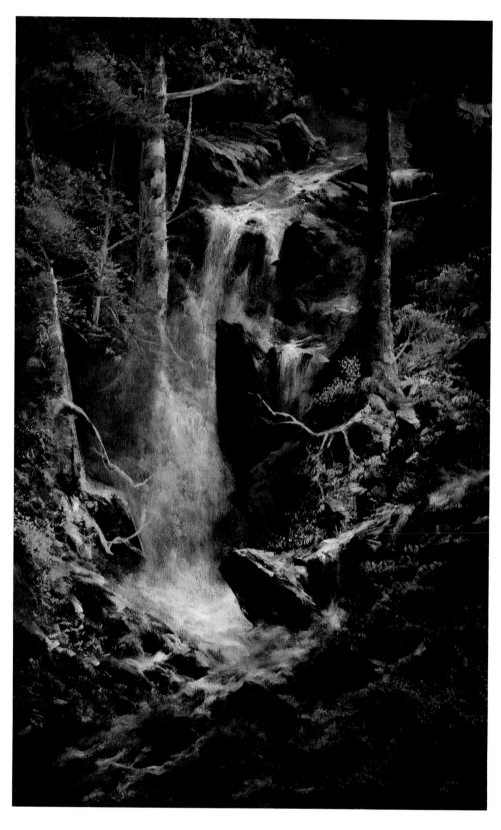

68 Ransom Gillet Holdredge
Scene in the Santa Cruz Mountains, n.d.

In the Santa Cruz Mountains

An easy ride next morning through quiet rural roads, and a village or two where loafers on sugar-barrels were dallying with watermelons, brought us to the city of Santa Cruz, lying at the north bend of Monterey Bay. . . .

The mountain belt that rises to the north of Santa Cruz carries a particularly fine forest of redwoods. I could not think of missing these noble giants, so once more I abandoned the coast for a few days. . . . The road followed the course of the beautiful San Lorenzo River, and I was soon again in the companionship of the trees, – a mingling of sequoia, spruce, alder, bay, box-elder, and maple. The cañon is a deep one, and the narrow road is cut into its western side, giving fine views up and down the wooded gorge.

Automobiles were unusually numerous and irresponsible, charging down on us round the sharpest curves with no formalities of horn-blowing. After Anton [Chase's horse] had passed through various stages of indignation and alarm, he could see nothing for it but to turn and bolt from every car we met, and I had some exciting moments while we pirouetted about on the edge of the five-hundred-foot chasm.

As I was eating my lunch . . . , a sound of shouting began to come up out of the cañon. It was in a peculiar sing-song drawl, and came nearer and nearer until, when it arrived close to where I sat, I stood up to see what phenomenon was about to appear. There was a creaking and cracking of underbrush, and then the heads of a yoke of oxen rose above the level of the road, and so remained while two pairs of solemn eyes took stock of me and my companion. Gradually six yoke emerged, followed by a man with a goad, who was the author of the melancholy music, and then by a wagon and trailer on which was a single huge log of redwood. They went quartering about from side to side of the road, and when four similar processions had followed them, and they had all come to anchor, the hubbub ceased, half the oxen lay down, and the drivers gathered at the spring for the noon meal. Just beyond, a side road led off to a grove of exceptionally fine sequoias. . . .

The great trees themselves . . . are wonderful and stately enough, the tall, tapering shafts rising in superb grace and power, flecked with purple and gold along their fluted channellings. A forest of their kind surrounds them, mingled with a few other species, and the clear, bright river ripples or steals along as seductively as river can do. . . .

Our road next day continued for a few miles along the cañon of the San Lorenzo as far as a small town, called Boulder Creek, chiefly remarkable for supporting an equipment of twenty-one saloons. From here I turned more westerly, following the course of the pretty stream from which the town is named, in order to visit the California Redwood Park, a tract of specially fine timber which has been rescued by the State from destruction and set aside as a public pleasure-ground. . . .

J. Smeaton Chase, *California Coast Trails*, 1913

These [redwood] forests have almost an oppressive effect upon the mind. A deep silence reigns; almost the only sound is that of some torrent coming down from the mountains, or the distant roar of the surf breaking upon the shore of the Pacific.
– William Henry Brewer, 1863

The summer crop of tourists had departed, and I found that the warden, whose duty it is to assign camping-places to visitors, had gone huckleberrying, like a wise official. . . . I made haste to pitch camp under a stately redwood, despite the warnings of a quarrelsome colony of squirrels. Here I spent a delightful Sunday, wandering beside brown creeks under superb sequoias and scarcely inferior spruces, and enjoying a veritable feast of huckleberries. It was my first introduction to the plant, and I found a double zest in the fruit when I saw what a sprightly and beautiful shrub supplied it.

I found the impressiveness of these splendid redwoods to be quite unlike that of their relatives, the Great Trees of the Sierra Nevada. Many of the trees in this belt of forest reach a diameter of over fifteen feet and a height of three hundred, the age of such patriarchs being known to exceed ten centuries. But they seemed to me to lack that individual majesty of bearing which the others express, and to gain their distinction rather from the cumulative effect of their statuesque beauty than from the solemnity of ponderous size and of primogeniture among living things.

I now turned again coastwards over a trail that traversed another noble tract of timber, known as the Big Basin. The shade was almost unbroken, and the trail carpeted deeply with fallen leaves of madroño and tan-bark oak. For hours the silence was unbroken but for Anton's muffled footfalls, and a curious distant sound, which greatly interested him, and which I guessed to be the moan of the syren at Pigeon Point, seven miles away. Now and then an acorn dropped sharply, or at a push of wind a few leaves whispering came down. The great stems of the redwoods were powdered with the gray rime of age, and the foliage showed the rich tinge of russet peculiar to this evergreen, the dead leaves of which long remain attached to the tree.

My admiration was constantly divided between the exquisite symmetry of the redwoods, the rugged magnificence of the spruces, and the rich red gleam of the madroño stems. The forest flowers were long past, but there was no lack for them; for here was a touch of scarlet or crimson from the frost-stained poison-oak, there a yellowing leaf-spray of tan-bark oak. All was gold, green, purple, and the sensitive warm or wan tones of autumn. . . .

. . . After some miles we crossed the west fork of Waddell Creek at a lovely place of dim pools, mossed rocks, and waving ferns. Reaching the next crest, on a sudden we were among arid brush and digger-pines, with a blaze of sunlight reflected from a white, shaly soil. After the hours of greenness and "dim religious light" the change was startling.

At the next rise I looked out upon the familiar sight of a deep seaward cañon up which the fog was creeping. Its waves were just rosied by the evening sun, and timbered shoulders of the mountain stood up, darkly purple, through the fleecy sea. Down this cañon we pursued our way in thoughtful mood attuned to the gathering shadows, and came by dusk to a lonely ranch where I made application for our lodging.

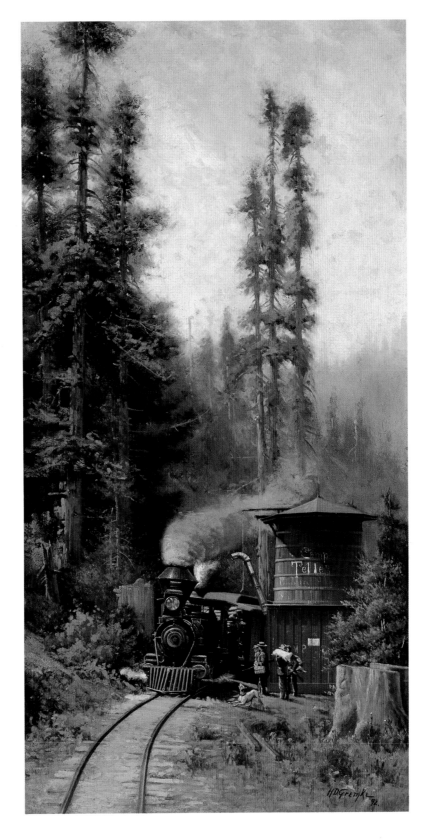

[Camp Teller] was a tank stop on the South Pacific Coast Railroad's narrow gauge line.

69 Deidrich Henry (Dick) Gremke
 Camp Teller, 1892

Monterey Bay

Robert Louis Stevenson,
The Amateur Emigrant, 1895

. . . It is the Pacific that exercises the most direct and obvious power upon the climate. At sunset, for months together, vast, wet, melancholy fogs arise and come shoreward from the ocean. From the hill-top above Monterey the scene is often noble, although it is always sad. The upper air is still bright with sunlight; a glow still rests on the Gabelano Peak; but the fogs are in possession of the lower levels; they crawl in scarves among the sandhills; they float, a little higher, in clouds of a gigantic size and often of a wild configuration; to the south, where they have struck the seaward shoulder of the mountains of Santa Lucia, they double back and spire up skyward like smoke. Where their shadow touches, colour dies out of the world. The air grows chill and deadly as they advance. The trade-wind freshens, the trees begin to sigh, and all the windmills in Monterey are whirling and creaking and filling their cisterns with the brackish waters of the sands. It takes but a little while till the invasion is complete. The sea, in its lighter order, has submerged the earth. Monterey is curtained in for the night in thick, wet, salt, and frigid clouds, so to remain till day returns, and before the sun's rays they slowly disperse and retreat in broken squadrons to the bosom of the sea. And yet often when the fog is thickest and most chill, a few steps out of the town and up the slope, the night will be dry and warm and full of inland perfume.

A windy bay at best, deep tides and squally surfaces, the waters of Monterey have other values than the colorist finds in them. Sardines, salmon, cod, tuna, yellowtail run with its tides. At most seasons of the year whales may be seen spouting there or are cast upon its shoals.
– Mary Austin, 1914

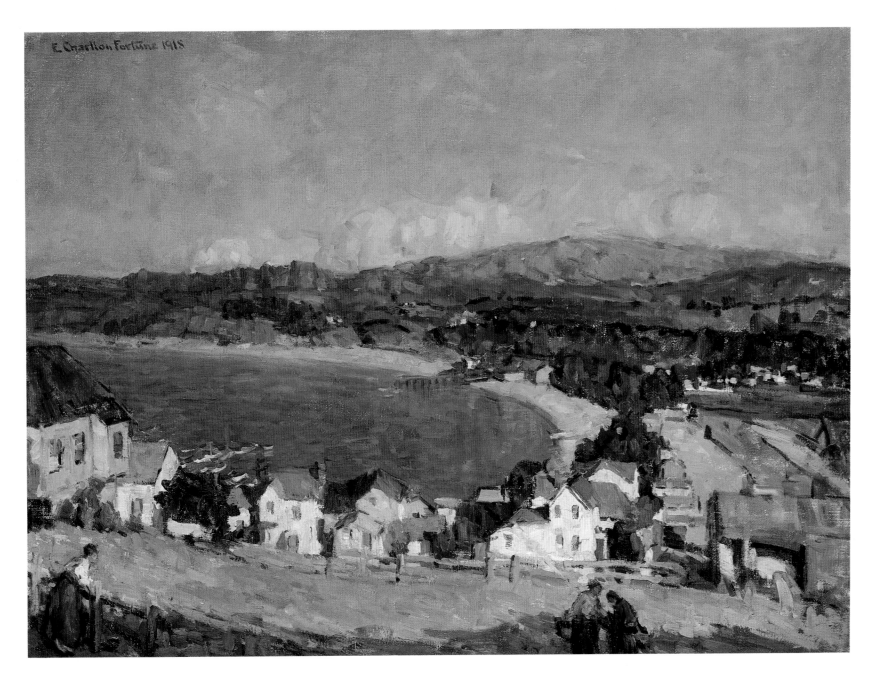

70 Euphemia Charlton Fortune
Monterey Bay, 1918

The Sea

Robert Louis Stevenson,
The Amateur Emigrant, 1895

The one common note of all this country is the haunting presence of the ocean. A great faint sound of breakers follows you high up into the inland cañons; the roar of water dwells in the clean, empty rooms of Monterey as in the shell upon the chimney; go where you will, you have but to pause and listen to hear the voice of the Pacific. You pass out of the town to the southwest, and mount the hill among pine woods. Glade, thicket, and grove surround you. You follow winding sandy tracks that lead nowhither. You see a deer; a multitude of quail arises. But the sound of the sea still follows you as you advance, like that of wind among the trees, only harsher and stranger to the ear; and when at length you gain the summit, out breaks on every hand and with freshened vigor, that same unending, distant, whispering rumble of the ocean; for now you are on the top of Monterey peninsula, and the noise no longer only mounts to you from behind along the beach towards Santa Cruz, but from your right also, round by Chinatown and Pinos lighthouse, and from down before you to the mouth of the Carmello river. The whole woodland is begirt with thundering surges. The silence that immediately surrounds you where you stand is not so much broken as it is haunted by the distant, circling rumour. It sets your senses on edge; you strain your attention; you are clearly and unusually conscious of small sounds near at hand; you walk listening like an Indian hunter; and that voice of the Pacific is a sort of disquieting company to you in your walk. . . .

. . . The boats that ride in the haven are of strange outlandish design; and, if you walk into the hamlet, you will behold costumes and faces and hear a tongue, that are unfamiliar to the memory. The joss-stick burns, the opium-pipe is smoked, the floors strewn with slips of coloured paper – prayers, you would say, that had somehow missed their destination – and a man guiding his upright pencil from right to left across the sheet, writes home the news of Monterey to the Celestial Empire.

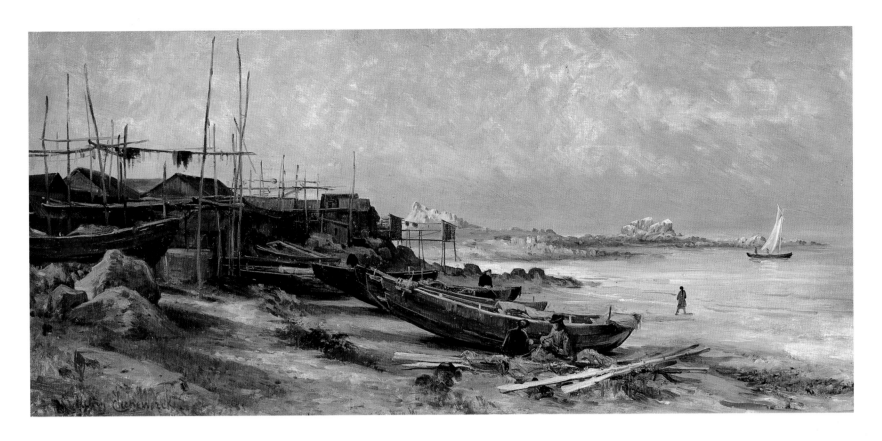

71 Henry Cleenewerck
Monterey, Chinese Fishing Village, c.1880

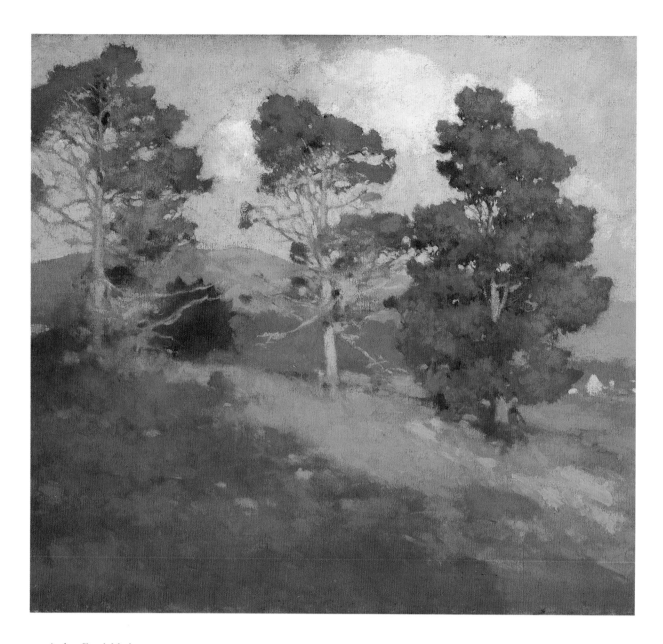

72 Arthur Frank Mathews
Monterey Pines, n.d.

Monterey Pines

. . . These pitch-pines of Monterey are, with the single exception of the Monterey cypress, the most fantastic trees. No words can give an idea of the contortion of their growth; they might figure without change in a circle of the nether hell as Dante pictured it; and at the rate at which trees grow, and at which forest fires spring up and gallop through the hills of California, we may look forward to a time when there will not be one of them left standing in that land of their nativity. At least they have not so much to fear from the axe, but perish by what may be called a natural although a violent death; while it is man in his short-sighted greed that robs the country of the noble redwood. Yet a little while and perhaps all the hills of sea-bound California may be as bald as Tamalpais.

Robert Louis Stevenson,
The Amateur Emigrant, 1895

. . . The ancient murrelet fattens for the long flight to the Alaskan breeding grounds, and in the wildest gales the little nocturnal auklets may be heard calling to one another above the warring thunder of the surf, or, when the nights are clear and the mists all banded low beneath the moon, they startle the beach wanderer with their high, keen notes and beetle whirring wings. Long triangular flights of curlew drop down these beaches against the westering sun, with wings extended straight above their heads.
– Mary Austin, 1914

Boats in a Fog

Robinson Jeffers, 1925. Poet
Jeffers built Tor House at Carmel
to overlook the sea.

. . . A sudden fog-drift muffled the ocean,
A throbbing of engines moved in it,
At length, a stone's throw out, between the rocks and the vapor,
One by one moved shadows
Out of the mystery, shadows, fishing-boats, trailing each other,
Following the cliff for guidance,
Holding a difficult path between the peril of the sea-fog
And the foam on the shore granite.
One by one, trailing their leader, six crept by me,
Out of the vapor and into it,
The throb of their engines subdued by the fog, patient and cautious,
Coasting all round the peninsula
Back to the buoys in Monterey harbor. A flight of pelicans
Is nothing lovelier to look at;
The flight of the planets is nothing nobler; all the arts lose virtue
Against the essential reality
Of creatures going about their business among the equally
Earnest elements of nature.

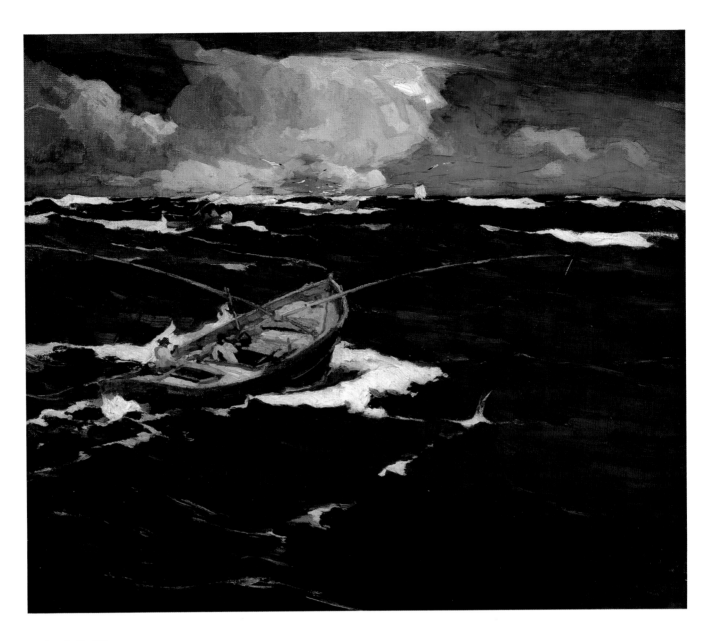

73 Armin Carl Hansen
Salmon Trawlers, 1918

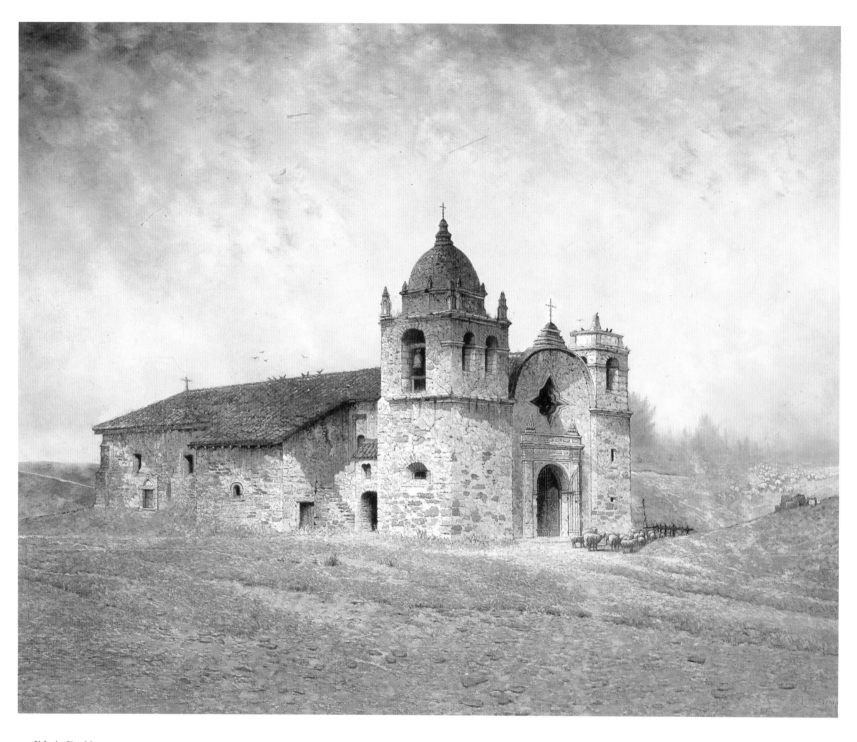

74 Edwin Deakin
Mission San Carlos Borromeo de Carmel, 1895

The Mission at Carmel

Carmel Valley breaks upon the bay by way of the river which chokes and bars, runs dry in summer, or carries the yellow of its sands miles out in winter, a winding track across the purple inlet. It is a little valley and devious, reaching far inland. Above its source the peaks of Santa Lucia stand up, having for their southern bulwark Palo Corona. Willows, sycamores, alders, wild honeysuckle, and great heaps of blackberry vines hedge the path of its waters.

Where the valley widens behind the low barrier that shuts out the sea, sits the Mission of San Carlo Borromeo, once the spiritual capital of Alta California. Here Junipero Serra, and after him the other padre presidentes, held the administration of Mission affairs and from here Serra wandered forth on foot, up and down this whole coast from San Diego to Solano with pacification and the seeds of civilization. Here on the walls, faintly to be traced beneath the scorn of time, he blazoned with his own hands the Burning Heart, the symbol of his own inward flame. Here, in his seventy-first year, he died and was buried on the gospel side of the altar. It is reported that his last act was to walk to the doorway to look once, a long look, on the hills turning amber under the August sun, on the heaven-blue water and the white hands of the surf beating the cliffs of Lobos, looked on the fields and the orchard planted by his own hand, on the wattled huts of the neophytes redeemed, as he believed them, to all eternity, after which he lay down and slept. It is further reported in the annals of the Mission that it was necessary to place a guard about the wasted body in its shabby brown gown, to defend it from the crowding mourners, craving relics of the blessed remains.

Mary Austin, *The Land of the Sun*, 1914

Across the neck of the peninsula, a matter of six or eight miles, cuts in the little bay of Carmel, a blue jewel set in silver sand. Two points divide it from the racing Pacific, the southern limb of Punta de Pinos, and the deeply divided rocky ledge of Lobos — lobos, the wolf, with thin raking granite jaws.
— Mary Austin, 1914

Ruins

William Henry Brewer, *Up and Down California*, 1861

The old Mission of Carmelo, in the Carmelo Valley, . . . is now a complete ruin, entirely desolate, not a house is now inhabited. The principal buildings were built around a square, enclosing a court. We rode over a broken *adobe* wall into this court. Hundreds (literally) of squirrels scampered around to their holes in the old walls. We rode through an archway into and through several rooms, then rode into the church. The main entrance was quite fine, the stone doorway finely cut. The doors, of cedar, lay nearby on the ground.

The church is of stone, about 150 feet long on the inside, has two towers, and was built with more architectural taste than any we have seen before. About half of the roof had fallen in, the rest was good. The paintings and inscriptions on the walls were mostly obliterated. Cattle had free access to all parts; the broken font, finely carved in stone, lay in a corner; broken columns were strewn around where the altar was; and a very large owl flew frightened from its nest over the high altar. I dismounted, tied my mule to a broken pillar, climbed over the rubbish to the altar, and passed into the sacristy. There were the remains of an old shrine and niches for images. A dead pig lay beneath the finely carved font for holy water. I went into the next room, which had very thick walls – four and a half feet thick – and a single small window, barred with stout iron bars. Heavy stone steps led from here, through a passage in the thick wall, to the pulpit. As I started to ascend, a very large owl flew out of a nook. Thousands of birds, apparently, lived in nooks of the old deserted walls of the ruins, and the number of ground squirrels burrowing in the old mounds made by the crumbling *adobe* walls and the deserted *adobe* houses was incredible – we must have seen *thousands* in the aggregate. This seems a big story, but *hundreds* were in sight at once. The old garden was now a barley field, but there were many fine pear trees left, now full of young fruit. Roses bloomed luxuriantly in the deserted places, and geraniums flourished as rank *weeds*. So have passed away former wealth and power even in this new country.

Point Lobos

Noon found us at Point Lobos. It is a superb headland overgrown with pines and cypresses that lean in perilous balance over the crashing sea, or stand statuesquely on rocky ledges, ideally pictorial. The cypresses are monarchial fellows, wonderful in size and evident age, and Lear-like in their storm-thrawn attitudes. Like the pines, they are strict natives of this locality, and give a unique charm to this delightful coast. By their manner of growth they reminded me of the monumental yews of English churchyards; and, indeed, there is much of the same solemnity in their gnarled stems, far-reaching, bony arms, and rich but gloomy foliage. . . .

I could not bring myself to miss any part of this enchanting coast, so next morning I took the road that follows the shore. . . . The shore-line is ideally broken and wonderfully rich in color; the water a play of emerald and sapphire hues breaking momentarily in sudden blaze of surf, or shaded to deeper tones by the brown sea banners of kelp. Promontory and cliff are peopled with fantastic forms of pine and cypress, sumptuous in sombre green or shagged with gray pennons of moss. Once the road ran for a mile or two under a deep cypress arbor, a green and brown tunnel lighted dimly by windows that opened on brilliant seas, and echoing with cadence of surf and scream of roving gull.

Many of the trees lie prone on the brown floor, mere tumbles of mossy green. Others are amorphous monsters with huge rheumatic knees and elbows, gray as the very bones of Time. At Cypress Point, the outer headland of the peninsula, where winds career most wildly, the gaunt wardens of the cliff have been torn, twisted, hunched, wrenched, battered, and hammered to the limit of tree resemblance. . . .

Beyond Cypress Point the shore falls to dunes of white sand, splashed with creeping sea-herbage, and trending northeasterly to Point Pinos, at the southern horn of Monterey Bay. Inland the ground rises wooded everywhere with pines; and it was deep pleasure to ride slowly along, hour after hour, in that fine companionship; on one hand the comfortable sigh of forest, on the other the long, solitary surge of the Pacific.

J. Smeaton Chase, *California Coast Trails*, 1913

The Whaling Beach

Robert Louis Stevenson,
The Amateur Emigrant, 1895

These long beaches are enticing to the idle man. It would be hard to find a walk more solitary and at the same time more exciting to the mind. Crowds of ducks and sea-gulls hover over the sea. Sandpipers trot in and out after the retiring waves, trilling together in a chorus of infinitesimal song. Strange sea-tangles, new to the European eye, the bones of whales, or sometimes a whole whale's car-case, white with carrion-gulls and poisoning the wind, lie scattered here and there along the sands. The waves come in slowly, vast and green, curve their translucent necks, and burst with a surprising uproar, that runs, waxing and waning, up and down the long keyboard of the beach. The foam of these great ruins mounts in an instant to the ridge of the sand glacis, swiftly fleets back again, and is met and buried by the next breaker. The interest is perpetually fresh. On no other coast that I know shall you enjoy, in calm, sunny weather, such a spectacle of Ocean's greatness, such beauty of changing colour, or such degrees of thunder in the sound.

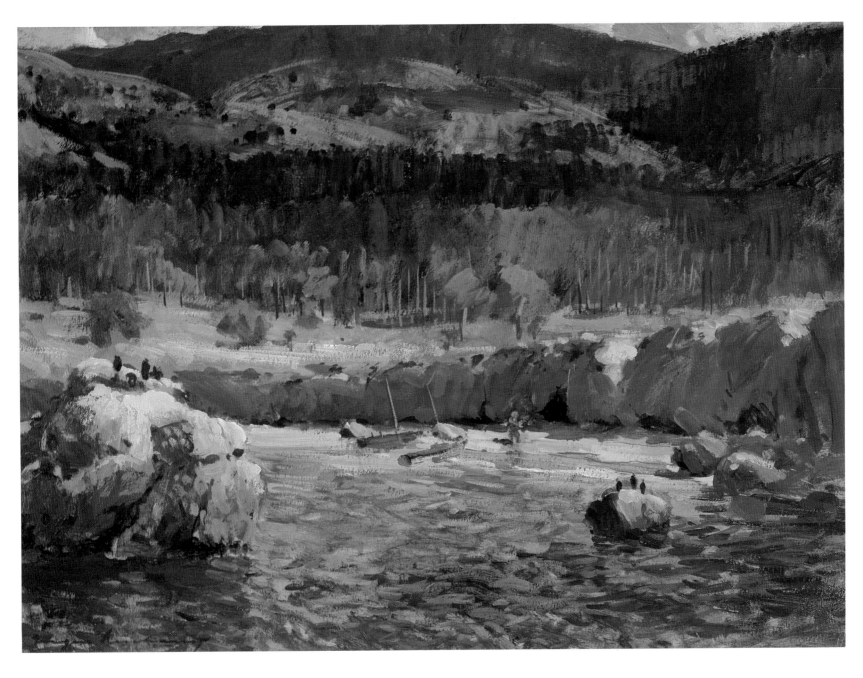

75 Karl Eugen Neuhaus
 Whaler's Cove, Point Lobos, n.d.

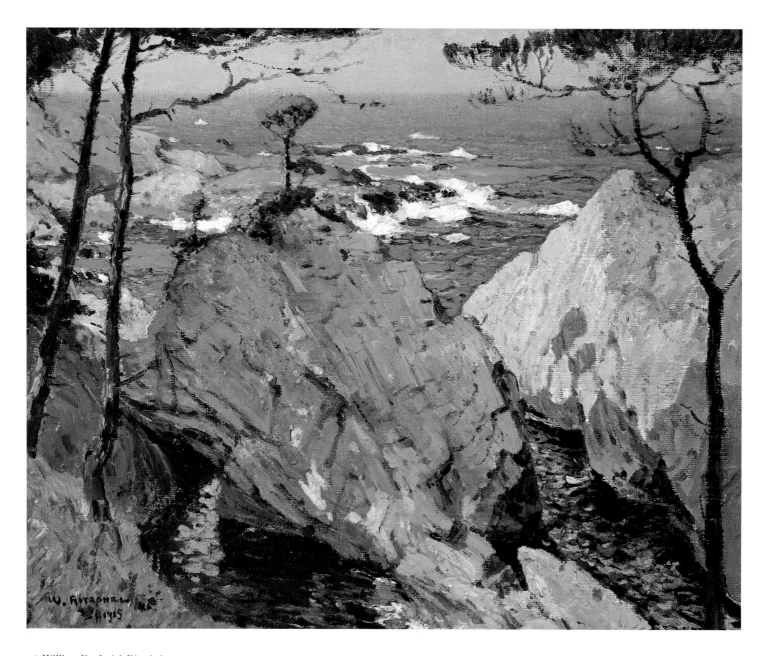

76 William Frederick Ritschel
The Poet's Cove, 1915

The Cove

They left Carmel River and Carmel Valley behind, and with a rising sun went south across the hills between the mountains and the sea. The road was badly washed and gullied and showed little sign of travel.

"It peters out altogether farther down," Billy said. "From there on its only horse trails. But I don't see much signs of timber, an' this soil's none so good. It's only used for pasture – no farmin' to speak of."

The hills were bare and grassy. Only the canyons were wooded, while the higher and more distant hills were furry with chaparral. Once they saw a coyote slide into the brush, and once Billy wished for a gun when a large wildcat stared at them malignantly and declined to run until routed by a clod of earth that burst about its ears like shrapnel.

Several miles along Saxon complained of thirst. Where the road dipped nearly at sea level to cross a small gulch Billy looked for water. The bed of the gulch was damp with hill-drip, and he left her to rest while he sought a spring.

"Say," he hailed a few minutes afterward. "Come on down. You just gotta see this. It'll 'most take your breath away."

Saxon followed the faint path that led steeply down through the thicket. Midway along, where a barbed wire fence was strung high across the mouth of the gulch and weighted down with big rocks, she caught her first glimpse of the tiny beach. Only from the sea could one guess its existence, so completely was it tucked away on three precipitous sides by the land, and screened by the thicket. Furthermore, the beach was the head of a narrow rock cove, a quarter of a mile long, up which pent way the sea roared and was subdued at last to the gentle pulse of surf. Beyond the mouth many detached rocks, meeting the full force of the breakers, spouted foam and spray high in the air. The knees of these rocks, seen between the surges, were black with mussels. On their tops sprawled huge sea-lions tawny-wet and roaring in the sun, while overhead, uttering shrill cries, darted and wheeled a multitude of sea birds.

Jack London, *The Valley of the Moon*, 1913

Salinas Valley

John Steinbeck, *East of Eden*, 1952

The Salinas Valley is in Northern California. It is a long narrow swale between two ranges of mountains, and the Salinas River winds and twists up the center until it falls at last into Monterey Bay.

I remember my childhood names for grasses and secret flowers. I remember where a toad may live and what time the birds awaken in the summer – and what trees and seasons smelled like – how people looked and walked and smelled even. The memory of odors is very rich.

I remember that the Gabilan Mountains to the east of the valley were light gay mountains full of sun and loveliness and a kind of invitation, so that you wanted to climb into their warm foothills almost as you want to climb into the lap of a beloved mother. They were beckoning mountains with a brown grass love. The Santa Lucias stood up against the sky to the west and kept the valley from the open sea, and they were dark and brooding – unfriendly and dangerous. I always found in myself a dread of the west and a love of the east. Where I ever got such an idea I cannot say, unless it can be that the morning came over the peaks of the Gabilans and the night drifted back from the ridges of the Santa Lucias. It may be that the birth and death of the day had some part in my feeling about the two ranges of mountains.

From both sides of the valley little streams slipped out of the hill canyons and fell into the bed of the Salinas River. In the winter of wet years the streams ran full-freshet, and they swelled the river until sometimes it raged and boiled, bank full, and then it was a destroyer. The river tore the edges of the farm lands and washed whole acres down; it toppled barns and houses into itself, to go floating and bobbing away. It trapped cows and pigs and sheep and drowned them in its muddy brown water and carried them to the sea. Then when the late spring came, the river drew in from its edges and the sand banks appeared. And in the summer the river didn't run at all above ground. Some pools would be left in the deep swirl places under the high bank. The tules and grasses grew back, and willows straightened up with the flood debris in their upper branches. The Salinas was only a part-time river. The summer sun drove it underground. It was not a fine river at all, but it was the only one we had and so we boasted about it – how dangerous it was in the wet winter and how dry it was in the dry summer. You can boast about anything if it's all you have. Maybe the less you have, the more you are required to boast.

I think of Bolsa Nueva, a new purse; Morocojo, a lame moor (who was he and how did he get there?); Wild Horse Canyon and Mustang Grade and Shirt Tail Canyon. The names of places carry a charge of the people who named them, reverent or irreverent, descriptive, either poetic or disparaging.
– John Steinbeck, 1952

The floor of the Salinas Valley, between the ranges and below the foothills, is level because this valley used to be the bottom of a hundred-mile inlet from the sea. The river mouth at Moss Landing was centuries ago the entrance to this long inland water. Once, fifty miles down the valley, my father bored a well. The drill came up first with topsoil and then with gravel and then with white sea sand full of shells and even pieces of whalebone. There were twenty feet of sand and then black earth again, and even a piece of redwood, that imperishable wood that

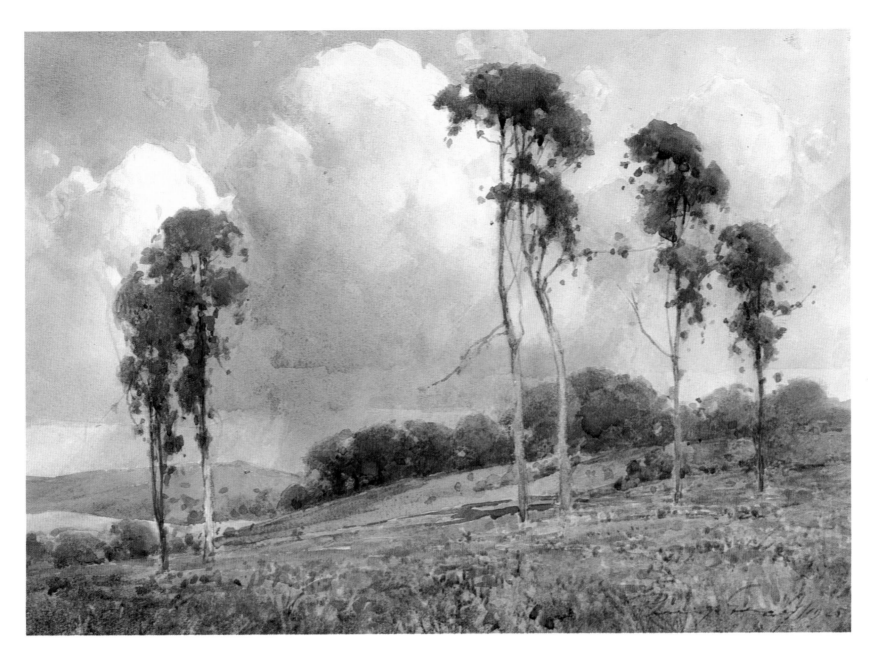

77 Henry Percy Gray
California Poppies and Eucalyptus, 1925

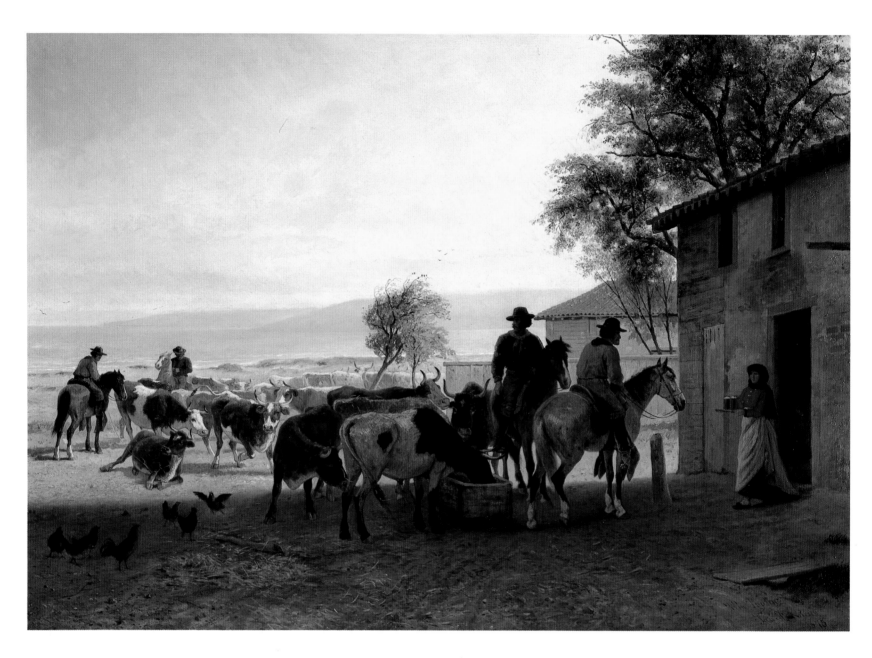

78 Carl Wilhelm (William) Hahn
Ranch Scene, Monterey, California, 1875

does not rot. Before the inland sea the valley must have been a forest. And those things had happened right under our feet. And it seemed to me sometimes at night that I could feel both the sea and the redwood forest before it.

On the wide level acres of the valley the topsoil lay deep and fertile. It required only a rich winter of rain to make it break forth in grass and flowers. The spring flowers in a wet year were unbelievable. The whole valley floor, and the foothills too, would be carpeted with lupins and poppies. Once a woman told me that colored flowers would seem more bright if you added a few white flowers to give the colors definition. Every petal of blue lupine is edged with white, so that a field of lupins is more blue than you can imagine. And mixed with these were splashes of California poppies. These too are of a burning color – not orange, not gold, but if pure gold were liquid and could raise a cream, that golden cream might be like the color of the poppies. When their season was over the yellow mustard came up and grew to a great height. When my grandfather came into the valley the mustard was so tall that a man on horseback showed only his head above the yellow flowers. On the uplands the grass would be strewn with buttercups, with hen-and-chickens, with black-centered yellow violets. And a little later in the season there would be red and yellow strands of Indian paintbrush. These were the flowers of the open places exposed to the sun.

Under the live oaks, shade and dusky, the maiden-hair flourished and gave a good smell, and under the mossy banks of the water courses whole clumps of five-fingered ferns and goldy-backs hung down. Then there were harebells, tiny lanterns, cream white and almost sinful looking, and these were so rare and magical that a child, finding one, felt singled out and special all day long.

When June came the grasses headed out and turned brown, and the hills turned a brown which was not a brown but a gold and saffron and red – an indescribable color. And from then on until the next rains the earth dried and the streams stopped. Cracks appeared on the level ground. The Salinas River sank under its sand. The wind blew down the valley, picking up dust and straws, and grew stronger and harsher as it went south. It stopped in the evening. It was a rasping nervous wind, and the dust particles cut into a man's skin and burned his eyes. Men working in the fields wore goggles and tied handkerchiefs around their noses to keep the dirt out.

The valley land was deep and rich, but the foothills wore only a skin of topsoil no deeper than the grass roots; and the farther up the hills you went, the thinner grew the soil, with flints sticking through, until at the brush line it was a kind of dry flinty gravel that reflected the hot sun blindingly. I have spoken of the rich years when the rainfall was plentiful. But there were dry years too, and they put a terror on the valley. The water came in a thirty-year cycle. There would be five or six wet and wonderful years when there might be nineteen to twenty-five inches of rain, and the land would shout with grass. Then would come six or seven pretty good years of twelve to sixteen inches of rain. And then the dry years would come, and sometimes there would be only seven or eight inches of

Places were also named from the way the expedition felt at the time: Buena Esperanza, good hope; Buena Vista because the view was beautiful; and Chualar because it was pretty. The descriptive names followed: Paso de los Robles because of the oak trees; Los Laureles for the laurels; Tularcitos because of the reeds in the swamp; and Salinas for the alkali which was white as salt.
– John Steinbeck, 1952

Then places were named for animals and birds seen – Gabilanes for the hawks which flew in the mountains; Topo for the mole; Los Gatos for the wild cats. The suggestions sometimes came from the nature of the place itself: Tassajara, a cup and saucer; Laguna Seca, a dry lake; Corral de Tierra for a fence of earth; Paraiso because it was like heaven.
– John Steinbeck, 1952

rain. The land dried up and the grasses headed out miserably a few inches high and great bare scabby places appeared in the valley. The live oaks got a crusty look and the sagebrush was gray. The land cracked and the springs dried up and the cattle listlessly nibbled dry twigs. Then the farmers and the ranchers would be filled with disgust for the Salinas Valley. The cows would grow thin and sometimes starve to death. People would have to haul water in barrels to their farms just for drinking. Some families would sell out for nearly nothing and move away. And it never failed that during the dry years the people forgot about the rich years, and during the wet years they lost all memory of the dry years. It was always that way.

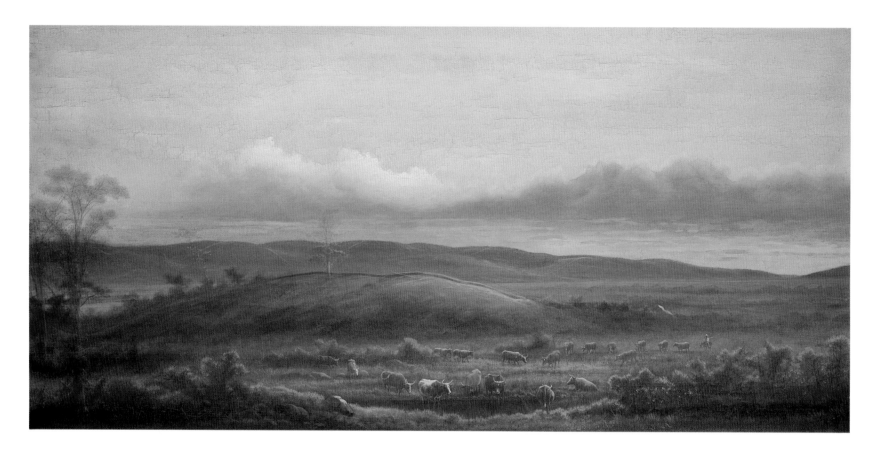

79 James Walker
 Pastoral Scene, Salinas River Valley, c. 1850

Ploughing in the San Joaquin

The ploughs, thirty-five in number, each drawn by its team of ten, stretched in an interminable line, nearly a quarter of a mile in length, behind and ahead of Vanamee. They were arranged, as it were, *en echelon . . .* , each succeeding plough its own width farther in the field than the one in front of it. Each of these ploughs held five shears, so that when the entire company was in motion, one hundred and seventy-five furrows were made at the same instant. . . . Each driver was in his place, his glance alternating between his horses and the foreman nearest at hand. Other foremen, in their buggies or buckboards, were at intervals along the line, like battery lieutenants. Annixter himself, on horseback, in boots and campaign hat, a cigar in his teeth, overlooked the scene.

The division superintendent, on the opposite side of the line, galloped past to a position at the head. For a long moment there was silence. A sense of preparedness ran from end to end of the column. All things were ready, each man in his place. The day's work was about to begin.

Suddenly, from a distance at the head of the line came a shrill trilling of a whistle. At once the foreman nearest Vanamee repeated it, at the same time turning down the line, and waving one arm. The signal was repeated, whistle answering whistle, till the sounds lost themselves in the distance. At once the line of ploughs lost its immobility, moving forward, getting slowly under way, the horses straining in the traces. A prolonged movement rippled from team to team, disengaging in its passage a multitude of sounds – the click of buckles, the creak of straining leather, the subdued clash of machinery, the cracking of whips, the deep breathing of nearly four hundred horses, the abrupt commands and cries of the drivers, and, last of all, the prolonged, soothing murmur of the thick brown earth turning steadily from the multitude of advancing shears.

The ploughing thus commenced, continued. The sun rose higher. Steadily the hundred iron hands kneaded and furrowed and stroked the brown, humid earth, the hundred iron teeth bit deep into the Titan's flesh. Perched on his seat, the moist living reins slipping and tugging in his hands, Vanamee, in the midst of this steady confusion of constantly varying sensation, on this swaying, vibrating seat, quivering with the prolonged thrill of the earth, lapsed to a sort of pleasing numbness, in a sense, hypnotized by the weaving maze of things in which he found himself involved. To keep his team at an even, regular gait, maintaining the precise interval, to run his furrows as closely as possible to those already made by the plough in front – this for the moment was the entire sum of his duties. But while one part of his brain, alert and watchful, took cognizance of these matters, all the greater part was lulled and stupefied with the long monotony of the affair.

The ploughing, now in full swing, enveloped him in a vague, slow-moving whirl of things. Underneath him was the jarring, jolting, trembling machine; not a clod was turned, not an obstacle encountered, that he did not receive the

Frank Norris, *The Octopus: A Story of California*, 1901

The silence was infinite. After the harvest, small though that harvest had been, the ranches seemed asleep. . . . It was the period between seasons, when nothing was being done, when the natural forces seemed to hang suspended. There was no rain, there was no wind, there was no growth, no life; the very stubble had no force even to rot. The sun alone moved.
– Frank Norris, 1901

183

swift impression of it through all his body, the very friction of the damp soil, sliding incessantly from the shiny surface of the shears, seemed to reproduce itself in his finger-tips and along the back of his head. He heard the horse-hoofs by the myriads crushing down easily, deeply, into the loam, the prolonged clinking of trace-chains, the working of the smooth brown flanks of the harness, the clatter of wooden hames, the champing of bits, the click of iron shoes against pebbles, the brittle stubble of the surface ground cracking and snapping as the furrows turned, the sonorous, steady breaths wrenched from the deep, labouring chests, strap-bound, shining with sweat, and all along the lines the voices of the men talking to the horses. Everywhere there were visions of glossy brown backs, straining, heaving, swollen with muscle; harness streaked with specks of froth, broad, cup-shaped hoofs, heavy with brown loam, men's faces red with tan, blue overalls spotted with axle-grease; muscled hands, the knuckles whitened in their grip on the reins, and through it all the ammoniacal smell of the horses, the bitter reek of perspiration of beasts and men, the aroma of warm leather, the scent of dead stubble – and stronger and more penetrating than everything else, the heavy, enervating odour of the upturned, living earth.

At intervals, from the tops of one of the rare, low swells of the land, Vanamee overlooked a wider horizon. . . . Everywhere throughout the great San Joaquin, unseen and unheard, a thousand ploughs up-stirred the land, tens of thousands of shears clutched deep into the warm, moist soil.

It was the long stroking caress, vigorous, male, powerful, for which the Earth seemed panting. The heroic embrace of a multitude of iron hands, gripping deep into the brown, warm flesh of the land that quivered responsive and passionate under his rude advance, so robust as to be almost an assault, so violent as to be veritably brutal. There, under the sun and under the speckless sheen of the sky, the wooing of the Titan began, the vast primal passion, the two world-forces, the elemental Male and Female, locked in a colossal embrace, at grapples in the throes of an infinite desire, at once terrible and divine, knowing no law, untamed, savage, natural, sublime. . . .

Annixter had disappeared. He had ridden farther on to the other divisions of his ranch, to watch the work in progress there. At twelve o'clock, according to his orders, all the division superintendents put themselves in communication with him by means of the telephone wires that connected each of the division houses, reporting the condition of the work, the number of acres covered, the prospects of each plough traversing its daily average of twenty miles. . . .

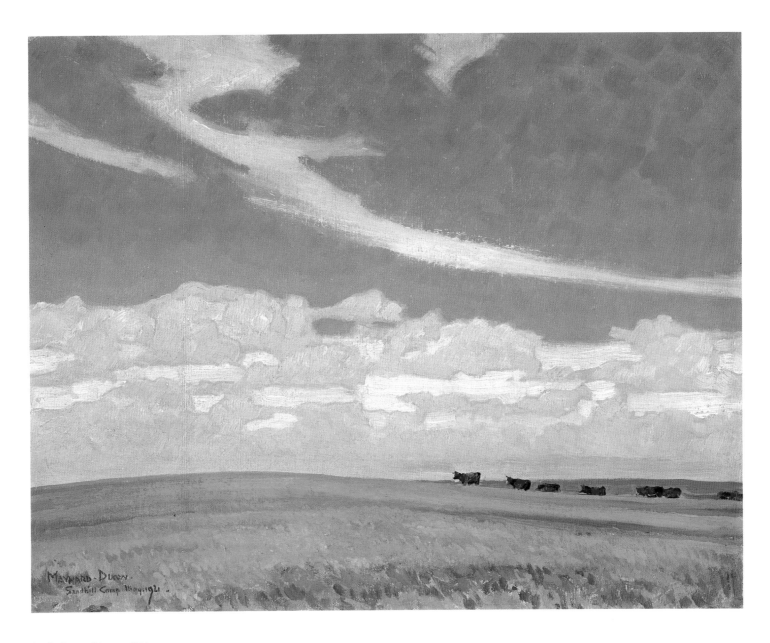

80 Lafayette Maynard Dixon
Prairie After Storm, *1921*

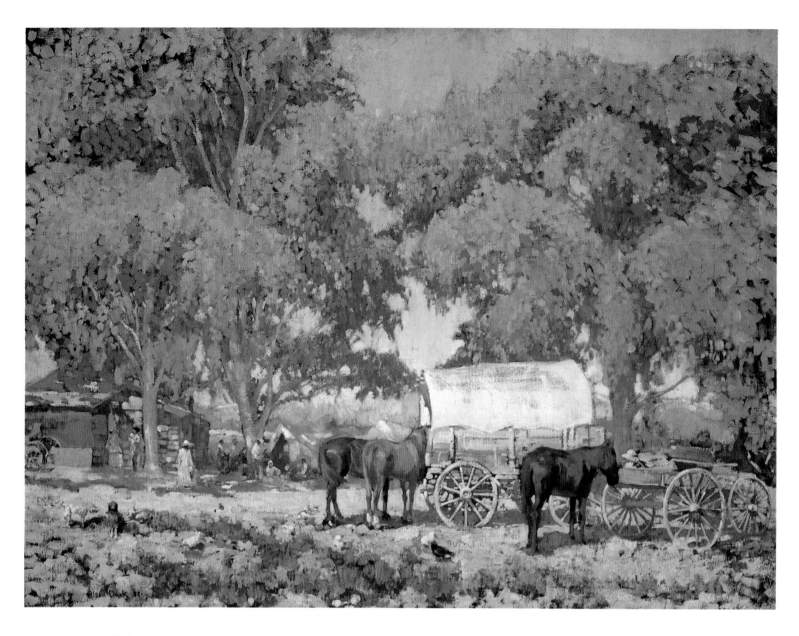

81 Alson Skinner Clark
The Fruit Pickers, 1922

A Golden Valley

Bakersfield lies on what is called Kern Island, a large tract of extraordinarily rich alluvial land, abundantly watered by the Kern River, which flows about and past it into Kern Lake after emerging from the mountains through a romantic pass within sight of the town.

Charles Nordhoff, *California: For Health, Pleasure, and Residence*, 1874

This pass, as well as Kern Lake, I hear, Bierstadt is soon to visit at the instance of General Beale, the owner of the Tejon Rancho near here. It is too early in April to go into the mountains, or I should be tempted to precede Mr. Bierstadt; for the head-waters of the Kern are said to contain some scenery equal to the Yosemite in grandeur and stupendous proportions, and the region is very little known except to a few hunters and frontiersmen. . . .

The slope of the Sierra from Visalia down to Bakersfield will, now that the region is easily accessible to tourists, become for the first time generally known, and I do not doubt it will next year be one of the great haunts of travelers to this State; for, aside from the mountain scenery, to persons fond of hunting and fishing, Kern River, and Kern and Buena Vista lakes offer greater attractions than perhaps any part of the United States. The river abounds in large trout; the lakes and the slough or strait which unites them are also filled with fish, and abound with wild life of almost every kind. Ducks, geese, cranes, swans, and snipe swarm on and near the shores. In the tule reeds, far out in the lake, you find the raccoon perched on high, watching for fish and ducks; otter and beaver, the first in large numbers, are shot by neighboring sportsmen; and in the mountains which surround these lakes, at a little distance, the California lion, the grizzly and cinnamon bears, the wild-cat (a formidable little beast), antelope, deer, and fox are to be found by those who care to look for them.

On the Mojave Desert – which is so far from being a desert that it is covered with luxuriant vegetation, and is called a desert because it is without running streams of water – great herds of antelope are grazing at this time and the young are frequently caught with the lasso by Mexicans.

All this, with the grand and novel scenery of the Kern River and the country adjoining, will form no slight inducement to travelers; indeed, I advise every man who comes over here for four or six weeks to give at least two weeks to this southern country; and he will regret that he has not three times the time to give it.

You will hear in San Francisco, no doubt, as I did, that it is a wild country in which every one goes armed, and where you may with very little trouble lose your life or your purse. But it is not true. Contrary to the advice of friends, I brought no arms with me; I found every body civil, and my precious person and property perfectly secure.

Bakersfield has as of yet no hotel; but this I hear is to be remedied this summer. Until it is, no one should take ladies down there, for the accommodations are of the rudest. A traveler in this part of Southern California will do well to

provide himself with a pair of good blankets in San Francisco, Stockton, or Visalia; then he is independent; for with these and an overcoat he can, if it is necessary, sleep on the verandah of a store or on the ground, and he need not fear catching cold.

The most valuable fruits and other products known to commerce grow here safely and easily; life and property are secure; there is nothing here, except idleness, ignorance, and unthrift, to prevent farmers, in a few years, becoming rich. . . . A peach orchard begins to bear the second year after planting the pits; I have seen vines – such as grow only in hot-houses with us at home – which bore and matured clusters of grapes the same year in which the cuttings were planted; the apple bears handsomely at three years from the nursery; the dwarf pear, which has so generally failed with us, every body tells me bears here constantly; in the vegetable-garden the tomato ripens in almost every month of the year; the strawberry blossoms in February, and there is no month in which, with but little care, the family can not get an abundant and varied supply of vegetables from the garden.

But the farming is, for the most part, slipshod and disgraceful. In the whole San Joaquin Valley, from Stockton to the Tejon Pass, I have not seen even a dozen well-kept farms, and yet I have traveled slowly and kept my eyes open. In some other parts of the State I have seen thorough and intelligent farming; I have always found the men who practiced it not merely comfortable, but rich, or rapidly becoming rich.

It should be said that the Valley has hitherto attracted but little attention from farmers with capital. Without railroad communications, it did not tempt them; and it must be added that a great many people have quietly got rich in it by the most slip-shod farming. You would be surprised to see how much wealth is in the hands of farmers and graziers about a place like Visalia—and what poor use they make of it.

Up and down this empire belt proceed two great companies, the hordes of "fruit-hands" and the army of bees following its successive waves of fruit and bloom. Gangs of pruners, pickers, and packers are shifted and shunted as the crop demands. Interesting economic experiments transact themselves under the worried producer's eye, alien race contending with alien race. The jarring interests of men have by no means worked out the absolute solution, but the bees have long ago settled their business. They kill the drones and gather the honey for the gods who kindly provide them with hives. . . .
– Mary Austin, 1914

A Tribute to California
Nature has designed our young queen, sitting by the
sunset sea, bathing her feet in its pacific waters, her
flowing hair touching our golden hills, her fairy fin-
gers plucking the peach and the lily the year round —
as one of the brightest constellations in the galaxy of
stars of our never to be ruptured Union. No land so
favored; none so promising.
— Charles Maclay,
* developer of San Fernando Valley*

6. Morro Bay through the Great Valley to Los Angeles

Morro Bay, Santa Barbara, Tejon Pass, San Fernando Valley, Pasadena, the Arroyo Seco, Los Angeles, San Gabriel Cañon, Arcadia, Riverside, Anaheim, Santa Ana Canyon

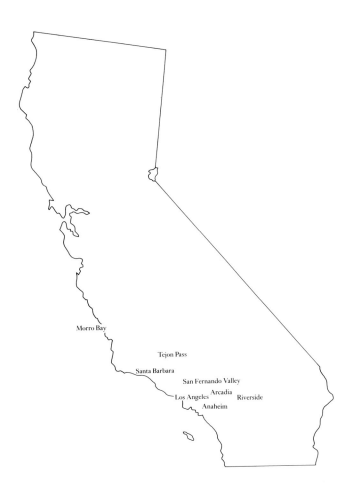

Morro Bay

San Luis Obispo Holiday Tribune,
January 1, 1882

The temperature of the coast section [of the County of San Luis Obispo] is more uniform in the winter than it is in the spring and summer months. In the latter months the prevailing northwest winds occasionally blow with some violence immediately along the coast and through the valleys which open fairly to the sea, and drive through them great fog drifts, which rise from the ocean in the evenings and settle down at night close to the earth. The light glare of the fog presents a striking contrast with the sombre slopes of the hills and mountains, with their sharp summit lines cutting clear against the dark blue of the night sky. But at sunrise the fog rises, and rolling up the mountain sides, disappears. . . .

The Morro or Estero Bay is situated ten miles south of Cayucos. The channel is narrow and winds around the base of Morro Rock, which serves to protect the entrance to the harbor or bay, which is perfectly land-locked. The channel carries about nine feet at low water. The rise and fall of the tide is about five and a half feet. A town has been built upon the shores of the bay, and small steamers run regularly between it and San Francisco.

[The town of Morro] has generally a dull appearance as its business is at present contracted. . . . When the country in the neighborhood becomes more settled than it is at present with a farming population, the business of the town will unquestionably increase and impart new life to it. It contains a hotel building, two stores, a fine school-house, which is also used as a church, and some comfortable looking private dwellings with gardens. Its population is about 100. . . .

The productiveness of the valley bottom lands cannot be surpassed. When well cultivated the yield is enormous, one hundred bushels of barley to the acre have been raised, and wheat has yielded as high as sixty bushels. The yield of corn and beans is also very large. The farming era did not fairly commence in these valleys until the year 1866, although a limited amount of acreage had been annually sown previously in wheat, corn, beans, potatoes and vegetables. Last year 70,000 acres were sown in wheat, barley, flax, corn and beans. But there are yet large areas of rich valley lands which remain untouched by the plow, and used solely for grazing purposes.

There enters in this cañada at its southern side an immense estero that seems to us to be a port; its mouth is open toward the southwest and we observed that it was covered with reefs that occasioned furious breakers; a little distance further to the north we saw a great rock that was the shape of a dome, and that at low water is isolated and separated from the coast less than a musket-shot. From the morro the shore makes to the west and northwest.
– Fray Juan Crespi, 1769

All the fruits of the temperate zone and some semi-tropical varieties are successfully cultivated in the valleys lying close to the western slope of the Santa Lucia range. The varieties of the grape now found in the very few vineyards which has as yet been planted in these localities are the Black Prince, Flame Tokay, Muscat of Alexandria, Black Hamburg, Black Morocco, Zinfandel, Riesling, Frontignan and the Mission. The fruit develops well and is of excellent flavor. The olive, apricot, plum, almond and fig trees yield their fruits in great abundance. Indeed, it would seem that no climate or soil can be more propitious to the successful cultivation of these latter fruits than can be found in the valleys lying under the shadow of this range. . . .

There is a topographical feature of this section which is of great advantage to

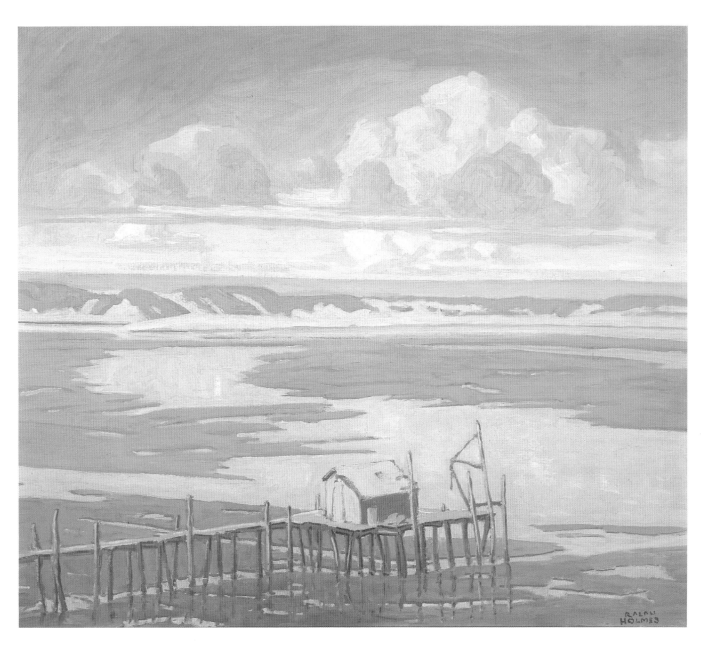

82 Ralph William Holmes
Low Tide, Morrow [Morro] Bay, n.d.

the agricultural interests. A chain of highlands or hills line the coast, rising in many places directly from the water's edge. They begin just south of Santa Rosa creek and extend to within a few miles of Cayucos, where a break occurs. Immediately south of Morro or Estero bay they again follow the coast line to within a few miles of the southern boundary of the county. The northern section, lying between Santa Rosa creek and Cayucos, does not exceed 250 feet in height. But south of the Morro, they attain in places an altitude of 2000 feet. They protect the valleys from the too direct and unintermitting influences of the sea air, excepting the exposed lower portions of those which open fairly to the sea. The protection thus afforded by this natural barrier, enables the farmers to raise fine grades of wheat, the most valuable of all the cereals. . . .

Between the Osos and Laguna and the Chorro Valleys, and extending south of the City of San Luis Obispo, is a chain of buttes. They terminate with Morro Rock, which rises perpendicularly from the sea. The higher ones attain an altitude of 1500 feet. They seem to lie in a straight line and apparently equidistant. Viewed from a distance they appear like huge sentinels. Sentinel peaks would seem an appropriate name for them. They are of a light gray trachyte porphyry, with a belt of serpentine at their southern base. The smaller ones, south of the city, are almost exclusively of serpentine. The trachytic buttes have precipitous crests, and many large rounded boulders are found on their slopes. The serpentine buttes south of the city are more rounded in outline.

. . . San Luis Peak rises majestically to the height of 1200 feet, throwing its huge shadow over the city when the sun is sinking toward the western horizon, but leaving the summits of the opposite heights all aglow with violet tints. It stands alone. The steep and rugged declivities of its rocky crest are frequently wreathed with silvery mists, and strikingly contrast with its lower slopes and ravines, fringed in places with scattered oaks and fertilized by numerous springs flowing from the fissures of the rocks above.

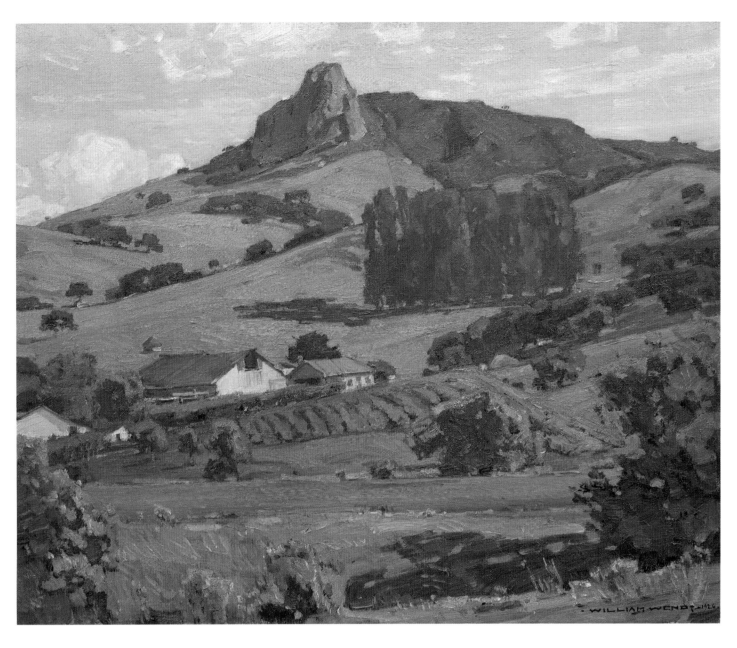

83 William Wendt
The Vineyard (Ranch near Morro Bay), 1926

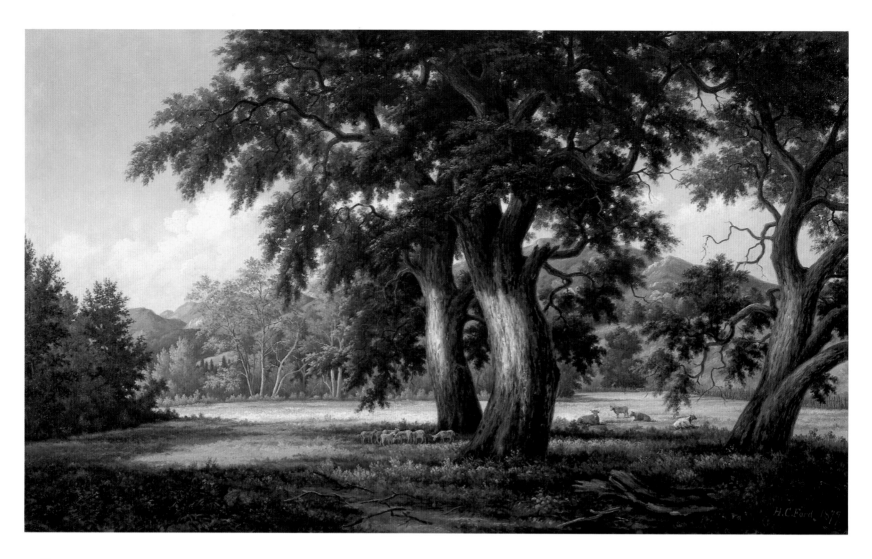

84 Henry Chapman Ford
 Glen Annie Canyon, 1879

Gaviota Pass

I now turned again toward the coast, taking a road which crosses the mountains by the Gaviota Pass, a few miles to the west of the one by which I had come.

J. Smeaton Chase, *California Coast Trails*, 1913

I was more than ever delighted by the beauty of this region, which for mile on mile is a literal park of undulating hill-land decorated with kingly oaks, many of which must be full twenty feet in girth of stem. Along the watercourses grew sycamores commensurate in size, which gave the name of Alisal to this grant. A mild wind blew from the north, and before it the waves of shining grass flowed past in rich volume. Doves called and jays chuckled from every tree, and quail ran nimbly before us down the road. Chino[Chase's horse], well rested and fortified with hay and grain, was in good fettle, and marched along gaily, noting the green landscape with an approving eye. . . .

We had travelled so easily that it was close upon sunset when we reached the pass. Just beyond the summit I made camp under some oaks in a hollow where a small stream ran. The forage was unusually good, a thick mat of burr-clover almost a foot high. Chino affectionately rubbed his nose about in it in sheer joy, and ripped away with sighs of pleasure. I was not so well provided. The stream was so strong of alkali that the tea curdled in the boiling water; the best place I could find for sleeping slanted unpleasantly; and the south wind brought in such a dense fog from the sea that by morning my oilskin top-covering was like a hydrographic model, with watersheds, creeks, main streams, and reservoirs all in detail. However, I made my morning coffee doubly strong to offset the alkali and ward off what people used to call the "humours."

It must be by virtue of these dense and frequent fogs that the oaks of this region grow to such rare perfection. By this means they not only receive the necessary moisture for growth, which the roots would supply, but are enabled often actually to bathe and revel in it. They have not only bread, but wine; are comforted as well as fed; and their plump and cheerful faces reflect their enjoyment.

Now Santa Barbara . . . The only instance of the simoon on this coast, mentioned either in its history or traditions, was that occurring at Santa Barbara on Friday, the 17th of June, 1850. . . . About 1 o'clock P.M. . . . a blast of hot air from the northwest swept suddenly over the town, and struck the inhabitants with terror. It was quickly followed by others. At two o'clock the thermometer exposed to the air rose to 113°, and continued at or near that point for nearly three hours, while the burning wind raised dense clouds of impalpable dust. No human being could withstand the heat. All betook themselves to their dwellings. . . . Calves, rabbits, birds, etc., were killed, trees were blighted, fruit was blasted and fell to the ground, burned only on one side; the gardens were ruined. At five o'clock the thermometer fell to 122°, and at seven it stood at 77°.
– Walter Lindley, M.D., and Joseph Widney, M.D., 1888

Vancouver at Santa Barbara

George Vancouver, *The Voyage of Discovery*, 1792–1794. Captain Vancouver left England in 1791 to continue the explorations of Captain James Cook, with whom he had sailed to the northwest coast of America ten years earlier.

On a light breeze springing up from the westward, at about eight o'clock, we directed our course along shore to the eastward; our progress was very slow, owing to light winds, though the weather was very pleasant. About two in the afternoon we passed a small bay, which appeared likely to have afforded good anchorage, had it not been for a bed of seaweed that extended across its entrance, and indicated a shallow rocky bottom.

Within this bay a very large Indian village was pleasantly situated, from whence we were visited by some of the inhabitants; amongst whom was a very shrewd intelligent fellow, who informed us, in the Spanish language, that there was a mission and a Presidio not much further to the eastward. About five in the evening this establishment was discovered in a small bay, which bore the appearance of a far more civilized place than any other of the Spanish settlements. . . . The Presidio was nearest to the sea shore, and just shewed itself above a grove of small trees, producing with the rest of the buildings a very picturesque effect.

As I purposed to anchor somewhere for the night, and as this bay seemed likely not only to answer that purpose, but another equally essential, that of procuring some refreshments, we hauled in, and anchored in six fathoms water, sandy bottom. . . .

. . . I immediately sent Lieutenant [Spelman] Swaine to inform the commanding officer at the Presidio of our arrival, and as I intended to depart in the morning, to request that the Indians, who had shewn a great desire to trade with us, might be permitted to bring us, in the course of the night, such articles of refreshment as they had to dispose of; which, as we understood, consisted of an abundance of hogs, vegetables, fowls, and some excellent dried fish.

Mr. Swaine returned after meeting with a most polite and friendly reception from the commandant Senor Don Felipe Goycochea . . . The general deportment of this officer was evidently the effect of a noble and generous mind; and as this place, which was distinguished by the name of Santa Barbara, was under the same jurisdiction as San Francisco and Monterey, our very friendly reception here rendered the unkind treatment we had received on our late visits at . . . two other establishments the more paradoxical, and was perhaps only to be referred to the different dispositions of the persons in power. . . .

Our business being . . . in a train for easy execution, the agreeable society of our Spanish friends, the refreshments we procured, and the daily recreation which the country afforded, rendered our situation at Santa Barbara extremely pleasant. . . .

We were attended at breakfast . . . Monday the 18th [1793] with our friends from the shore; and the want of wind detained us at anchor until near noon; when we took leave of our Santa Barbara friends . . .

To sail into the bay, or more properly speaking the roadstead, of Santa Barbara, requires but few directions, as it is open and without any kind of interrup-

From the west window of my room I look out on the mission buildings. The sun rests on them from sunrise to sunset, and they seem to me to say more than any human voice on record can convey.
– Helen Hunt Jackson, 1882

tion whatever; the soundings on approaching it are regular, from 15 to 3 fathoms; the former from half a league to two miles, the latter within a cable and half of the shore. Weeds were seen growing about the roadstead in many places; but, so far as we examined, which was only in the vicinity of our anchorage, they did not appear to indicate shallower water, or a bottom of a different nature. The shores of the roadstead are for the most part low, and terminate in sandy beaches to which however its western point is rather an exception, being a steep cliff moderately elevated; to this point I gave the name of Point Felipe, after the commandant of Santa Barbara.

Santa Barbara fulfils her comfortable destiny, dozing among palms and roses beside the bluest of seas.
– J. Smeaton Chase, 1913

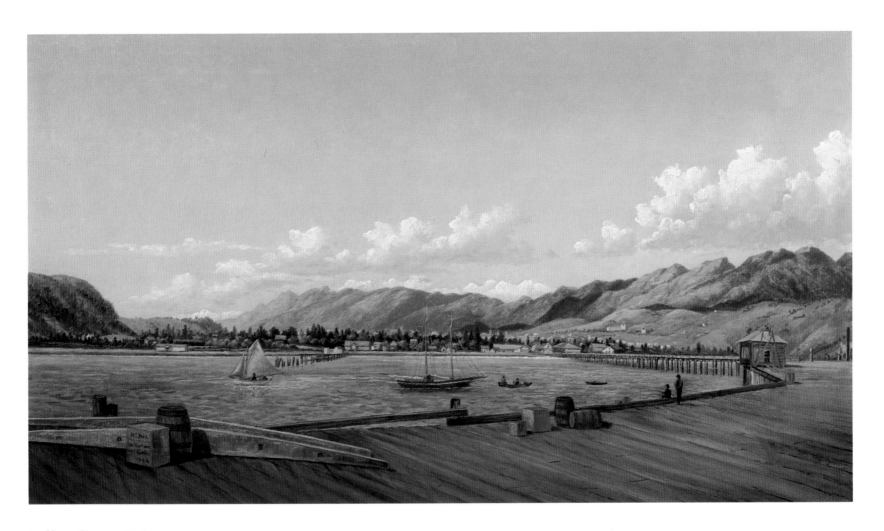

85 Henry Chapman Ford
Santa Barbara Harbor, 1884

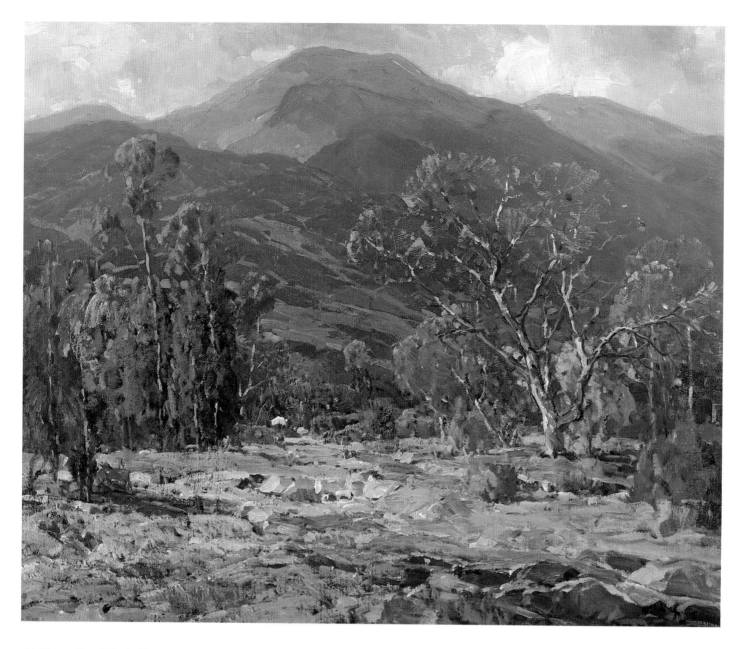

86 Hanson Duvall Puthuff
Transient Shadows, Sespe Canyon, n.d.

From Mountain Divide to Seacoast

J. Smeaton Chase, *California Coast Trails*, 1913

The trail, which had risen gradually, now crossed a divide between two high grassed hills, and I looked out upon the open valley, chequered in dark green of beets and pale gold of stubble, running level to the sea, six or eight miles away. Fifteen or twenty miles out to the west lay a group of rocky islands, the nearest one an odd conglomeration of spikes and splinters, the others more formal in outline. They were the Santa Barbara Channel Islands, Anacapa, Santa Cruz, Santa Rosa, and San Miguel. Somewhere on the last-named (which is the most westerly) is the resting-place of the brave navigator Juan Rodriguez Cabrillo, who, only fifty years after Columbus's epoch-making voyage, coasted far up "the Californias," to die, as he was returning, on this lonely outpost of the wonderful new world.

With a backward glance at the fine shape of Boney Mountain, his crags still attractively shrouded in a mystery of cloud, I started down the steep descent. The trail soon broadened to a wagon-road, and before long I rode out on the rich farming land of the Guadalasca Ranch. To this succeeded a long, straight county road, bordered by prosperous fields of beans and beets, the staples of the county; and in due time we entered the sleepy little coast village of Hueneme, where I put up my horse at the decaying livery-stable, and found clean and simple quarters for myself at the village inn.

. . . The place has an air of restfulness which is pleasant, . . . and, moreover, it has a lighthouse, – a modest wooden building, but, like all lighthouses, a fascinating object. As I stood on the shore in the dusk, and watched the steady beam of light streaming out over the gray wash of the ocean, there seemed something godlike in its kindly vigilance. All night it shone into the little room where I slept, throwing its moonlike beam every few seconds upon the white wall beside my bed.

Bear Fight

Major Horace Bell, *Reminiscences of a Ranger*, 1881. Butts, an adopted son of Thomas H. Benton, served as an officer in the regular army and then, in 1854 and 1855, as senior editor of the *Southern Californian*. He was hero of the remarkable bear fight in 1853.

It happened in San Luis Obispo County. I believe it was at the ranch of Captain Wilson that a party was made up to kill an immense grizzly "who would pick up a full-grown cow and walk away with her in his mouth, with as much ease as a mastiff would carry a rabbit." . . . The grizzly was found on the edge of the plain near a chaparral, and was immediately attacked by the hunters who lodged several balls in his body with which he escaped. The party commenced to beat the bush to get the bear out, and against the remonstrances of all, Butts followed the bear's trail into the thicket. The trail soon entered the dry, gravelly bed of an arroyo and was easily followed. Butts had followed the bear's track for about a half mile when suddenly he lost it. Being confused he stopped to deliberate, and was standing within a few feet of the bear that had lain down in the shade of a clump of chaparral on the side of the arroyo. With a great growl it sprang upon him so suddenly that he had no possible chance of using his Jeager, but as he went down under the ponderous weight of the bear he got his hunting knife out of its scabbard, and then the mortal strife commenced. Butts declared that he never lost his presence of mind, but endeavored to stab the bear in its vital parts, and that time after time he thrust his eight-inch blade to the hilt in the bear's body as it stood over him biting and tearing him with its claws. Butts said "the last sensation I had was the brute dragging itself over me, and its entrails trailing across my face." A half hour later the two combatants were found – the bear dead, Butts torn into pieces and apparently so. After examination showed that the bones of his face were so crushed that he was disfigured for life; the bones of his left arm and right leg were fractured in several places, some of his ribs were crushed in, and his body and legs were literally cut into strips.

It turned out that the bear had been severely wounded by the shots fired into it, but not mortally; that Butts' knife had twice penetrated the lungs and once entered the heart, and that an incision was made in its bowels nearly a foot long. A litter was hastily constructed and poor Butts was carefully carried to the ranch, a surgeon sent for, and then some of the party with some Indians and a Mexican cart and oxen went for the bear which, after an immense amount of difficulty was successfully transported to the ranch, skinned, cut into pieces, and when weighed pulled down 2100 pounds averdupois – almost incredible to believe.

We had a bull and bear fight . . . in Los Angeles in '54. The bear was a half-grown young fellow, and would have weighed not exceeding 500 or 600 pounds. Colonel Butts went to the arena to take a look at the combatants prior to the fight. After examining the bear critically he turned away, remarking, "Well if I couldn't whip that bear in a rough-and-tumble, I wouldn't consider myself anything in a bear fight."

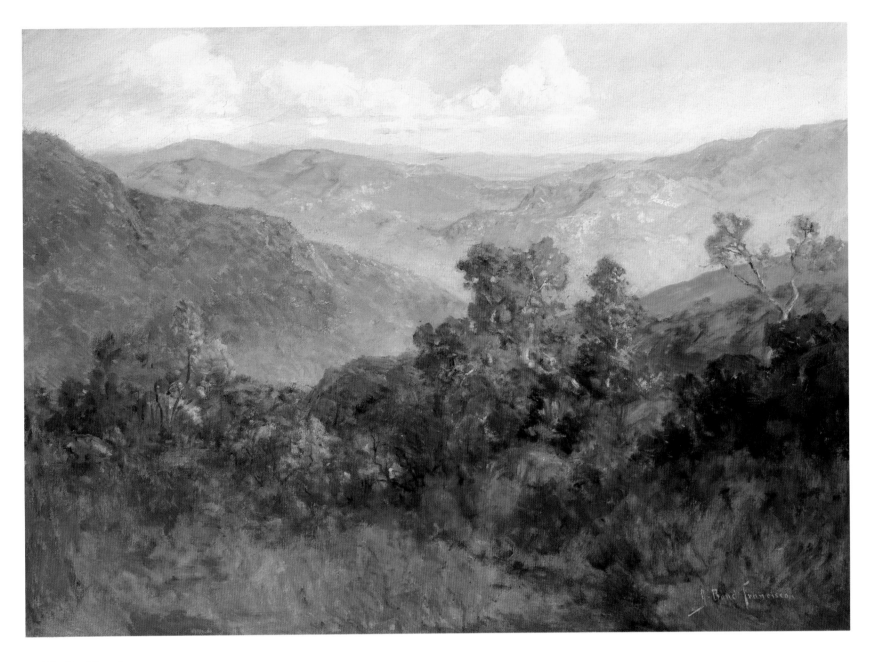

87 John Bond Francisco
The Foothills of California, Tejon Ranch,
Ventura County, n.d.

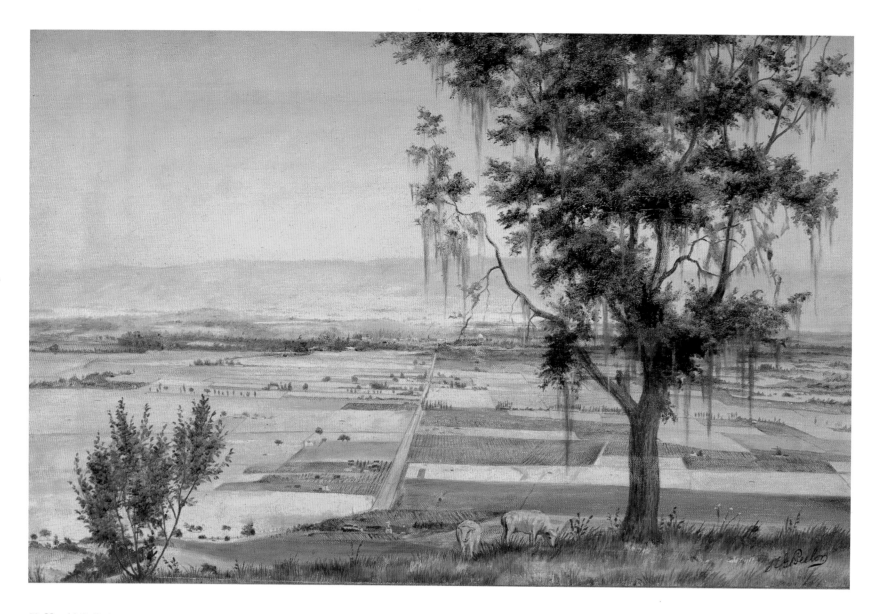

88 Harold G. Peelor
San Fernando Valley, n.d.

Opening the Valley

The San Fernando Valley, through which I rode next day, is an example of those famous ranches in which the lands of California were held by grantees of the Spanish or Mexican Government. This was one of the last of them to remain unbroken, and was now in process of being surveyed for selling off to settlers of the new order. It opened before me in league on league of grain, waving ready for harvest, a crop to be measured by the thousands of tons. The landscape flickered under an ardent sun, and as we plodded hour after hour along the tedious straight road, escorted by clouds of pungent dust, I panted for the clean, crisp breezes which I knew were blowing just beyond the low range of the Santa Monica Mountains to the south. No single tree offered respite of shade, and the two or three ranch-houses we passed looked almost hideous in their blistering whitewash.

J. Smeaton Chase, *California Coast Trails*, 1913

Pasadena

Robert Glass Cleland, *The Cattle on a Thousand Hills: Southern California 1850–1880*

Pasadena owed its origin to an association called the "California Colony of Indiana." Organized by a group of friends meeting at the home of Dr. T. B. Elliott in Indianapolis in May, 1873, the association arranged to send an advance party to California to select a suitable site for settlement; but the financial panic of that year disrupted the group and compelled many of the prospective settlers to abandon the California adventure.

Some of the representatives of the Indiana Colony, however, had already reached California before the association broke up. One member of this advance guard was D. M. Berry, the colony's secretary. After visiting a number of possible sites, Berry and a few others decided on a part of the old Mexican grant known as the Rancho San Pasqual, lying east of the Arroyo Seco, and organized the "San Gabriel Orange Association," sold shares in the new company for $250 each, and bought some 4,000 acres for the prospective owners. The new settlement was called "Pasadena," presumably from a Chippewa word freely translated to mean the Crown of the Valley.

From the very first, Pasadena enjoyed a distinctive reputation. To an unusual degree the settlers met the requirement laid down by a man of wide experience and sound judgment who answered the question, "What should the emigrant bring to southern California?" with the laconic but completely satisfactory answer, "Religion, money, brains, and industry."

The holdings of the San Gabriel Orange Grove Association were divided into tracts ranging from 15 to 180 acres in size; but almost from the beginning the settlement began to assume an urban character. The settlers established a school, a church, and a newspaper called the *Chronicle*; boasted that in nine years not a single criminal case had originated in the colony; and incorporated the "Pasadena Library and Village Improvement Society," of which an early writer declared, "It is believed that the operations of this society must be highly advantageous to the community in conserving the moral and mental condition of the people, in cultivating a love and taste for the beautiful, and in beautifying and adorning the streets and public grounds."

89 Benjamin Chambers Brown
Breezy Day – Pasadena, n.d.

Fighting for Water Rights

Margaret Collier Graham, "The Withrow Water Rights," 1895. Graham's fiction concentrated on labor and water rights issues in Southern California.

Melissa caught her breath, and turned and gazed fixedly through the shimmering haze of the valley toward Los Angeles. The girl herself did not know the resolution that was shaping itself from all the tangled facts and fancies of her brain. Perhaps, if she had been held to strict account, she would have said it was an impulse, "a sudden notion" in her parlance, that prompted her to arise the next morning, before the faintest thrill of dawn, and turn her steps toward the town in the valley. . . . She felt relieved when the greasewood shut the cabin, with its trailing pepper-trees and dusty figs and geraniums, from her sight, and she was alone on the mountain road. . . . There had been no fog in the night, and from the warm stillness of the early morning air the girl knew that the heat had not abated. She was quite unmindful of the landscape, gray and brown and black in the waning light of the misshapen and belated moon, and she was far from knowing that the man she was making this journey to save would have thought her a fitting central figure in the soft blur of the Millet-like etching of which she formed a part.

She threw back her sunbonnet and trudged along, carrying her shoes tied together by their leathern strings and hung across her arm, – an impediment to progress, but a concession to urban prejudices which she did not dream of disregarding. She meant to put them on in the seclusion of the Arroyo Seco, where she could bathe her dusty feet and rest awhile; but remembering the heat of yesterday, she wished to make the most of the early morning, deadly still and far from refreshing though it was. . . . The sea-breeze would come up later, she hoped, not without misgivings; and the grapes were beginning to turn in the vineyards along the road; she would have something to eat with the bit of corn-bread in her pocket. Altogether she was not greatly concerned about herself or the difficulties of her journey, so absorbed was she in the vague uncertainty that lay at its end.

The sun rose hot and pitiless, and the dust and stones of the road grew more and more scorching to her feet. The leaves of the wild gourd, lying in great star-shaped patches on the ground, drooped on their stems, and the spikes of dusty white sage by the road hung limp at the ends, and filled the air with their wilted fragrance. The sea-breeze did not come up, and in its stead gusts of hot wind from the north swept through the valley as if from the door of a furnace. People talked of it afterward as "the hot spell of 18 – ," but in Melissa's calendar it was "the day I walked to Loss Anjelus," – a day so fraught with hopes and fears, so full of dim uncertainties and dread and longing, that the heat seemed only a part of the generally abnormal conditions in which she found herself.

It was afternoon before she reached the end of her journey, entering the town between rows of low, soft-tinted adobes, on the steps of which white-shirted men and dusky, lowbrowed women and children ate melons and laughed lazily at their neighbors, showing their gleaming teeth. She knew where the court-house stood, its unblushing ugliness protected by the rusty Frémont cannon, and made her way wearily toward it through the more modern and busier streets. . . .

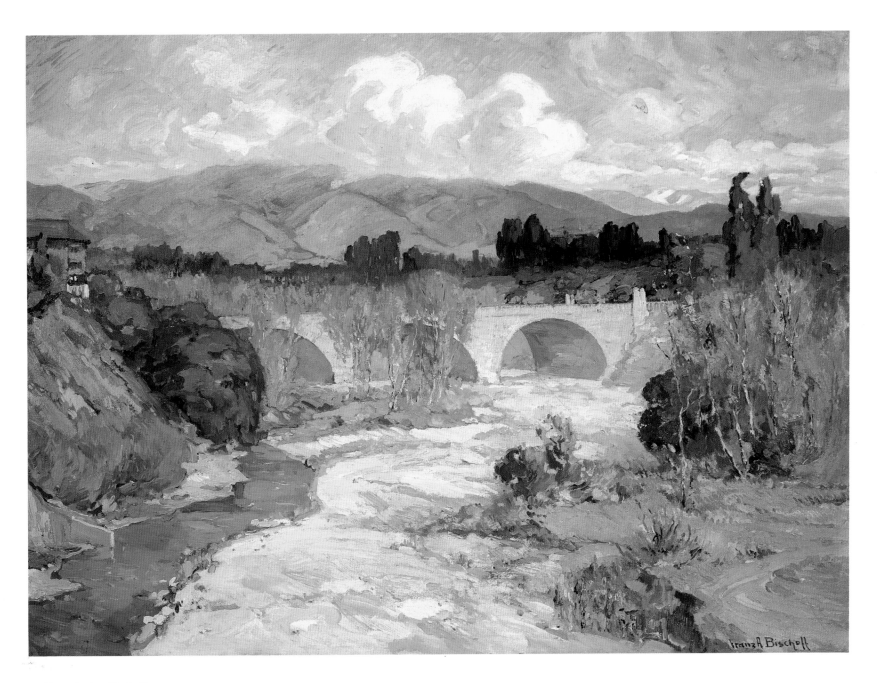

90 Franz Arthur Bischoff
The Bridge, Arroyo Seco, 1912

Life in Southern California

Walter Lindley, M.D., and Joseph Widney, M.D., *California of the South*, 1888

. . . Most new lands go through the slow processes of a rude pioneer-life before the comforts and the conveniences of a matured civilization are a possibility; and the first waves of population, while made up of the more energetic elements from older communities, are yet not marked by a high degree of cultivation or mental refinement. The class of immigration which has come to Southern California is, in many respects, the opposite of this; it has been made up largely of the best and most highly-cultivated elements of older communities.

Under the old Spanish *régime*, . . . when the Anglo-Teuton was yet almost unknown in the land, the country, as headquarters of the Spanish colonial system for the coast, possessed many of the elements of a kindly and refined civilization. It was isolated, . . . slumbering away the years, like some dreary valley of peace. The years came and went, and the restless currents of the world swept by and left it undisturbed. Yet around the old mission, and upon the broad *ranchos*, and in the quiet *pueblos*, was a kindly, courteous, old-time life which had in it none of the roughness of the frontier. . . . Yet it came of a blood as truly and intensely American as that which dates from Jamestown or Plymouth Rock. It is even an older American blood, for it dates from the *conquistadors*, and the shores of the Gulf. . . .

These two bloods share the Western Continent between them. . . . They met here, and were friends. The old Campo Santo and the Anglo-Teuton grave-yard hold in their restful sleep hearts as kindly for each other as though no bar of blood or religion ever stood between. The writer has known no warmer friends — none for whom a more tender feeling of kindly regret lingers through the years — than some whose greetings were worded in the courteous speech of Castile.

One face especially comes up from the past with the softened memories of years of personal friendship, and of many a pleasant day spent together in the old ranch-house — the face of Don Manuel Dominguez. It is wrinkled with the touch of nearly eighty years, eyes dimmed by age, yet having in them the light of a simple-hearted, honest life.

"Your ancestors," he would often exclaim . . . , "crossed the continent by one road, mine by another. For nearly three centuries we have between us possessed the land. We are not *estrangeros*; we are Americans!"

As the old man lay dying, he said, gently, in Spanish, thinking evidently . . . that he was bargaining: "I will pay so much; I will pay no more; *I will pay no less*, for that amount is just."

I thought, as I heard him talking, that the remark was typical of the man, and . . . of that older Spanish life of which he was a lingering representative.

[Los Angeles] is old as a picturesque, sleepy, free-and-easy, Spanish pueblo, but new, as a thriving, progressive American city. . . . old, as a station where the solitary horseman stopped for rest and refreshment — new, as a railroad center, where nearly a hundred loaded trains daily discharge their passengers and merchandise; old, as a Catholic mission, where the noble-hearted, self-sacrificing priests, under the beneficent guidance of Padre Junipero, held sway — new, as a cosmopolitan city, where a hundred Protestant churches vie with the cathedral chimes in directing the thoughts of man heavenward.
– Walter Lindley, M.D., and Joseph Widney, M.D., 1888

91 Paul Lauritz
Old Los Angeles, 1922

Life or Death in Los Angeles

Major Horace Bell, *On the Old West Coast*, 1881

The first Los Angeles mob raised its horrid head in 1851 when a Mexican named Zavalete was hanged. From that time on mob rule and lynchings showed a healthy growth from year to year until in 1861 the great traveler, J. Ross Browne, visiting here, was moved to contribute to *Harper's Weekly* in New York some astonishing observations on life and death in the City of the Angels. He said he was familiar with all manner of game hunting the world over – buffalo, bear and wild turkey in the West; tigers in India, lions in Africa and jaguars in South America – but that Los Angeles was the first place he had ever been where he had been honored with an invitation to go man hunting.

"Why," wrote the globe-trotting Browne, "you would sit at the breakfast table of the Queen of the Angels and hear the question of going out to shoot men as commonly discussed as would be duck shooting in any other country. At dinner the question would be, 'Well, how many did they shoot to-day? Who was hanged?'" . . .

Thirteen years of American rule had certainly demonstrated to the benighted sons of Mexico the superiority of our civilization. We had evolved a very simple rule for the classification of the population. A man was either a manhunter, or he was one of the hunted. That is, if he amounted to anything at all. If in neither classification, then he was a mere nonentity. The decent minority – for there was such a group of nonentities – wondered when and where it would all end. It was barbarism gone to seed. . . .

John Jones was the first man in Los Angeles to curry a horse American-fashion.

James Augustus baked the first loaf of American bread.

John G. shod the first horse and Tom P. built the first wagon.

Dick Smith opened the first peanut establishment and Harry Smith drove the first dray.
– P. C. Remondino, M.D., 1892

Ever since that earlier day when the mayor of the town had resigned his position in order to go out and lynch a prisoner who was under the protection of the law of the land Los Angeles was ruled by a lawless mob. It must be acknowledged that the law as administered by the legal courts was not much better than that administered by the lynchers for the reason that the mob elected the judges and the sheriffs and all the rest of the county officers and if they failed to stand in with the rowdies, the gamblers, the saloonkeepers and the squawmen, they couldn't be reelected.

All this is disagreeable to recall and to record, but it is a part of the city's history. The people of Los Angeles made that history. They sowed the wind and reaped the whirlwind. . . .

It was on [October 24, 1871] the mob rose in its maximum fury and turned itself loose on the hapless, helpless Chinese population. It murdered, robbed, pillaged at will and gloried in it until the indignation of the self-respecting people of the town and of the outlying ranches and settlements brought an end to the orgy. On that October day barbarism rose to its full tide. From then on it began to ebb, very slowly at first, but perceptibly until, after the coming of the Southern Pacific Railroad from the north, connecting Los Angeles finally with the rest of the world by modern transportation methods, the city definitely entered the list of orderly American municipalities. Ruffianism was put down with a heavy

hand and most of the old mob leaders disappeared. Occasionally an old resident may still recognize an ancient relic of those turbulent years hobbling around the Plaza or Chinatown, decrepit, wrinkled, wrecked and ragged; but his once incendiary call can never again thrill a throng to violence.

Los Angeles was for a long time beyond the reach of religious missionaries. Their influence was absolutely ineffective. But by and by there came a civilizer and this was the railroad. The Southern Pacific found its way hither across the high Tehachepi, down over the burning Mojave Desert, through the twisting Soledad Pass, under the sheer San Fernando mountains through a tunnel costing seven millions of dollars and burst like a white light upon the land of darkness. From the day the whistle of the first S. P. locomotive was heard in Los Angeles our civilization started on the upgrade. The missionaries of this civilization that redeemed us were Leland Stanford, Charles Crocker, Mark Hopkins and Collis P. Huntington. Whether it was their intention or not this was the result. They raised us from barbarism into moral daylight.

I said to the pastor, "Do you think God wants me to be a missionary?" He said, "Let's pray about it." So we both knelt down and prayed. When we rose from our knees, he said these words to me – they still ring in my ears as the voice of God speaking to my soul – "God needs businessmen as well as missionaries." I answered, "I will do my best to be God's businessman."
– Robert G. Le Tourneau, 1920

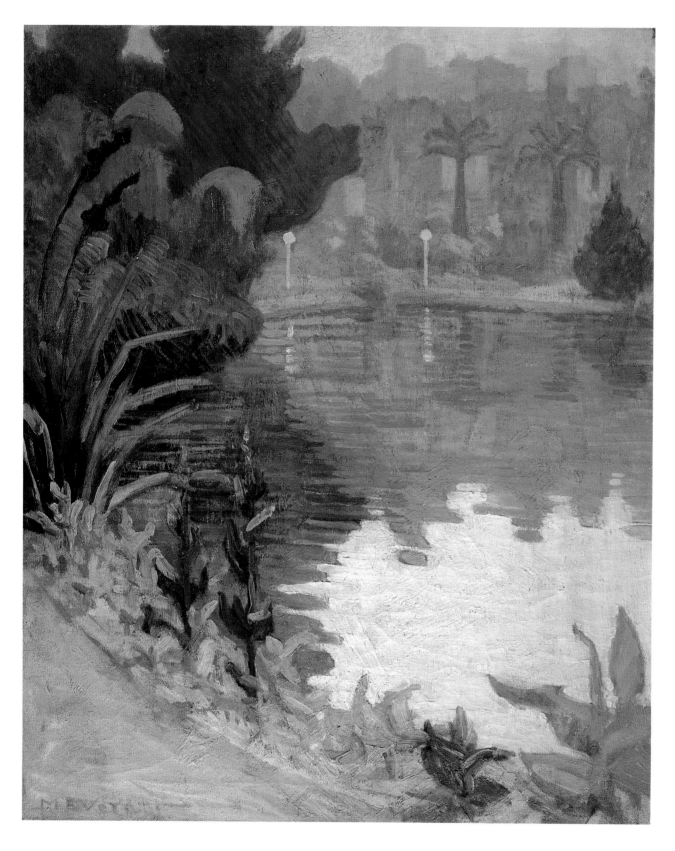

92 Mary Orwig Everett
Misty Morning, c.1926

A Geometry of Gardens

Los Angeles itself[in 1858], was difficult to classify, for it could scarcely be called either city, town, or pueblo. Orchards and vineyards came almost to the doorways of the shops; flowers bloomed in nearly every yard; picturesque adobe houses delighted the eye of the traveler; and both stranger and householder found the community a place of tranquillity and peace. "In the suburbs, there is a beauty perceived through the droughts," wrote one of the chance visitors in the late sixties.

There is an embroidered and flowery geometry of gardens, and arbors in the vineyards and villas nested among weeping willows, and dark solemn olives, and pimientos delicate in their fringe of foliage and swinging scarlet pouches of seeds. Borne across a thousand aromatic groves of orange and citron and California walnut, the long Pacific breeze comes up; and returning, travels again along the labyrinth to the sea, swinging in the streets of the city its morning and evening censer of sweet incense.

Robert Glass Cleland, *The Cattle on a Thousand Hills: Southern California 1850–1880*

On the immediate coast the difference in temperature from month to month, or from one part of the year to another, is so slight that the coast may really be said to have no seasonal limit or periodical seasonal line of demarcation that is defined by temperature.
– Peter Charles Remondino, M.D.

The Southern Rivers

P. C. Remondino, M.D., *The Mediterranean Shores of America*, 1892

The rivers of this region are not many. The watershed of the mountains being to the south and west, all of its rivers flow toward the ocean; the character of the soil and its sloping condition make drainage a thing of the greatest facility. As a natural result, the rain-fall is quickly carried out to the sea; and, although the main streams may, during the winter rains from mountains, be converted into turbulent torrents of mad and swift-flowing waters, they are in the summer but the apparently dry beds of the former streams. When the rains have been slowly pouring and long-continued, giving the hill-sides ample time for a thorough saturation, the streams rise very slowly and are much later in reaching the sea. After a season of ample rains, the rivers run in broad, deep currents to the ocean, carrying a vast amount of sand and soil in their rapid descent. This may last until late in the summer; the volume of waters then slowly diminishes, the currents are less rapid, and soon the lessening waters uncover the sandy river-beds. This process gradually proceeds inland, until the whole river-course is a dry, sandy channel, that may extend twenty or more miles upward from the sea-shore toward the mountains, where the former river still exists, in the shape of a small rivulet, that here ends in the sands. The river has not, however, entirely lost all its identity; the volume of water which it still carries is far in excess of what is visible. It is simply a subterranean river, and one or two feet of digging in any part of its course, from the point of its sinking out of sight in the hills to its outlet at the sea-shore, demonstrates the existence of the fresh-water stream. The San Gabriel River has the largest and most productive water-shed, as it obtains its supply from the long chain of Sierra Madre and other mountains that face to the south, this being the direction from whence the greatest amount of moisture is condensed. The Los Angeles River is a small stream all through the summer.

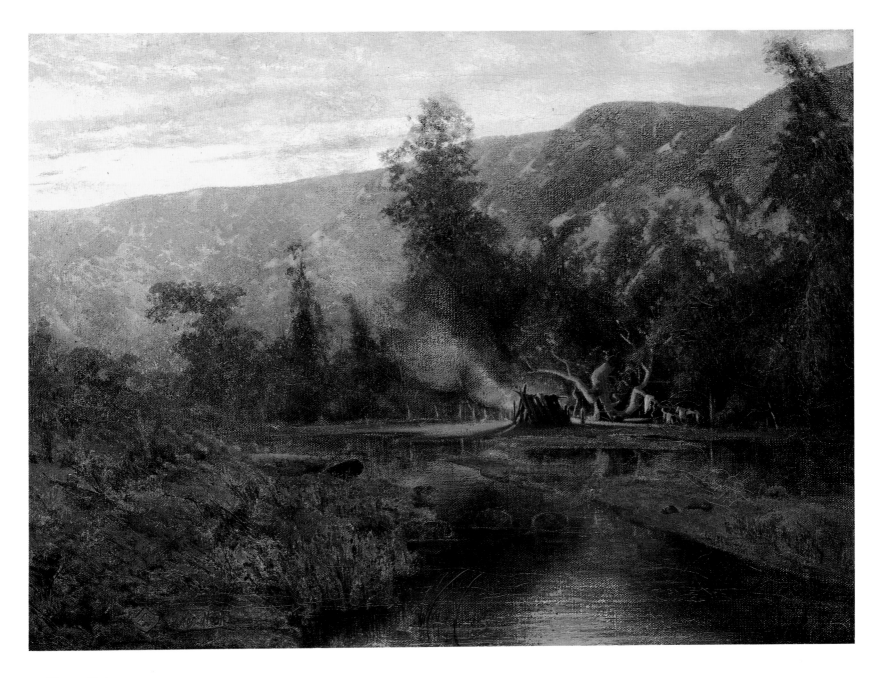

93 Thomas Nash
Hobo Camp, Los Angeles River, 1908

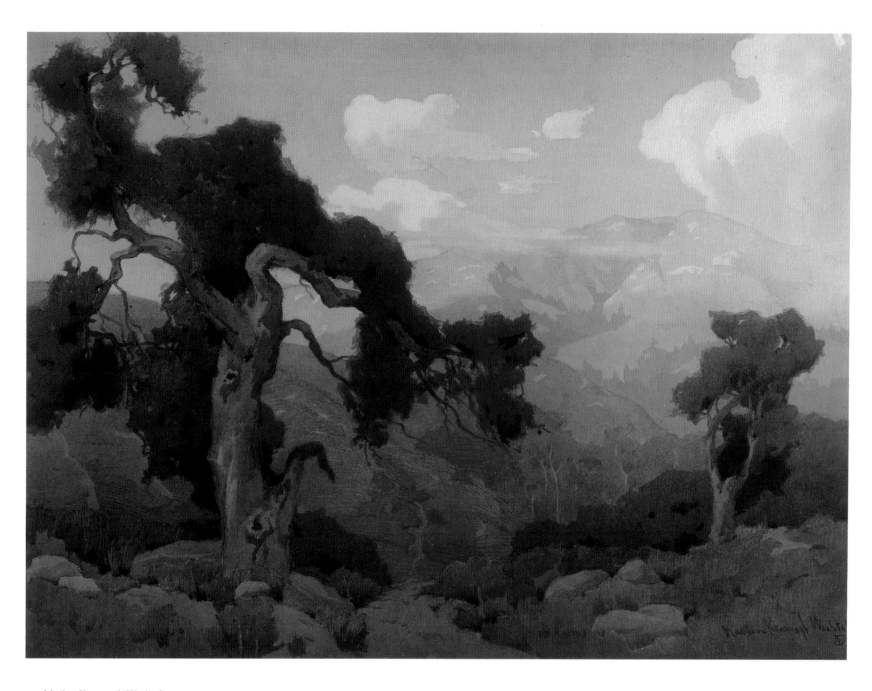

94 Marion Kavanagh Wachtel
 In San Gabriel Cañon, c.1920

Gold in the South

The San Gabriel Cañon, source of the most important river in the Sierra Madre range, became the scene of an unusually rich bonanza in 1850. A short time after the initial discovery, the *Southern Vineyard* reported the location of a gold-bearing vein at least two miles long and said that three hundred prospectors were already working in the cañon. Los Angeles newspapers carried the following advertisement:

San Gabriel Mines Stage Line!
 The undersigned have established a line of Stages from this city to the above mines, leaving Los Angeles tri-weekly on Mondays, Wednesdays and Fridays at 7 A.M. Returning leaves Prospect Bar on Tuesdays, Thursdays and Saturdays.

Fare:

To San Gabriel Mission	$1.00
Santa Anita Mines	2.50
Mouth of Cañon	3.00
Through to Prospect Bar	6.00

Express and Freight Business attended to on reasonable terms.
Roberts and Williams.

The Los Angeles *Star* of March 10, 1860, stated that eight companies were engaged in bringing water into the camp called Eldoradoville, "so as to ground sluice or hydraulic wash." The article also included a very long and elaborate set of mining laws, embracing some twenty-seven items, and concluded by saying, "The writer of these lines is confident from his experiences in the upper country that . . . the returns of gold dust from the San Gabriel will be second to those of no other river in the state."
 During the course of the next few years, the cañon's innumerable bars and gravel beds yielded considerable quantities of gold; and mining camps, similar to those of the northern Sierra, sprang up and died away almost as rapidly as Jonah's celebrated gourd. True to type, such camps had their saloons, gambling houses, periodic shooting affrays, and self-imposed mining codes.

Robert Glass Cleland, *The Cattle on a Thousand Hills: Southern California 1850–1880*

The Mission at San Gabriel

J. Smeaton Chase, *California Coast Trails*, 1913

The road we [Chase is accompanied by the painter Carl Eytel] were riding along might have been in Surrey or Virginia, so tall were the hedges that half hid the fence in their wild sweet tangle. You will not see much of the verdure in travelling California roads by midsummer. Our sun is a thirsty one, and for half the year the landscape at close range is one of dry brown earth and shrivelled herbage, though distance may wash it over with amethyst, as Memory does with the unhappy landscapes of the mind. But the land about El Monte is damp and low-lying: green meadows and fields of alfalfa stretched on either hand, and the road was triple-bordered, first with vivid ribbons of grass starred with dandelions, next with rustling bulrushes or arroy evening-primroses, and then with a fifteen-foot thicket of bushes over which rolled a flood tide of wild grapevines, their tendrils reaching far up into the air in the determination to grasp their fill of summer.

The village of El Monte is a rather pretty little place, not too much modernized, with plenty of big poplar and eucalyptus trees swaying above the modest cottages. . . . The place stands near the bank of the San Gabriel River, a dozen miles or so east of Los Angeles, and four miles from San Gabriel, that dusty little hamlet the long drowse of whose one street of adobes is broken nowadays by half-hourly convulsions when the electric car comes clanging with its load of tourists to "do" the venerable Mission. . . . The first Mission San Gabriel was built in the year 1771, close to the river, and about five miles south of the present church. It was abandoned after five years, by reason of some disability of site, and a second building was consecrated, in the present position, in the fateful year of 1776. It, also, was temporary, and in 1796 the third and permanent structure took its place.

The Southern winter blossomed royally. Bees held high carnival in the nodding spikes of the white sage, and now and then a breath of perfume from the orange groves in the valley came up to mingle with the wild mountain odors.
– Margaret Collier Graham, 1895

As the site of the first building was but a short distance off our road, we diverged to see what might remain to keep the memory of its brief existence. . . . We thought we could trace the outline of a rectangle, marked by a slight inequality of the surface of the ground, which might indicate the ruins of adobe walls that had sunk back, literally "earth to earth," to their original clay. It was in the middle of a field of yellowed grass sprinkled with gray bushes of horehound and defiled with the carcass of a dead buzzard. Hum of bees, murmur of summer wind, twinkle of river shallows, these were all as of old. The rest was silence. . . .

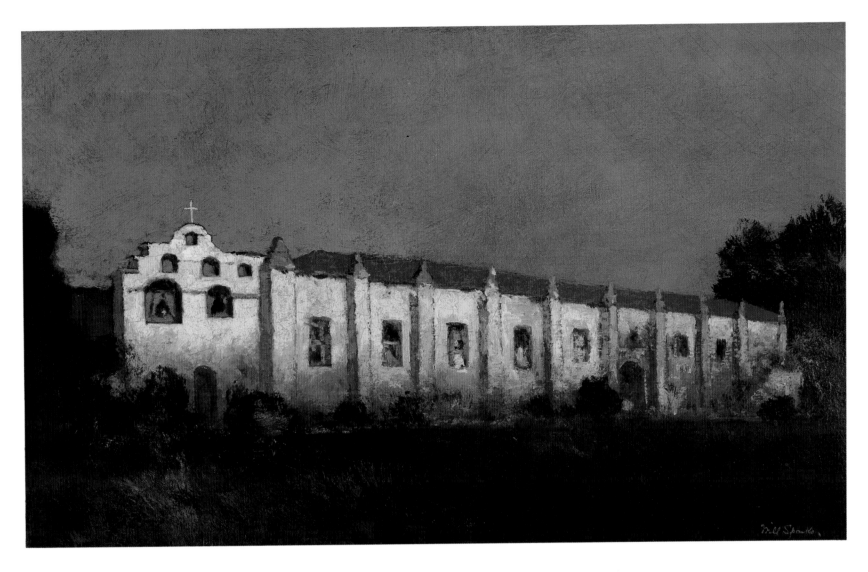

95 Will Sparks
San Gabriel Archangel Mission, n.d.

The Baldwin Estate

Robert Glass Cleland, *The Cattle on a Thousand Hills: Southern California 1850–1880*

In July of 1870 Isaias W. Hellman, William Workman, his son-in-law, F. P. F. Temple, and James R. Toberman started a second Los Angeles bank, under the name of Hellman, Temple, and Company. The Farmers and Merchants Bank, oldest and one of the most distinguished of present-day southern California banks, opened for business on April 10, 1871. Five years later the Commercial Bank, forerunner of what later became the First National Bank of Los Angeles, was organized.

Hayward and Company, the first of the banks just mentioned, soon retired voluntarily from the field. Hellman presently withdrew from Hellman, Temple, and Company to form the Farmers and Merchants Bank and left his former associates to continue under the name of Temple and Workman. The venture came to an early and tragic end. Neither Temple nor Workman was qualified either by experience or temperament for the business. They were constitutionally unable to refuse a loan to a friend or indeed to anyone else who came to the bank professing to be in need. They could not understand that the Los Angeles and the California of 1870 were not the Los Angeles and the California they had known when they first came to dwell in "the land of the large and charitable air." The cashier, who actually ran the bank, was either incompetent or unwilling to risk his position by insisting upon the adoption of sound financial policies.

So, in the panic of 1875, the Temple and Workman Bank became virtually insolvent and the partners borrowed $210,000 from E. J., or "Lucky," Baldwin of San Francisco, master of a fortune from Comstock Lode, landowner, speculator, a hard and ruthless man, to save them from disaster.

Before making the loan, Baldwin warned the two partners that he would expect full payment when the note fell due and reject any plea for an extension of time or any other consideration. As security, he not only demanded a mortgage on all the properties owned by Temple and Workman but also on a near-by ranch of 2,200 acres that belonged to their close friend, Juan M. Sanchez. Against urgent advice of many business men in Los Angeles, Sanchez foolishly agreed, like the old Californian that he was, to permit the mortgage to be placed against his property to accommodate his friends.

A few weeks after Workman and Temple received the money, the bank failed. Baldwin foreclosed his mortgages and thereby acquired four separate ranches – a total of nearly 27,000 acres – a frontage of 240 feet on Spring Street, and 80 additional acres in Los Angeles. Sanchez was left bankrupt. Temple suffered the same fate. The seventy-six-year-old William Workman, broken in fortune and hope, shot himself through the head. The effects of the panic of the mid-seventies and the Temple-Workman failure were thus summarized by Remi A. Nadeau in *City Makers*, a historically valuable, pleasantly flavored study on early Los Angeles.

A summary of the Los Angeles Directory for 1875 showed the following classifications: 107 carpenters, 72 fruit dealers, 50 attorneys-at-law, 43 blacksmiths, 33 printers, 32 physicians and surgeons, 30 boot and shoe dealers and makers, 30 butchers, 28 teachers, 28 wagon and carriage makers, 27 saddle and harness makers, 23 upholsterers, 23 house and sign painters, 22 clergymen, 22 livery, feed and sale stables, 2 real estate men, 19 clothing and dry goods dealers, 19 bakers, 18 hotels and lodging houses, 28 dealers in general merchandise, 14 jewelers, 13 editors and publishers, 11 restaurants, 10 drug stores.

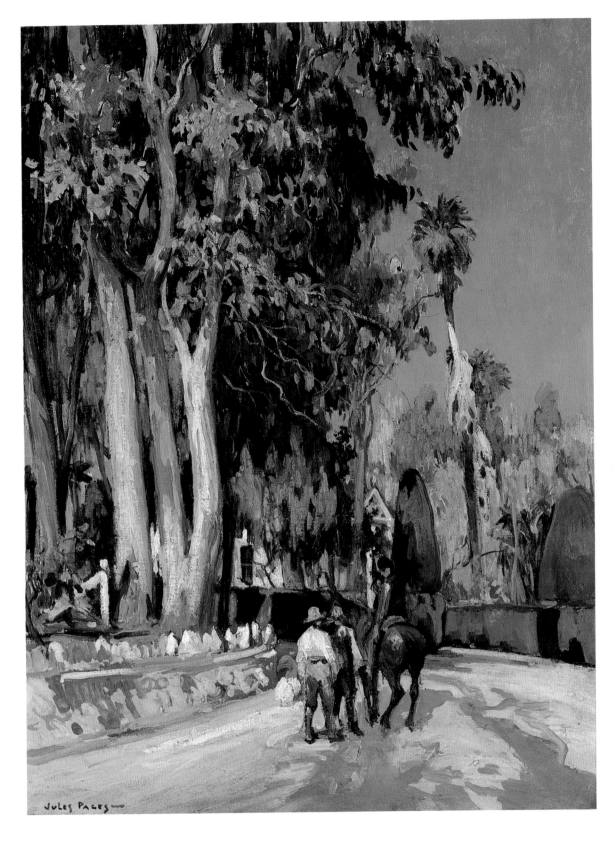

96 Jules Pages
Baldwin Estate – Arcadia, n.d.

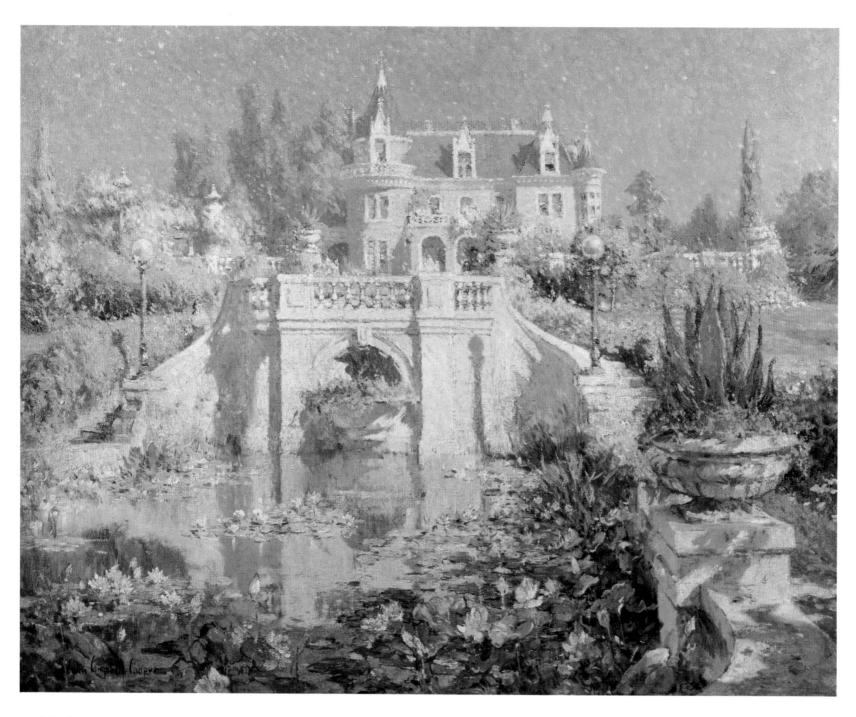

97 Colin Campbell Cooper
Kimberly Crest, *c.1929*

The Drives

Making the botanical beauties and oddities of the region available to the sight-seer were the spacious drives of the day, some of which were well-sprinkled to keep down the dust. Riders in carriage and buggies could relax along avenues lined with palms and pines, or eucalyptus and oaks. Tallyhos, drawn by four or six horses, took gay parties to picnic grounds at beaches or in canyons. Santa Barbara had twenty-eight drives. Euclid Avenue in Ontario, running for miles straight from the valley floor up into the foothills, with a wooded parkway in the center and pepper trees on either side, was one of the vaunted sights of the region. A carriage ride along Magnolia Drive in Riverside, 200 feet wide, lined by pepper and palm trees and curving through a landscape of lemons and oranges was an experience visitors found without parallel.

To many at the time, and to many in retrospect, the region during its glowing era was the proper site for a town named Arcadia, adjoining the ranch of "Lucky" Baldwin, and for the Hotel Arcadia, catering to wealthy visitors on the palisades at Santa Monica, or for the aristocratic subdivision in San Diego called Golden Hill, zoned to exclude private barns. There was rural space or primeval landscape between towns and cities, each town was a distinct entity, roads wound across the natural surface of plain and hill, and long miles of beach were wild and open to the occasional beach party of merrymakers arriving by horse and buggy. Southern California was a place apart to most Americans, who periodically endured big blizzards, deep snows, long winters, and also tornadoes, hurricanes, and sticky summers.

Richard G. Lillard, *Eden in Jeopardy*, 1966

A City Founder's Circular

Judge J. W. North, founder of Riverside

In addition to the production of all the grains, fruits and vegetables of the East, which are here produced in double quantity, . . . this soil and climate are peculiarly adapted to the growth of oranges, lemons, limes, figs, English walnuts, olives, almonds, raisin-grapes, wine-grapes, peanuts, sweet potatoes, and to silk culture. The sorghum and sugar beet are said to more than double the yield in the East. The net profits per year, from the semi-tropical fruit and silk culture, are estimated at as high as one thousand dollars per acre. Mining districts, within reach, furnish a ready market for all products. Ornamental trees, and flowering shrubs and vines, grow with wonderful rapidity. It is safe to say that as much can be done in ornamental gardening in three years, as can be done in the East in ten. The Pepper tree, one of the cleanest and most beautiful of shade trees, grows with astonishing rapidity. The orange groves, in which may always be seen both fruit and blossoms, are unrivalled in beauty. The Pomegranate, always with fresh foliage, bearing fruit and flowers; the Lemon and Lime, always ornamental, as well as profitable; the Oleander tree, wonderfully rapid in its growth, always green, and always ornamented with gorgeous blossoms; and other flowering trees and vines, easy of cultivating here, are sights very inviting to Eastern eyes. . . .

We would suggest to our friends the policy of buying only small portions of land. The great error is getting too much, and cultivating too little; or cultivating large farms imperfectly. On large farms people must necessarily be widely separated; on small lots they can enjoy the society of near neighbors, and have all the advantages of town or city life. . . . Small farms, near neighbors, and a compact settlement are best for all.

While vegetable gardens grew no plants unknown back East, except the giant thistles called artichokes, they did grow plants that seemed extraordinarily out of season in late fall, in midwinter sometimes, and in early spring. Everywhere [in the 1890s] growers spoke of big fruits and vegetables, unusual varieties, of quick growth, of marvels of one sort or another – a cucumber seven feet long, a strawberry that took three bites to finish, a grapevine that produced six tons a year.
– Richard G. Lillard, 1966

The Anaheim Experiment

... The systematic laying out and planting of a tract of country upon a plan decided beforehand and faithfully carried out is, I think, peculiar as yet to Anaheim, though I wonder much that it has not had frequent and numerous imitators in California, which is peculiarly adapted for such experiments.

In 1857 – fifteen years ago – several Germans proposed, in San Francisco, to some of their countrymen to purchase, by a general effort, a piece of land, lay it out into small individual farms, plant these with grapes for wine, and to do all this by one general head or manager, and in the cheapest and best manner possible.

After some discussion, fifty men joined to buy a tract of 1165 acres of land south-west of Los Angeles. They paid for this two dollars per acre, and took care to get for this price also a sufficient water-right for irrigation.

The land was selected and bought by the leader in the enterprise, Mr. Hansen, of Los Angeles, a German who had long lived in California, and who is a man of culture and ideas, and desired to see what could be done by co-operation in this direction. He became, subsequently, so much interested in the success of the plan he had formed, that he was the manager of the colony in all its preparatory stages; and as he is an engineer, and a capable, honest, and patient man, he was, I think, a very valuable person.

The Anaheim Company consisted ... of mechanics, in the main. There were several carpenters, a gunsmith, an engraver, three watchmakers, four blacksmiths, a brewer, a teacher, a shoe-maker, a miller, several merchants, a bookbinder, a poet (of course, as they were Germans), four or five musicians, a hatter, some teamsters, a hotel-keeper, and others: not a farmer among them all, pray notice.

Moreover ... there is some reason to believe that the members of this company were not even eminently successful in their callings. They were not getting rich in San Francisco, where most of them lived. Several of them had money ahead, but most of them, ... I hear, were men ready enough to better their fortunes, but to whom it would have been impossible to buy for cash a ready-made farm of even twenty acres.

Well, it was agreed to divide the 1165 acres into fifty twenty-acre lots, and fifty house lots in the village, leaving some lots for school-houses and other public buildings, fourteen in number.

The first contribution or payment toward the common stock bought the land. Thereupon Mr. Hansen was, very wisely, chosen resident manager, and the share-holders quietly went on with their pursuits in San Francisco, taking care only to pay up the calls on their stock as they became due.

It was the manager's duty, meantime, to go on with the improvement of the lots. This he did with hired labor – Indians and Californians.

He dug a main ditch about seven miles long, to lead the irrigating water over

Charles Nordhoff, *California: for Health, Pleasure, and Residence*, 1874

Families have lived for several years—my own being of the number—with wide-opened windows, without awnings in summer or fires in the winter, in the greatest of comfort, showing the ease, practicability, and comfort with which free and constant ventilation can be practiced in this climate.
– Peter Charles Remondino, M.D.

Southern California presents a most gloriously invigorating, tonic and stimulating climate, very much superior to any thing I know of, the air is so pure and much drier than at Mentone or elsewhere; and although it has those properties, it has a most soothing influence on the mucous membrane, even more so than the climate of Florida, and without the enervating effect of that. . . . All the leading physicians of the world agree that [such a climate] is the best for the great majority of cases of suffering from pulmonary diseases or from a lowered vitality. The patient needs a climate in which he can spend most of the day out-of-doors. . . . As for going out, I have constantly been out evenings. During the past winter, out of one hundred and fourteen days I spent one hundred and six in the open air.
– Letter from Anaheim, July 26, 1872

the whole area, with four hundred and fifty miles of subsidiary ditches, and twenty-five miles of feeders to these.

He planted on each twenty-acre lot eight acres in vines (8000 vines), and some fruit-trees.

He fenced each lot with willows, making five and a quarter miles of outside and thirty-five miles of inside fencing. These willows are now topped for fire-wood, and, as they grow rapidly, they give a very fresh and lovely green to the aspect of Anaheim. This done, he continued to cultivate, prune, and keep up the whole place.

At the end of three years, in 1860, all the assessments were paid; each stock-holder had paid $1200, and a division of the lots was made. This was done by a kind of lottery. All the lots were viewed, and assessed at their relative value, from $1400 to $600, according to situation, etc.

When a lot was drawn, if it was valued over $1200, the drawer paid the difference; if less, he received the difference. . . .

When all were drawn, there was a sale of the effects of the company – tools, horses, etc.; and, on balancing the books, it was found that a sum remained on hand which sufficed for a dividend of over one hundred dollars to each share-holder. . . . For [but $1080] each had twenty acres and a town lot 150 by 200 feet, with 8000 bearing grapevines, and some fruit-trees.

Then most of the owners broke up at San Francisco and came down to take possession. Lumber for building was bought at wholesale; . . . a school-house was quickly erected; shop-keepers flocked in and bought the town lots; a news-paper was begun; mechanics of different kinds were attracted to the colony; and the colonists themselves had at once about them all the conveniences for which, had they settled singly, they would have had to wait many years.

. . . These colonists were not either farmers or gardeners by trade. Only one had ever made wine. They began as green hands; and some of them borrowed money to make their improvements, and had to pay heavy interest. They had to build their houses, and make their gardens, and support their families. Here is briefly the results of the experiment:

1. There was a struggle for some years, but in this early time, every body tells me, they all had abundance to eat, a good school for their children, music and pleasant social amusements, and they were their own masters. There is no win-ter here for the struggling poor man to dread or provide for.

2. Only one of the original settlers has moved away; and the sheriff has never issued an execution in Anaheim.

3. The property which cost $1080 is now worth from $5000 to $10,000; and I do not believe more than one in ten of the colonists would have been worth to-day, had they remained at their trades in San Francisco, any money at all.

4. There are no poor in Anaheim.

5. It is the general testimony that the making of wine and brandy has not caused drunkenness among the colonists. . . .

6. I have not a doubt that the moral standard of the people has been greatly improved. Their children are well trained; the men are masters of their own lives; they have achieved independence, and what to an average New York mechanic would seem the ideal of a fortunate existence. The average *clear* income from their vineyards, which now contain mostly sixteen acres, is about $1000 per annum. Some few fall below this, but most of them, I was told, go above. They have besides this, of course, their gardens, which here yield vegetables all the year round; their chickens – in short, the greater part of their living. They live well; it is a land of plenty; and to me, who remembered how painful and unpleasant is the life of a mechanic or artisan in New York, it was a delight to see here men and women who had redeemed themselves by their own efforts from this drudgery and slavery.

Southern California, which has never endured any but the cool caress of token glaciation, on San Gorgonio Mountain, now endures the inhumane, man-made power of dipper shovels; cranes and shovels; dragline buckets; front loaders; pusher tractors; leveling drag scrapers; tongue scrapers; scarifiers; land levelers; dump trucks; off-the-road dumpers; rear dumps; bottom dumps; side dump trucks; graders; rollers; tamping rollers; vibrating compactors; shovel cranes on caterpillar treads for dirt moving; elevating scrapers that pile twenty-one cubic yards in one minute; earth-ripper backhoe crawlers; tandem pushers; sheepfoot compactors . . . ; dozer rippers and rooters for hardpan and stumps; bulldozers with back ripper teeth, with blades for slashing at rock, with prongs for seizing and jerking up stumps; shoulder trenchers; skiploaders; and power shovels.
– Richard G. Lillard, 1966

Santa Ana Cañon

J. Smeaton Chase, *California Coast Trails*, 1913

. . . We entered a league-long valley from which rose smooth slopes of pale-golden grass. The rounded swells and folds of the land took the light as richly as a cloth of velvet. In the bottom lay the creek, in isolated pools and reaches, its course marked sharply by a border of green grass and rushes. Red cattle grazed everywhere or stood for coolness in the weed-covered pools. The hillsides were terraced by their interlacing trails. Elders and willows grew at wide intervals, a blot of shadow reaching from each. Under them the rings of bare gray earth were tramped hard as brick where generations of cattle had gathered for shade. In one side reach of the valley was a little bee-ranch of a score or two of hives, with the typical shanty of the bee-man closed and apparently deserted. It was an "off-year" for bees near the coast: excess of fog had spoiled the honey-flow.

As we rode, blue mountains rose on the northern horizon. They were the Santa Ana Mountains, fifteen miles away. That was the only ingredient in the view that could come under the term "picturesque"; the rest was open, bald, commonplace. European painters – American, too, all but a few – would have declared it crude and impossible. The yellow horizon was cut on the blue of the sky in a clean, hard line. At one spot, where the creek in winter flood had cut out a fifteen-foot bluff, the shadow was a slash of inky blackness on the glaring expanse of sun-bleached grass. There was always a buzzard or two swinging slowly in the sky, and once one rose near by with a heavy, shambling flight from his surfeit on the carcass of a dead steer. That was all: but to [Carl] Eytel [the painter who accompanied Chase], and indeed to me, though I am no artist, it was complete and perfect. If beauty consists, as theorists, I understand, declare, in the true expression of spirit, then certainly this landscape complied with the terms. It was a very summary of the native and original California del Sur, California of the South, as Nature designed it. And even the sophisticated mind, trained to weigh tone values and balance of line, found the composition ideal in its magnificent Western simplicity. Pretty? a thousand miles from it. Picturesque? the very word sounds puerile. But simple, strong, dignified (which I take to be the primaries of art, after all), these were the very facts of the case, the materials of the landscape.

The tides on the Channel shores are of the greatest regularity as to the limit of their rise and fall, owing to the entire want of disturbing elements in the shape of storms or any unusual winds. The spring tides rise 5.6 feet above average low-water mark and the neap tides fall 4.2 feet below. The daily papers on the coast are in the habit of publishing tide-tables; so that the tourist or invalid can readily ascertain the time of the lowest tide, when he may gather sea-mosses or other specimens of natural history belonging to marine life.
– Peter Charles Remondino, M.D., 1892

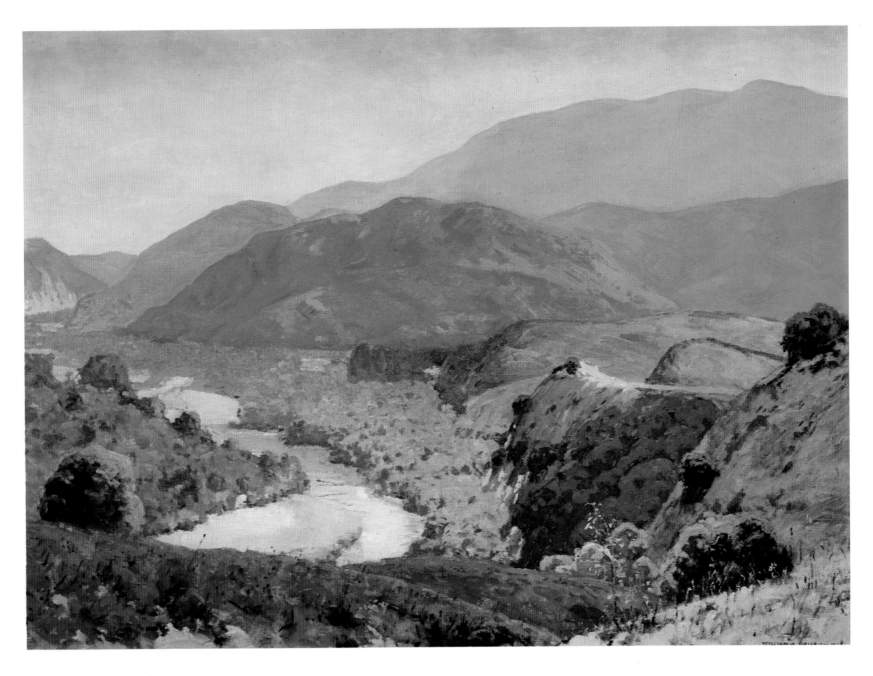

98 William Alexander Griffith
Santa Ana Canyon, 1928

The west-bound tourist should supply himself with lunch enough to last four days. He should have an abundance of canned fruit, jellies, boneless chicken, meat, butter, and condensed milk. He should have a spirit-lamp and be prepared to make his own tea or coffee; he should carry eggs, salt, and pepper. Take all these things, and try to get along without eating any of them. There are excellent eating-stations along the various routes, but trains are apt to be behind time, and frequently the traveler who has not provided for himself must wait until eleven or twelve o'clock for breakfast or till midnight for his dinner. The suggestion of Rev. E. P. Roe, author of "Barriers Burned Away," that the overland roads furnish tea, coffee, and sandwiches when trains are delayed is a good one, but nevertheless a lunch-basket is a great desideratum. It is, on the whole, much better for health and comfort to eat at the stations and get freshly-cooked food whenever the railroad eating-stations are reached at reasonable hours. The traveler should always carry something with him to guard against constipation. A sedlitz-powder, a teaspoonful of Rochelle salt, or a tablespoonful of Hunyadi Janos taken before breakfast, is a simple and efficient preventative. A bottle of paregoric, a bottle of aromatic spirits of ammonia, and a flask of good whiskey, are all excellent things to carry in the satchel. If you do not need them, some fellow-traveler will. The sensible transcontinental traveler throws aside unnecessary conventionalities, and in twenty-four hours becomes well acquainted with every occupant of his Pullman. Elderly ladies and children generally are the earliest passengers to start the social ball rolling.

– Walter Lindley & Joseph Widney

7. The Southern Coast

Santa Catalina Island, Laguna Beach, San Juan Capistrano, La Jolla, San Diego Bay

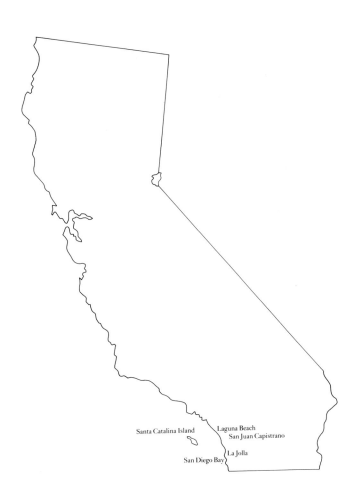

Santa Catalina Island

Laguna Beach
San Juan Capistrano

La Jolla

San Diego Bay

Santa Catalina

Walter Lindley, M.D., and Joseph Widney, M.D., *California of the South*, 1888

. . . Santa Catalina Island [is] twenty-three miles long, with an average breadth of four miles in the southern part, and two miles to the northern. It rises to a height of three thousand feet, and is remarkable for the great transverse break or depression, five miles from the northern end, running partly through it, and forming a cove or anchorage on each side. The land connecting these is very low, say not over thirty feet; but the hills rise up on each side two or three thousand feet, and when sighted from the north or south, the whole appears like two very high islands.

The harbor on the southern side is eighteen and a half miles from San Pedro. There is also a safe anchorage and harbor on the northern side. There are several other fair harbors on the coast opposite the mainland. There are a number of pretty elevated valleys, several mineral springs, and wells of good water.

Dr. T. J. McCarty, Professor of Chemistry in the Medical College of the University of Southern California, says: "I procured samples of water from a half-dozen springs, and below appears the analysis of water from one more highly charged with saline matters than any of the others examined. The spring is found at an elevation of several hundred feet and contains –

In one plot:	*Grains:*	*In one plot:*	*Grains:*
Sodium chloride	79.5	Calcium sulphate	6.0
Magnesium chloride	21.0	Magnesium carbonate	2.0
Magnesium sulphate	32.5	Iron and aluminium	Traces
Sodium sulphate	20.5	*Total solids*	161.5

"This water would be classed among the purgative mineral waters, and as such will commend itself."

James Lick bought this island in 1864 of the United States Government for $12,000. In 1874 his heirs tried to sell it for $1,000,000 but failed. In 1887 George R. Shatto, of Los Angeles, bought it for $225,000. This island has always been a popular summer resort for Californians. Although there were no accommodations whatever, yet thousands of people went over and camped in order to enjoy the benefits of the climate and bathing, and the pleasures of fishing. There are many wild goats on the south side of the island, that give rare game for amateur Nimrods. The water along the northeast shore is remarkably warm, and people who get chilled on the mainland bathe here with pleasure. Boating is a delightful pastime. The water is always calm, and so clear that fish, mosses, and pebbles can be distinctly seen many feet below the surface. The island has evidently at one time been densely populated, and numerous earthen pots, stone weapons, and bones are to be found in the mountains. Catalina is plainly visible from Los Angeles, forty miles away.

By the time this work is published there will be an excellent hotel here. Steamers make daily trips from Catalina to San Pedro, connecting with Los Angeles trains. It was discovered by Cabrillo in 1542, and named La Victoria,

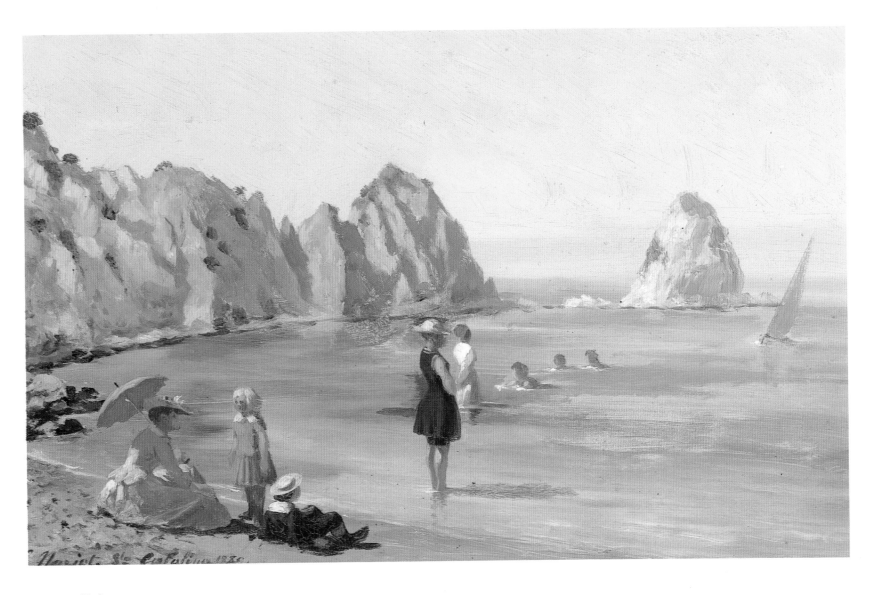

99 Erneste Narjot
Santa Catalina Island, 1889

after one of his vessels. It received its present name from Vizcaino in December, 1602, when it was thickly settled by a people reported to be very ingenious, especially in pilfering. Father Ascencion, who accompanied this expedition, describes a temple to the sun, found near the two harbors, with images and idols.

Tourists will find a visit to this island novel, interesting, and pleasant. The round trip from Los Angeles, and twenty-four hours at the hotel, costs about five dollars.

I never knew an instance of a person of either sex or any age among the Californians suffering from toothache or decay of teeth, but all preserved their teeth in good condition to extreme old age; at the same time, they did not take any special care of them. I can account for the excellent preservation of the teeth only upon the ground of an extremely simple mode of living and their temperate habits.
– William Heath Davis, 1889

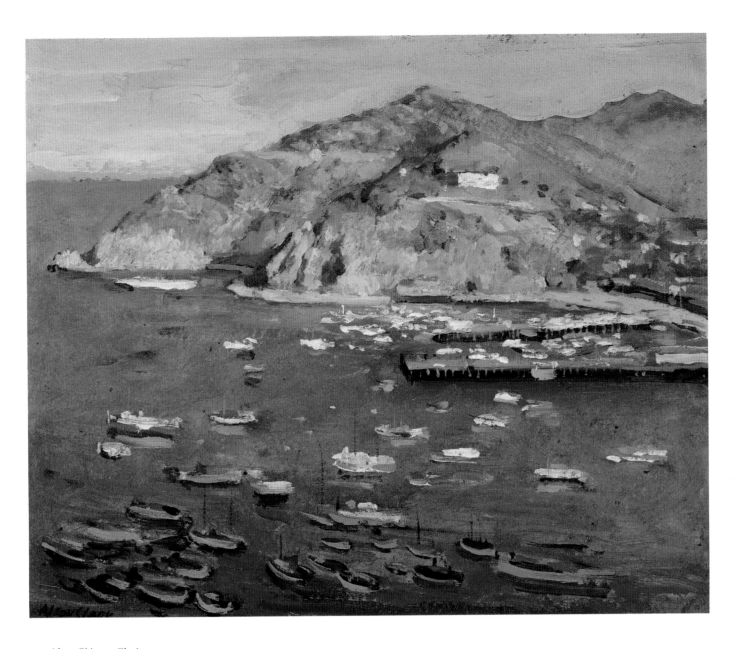

100 Alson Skinner Clark
Catalina, 1920

The Coast at Laguna

J. Smeaton Chase, *California Desert Trails*, 1919

Here, warm ochres, creams, and drabs alternate on the broken cliff faces with olive-greens, grays, and masses of ashy rose; and the herbage of the tops carries out the same general class of tone. Cactus growing to the cliff edges gives a touch wholly characteristic of the region. But the long, wing-like reaches of the land line, where ten miles of coast will contain twice that number of little emerald bays barred one from the other by white arms of spray, brought constantly to my mind the rocky shores of Guernsey and Jersey. . . . Such resemblances are full of pleasure: they keep one's thought unstagnant and ever on the wing; and, better yet, they reach down and stir sometimes those subtlest strings of all, that vibrate in the dark, quiet chamber of the mind where lies the well of tears, keeping that unstagnant, too.

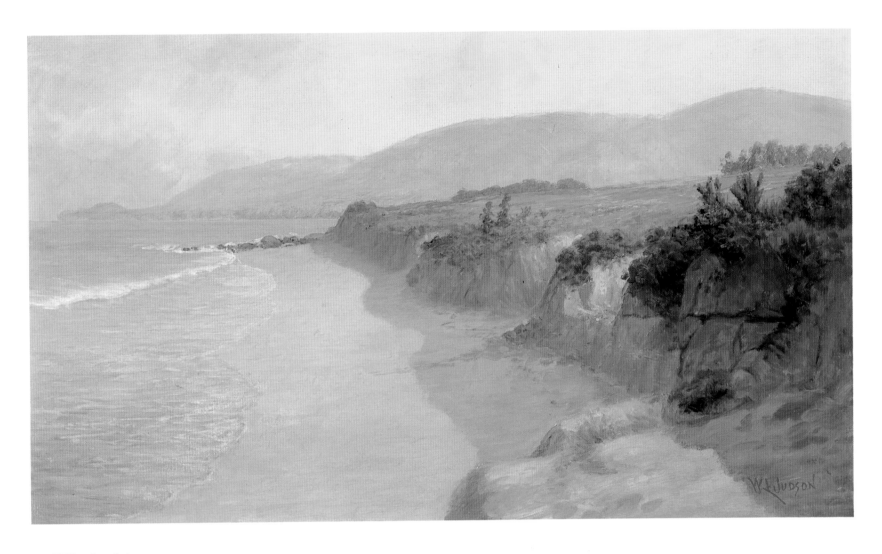

101 William Lees Judson
Laguna Coast, n.d.

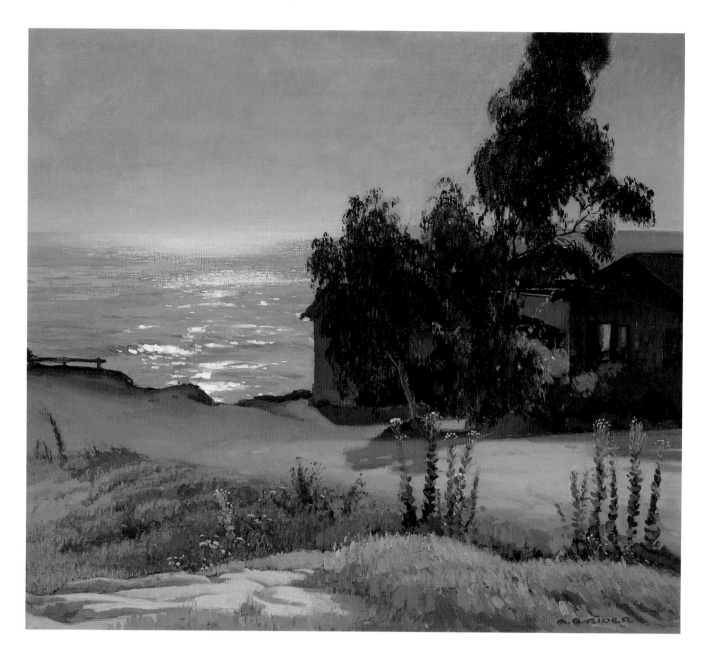

102 Arthur Grover Rider
 Oak Street, Laguna Beach, California, 1928

Eucalyptus

The landscapes of California have been greatly enriched by the acclimatization here of the eucalyptus. It is not often that the presence of an imported ingredient adds a really natural element to the charm of scenery; but the eucalyptus, especially the *globulus* variety that has become so common throughout the State, has so truly native an appearance that it seems as if its introduction from Australia must have been more in the nature of a homecoming than of an adoption. The wide, treeless plains and valleys which once lay unrelieved and gasping under the summer sun, and inspired similar sensations in the traveller, are now everywhere graced by ranks and spinneys of these fine trees, beautiful alike, whether trailing their tufty sprays in the wind, or standing, as still as if painted, in the torrid air.

When the winter rains come there are no trees that so abandon themselves to the spirit of the time. With wild sighs and every passionate action they crouch and bend as if in the very luxury of grief, and toss their tears to the earth like actors protesting their sorrows on a stage.

The long, scimitar-like leaves are as fine in shape as can be imagined, and each tree carries a full scale of colors in its foliage, – the blue-white of the new, the olive of the mature, and the brilliant russets and crimsons of the leaves that are ready to fall. The bark is as interesting as the foliage, its prevailing color a delicate fawn, smooth enough to take on fine tone reflections from soil and sky. Long shards and ropes of bark hang like brown leather from stem and branches, making a lively clatter as they rasp and chafe in the wind, and revealing, as they strip away, the dainty creams and greenish-whites of the inner bark.

The tree's habit of growth sets off its beauties to the best advantage, long-spaces of the trunk, arms, and smaller branches showing all their handsome colors and "drawing" between the dense plumes of foliage. In early summer the tree flowers with a profusion of blossoms uniquely tasteful, and later, the seed-vessels are as quaint and curious as rare sea-shells. To crown all, the tree is as fragrant as sandalwood, and the scent a hundred times more robust than that exotic perfume, which is fit only for seraglios and the effeminate paraphernalia of Mongolian decadence.

J. Smeaton Chase, *California Coast Trails*, 1913

Laguna Cañon

J. Smeaton Chase, *California Coast Trails*, 1913

Turning southward and rounding the outermost point of the San Joaquin Hills, we began to descend into the Laguna Cañon. Utilitarian reflections were not suffered entirely to occupy my thoughts. As we rode, my companion [the artist Carl Eytel] noted with a painter's instinct the broad simplicity of line and color. Yellow bays of stubble washed far up into the folds of the hills, and on their wide expanses solitary oaks or islands of brush were stamped in spots of solid umber. The gray thread of road stretched on before us, appearing and lapsing as it followed the gentle contours of the land; and over all a sky of pure cobalt had succeeded to the broken grays and purples of the morning.

At the head of the long descent to the coast lay a lagoon bordered with rustling tules and populated by files of water-fowl. Here and there a heron or a sandhill crane stood sunk in abysmal reflections. Brush began to cover the hillsides, the half-tone drabs and sages relieved with the uncompromising green of the tuna cactus, these last decorated with vivid yellow blossoms that sprouted like jets of flame from the edges of the lobes.

The cañon in its lower half is highly picturesque. Steep hills close it in, and curious caverns, some of them of large size, give a touch of mystery to their rocky sides. This quality of the scene was heightened when suddenly the sea-fog that lay continually in wait along the frontier of the coast, gaining a temporary advantage by some slackness of the enemy, poured over the mountain to the southwest and cast the whole mass into impressive gloom. On the instant the leaf was turned, brush was transmuted to heather, from California I was translated to Scotland. Fringes of sad gray cloud drooped along the summits or writhed entangled in the hollows of the hills. One who did not know the almost impossibility of rain at midsummer in this region would have declared that it was imminent. A strong breeze blew salty in our faces; but when by mid-afternoon we rode into the village of Laguna Beach, the sun held sway. So the unceasing warfare goes along this coast.

Laguna Beach is a main resort of California artists, and the next morning we devoted to a foregathering with certain of them who chanced to be painting in the neighborhood. Then there was great comparison of sketchbooks, and expositions upon line, balance, and mass: not even the spectrum was out of range. With Bohemian hospitality and a notable combustion of tobacco the hours sped away, until, soon after midday, we saddled up to move a short distance farther down the coast.
– J. Smeaton Chase, 1913

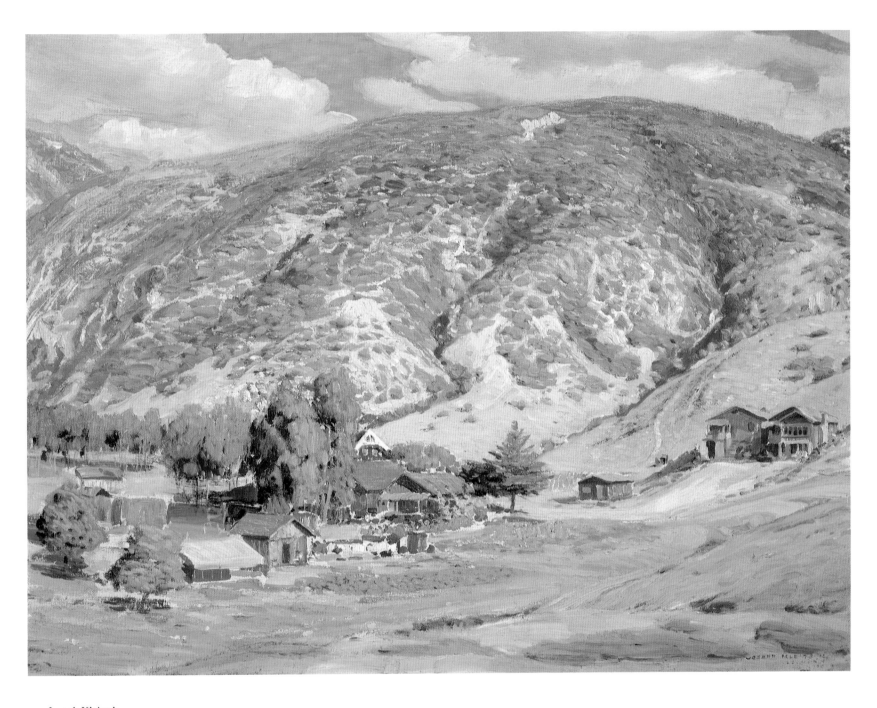

103 Joseph Kleitsch
 Laguna Beach, 1926

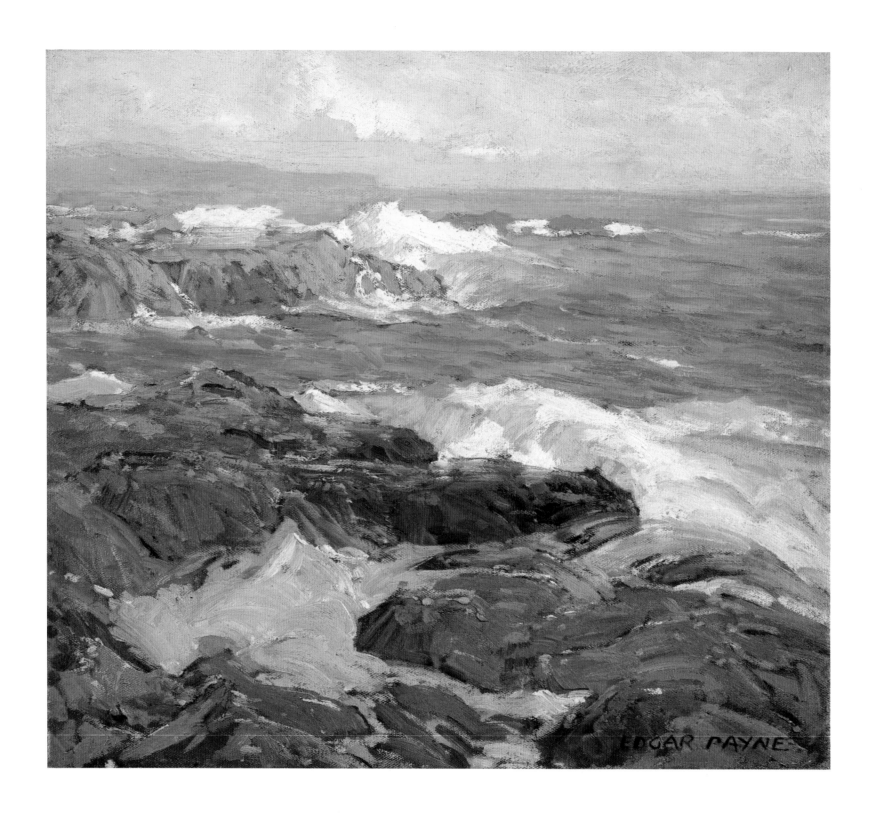

104 Edgar Alwyn Payne
Laguna Sea, n.d.

Hump-backed Whale

This being the spring season, all the . . . open ports upon the coast [were] filled with whales, that had come in to make their annual visit upon soundings. For the first few days . . . we watched them with great interest – calling out "there she blows!" every time we saw the spout of one breaking the surface of the water; but they soon became so common that we took little notice of them. They often "broke" very near us, and one thick, foggy night, during a dead calm, while I was standing anchor-watch, one of them rose so near, that he struck our cable, and made all surge again. He did not seem to like the encounter much himself, for he sheered off, and spouted at a good distance. We once came very near running one down in the gig, and should probably have been knocked to pieces and blown sky-high. We had been on board the little Spanish brig, and were returning, stretching out well at our oars, the little boat going like a swallow; our backs were forward (as is always the case in pulling), and the captain, who was steering, was not looking ahead, when, all at once, we heard the spout of a whale directly ahead. "Back water! back water, for your lives!" shouted the captain; and we backed our blades in the water and brought the boat to in a smother of foam. Turning our heads, we saw a great, rough, hump-backed whale, slowly crossing our fore foot, within three or four yards of the boat's stem. Had we not backed water just as we did, we should inevitably have gone smash upon him, striking him with our stem just about amidships. He took no notice of us, but passed slowly on, and dived a few yards beyond us, throwing his tail high in the air. He was so near that we had a perfect view of him, and, as may be supposed, had no desire to see him nearer. He was a disgusting creature; with a skin rough, hairy, and of an iron-grey color. This kind differs much from the sperm, in color and skin, and is said to be fiercer. We saw a few sperm whales; but most of the whales that come upon the coast are fin-backs, hump-backs, and right-whales, which are more difficult to take, and are said not to give oil enough to pay for the trouble. For this reason, whale-ships do not come upon the coast after them. Our captain, together with Captain Nye of the *Loriotte*, who had been in a whale-ship, thought of making an attempt upon one of them with two boats' crews, but as we had only two harpoons and no proper lines, they gave it up.

During the months of March, April, and May, these whales appear in great numbers in the open ports of Santa Barbara, San Pedro, etc., and hover off the coast, while a few find their way into the close harbors of San Diego and Monterey. They are all off again before midsummer, and make their appearance on the "off-shore ground." We saw some fine "schools" of sperm whales, which are easily distinguished by their spout, blowing away, a few miles to windward, on our passage to San Juan.

Richard Henry Dana, Jr., *Two Years Before the Mast*, 1840

San Juan

Richard Henry Dana, Jr., *Two Years Before the Mast*, 1840

Coasting along on the quiet shore of the Pacific, we came to anchor, in twenty fathoms' water, almost out at sea, as it were, and directly abreast of a steep hill which overhung the water, and was twice as high as our royal-mast-head. We had heard much of this place from the *Lagoda*'s crew, who said it was the worst place in California. The shore is rocky, and directly exposed to the south-east, so that vessels are obliged to slip and run for their lives on the first sign of a gale; and late as it was in the season, we got up our slip-rope and gear, though we meant to stay only twenty-four hours. We pulled the agent ashore, and were ordered to wait for him, while he took a circuitous way round the hill to the mission, which was hidden behind it. We were glad of the opportunity to examine this singular place, and hauling the boat up and making her well fast, took different directions up and down the beach, to explore it.

San Juan is the only romantic spot in California. The country here for several miles is high table-land, running boldly to the shore, and breaking off in a steep hill, at the foot of which the waters of the Pacific are constantly dashing. For several miles the water washes the base of the hill, or breaks upon ledges and fragments of rocks which run out into the sea. Just where we landed was a small cove, or "bight," which gave us, at high tide, a few square feet of sand-beach between the sea and the bottom of the hill. This was the only landing place. . . . What a sight, thought I, must this be in a south-easter! The rocks were as large as those of Nahant or Newport, but, to my eye, more grand and broken. Besides, there was a grandeur in everything around, which gave almost a solemnity to the scene: a silence and solitariness which affected everything! Not a human being but ourselves for miles; and no sound heard but the pulsations of the great Pacific! and the great steep hill rising like a wall, and cutting us off from all the world, but the "world of waters!" I separated myself from the rest, and sat down on a rock, just where the sea ran in and formed a fine spouting horn. Compared with the plain, dull sand-beach of the rest of the coast, this grandeur was as refreshing as a great rock in a weary land. It was almost the first time that I had been positively alone – free from the sense that human beings were at my elbow, if not talking with me – since I had left home. My better nature returned strong upon me. Everything was in accordance with my state of feeling and I experienced a glow of pleasure at finding that what of poetry and romance I ever had in me, had not been entirely deadened by the laborious and frittering life I had led. Nearly an hour did I sit, almost lost in the luxury of this entire new scene of the play in which I had been so long acting, when I was aroused by the distant shouts of my companions, and saw that they were collecting together, as the agent had made his appearance, on his way back to our boat.

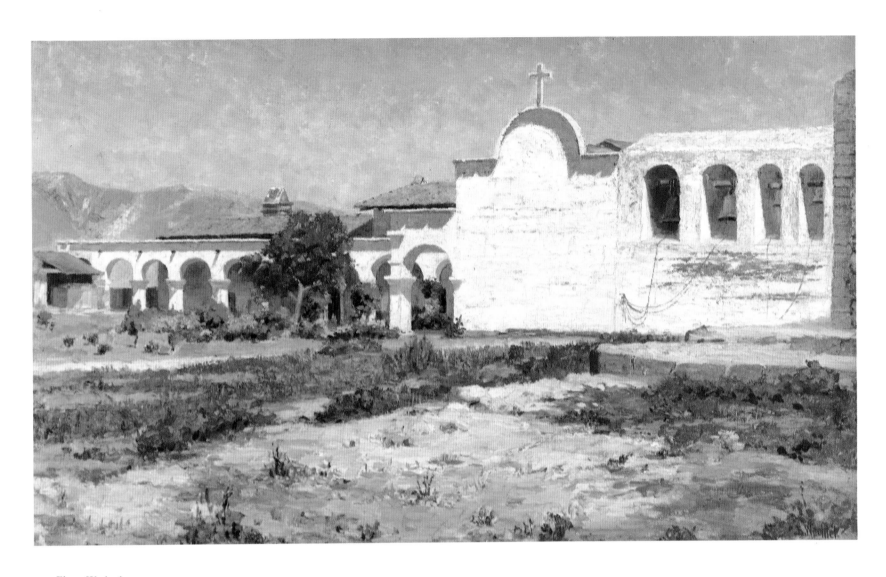

105 Elmer Wachtel
Capistrano Mission, c. 1900

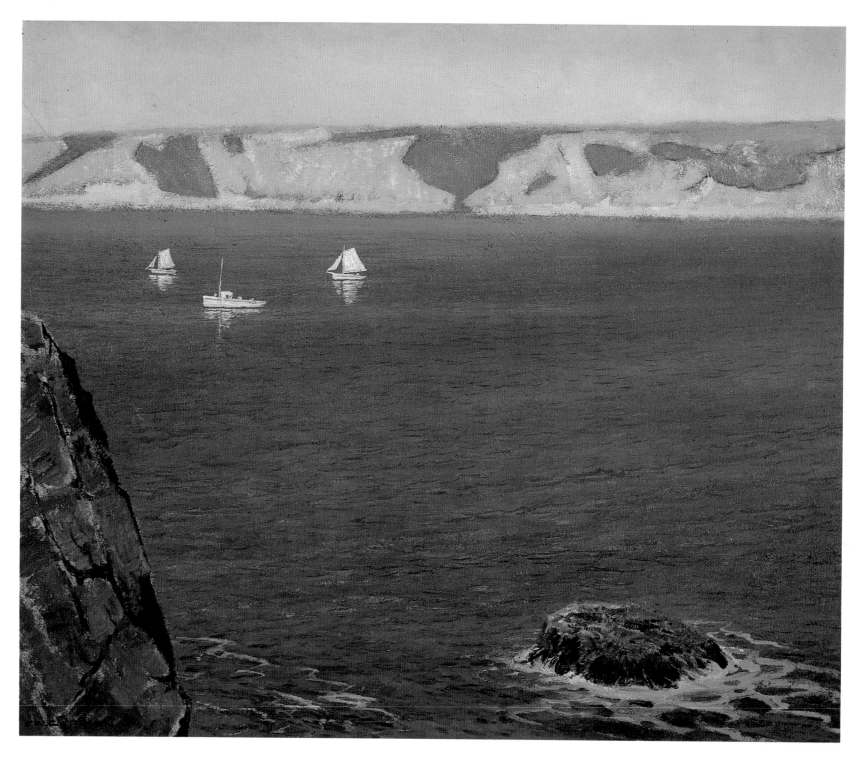

106 Frank William Cuprien
Shadows of Evening, La Jolla, n.d.

Sea Life at La Jolla

In the neighborhood of La Jolla – a sea-side resort with a cove with the sea-waves beating into deep and fantastic caves, made by wave-action into the face of the nearly perpendicular cliff – the bright-hued, gold-tinted, and bright-red and blue fish can often be seen, with seals basking in the outer edge of the cove, while schools of whales or porpoises sport out at sea, – a queer mingling of the sea-denizens of the warm seas of the tropics and the dark-blue, cold waters of the arctic regions, bringing up simultaneous visions of the bright coral reefs and cocoa-nut palms of the South and the chilly glaciers and icebergs of the far North. . . . These are conditions almost incomprehensible and irreconcilable when occurring together, and they must be seen to be appreciated. As stated by Charles Dudley Warner: it is incongruous that he should be looking at a date-tree while wearing his overcoat; and he is puzzled that a thermometrical heat that should enervate him elsewhere stimulates him here. "It is fraud," he says, "all this visible display of summer, and an almost summer at that; it is really a cold country."

P. C. Remondino, M.D., *The Mediterranean Shores of America*, 1892

Great golden sunfish doze upon the tides, flying fish go by in purple and silver streaks, and under the flat bays, which take, at times, color that rivals the lagoons of Venice, forests of kelp, acrawl with rainbow-colored life, sleep and sway upon tides unfelt of men.
– Mary Austin, 1914

A Smuggler's Complaint

George W. Eayrs, letter, 1813.
Eayrs was a contrabander.

Moste Noble & Excellent Sir, Vice Roy of Mexico: Being a Prisoner in this place [San Diego] and moste disagreeably situated, I have to deplore of Your Excellency as spedy relief as the nature of my captivity and dificulty of the times will admit of – My ship was taken possession of, by an armed party in a long Boat from the Ship Flora Dn Nicholas Noe belonging to Lima – I used no means of defence whatever, my sole visit here being for supplis –

Since being a Prisoner, I have been treated inhumanely, even so if the two Countrys had been at War – It is but about leaven Years since (by being left at Monterrey I passed this whole Continent, Via Mexico & the Havana, and I must confess I was treated with humanity – I have commanded the Ship Mercury, since January 1808, nearly six Years my Trade has been chiefly with the Russian Governor & the Savages on the N West Coast of America, In the Winter seasons, when the Weather has been blustering, I have run as far South as California for the purpose of Supplys, & one Year was imployed hunting Furs from Columbies River to this Coast – It is true, I have made a little Traffic with the Californians, & have not the least wish to conceal my whole Trade in this six Years, whatever damage it may lay me liable to. . . .

Haveing ben nearly seven months at the Russian settlement in Latd 57° North for the purpose of Repairing my ship . . . I directed my Course for the Russian settlement on New Albian in Latd 39 or 40° North, for the purpose of landing six Hogheads of molasses, & some Cloathing that the Governor had pute on board . . . he likewise pute on board, . . . a Box containing six Gold & Silver Watches, one of which was made a Present to him by the Emperor, all these to be left at Canton – for Repairs – The Cloaths I landed, but the Molasses, the Russian Commandr could not take, haveing no Boat fit for the purpose – After landing these Goods set sail for Monterrey, at which place I lay off two Days, but being a thik fog could not enter. . . . I set Sail for Point Conception, . . . where I arrived on the first of April June [sic], . . . The next morning at Day light, my ship was taken possession. . . .

I have a Young Female with me which I have had several Years, with whom I esteem equal the same as if I was lawfulle marryed to hir, and a Daughter, only twenty five Days old when the Ship was taken – The second Day after I arrd at this Place, I was Ordered on Shore with my little Family, & after overhawling my Trunks &c, was permitted to take them with me, with some Articles of Cookery. . . . On the 19 June I was sent for early in the morning by Arwayus [Arguello's] Son – said for the purpose of giveing in my Deposition – . . . A Kind of a Deposition was Written, but I no not what – while this was doing, I once wished to return to the House I lived at, but that was denied me – What was the basest of all, I found on my arrival at the House, my Girl packing up hir things & looking as if she had been beeten, while I was absent, a Padre, several Girls, Dr Nicholas, Clark & others, had been there and ordered hir to pack up

and leave the House amedeatly, that I was in confinment and would never see hir more. . . .

I send Yours Excellency here inclosed, an Invoice of the Mercury's Cargo, Provisions &c – The Furs I cannot estimate their Value, nor the Ship. The six Hogsheads of Molasses is going to ruin at Snt Barbara, & the six Watches I presume, will be of as little Value, as they cannot be repaired on this Continent – Those things belonging to the Russian Govenor, what ever may be concluded on my Ship & property, according to the owner again. . . .

Should the United States be oblige to go to War with Spain, I can expect nothing, In which case, I earnestly request the humanity of Your Excellency, to permit me to depart for the Russian Settlement, this will save great expence to Your Excellency, and relave both me and my little Family from distress and Prison –
. . . .

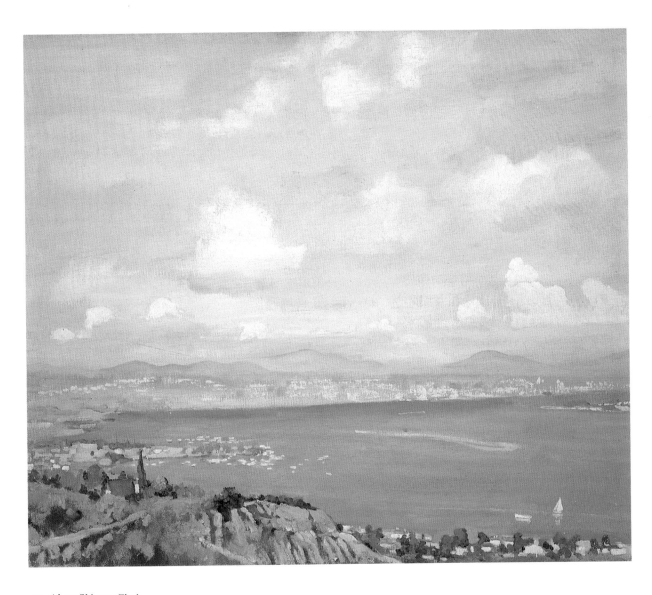

107 Alson Skinner Clark
San Diego Bay, c. 1935

Arriving at San Diego

J. Smeaton Chase, *California Coast Trails*, 1913

. . . We were practically at San Diego, the southern limit of our joint expedition. The event warranted an uncommon supper, and thereafter we lay at ease while we smoked and indulged the retrospective vein. The sky was all but cloudless, the stars shone cheerfully down, and the mild and friendly air for which San Diego is renowned invited us to pleasant slumber or equally pleasant reverie. A vagrant mosquito now and then sounded his unrelenting horn, but was easily discouraged or squashed. Even while we praised the charms of lying awake, we fell asleep, and when I awoke, the moon, her last quarter half spent, looked down on me from a stage of her journey that told me it was near morning. Before it was daylight the sky was overcast, for the sea-fog had come in on the wings of the morn, – an arrangement that is always agreeable to me, since it allows of breakfast being cooked without enduring a superfluous blast of sun. I confess I find the manufacture of flapjacks over a smoky fire, with a fervent sun castigating me from above, an exercise that puts too much strain upon the early morning temper.

The next day was Sunday, so we did not break camp. The peace of the day was somewhat disturbed by a promiscuous bombardment from the sportsmen of San Diego, who arrived early, and in unreasonable numbers, to bag the Mission doves and rabbits. We pastured the horses well out in the open where they would be in plain view, and ourselves sat in partial security under the lee of a scrap of adobe wall, gazing off at the mellow fragment of Western antiquity, with its romantic setting of waving palms and black and silver olives, and trying without too great exertion to call up to mind the long-past days when the scene that now lay so solitary before us was busy with cowled monks, Indian neophytes, and Spanish men-at-arms.

Early on Monday morning we set off westward down the valley, and came by the middle of the morning to the northern suburb of San Diego, which is called Old Town, in distinction from the modern city.

It lies at the head of the superb bay of San Diego, while the newer city occupies the middle sweep. Its great interest is the old mansion of the Estudillo family, a good example of the early Californian residence, which has lately been restored and is used as a tourist attraction. A small restaurant takes up one of the rooms, where genuine Spanish dishes are served by velvet-eyed senoritas. We called for *tamales*. . . .

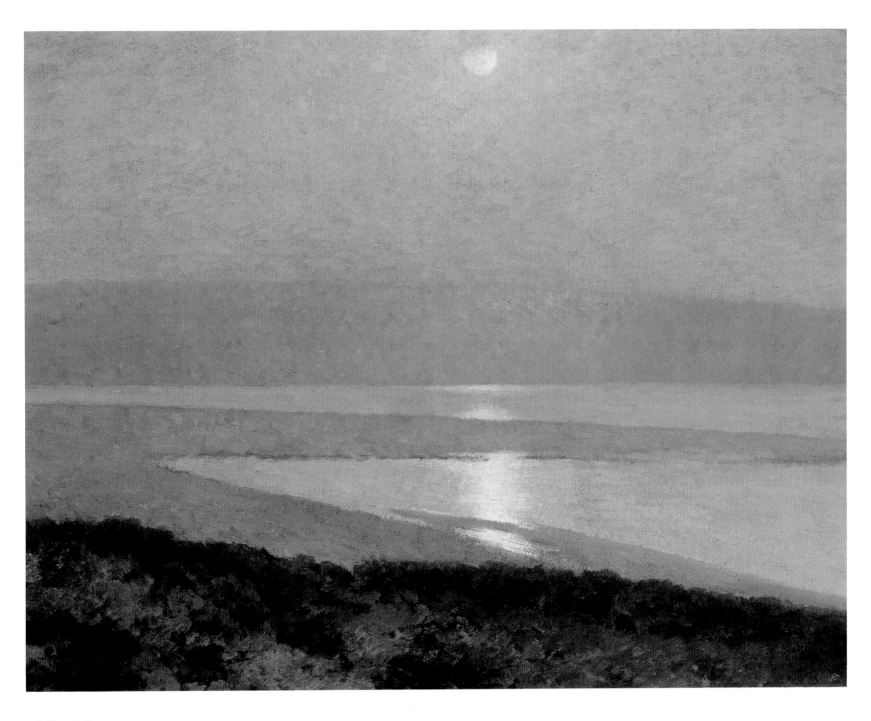

108 Maurice Braun
Moonrise, San Diego, n.d.

Harbor

J. Smeaton Chase, *California Coast Trails*, 1913

San Diego is a prosperous, energetic place, which is rapidly adding to its present population of some forty thousand contented people. I own I was best pleased to walk along the water-front by the rows of little amphibian huts that I remembered from former days. Flowers bloomed in cans and boxes all about these humble dwellings, and boats slapped idly on the water by the crazy landing-stages. Odors unnamed because unnamable greeted me with claims on my friendly remembrance, and the new generation of water-front children seemed no less arch and engaging than those of yore.

Three steamers lay at the wharves, and two large lumber schooners swung in the tideway. A knot of torpedo boats were anchored on the Coronado side of the bay. Point Loma, famous among Theosophists, stood up well and boldly, a worthy headland for the abutment of a sovereign state: and in the south, beyond the forlorn wastes of National City, rose wistful and pale the blue highlands of Mexico.

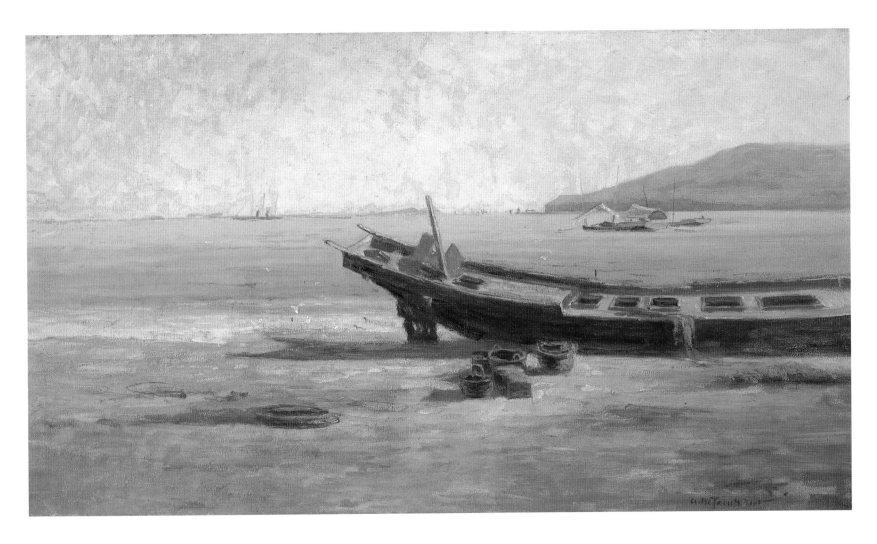

109 Ammi Merchant Farnham
 Chinese Boat, Point Loma in Background, c.1895

The Artists
Illustrations
Bibliography
Index

The Artists

Arthur William Best 1859–1935
Born near Petersboro, Canada, Best moved to San Francisco in 1895.

Albert Bierstadt 1830–1902
Born in Solingen, Germany, and brought to America by his parents at 2, Bierstadt first journeyed into the West in 1859 with the government survey expedition led by Colonel Frederick W. Lander. He studied in Rome and Düsseldorf for 4 years. He made two additional western journeys, including California, in 1863 and in 1871–73. His heroic, grandiose paintings of America's natural beauty awakened a sense of national pride. He is referred to as "the founder of the Western school of landscape painting."

Franz Arthur Bischoff 1864–1929
Born in Bomen, Austria, Bischoff immigrated to the United States in 1885. His early art training was in Vienna, and he first visited California in 1900. In 1906 he moved to Los Angeles and established a studio.

John Guzton de la Mothe Borglum 1867–1941
Born near Bear Lake, Idaho, Borglum went to Los Angeles at 17 with his family and worked as a lithographer. He studied in San Francisco with Virgil Williams and William Keith at the Mark Hopkins Institute. In Paris, at the Académie Julian and L'École des Beaux-Arts, he turned to sculpture. His most famous work is the heads of the presidents at Mount Rushmore.

Maurice Braun 1877–1941
Born in Nagy Bittse, Hungary, Braun immigrated with his family to America in 1881. Braun was a student of William Merritt Chase in New York. In 1910, he moved to San Diego, where he founded the San Diego Academy of Art. Henry

Joseph Breuer 1860–1932
Born in Philadelphia, Breuer settled in San Francisco in 1888 and painted along the coast from Santa Barbara to Oregon, working out of and living in a horse-drawn wagon. He studied art in Paris where he was influenced by Corot. Breuer was a member of the Bohemian Club.

George Douglas Brewerton 1827–1901
Born in Newport, Rhode Island, Brewerton was trained at West Point; when war with Mexico broke out, he was sent to California. His California sketches served later as the basis for his oil paintings and book illustrations.

Alburtus Del Orient Browere 1814–1887
Born in Tarrytown, New York, Browere was a largely self-taught historical painter. He voyaged to California in 1852 as a gold prospector and stayed 4 years. He often painted himself into his works as a red-shirted miner. In 1858 he returned to San Francisco.

Benjamin Chambers Brown 1868–1942
Born in Marion, Arkansas, Brown was trained as a photographer early in his life. He studied at the St. Louis School of Fine Arts and in Paris at Académie Julian. In 1896 he moved to Pasadena and turned his attention from portraiture to the local landscape.

Alson Skinner Clark 1876–1949
Born in Chicago, Clark studied with William Merritt Chase at the Art Students League in New York and in Paris at Académie Julian. He settled in Southern California in 1919; the following year, with Guy Rose, he formed the teaching faculty of Pasadena's Stickley Art School.

Henry Cleenewerck
Born in Walton, Belgium, Cleenewerck immigrated to California by way of Cuba in 1879. He was active as an artist in San Francisco until 1903.

Colin Campbell Cooper 1856–1937
Born in Philadelphia, Cooper was trained there at the Pennsylvania Academy of Fine Arts and at the Académie Julian, Vitti Academy, and L'École Delecluse in Paris. He first came to California in 1915; in 1921 he settled in Santa Barbara, where he was dean of painting at the School of Arts.

William Alexander Coulter 1849–1936
Born in Glenariff, County Cork, Ireland, Coulter went to sea at 13 and learned the details of every ship on which he sailed. In 1869, he arrived in San Francisco and worked as a sailmaker. Coulter was a largely self-taught artist except for 3 years of study in Europe.

Gordon Coutts 1868–1937
Born in Glasgow, Coutts studied art in Glasgow, London, and at the Académie Julian in Paris. In 1902, he moved to San Francisco, where he joined the Bohemian Club. He settled in Palm Springs in 1925.

Frank William Cuprien 1871–1948
Born in Brooklyn, Cuprien studied music and art in Munich, Paris, and Leipzig until 1905, when he left for America. He taught for 5 years at Baylor University in Texas and in 1910 he was lured to Laguna Beach, California, by his love of painting.

Marius Dahlgren 1844–1920
Born in Skelsior, Denmark, in 1844, Dahlgren studied at the Royal Academy in Denmark and immigrated to America in 1872. He moved from Salt Lake City to San

Jose, California, and then in 1878 to Oakland. He was a member of the San Francisco Art Association.

Edwin Deakin 1838–1923
Born in Sheffield, England, Deakin is believed to be a self-taught artist. He immigrated to America in 1856. In 1870 he moved to San Francisco, where he joined the Bohemian Club. Deakin is best known for his series of 21 California mission paintings. Although he saw the missions long after they had fallen to ruin, he painted them as he imagined they had originally appeared.

Gideon Jacques Denny 1830–1886
Born in Wilmington, Delaware, Denny worked as a sailor and arrived in San Francisco in 1849 with the Gold Rush. Denny was a pupil of Samuel Marsden Brookes.

Maynard Dixon 1875–1946
Born on a ranch near Fresno, California, Dixon studied in San Francisco with Arthur Frank Mathews and Raymond Yelland.

Mary Orwig Everett 1876–1948
Born in Mifflinburg, Pennsylvania, Everett moved to California in 1919 and maintained residences in Los Angeles and Laguna Beach. She was a student of William Merritt Chase in New York.

Ammi Merchant Farnham 1846–1922
Born in Silver Creek, New York, Farnham studied at the Munich Academy along with Frank Duveneck and at the Royal Academy of Bavaria at 18 years of age. He settled in San Diego in 1886.

Henry Chapman Ford 1828–1894
Born in Livonia, New York, Ford served in the Civil War and provided sketches for the illustrated press. He studied art in Paris and Florence. In 1875 he moved to Santa Barbara. His paintings and etchings of the missions were responsible for the revival of interest in California's Spanish heritage and, indirectly, for their restoration. In Santa Barbara, he was a respected teacher.

Victor Clyde Forsythe 1885–1962
Born in Orange County, California, Forsythe painted his first western landscape in 1904 from a train bound for New York. He studied at the Los Angeles School of Art and Design. Forsythe was famous for his cartoons and comic strips; he immersed himself in western folklore, often living in ghost towns.

Euphemia Charlton Fortune 1885–1869
Born in Sausalito, California, Fortune studied art at Edinburgh College of Art in Scotland and St. John's Wood School of Art in London. She was also a student of

Arthur Frank Mathews. Fortune returned to California in 1905. She was among the first to introduce the impressionist palette to California early in the century.

John Bond Francisco 1863–1931
Born in Cincinnati, Francisco settled in Los Angeles in 1887. He studied in Berlin, Munich, and at the Académies Julian and Colarossi in Paris. Francisco's career combined art and music; he formed the Los Angeles Symphony Orchestra in 1897. He was a pupil of Elmer Wachtel.

George Albert Frost 1843–?
Born in Boston, Frost attended the Royal Academy of Belgium. He was active as a painter in California from 1872 to 1889.

Henry Percy Gray 1869–1952
Born in San Francisco, Gray continued a family tradition – twelve of his British ancestors were artists. He studied at the School of Design under Emil Carlsen and in New York City with William Merritt Chase. Gray returned from New York to San Francisco in 1906 and lived in Burlingame, Alameda, and San Anselmo. He was a member of the Bohemian Club.

Deidrick Henry (Dick) Gremke 1860–1939
Born in San Francisco, Gremke was the pupil of Raymond Dabb Yelland at the School of Design; he was also a photographer. Gremke painted murals for the stations of the Santa Fe and Southern Pacific Railroads.

William Alexander Griffith 1866–1940
Born in Lawrence, Kansas, Griffith studied in Paris at the Académie Julian. In 1918 he visited the painter Benjamin Brown in Laguna Beach and moved there in 1920.

Carl Wilhelm (William) Hahn 1829–1887
Born in Ebersbach, Saxony, Germany, Hahn, at 14, studied at the Royal Academy of Art in Dresden and at the Düsseldorf Academy. Hahn was influenced by the painter Emanuel Leutze. Some of his first watercolors were purchased by the King of Saxony. In 1869 Hahn met William Keith in Düsseldorf and went with him in 1872 to San Francisco.

Armin Carl Hansen 1886–1957
Born in San Francisco, Hansen was instructed by his father Herman, a painter of the old West and frontier life. Hansen studied at the Mark Hopkins Institute under Arthur Frank Mathews and at the Royal Academy in Stuttgart. He taught at the University of California at Berkeley and settled in Monterey in 1913.

Herman Herzog 1831–1932
Born in Bremen, Germany, Herzog studied at the Düssel-

dorf Academy and established his reputation, with sales to nobility, including Queen Victoria. He immigrated to America in 1869. Herzog made his first trip to the West in 1873.

Thomas Hill 1829–1908
Born in Birmingham, England, Hill immigrated to America in 1844. He trained at the Pennsylvania Academy of Fine Arts in Philadelphia. Hill, Albert Bierstadt, and Virgil Williams became friends in Massachussets. In 1861 Hill journeyed overland from Massachussets to California and settled in San Francisco. In 1862 he made his first trip to Yosemite with William Keith and Williams. In 1865 Hill, Williams, and the photographer Carleton Watkins were commissioned by Frederick Law Olmsted to make a study of Yosemite and the Mariposa Redwood Grove to warrant their establishment as state parks. Hill is believed to have committed suicide.

Ransom Gillet Holdredge 1836–1899
Born in New York City, Holdredge came to California in the late 1850s and worked as a draughtsman at Mare Island Naval Yard. Holdredge studied in Paris. He is believed to have worked as a field artist for Scribner's Publications and to have been with Major Reno's troops at the time of the Custer massacre in 1876. He traveled extensively, living with various Indian tribes.

Ralph William Holmes 1876–1963
Born in La Grange, Illinois, Holmes came to Southern California in 1918. He studied in Paris and painted murals in Atascadero.

William Smith Jewett 1812–1873
Born in South Dover, Duchess County, New York, Jewett abandoned a promising career in New York to join the Gold Rush in California in 1849. He studied art at the National Academy of Design. Jewett is considered to be California's first professional portrait painter.

William Lees Judson 1842–1928
Born in Manchester, England, Judson immigrated to America with his family in 1852. He studied in New York City and at the Académie Julian in Paris. In 1893 he moved to California, where he was an art professor at the University of Southern California and founder of the University of Southern California College of Fine Arts.

William Keith 1838–1911
Born in Old Mendrum, Aberdeenshire, Scotland, Keith immigrated with his family to America in 1850 and was apprenticed to an engraver as a teenager. In 1858 he moved to San Francisco and established his own engraving business. Keith studied with San Francisco artist Samuel Marston Brookes and in Düsseldorf. In 1872 he met John Muir, who took him to the most remote areas of Yosemite.

Keith who settled in Berkeley, has been called "Dean of California Artists" and "California's Old Master."

John Ross Key 1832–1920
Born in Hagerstown, Maryland, Key was raised by his grandfather, Francis Scott Key, the author of "The Star Spangled Banner." Key studied art in Munich and Paris. In 1869 he moved to San Francisco.

Joseph Kleitsch 1885–1931
Born in Banad, Hungary, Kleitsch studied art in Budapest, Munich, and Paris. In 1920 he moved to California, settled in Laguna Beach, and established the Kleitsch Academy.

Lorenzo Palmer Latimer 1857–1941
Born in Gold Hill, California, in Placer County, Latimer settled in San Francisco and studied under Virgil Williams at the School of Design. He was a member of the Bohemian Club. In 1906 he taught at the University of California.

Paul Lauritz 1889–1976
Born in Larvik, Norway, Lauritz moved to Canada at 16 to live with his sister; he worked as a commercial artist. Lauritz studied art with the local and foreign artists in Larvik. The meager existence in commercial art led him to the Gold Rush in Alaska, where he was an unsuccessful miner. In 1919 he settled in Los Angeles.

Fernand Lungren 1857 or 1859–1932
Born in Hagerstown, Maryland, or Toledo, Ohio, Lungren studied under Thomas Eakins at the Pennsylvania Academy of Fine Arts and in Paris at the Académie Julian. In 1892 he visited Southwestern pueblos; he was made a member of several tribes. In 1905 he moved to Los Angeles and in 1907 settled in Santa Barbara.

Arthur Frank Mathews 1860–1945
Born in Markesan, Wisconsin, Mathews moved with his family to Oakland at 6. He studied at the San Francisco School of Design under Virgil Williams and at the Académie Julian in Paris. After the 1906 earthquake, he moved to San Francisco and became a central figure in the California Arts and Crafts movement. Mathews was a member of the Bohemian Club.

Thomas Moran 1837–1926
Born in Bolton, Lancashire, England, Moran immigrated with his family in 1844 to America, where he was apprenticed to a wood engraver. In 1871, he made his first trip West as a member of F. V. Hayden's expedition to Yellowstone, which persuaded Congress to declare the area the first national park. In 1922 he settled in Santa Barbara. Mount Moran in the Tetons and Moran Point in Yosemite were named for him.

Charles Christian Nahl 1818–1878
Born in Kassel, Germany, into a family of artists that dated back to the early seventeenth century, Nahl was christened Carl Christian Heinrich; in 1846 he took the name Charles. Nahl studied at the Kassel Academy and in Paris. With his family and August Wenderoth, Nahl left France in 1849 for America because of the turmoil caused by the French Revolution. In 1851, lured by the Gold Rush, he arrived in San Francisco. He spent a short time in the Yuba River Valley and began sketching miners. One of Nahl's best-known commercial works is the grizzly bear on the California state flag.

Erneste Narjot 1826–1898
Born in Saint Malo, France, Narjot joined the California Gold Rush in 1849. He studied art in Paris. Narjot made a mining expedition to Mexico, returning to San Francisco in 1865. While completing a commission to paint the ceiling of Leland Stanford's tomb at Stanford University, he splashed paint in his eyes and was permanently blinded.

Thomas Nash
Nash painted in Northern California at the turn of the century.

Karl Eugen Neuhaus 1879–1963
Born in Wuppertal, Germany, Neuhaus studied at the Royal Art School in Kassel and the Berlin Royal Institute for Applied Arts. In 1904 he immigrated to San Francisco. Neuhaus was head of the art department at the University of California at Berkeley and a member of the Bohemian Club.

Jules Pages 1867–1946
Born in San Francisco on May 16, 1867, Pages worked as an apprentice at his father's engraving business. He studied in Paris at the Académie Julian and later taught and served as its director. Pages remained in France for 40 years but returned often to paint and exhibit.

Edgar Alwyn Payne 1882–1947
Born in Washburn, Missouri, Payne was a self-taught artist. He first visited California in 1911. He produced a color motion picture called Sierra Journey. *Payne Lake in the Sierra is named for him.*

Harold G. Peelor 1856–1940
Born in New York City, Peelor moved to San Jose in 1900. Peelor usually painted towns in the San Jose area.

Carl von Perbandt 1832–1911
Born in Lagendorf, East Prussia, von Perbandt studied at the Düsseldorf Academy. He immigrated to America in 1870; in 1877 he moved to San Francisco. For 5 years he lived in the rural areas of Sonoma, Mendocino, and Humboldt counties, among the Pomo Indians. In 1903 von Perbandt returned to Germany.

Charles Rollo Peters 1862–1928
Born in San Francisco, Peters studied under Virgil Williams, Chris Jorgensen, and Jules Tavernier. He went to Paris and studied at L'École des Beaux-Arts and the Académie Julian. Upon his return, he settled in Monterey. He was a member of the Bohemian Club.

Hanson Duvall Puthuff 1875–1972
Born in Waverly, Missouri, Puthuff arrived in Los Angeles in 1903. He studied at the University of Denver Art School.

Granville Richard Seymour Redmond
1871–1935
Born in Philadelphia, Redmond was deafened by scarlet fever at 3. His family moved to San Jose, California, in 1874. Redmond attended the Berkeley School for the Deaf, then studied at the San Francisco School of Design with Arthur Frank Mathews and at the Académie Julian in Paris. In 1898 he moved to Los Angeles. His ability in sign language was put to good use in 1917 when he became a bit player in the silent movies. He became a close friend of Charlie Chaplin and was instrumental in perfecting Chaplin's pantomime technique. Redmond appeared in several movies; his most memorable role was that of the sculptor in City Lights.

Joachim Ferdinand Richardt 1819–1895
Born in Brede, Denmark, in 1819, Richardt studied at the Royal Academy in Copenhagen and established a reputation in his native land with sales of his paintings to the King of Denmark, the Russian czar, and British royalty. He arrived in New York City in the early 1850s. In 1875 he moved to San Francisco and soon discovered Yosemite.

Arthur Grover Rider 1886–1975
Born in Chicago, Rider settled in Laguna Beach in the early 1930s. He studied at the Chicago Academy of Fine Arts and later in Spain with Joaquin Sorolla.

William Frederick Ritschel 1864–1949
Born in Nuremberg, Germany, Ritschel studied at the Royal Academy in Munich. In 1895 he immigrated to America, and in 1911 he settled in Carmel.

Julian Walbridge Rix 1850–1903
Born in Peacham, Vermont, Rix moved with his family to San Francisco. Briefly, Rix was a pupil of Virgil Williams at the San Francisco School of Design, but he remained largely self-taught. He was a close friend of Jules Tavernier and was a member of the Bohemian Club. In 1888 Rix provided illustrations for John Muir's Picturesque California *of 1889.*

Guy Rose 1867–1925
Born in San Gabriel, California, Rose was the son of a former senator – a large landholder and a rancher in Southern California. Rose studied at the School of Design under Virgil Williams and Emil Carlsen and in Paris at the Académie Julian. In 1849 he was the first Californian to receive an award from the Paris Salon. In 1914 he moved to Pasadena and served as director at the Stickney Art School.

Frederick Ferdinand Schafer 1839–1927
Born in Germany, Schafer, a self-taught artist, painted in northern California after 1878.

Will Sparks 1862–1937
Born in St. Louis, Sparks studied in Paris at Académies Julian and Colarossi, supporting himself as an anatomical illustrator for Louis Pasteur. In 1886 he met Mark Twain at the St. Louis Exposition. Twain's vivid descriptions of California convinced Sparks to move to San Francisco in 1888. He maintained a studio in San Francisco and taught anatomy at the University of California's medical school. Sparks was a member of the Bohemian Club.

Elmer Wachtel 1864–1929
Born in Baltimore, Wachtel studied in New York with William Merritt Chase at the Art Students League and in London at the Lambeth School. In 1882 he moved to San Gabriel, California. He married Marion Kavanagh in 1904.

Marion Kavanagh Wachtel 1876–1954
Born in Milwaukee, Wisconsin, Wachtel came to San Francisco in 1903 employed by the Santa Fe Railway Company to paint landscapes in their ticket offices. She was a pupil of William Keith, who suggested she contact Elmer Wachtel upon moving to Southern California; the two were married in 1904.

James Walker 1818–1889
Born in Northamptonshire, England, Walker immigrated with his family to America in 1823. In his early 20s he left home and went to Mexico, where he became interested in the Spanish-American culture. When the war broke out between the United States and Mexico, he was imprisoned but escaped to the States. In the late 1860s he moved to California and concentrated on genre scenes of the Mexican culture.

Thaddeus Welch 1844–1919
Born in La Porte, Indiana, Welch moved to California in 1866 and studied under Virgil Williams. In 1874 he studied at the Royal Academy in Munich, where he, Frank Duveneck, and William Merritt Chase became close friends. In 1883 he married. He and his wife camped in the Marin County hills until they found an affordable cabin in San Geronimo Valley. Welch was a member of the Bohemian Club.

Frederick Wenderoth 1819–1884
Born in Kassel, Germany, Wenderoth studied under his father, Carl, and at the Kassel Academy. Wenderoth moved to New York in 1849 with the Nahl family. In 1851, lured by the Gold Rush, Wenderoth and the Nahls moved to California and settled in Sacramento. Later they moved to San Francisco where he worked primarily as a daguerrotypist and painter.

William Wendt 1865–1946
Born in Bentzen, Germany, Wendt was a self-taught painter. In 1906 he and his wife moved to Los Angeles. Wendt was often referred to as the "Dean of Southern California."

Virgil Williams 1830–1886
Born in Dixfield, Maine, Williams was a descendant of Roger Williams, founder of Rhode Island. He studied under Daniel Huntington in New York and in Rome with William Page. In 1862 he was commissioned to go to San Francisco to design and install an art gallery at Woodward's Gardens, a new amusement park in Mission Valley. He was an instructor at Mills Seminary, the California School of Design, and the University of California at Berkeley. In 1874 he served as director of the School of Design. Williams, William Keith, and Thomas Hill were close friends.

Theodore Wores 1859–1939
Born in San Francisco, Wores was one of the first pupils enrolled in the San Francisco School of Design where he studied under Virgil Williams. Later he studied in Munich at the Royal Academy with Frank Duveneck and William Merritt Chase. In 1898 he returned to San Francisco and became dean of the San Francisco Art Institute in 1907.

Raymond Dabb Yelland 1848–1900
Born in London, Yelland immigrated with his family to America at 3. He was born Raymond Dabb but added his mother's maiden name, Yelland. He studied at the National Academy of Design and in Paris. Yelland went to San Francisco in 1874 to teach art at Mills College in Oakland and in 1888 became director of the School of Design. He also taught drawing at the University of California at Berkeley.

Illustrations

Unless otherwise specified, the medium of the artwork is oil on canvas.

1 Charles Christian Nahl
California Grizzly Bear, c. 1856, watercolor on paper, 9 × 12 inches. Collection of the City of Monterey, California. Photography by Wei Chang Photography.

2 Arthur Frank Mathews
Discovery of Bay of San Francisco by Portola, 1896, 70¼ × 58½ inches. Signed and dated l/l: Arthur F. Mathews 1896. Collection of Garzoli Gallery, San Rafael, California. Photography by Cecile Keefe.

3 Herman Herzog
Seal Rock, San Francisco, California, c. 1874, 18 × 26 inches. Signed l/r: H. Herzog. Inscribed on verso: Seal Rock San Francisco California. Collection of Garzoli Gallery, San Rafael, California. Photography by Cecile Keefe.

4 Unknown Artist
The Golden Gate, 1879, oil on board, 12½ × 19⅛ inches. Inscribed l/r: The "Golden Gate", 12-10-79. Collection of The Fine Arts Museums of San Francisco. Museum purchase, Volunteer Art Acquisition Fund in honor of Director Emeritus Ian McKibbin White.

5 Raymond Dabb Yelland
The Golden Gate (Looking In), 1880, 40 × 72 inches. Signed and dated l/r: R. D. Yelland 1880. Inscribed on verso: "The Golden Gate" (Looking In). Collection of Garzoli Gallery, San Rafael, California. Photography by Cecile Keefe.

6 Charles Rollo Peters
Fisherman's Wharf, 1885, 22½ × 36½ inches. Signed and dated l/r: Chas. R. Peters 1885. Collection of Dr. Albert Shumate, San Francisco, California. Photography by Cecile Keefe.

7 William Alexander Coulter
San Francisco Fire, 1906, 60 × 120½ inches. Signed and dated l/r: W. A. Coulter San Francisco April 20, 1906. Collection of Hirschl and Adler Galleries, Inc., New York, New York. Photography by Helga Photo Studios.

8 Raymond Dabb Yelland
Cities of the Golden Gate, 1893, 55 × 96½ inches. Signed and dated l/l: R. D. Yelland 1893. Collection of University Art Museum, University of California at Berkeley. Gift of the artist.

9 Marius Dahlgren
Alameda County Courthouse, East Oakland, 1882, 11 × 17½ inches. Signed and dated l/r: Marius Dahlgren 1882. Collection of The Oakland Museum. The Oakland Museum Kahn Collection. Photography by M. Lee Fatherree.

10 Joachim Ferdinand Richardt
Oaks at Madison and 8th Streets, Oakland, California, 1869, 14¼ × 21¼ inches. Signed center l/l: F. Richardt. Collection of The Oakland Museum. Gift of Mr. Lester M. Hale. Photography by M. Lee Fatherree.

11 Carl Wilhelm (William) Hahn
Horses Grazing, Berkeley, California, 1875, 20 × 34¼ inches. Signed and dated l/r: Wm. Hahn San Francisco 1875. Collection of Anthony R. White.

12 Edwin Deakin
Outdoor Study on Strawberry Creek, 1892, 24 × 16 inches. Signed and dated l/l: Edwin Deakin 1892. Collection of The Oakland Museum. Miriam Dungren Cross Memorial Fund. Photography by M. Lee Fatherree.

13 William Keith
View of Bay from Piedmont (Reverend Joseph Worcester's House), 1883, oil on panel, 16 × 23½ inches. Signed and dated l/l: W. Keith '83. Collection of Harmon C. Bell, Piedmont, California. Photography by Cecile Keefe.

14 Arthur William Best
Mount Tamalpais, c. 1900, 20 × 28 inches. Signed l/l: A. W. Best. Collection of Nan and Roy Farrington Jones, Ross, California. Photography by Cecile Keefe.

15 Granville Richard Seymour Redmond
Lupine and Poppies, Marin, n.d., 25¼ × 30¼ inches. Signed l/l: Granville Redmond. Collection of Oscar and Trudy Lemer, Daly City, California. Photography by M. Lee Fatherree.

16 Thaddeus Welch
Marin County Hills, 1899, 20 × 36½ inches. Signed and dated l/r: T. Welch '99. Collection of The Fine Arts Museums of San Francisco. Bequest of Louis Sloss.

17 Erneste Narjot
Quail Hunting in Marin, 1877, 30 × 20 inches. Signed and dated l/l: E. Narjot California 1877. Collection of Dr. and Mrs. Edward H. Boseker, Santa Ana, California.

18 Henry Percy Gray
Marin Landscape, n.d., watercolor on paper, 19½ × 27½ inches. Signed l/l: Percy Gray. Collection of Dominican Sisters of San Rafael. Photography by Cecile Keefe.

19 Virgil Williams
View South from Sonoma Hills toward San Pablo Bay and Mount Tamalpais, 1864, 30¼ × 48 inches. Signed and dated l/r: Virgil Williams 1864. Private Collection. Photography by Cecile Keefe.

20 Virgil Williams
Mount St. Helena from Knight's Valley, n.d., 26 × 41½ inches. Signed l/l: V. Williams. Collection of The Oakland Museum. The Oakland Museum Kahn Collection. Photography by M. Lee Fatherree.

21 Jules Pages
Sonoma County Landscape, n.d., 12 × 18 inches. Signed l/l: Jules Pages. Collection of the family of Victor Reiter. Photography by M. Lee Fatherree.

22 Gideon Jacques Denny, *"City of Lakeport" on Clear Lake*, 1876, 22 × 36 inches. Signed and dated l/l: G. J. Denny 1876. Collection of Alfred C. Harrison, Jr.

23 Raymond Dabb Yelland
Russian River, Sonoma County, n.d., oil on board, 11 × 15 inches. Signed l/r: R. D. Yelland. Collection of the California Historical Society. Photography by Cecile Keefe.

24 Julian Walbridge Rix
Twilight Scene with Stream and Redwood Trees, n.d., 83½ × 46½ inches. Collection of The Oakland Museum. Bequest of Dr. Cecil E. Nixon. Photography by M. Lee Fatherree.

25 Carl von Perbandt
Pomo Indians Camped at Fort Ross, 1886, oil on canvas mounted on masonite, 54 × 84 inches. Signed and dated l/r: C. v. Perbandt Fort Ross '86. Collection of The Oakland Museum. The Oakland Museum Kahn Collection. Photography by M. Lee Fatherree.

26 William Keith
Mount Shasta, c. 1880, 23½ × 29½ inches. Signed l/r: W. Keith. Collection of Stanford University Museum. Gift of Carlotta Mabury in honor of her sister Eugenia Mabury Fosberg.

27 John Ross Key
Mt. Diablo, 1871, 11¼ × 23¾ inches. Signed and dated l/r: J. R. Key 1871. Private Collection. Photography by Scott McCue.

28 Julian Walbridge Rix
Upper Sacramento River, c. 1876, 30 × 60 inches. Signed l/l: J. W. Rix. Collection of Garzoli Gallery, San Rafael, California. Photography by Darcie Westerlund.

29 Carl Wilhelm (William) Hahn
Harvest Time, 1875, 36 × 70 inches. Signed and dated l/l: Wm. Hahn San Francisco 1875. Collection of The Fine Arts Museums of San Francisco. Gift of Mrs. Harold R. McKinnon and Mrs. Harry L. Brown.

30 Will Sparks
Late Sunset, n.d., 12 × 18 inches. Signed l/r: Will Sparks. Collection of The Oakland Museum. Gift of Gary Schnitzer. Photography by M. Lee Fatherree.

31 Alburtus Del Orient Browere
View of City of Stockton, 1858, 19 × 30 inches. Signed and dated l/l: A. D. O. Browere 1858. Inscribed on verso: "A view of the city of Stockton, California from a sketch painted on the spot, January 1854." Collection of Alfred C. Harrison, Jr. Photography by Scott McCue.

32 William Smith Jewett
Hock Farm, 1851, 28 × 39 inches. Collection of The Oakland Museum. Anonymous Donor. Photography by M. Lee Fatherree.

33 Albert Bierstadt
California Spring, 1875, 54¼ × 84¼ inches. Signed l/r: A. Bierstadt. Collection of The Fine Arts Museums of San Francisco. Presented to the City and County of San Francisco by Gordon Blanding.

34 Alburtus Del Orient Browere
The Lone Prospector, 1853, 25 × 30 inches. Signed and dated l/r: A. D. O. Browere 1853. Collection of David and Bernadette Packard. Photography by Cecile Keefe.

35 Charles Christian Nahl
and Frederick Wenderoth
Miners in the Sierras, c. 1851–52, 54½ × 67 inches. Signed l/r: Nahl & Wenderoth. Collection of the National Museum of American Art, Smithsonian Institution. Gift of the Fred Heilbron Collection.

36 Alburtus Del Orient Browere
Mokelumne Hill, 1857, 34½ × 40½ inches. Signed and dated l/l: A. D. O. Browere 1857. Collection of the Bancroft Library, Honeyman Collection, University of California, Berkeley, California.

37 John Guzton de la Mothe Borglum
Staging in California, 1889, 60 × 108 inches. Signed and dated center l/l: J. G. Borglum 1889. Collection of the Joslyn Art Museum, Omaha, Nebraska.

38 William Smith Jewett
The Promised Land—The Grayson Family, 1850, 50⅞ × 65 inches. Signed and dated l/l: W. S. Jewett 1850. Collection of Berry-Hill Galleries, New York, New York.

39 Frederick Ferdinand Schafer, *After a Snowstorm in the Sierra Nevada Mountains, near Summit Station, Central Pacific Railroad*, 1885, 23⅜ × 15⅝ inches. Signed and dated l/r: F. Schafer '85. Collection of Elisabeth-Waldo Dentzel, California. Photography by Christopher Bliss.

40 William Keith
Donner Pass, c. 1890, 40 × 60 inches. Signed l/r: W.

Keith. Collection of the Palm Springs Desert Museum. Museum purchase with funds provided by the Evert B. and Ruth Finley Person Foundation.

41 Herman Herzog
Indian Hogans in the California Sierra, 1874–75, 36×48 inches. Signed l/r: H. Herzog. The Anschutz Collection. Photography by James O. Milmoe.

42 Edwin Deakin
Mount Tallac, California, from Cascade Lake, 1877, 30×50 inches. Signed and dated l/r: Edwin Deakin 1877. Collection of the California Historical Society. Photography by Cecile Keefe.

43 Lorenzo Palmer Latimer
Glacier above Upper Angora Lake, near Fallen Leaf, Lake Tahoe, California, 1915, watercolor on paper, 14×11 inches. Signed and dated l/l: L. P. Latimer 1915. Collection of Joan T. Shonnard, Reno, Nevada. Photography by Kenneth G. Kruger.

44 Thomas Hill
Thomas Hill and Virgil Williams, with Wives, Fishing, c. 1873, 14×11 inches. Collection of Garzoli Gallery, San Rafael, California. Photography by Cecile Keefe.

45 Albert Bierstadt
Lake Tahoe, California, 1867, 22×30 inches. Signed and dated l/r: A. Bierstadt '67. Collection of the Museum of Fine Arts, Boston. Gift of Martha C. Karolik for the Karolik Collection of American Paintings.

46 Albert Bierstadt
The Hetch-Hetchy Valley, California, c. 1874–80, 37⁵/₁₆×58⁵/₁₆ inches. Signed l/l: A. Bierstadt. Collection of Wadsworth Atheneum, Hartford. Bequest of Mrs. Theodore Lyman in memory of her husband.

47 Thomas Hill
Yosemite Falls, n.d., 60½×36 inches. Signed l/r: T. Hill. Collection of The Oakland Museum. Bequest of Dr. Cecil E. Nixon. Photography by M. Lee Fatherree.

48 Thomas Moran
Vernal Falls, Yosemite Valley, 1913, 30×20 inches. Signed and dated l/l: Moran 1913. Collection of Montgomery Gallery. Photography by Cecile Keefe.

49 Albert Bierstadt
Sunrise, Yosemite Valley, n.d., 36³/₈×52³/₈ inches. Signed l/r: A. Bierstadt. Collection of The Amon Carter Museum, Fort Worth.

50 Thomas Hill
Our Camp, n.d., 12×18 inches. Signed l/r: T. Hill. Collection of The Oakland Museum. The Oakland Museum Kahn Collection. Photography by M. Lee Fatherree.

51 Herman Herzog
Mirror Lake, Yosemite, c. 1874–75, 25×30 inches. Signed l/l: H. Herzog. Collection of the Birmingham Museum of Art. Gift of Coe Kerr Gallery, Inc.

52 William Keith
Sierra Nevada Mountains, 1876, 40⁵/₈×72⁵/₈ inches. Signed l/l: W. Keith '76. Collection of The Thomas Gilcrease Institute of American History and Art, Tulsa, Oklahoma.

53 Edgar Alwyn Payne
Sierra (Mount Ritter/Lake Ediza), c. 1924, 24×28 inches. Signed l/r: Edgar Payne. Inscribed on verso: Trouts above Momoth [Mammoth]. Collection of Mr. and Mrs. Martin Medak, San Pedro, California. Photography by American Photo.

54 Albert Bierstadt
The Grizzly Giant Sequoia, Mariposa Grove, California, c. 1872–73, oil on paper mounted on cardboard, 30×20½ inches. Signed l/l: A. Bierstadt. Collection The Los Angeles Museum of Art. Gift of Dr. Robert G. Majer.

55 Henry Joseph Breuer
Southern Sierras, 1915, 36×42 inches. Signed and dated l/r: H. J. Breuer 1915. Collection of Joseph Szymanski, Pasadena, California. Photography by Newell Color Lab.

56 William Keith
Upper Kern River, 1876, 75⅛×123¼ inches. Signed and dated l/l: Wm. Keith San Francisco 1876. Collection of Stanford University Museum. Stanford Family Collection.

57 Edwin Deakin
Owens Valley, 1884, 24×46 inches. Signed and dated l/l: Edwin Deakin 1884. Collection of the California Historical Society. Photography by Cecile Keefe.

58 Alson Skinner Clark
Death Valley, c. 1929–30, 30×32 inches. Signed l/l: Alson Clark. Inscribed on verso: Alson Clark "Owens River Valley." Collection of Mr. and Mrs. Martin Medak, San Pedro, California.

59 Fernand Lungren
Death Valley, Dante's View, n.d., 26×60 inches. Collection of the University Art Museum, Santa Barbara, California. Fernand Lungren bequest.

60 George Douglas Brewerton
Jornada del Muerto, 1853, 30×44 inches. Signed and dated l/l: Brewerton 1853. Collection of The Oakland Museum. The Oakland Museum Kahn Collection. Photography by M. Lee Fatherree.

61 Fernand Lungren
Evening at Dry Lake, Mojave Desert, n.d., 24×50 inches. Signed l/l: Lungren. Collection of G. Breitweiser, Santa Barbara, California. Photography by William B. Dewey.

62 Gordon Coutts
Desert Wash, c. 1913, 16×20 inches. Signed l/l: Gordon Coutts. Collection of John F. Miller.

63 Guy Rose
Palms, c. 1918, 18¼×15 inches. Signed l/r: Guy Rose. Collection of Roy Rose.

64 Victor Clyde Forsythe
Morning, 1923, 25×30 inches. Signed l/r: Clyde Forsythe. Collection of FFCA, Morton H. Fleischer Collection.

65 George Albert Frost
Belmont House of William C. Ralston, 1874, 15×30 inches. Signed and dated l/r: G. A. Frost 1874. Collection of the California Historical Society. Photography by Cecile Keefe.

66 Raymond Dabb Yelland
Summer Morning near Los Gatos, 1879, 28×48 inches. Signed l/r: R. D. Yelland. Inscribed on verso: "Summer Morning near Los Gatos." Collection of Garzoli Gallery, San Rafael, California. Photography by Cecile Keefe.

67 Theodore Wores
Tree Blossoms, 1920, 36×48 inches. Signed and dated l/l: Theodore Wores 1920. Gift of Drs. Ben and Jeff Shenson and Mrs. Theodore Wores to the permanent collection of the city of Santa Clara. Photography by Pat Kirk.

68 Ransom Gillet Holdredge
Scene in the Santa Cruz Mountains, n.d., 48×30 inches. Signed l/l: R. G. Holdredge. Collection of The Oakland Museum. Gift of Mr. and Mrs. Fred Bacsik. Photography by M. Lee Fatherree.

69 Deidrich Henry (Dick) Gremke
Camp Teller, 1892, 48¼×24 inches. Signed and dated l/r: H. D. Gremke '92. Collection of The Oakland Museum. The Oakland Museum Kahn Collection. Photography by M. Lee Fatherree.

70 Euphemia Charlton Fortune
Monterey Bay, 1918, 30×40 inches. Signed and dated u/l: E. Charlton Fortune 1918. Private Collection. Photography by Christopher Bliss.

71 Henry Cleenewerck
Monterey, Chinese Fishing Village, c. 1880, 14½×30½ inches. Signed l/l: Henry Cleenewerck. Collection of David and Bernadette Packard. Photography by Cecile Keefe.

72 Arthur Frank Mathews
Monterey Pines, n.d., 23×26 inches. Collection of The Oakland Museum. Gift of Concours d'Antiques, Art Guild. Photography by M. Lee Fatherree.

73 Armin Carl Hansen
Salmon Trawlers, 1918, 46½×52½ inches. Signed and dated l/r: Armin Hansen '18. Collection of Mrs. Justin Dart, Pebble Beach, California.

74 Edwin Deakin
Mission San Carlos Borromeo de Carmel, 1895, 50×60 inches. Signed l/r: Edwin Deakin. Collection of the Seaver Center for Western History Research, Natural History Museum of Los Angeles County.

75 Karl Eugen Neuhaus
Whaler's Cove, Point Lobos, n.d., oil on wood pulp board, 17¾×23⅝ inches. Signed l/l: Eugen Neuhaus. The Buck Collection, Laguna Niguel, California. Photography by Cristalen and Associates.

76 William Frederick Ritschel
The Poet's Cove, 1915, 21×25 inches. Signed and dated l/l: W. Ritschel N.A. 1915. Inscribed on verso: "The Poet's Cove" W. Ritschel NA 1915 N. York. Collection of Ned H. Hong, Ross, California. Photography by Cecile Keefe.

77 Henry Percy Gray
California Poppies and Eucalyptus, 1925, watercolor on paper, 10×13¾ inches. Signed and dated l/r: Percy Gray 1925. Collection of Rob and Lore Kral, Oakland, California. Photography by Cecile Keefe.

78 Carl Wilhelm (William) Hahn
Ranch Scene, Monterey, California, 1875, 36×40 inches. Signed and dated l/r: Wm. Hahn San Francisco 1875. Collection of The Oakland Museum. The Oakland Museum Kahn Collection. Gift of Mr. and Mrs. Sidney L. Schwartz, to honor Dr. and Mrs. John J. Sampson and in the memory of Mr. and Mrs. William E. Gump. Photography by M. Lee Fatherree.

79 James Walker
Pastoral Scene, Salinas River Valley, c. 1850, 21×41½ inches. Signed l/l: J. Walker. Collection of the Pajaro Valley Historical Association.

80 Maynard Dixon
Prairie after Storm, 1921, 16×20 inches. Signed and dated l/l: Maynard Dixon Sandhill Camp May 1921. Private Collection. Photography by Christopher Bliss.

81 Alson Skinner Clark
The Fruit Pickers, 1922, 36×46 inches. Signed and dated l/l: Alson Clark '22. Private Collection.

82 Ralph William Holmes
Low Tide, Morrow [Morro] Bay, n.d., 27¼×31¼ inches. Signed l/r: Ralph Holmes. Inscribed on verso: "Low Tide, Morrow." Collection of the Trust Company of the West, Los Angeles, California. Photography by Christopher Bliss.

83 William Wendt
The Vineyard (Ranch near Morro Bay), 1926, 25×30 inches. Signed and dated l/r: William Wendt 1926. Collection of Joseph L. Moure, Pasadena, California.

84 Henry Chapman Ford
Glen Annie Canyon, 1879, 30×50 inches. Signed and dated l/r: H. C. Ford 1879. Collection of the Santa Barbara Historical Society Museum. Photography by William B. Dewey.

85 Henry Chapman Ford
Santa Barbara Harbor, 1884, 14×26 inches. Signed and dated center l/l: H. C. Ford Sta. Barbara Cal 1884. Private Collection. Courtesy of the Santa Barbara Museum of Art.

86 Hanson Duvall Puthuff
Transient Shadows, Sespe Canyon, n.d., 26×30 inches. Signed l/r: H. Puthuff. Inscribed on verso: "Transient Shadows Sespe Canyon H. Puthuff." The Buck Collection, Laguna Niguel, California. Photography by Cristalen and Associates.

87 John Bond Francisco
The Foothills of California, Tejon Ranch, Ventura County, n.d., 33½×46 inches. Signed l/r: J.Bond Francisco. Collection of Mr. Jason Schoen, Houston, Texas. Photography by M. Lee Fatherree.

88 Harold G. Peelor
San Fernando Valley, n.d., 16×24 inches. Signed l/r: H. G. Peelor California. Collection of Elisabeth-Waldo Dentzel, California. Photography by Christopher Bliss.

89 Benjamin Chambers Brown
Breezy Day—Pasadena, n.d., 16×20 inches. Signed l/r: Benjamin C. Brown. Private Collection. Photography by Christopher Bliss.

90 Franz Arthur Bischoff
The Bridge, Arroyo Seco, 1912, 30×40 inches. Signed l/r: Franz A. Bischoff. Private Collection.

91 Paul Lauritz
Old Los Angeles, 1922, 24×30 inches. Signed l/l: Paul Lauritz. Collection of The Fieldstone Company, Newport Beach, California.

92 Mary Orwig Everett
Misty Morning, c. 1926, 30×24 inches. Signed l/l: M. Everett. Inscribed on verso: "Misty Morning" Mary Everett 980 So. Manhattan Place. Collection of George Stern, Fine Arts, Encino, California. Photography by Casey Brown.

93 Thomas Nash
Hobo Camp, Los Angeles River, 1908, 18×24 inches. Signed and dated l/l: Thos. Nash 1908. Inscribed on verso: Hobo Camp Los Angeles River Sept. 1908. Collection of the Arlington Gallery, Santa Barbara, California.

94 Marion Kavanagh Wachtel
In San Gabriel Cañon, c. 1920, watercolor on paper, 18×24 inches. Signed l/r: Marion Kavanagh Wachtel. Collection of Joseph L. Moure, Pasadena, California.

95 Will Sparks
San Gabriel Archangel Mission, n.d., 16×26 inches. Signed l/r: Will Sparks. Collection of David and Bernadette Packard. Photography by Cecile Keefe.

96 Jules Pages
Baldwin Estate—Arcadia, n.d., 20×15 inches. Signed l/l: Jules Pages. Private Collection. Photography by Christopher Bliss.

97 Colin Campbell Cooper
Kimberly Crest, c. 1929, 29½×36 inches. Signed l/l: Colin Campbell Cooper. Collection of FFCA, Morton H. Fleischer Collection.

98 William Alexander Griffith
Santa Ana Canyon, 1928, 31½×41½ inches. Signed and dated l/r: William A. Griffith 1928. Private Collection. Photography by Christopher Bliss.

99 Erneste Narjot
Santa Catalina Island, 1889, oil on board. Signed and dated l/l: E. Narjot 1889 St. Catalina. Collection of Oscar and Trudy Lemer, Daly City, California. Photography by Cecile Keefe.

100 Alson Skinner Clark
Catalina, 1920, oil on panel, 7¼×9½ inches. Signed l/l: Alson Clark. Private Collection, Irvine, California.

101 William Lees Judson
Laguna Coast, n.d., 17¾×29⅝ inches. Signed l/r: W. L. Judson. Collection of the Trust Company of the West, Los Angeles, California. Photography by Christopher Bliss.

102 Arthur Grover Rider
Oak Street, Laguna Beach, California, 1928,
32½ × 36½ inches. Signed l/r: A. G. Rider.
Inscribed on verso: Laguna Beach Art Association/
Oak Street 1928. The Buck Collection, Laguna
Niguel, California. Photography by Cristalen and
Associates.

103 Joseph Kleitsch
Laguna Beach, 1926, 32 × 41 inches. Signed l/r:
Joseph Kleitsch Laguna. Collection of the Laguna
Federal Memorial Collection. Photography by
Christopher Bliss.

104 Edgar Alwyn Payne
Laguna Sea, n.d., 18 × 20 inches. Signed l/r: Edgar
Payne. Private Collection, Beverly Hills,
California.

105 Elmer Wachtel
Capistrano Mission, c. 1900, 15 × 25 inches. Signed
l/r: E. Wachtel. Collection of FFCA, Morton H.
Fleischer Collection.

106 Frank William Cuprien
Shadows of Evening, La Jolla, n.d., 24 × 28 inches.
Signed l/l: F. W. Cuprien. Inscribed on verso:
"Shadows of Evening, La Jolla" by F. W. Cuprien
Laguna Beach. Collection of Marlene and Jim
Vitanza, Peregrine Galleries, Santa Barbara,
California.

107 Alson Skinner Clark
San Diego Bay, c. 1935, 26 × 32 inches. Signed l/l:
Alson Clark. Private Collection Photography by
Christopher Bliss.

108 Maurice Braun
Moonrise, San Diego, n.d., 22 × 28 inches. Signed l/r:
Maurice Braun. Private Collection. Photography
by Adam Avila.

109 Ammi Merchant Farnham
Chinese Boat, Point Loma in Background, c. 1895,
14 × 24 inches. Signed l/r: A. M. Farnham. Collec-
tion of G. Breitweiser, Santa Barbara, California.
Photography by William B. Dewey.

Bibliography
Bracketed dates indicate date of original publication.
Asterisks indicate copyright permission pending.

AUSTIN, Mary. *Land of Little Rain*, Boston: Hough-
ton Mifflin Co., 1950 [1903].
———. *The Land of the Sun*, London: A and C.
Black, 1914.
———. "The Temblor," in David Starr Jordan,
ed., *The California Earthquake of 1906*, San Fran-
cisco: A. M. Robertson, 1907.
BADÈ, William Frederic. *The Life and Letters of John
Muir* [1868–1869], Vol. I, Boston and New York:
Houghton Mifflin Company, 1924.
BELL, Major Horace. Lanier Bartlett, ed. *On the Old
West Coast*, New York: William Morrow & Co.,
1930 [1881].
———. *Reminiscences of a Ranger*, Santa Barbara:
Wallace Hebberd, 1917 [1881].
BOLTON, Herbert Eugene. *Fray Juan Crespi: Mis-
sionary Explorer on the Pacific Coast 1769–1774*,
Berkeley: University of California Press, 1927.
BRYANT, Edwin. *What I Saw in California* [with
Frémont Party], New York: Appleton & Co.,
and Philadelphia: George S. Appleton, 1848.
CAUGHEY, John Walton. *Gold Is the Cornerstone* [first
published as *The California Gold Rush*], Berkeley
and Los Angeles: University of California Press,
1948.
——— and Laree Caughey, eds. *California Heri-
tage: An Anthology of History and Literature*,
Itaska, Illinois: F. E. Peacock Publishers, 1948.
CHALFANT, Willie Arthur. *The Story of Inyo*,
Bishop, California: Pinon Bookstore, revised edi-
tion, 1933 [1922].
CHASE, J. Smeaton. *California Coast Trails: A Horse-
back Ride from Mexico to Oregon*, Boston and New
York: Houghton Mifflin Company, 1913.
———. *California Desert Trails*, Boston, New York:
Houghton Mifflin Co., 1919.
CLAPP, Louise. "The Shirley Letters from the Cali-
fornia Mines," in Jonathan Eisen and David
Fine, eds., *Unknown California*, New York: Mac-
millan, 1985 [1852].
CLELAND, Robert Glass. *The Cattle on a Thousand
Hills: Southern California 1850–1880*, San Marino:
The Huntington Library, 1951 [1941].
Reprinted with permission of the Henry E.
Huntington Library.
CORNELIUS, Brother. *Keith: Old Master of Califor-
nia*, New York: G. P. Putnam's Sons, 1942
[1875].
DANA, Richard Henry, Jr. Harold A. Small, ed.
Two Years Before the Mast, New York: Signet, New
American Library, 1964 [1840]. Includes
"Twenty-Four Years After" [1859].
DAVIS, William Heath. *Seventy-five Years in Califor-
nia*, San Francisco: John Howell—Books, 1929
[1889].
DEFLOT DE MOFRAS, Eugène. *Exploration du terri-
toire de l'Oregon, des Californies et de la mer Vermeille*

[1844], translated in Marguerite Eyer Wilbur, ed., *Deflot de Mofras' Travels on the Pacific Coast* [1937], and reprinted in John Walton and Laree Caughey, eds., *California Heritage: An Anthology of History and Literature*, Itaska, Illinois: F. E. Peacock Publications, 1948.

EISEN, Jonathan, and David Fine, eds., *Unknown California*, New York: Macmillan, 1985.

FARQUHAR, Francis P. *History of the Sierra Nevada*, Berkeley and Los Angeles: University of California Press in collaboration with the Sierra Club, 1965.

———, ed. *Up and Down California in 1860–1864: The Journal of William H. Brewer*, Berkeley and Los Angeles: University of California Press, 1966 [1930].

FERRIER, William Warren. *The Story of the Naming of Berkeley*, Berkeley: William Warren Ferrier, 1929 [pamphlet reprint of December 1928 and January 1929 *Berkeley Daily Gazette* articles].

FONT, Pedro. *Complete Diary of Anza's California Expeditions*, translated and edited by Herbert Eugene Bolton, Berkeley: University of California Press, 1933 [1776].

GEORGE, Henry. "What the Railroads Will Bring Us," in Jonathan Eisen and David Fine, eds., *Unknown California*, New York: Macmillan, 1985 [1868].

GRAHAM, Margaret Collier. *Stories of the Foot-Hills*, Boston and New York: Houghton Mifflin Company, 1895.

HALLEY, William. *The Centennial Year Book of Alameda County, California*, Oakland: William Halley, 1876.

HENDRICKS, King, and Irving Shepard, eds. *Letters from Jack London*, New York: Odyssey Press, 1965, letter to Cloudesley Johns, 23 February 1902, reprinted in Leslie Mandelson Freudenheim and Elisabeth Sussman, *Building with Nature: Roots of the San Francisco Bay Region Tradition*, Santa Barbara and Salt Lake City: Peregrine Smith, Inc., 1974.

HIGUERA, Prudence, *Century*, 1890, in John Walton Caughey and Laree Caughey, *California Heritage: An Anthology of History and Literature*, Itaska, Illinois: F. E. Peacock Publishers, 1948.

HOLLIDAY, J. S. *The World Rushed In*, New York: Simon and Schuster, 1980.*

JACKSON, Joseph Henry. *Anybody's Gold*, New York, London: D. Appleton-Century Co., Inc., 1941.

———, ed. *Gold Rush Album*, New York: C. Scribner's Sons, 1949.

JAMES, George Wharton. Revised by Edith E. Farnsworth. *The Lake of the Sky: Lake Tahoe in the High Sierras of California and Nevada*, Boston: L. C. Page and Co., 1928 [1915].

JEFFERS, Robinson. *Roan Stallion, Tamar, and Other Poems*, New York: Horace Liveright, 1925.*

KEELER, Charles. *The Simple Home*, San Francisco: P. Elder and Company, 1904.

KING, Clarence. Francis P. Farquhar, ed. *Mountaineering in the Sierra Nevada*, New York: W. W. Norton & Company, Inc., 1935 [1871].

KING, Reverend Thomas Starr. *Christianity and Humanity*, Boston: Houghton Mifflin [1863].

LE CONTE, Joseph. *A Journal of Ramblings through the High Sierra of California by the University Excursion Party*, New York: Sierra Club/Ballantine Books, 1971 [1875].

LEWIS, Oscar. *Here Lived the Californians*, New York: Rinehart, 1957.

LILLARD, Richard G. *Eden in Jeopardy*, New York: Alfred A. Knopf, 1966.*

LINDLEY, Walter, M.D., and Joseph Widney, M.D., *California of the South*, New York: D. Appleton and Company, 1888.

LONDON, Jack. *The Valley of the Moon*, Santa Barbara and Salt Lake City: Peregrine Smith, 1975 [1913].

LUDLOW, Fritz. *The Heart of the Continent: Seven Weeks in the Great Yo-semite*, *The Atlantic Monthly*, 13, June 1864.

MARGOLIN, Malcolm, ed. *The Way We Lived*, Berkeley: Heyday Books, 1981.

MERRIAM, C. Hart. *The Dawn of the World*. Fairfax, California: Tamal Land Press, 1976 [1910].

MILLER, Joaquin. *Unwritten History: Life Among the Modocs*, Eugene, Oregon: Orion Press, 1972 [1873].

MUIR, John. *The Mountains of California*, New York: The Century Co., 1922 [1894].

———. *The Yosemite*, Garden City, N.Y.: The Natural History Library, Anchor Books, Doubleday & Company, Inc., published in cooperation with The American Museum of Natural History, 1962 [1912].

NORDHOFF, Charles. *California: For Health, Pleasure, and Residence* [1874] and *Northern California, Oregon and the Sandwich Islands* [1875] reprinted in *Nordhoff's West Coast: California, Oregon and Hawaii*, London and New York: KPI, 1987.

NORRIS, Frank. *The Octopus: A Story of California*, Garden City, N.Y.: Doubleday & Company, Inc., 1901.

PALMER, Lyman L., *History of Napa and Lake Counties*, San Francisco: Slocum, Bower and Co., 1881.

PATENCIO, Chief Francisco, as told to Margaret Boynton, *Stories and Legends of the Palm Springs Indians*, Palm Springs: Palm Springs Desert Museum, 1943.

RADIN, Max, ed. "The Stone and Kelsey 'Massacre' on the Shores of Clear Lake in 1849: The Indian Viewpoint," *California Historical Society Quarterly*, Vol. 11, No. 3, September 1932.

RAMSEY, Jarold, ed. *Coyote Was Going There: Indian Literature of the Oregon Country*, Seattle: University of Washington Press, 1984.

REISNER, Marc. *Cadillac Desert: The American West and Its Disappearing Water*, New York: Viking, 1986.*

REMONDINO, Peter Charles, M.D. *The Mediterranean Shores of America: Southern California: Its Climatic, Physical, and Meteorological Conditions*, Philadelphia: F. A. Davis Co., 1892.

ROSALES, Vincente Pérez, *Rescuerdos del pasado*, in John Walton Caughey and Laree Caughey, eds., *California Heritage: An Anthology of History and Literature*, Itaska, Illinois: F. E. Peacock Publishers, 1948 [1890].

ROYCE, Josiah. Introduction by J. Loewenberg. *Fugitive Essays*, Freeport, New York: Books for Libraries Press, 1968 [1879].

San Luis Obispo Holiday Tribune, January 1, 1882, pp. 1–4.

STEINBECK, John. *East of Eden*, New York: Penguin, 1986 [1952].*

STEVENSON, Robert Louis. *The Amateur Emigrant: From the Clyde to Sandy Hook*, Chicago: Sonte and Kimball, 1895.

———. *The Silverado Squatters*, London: Chatto and Windus, 1883.

STEWART, George. *Ordeal by Hunger: The Story of the Donner Party*, Boston: Houghton Mifflin Company, 1936.

TAYLOR, Bayard. *Eldorado, or Adventures in the Path of Empire*, New York: Alfred A. Knopf, 1949 [1850].

TEALE, Edward Way, ed. *The Wilderness World of John Muir*, Boston: Houghton Mifflin Co., 1954.

TWAIN, Mark [Samuel Clemens]. "Letter 24," *Alta Californian*, June 2, 1867.

———. *Roughing It*, New York, Evanston, and London: Harper and Row, 1871.

VON KOTZEBUE, Captain Otto. *Journal*, in R. A. Thompson, *Fort Ross: The Russian Settlement in California*, Oakland: Biobooks, 1951 [1824].

WILBUR, Marguerite Eyer, ed. *Vancouver in California 1792–1794: The Original Account of George Vancouver*, Vol. 1, Los Angeles: Glen Dawson, 1953.

WOLF, Linnie Marsh. *Son of the Wilderness: The Life of John Muir*, New York: Alfred A. Knopf, 1945.

The WPA Guide to California: The Federal Writer's Project Guide to 1930s California, New York: Pantheon, 1984 [1939].

Bibliography for *The Artists*

BAIRD, Joseph A., Jr. *The West Remembered: Artists and Images, 1837–1973*, San Francisco: California Historical Society, 1973.

DAWDY, Doris Ostrander. *Artists of the American West: A Biographical Dictionary of Artists before 1900*, Vol. 3, Athens, Ohio: Swallow Press, 1985.

HARRISON, Alfred C., Jr. *William Keith: The Saint Mary's College Collection*, Ann Harlow, ed. Moraga, California: Hearst Art Gallery, Saint Mary's College, 1988.

HUGHES, Edan Milton. *Artists in California, 1786–1940*, San Francisco: Hughes Publishing Company, 1986.

MILLER, Dwight. *California Landscape Painting, 1860–1885: Artists around Keith and Hill*, Stanford: Stanford University Museum of Art, 1971.

MONTGOMERY GALLERY. *Visions of the Last Frontier*, San Francisco: Montgomery Gallery, 1987.

PORTER, Bruce, et al. *Art in California*, San Francisco: R. L. Bernier Publishers, 1916.

VAN NOSTRAND, Jeanne. *The First Hundred Years of Painting in California, 1775–1885*, San Francisco: John Howell – Books, 1980.

WESTPHAL, Ruth Lilly. *Plein Air Painters of California: The North*, Irvine, California: Westphal Publishers, 1982.

———. *Plein Air Painters of California: The Southland*, Irvine: California: Westphal Publishers, 1986.

ZAKIAN, Michael, and Katherine Plake Hough. *California's Western Heritage*, Palm Springs: Palm Springs Desert Museum, 1986.

Index

This book was designed by Jack Werner Stauffacher of the Greenwood Press, San Francisco, California. Type is Kis-Janson & digital composition by Wilsted & Taylor Publishing Services, Oakland, California. Color separation, printing, and binding by Toppan, Japan, through Overseas Printing Corporation.